WALLS
of
FAME

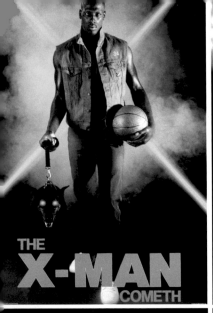

THE
X-MAN
COMETH

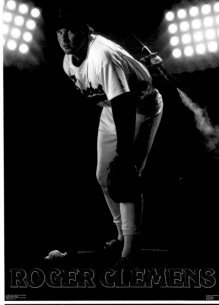

ROGER CLEMENS

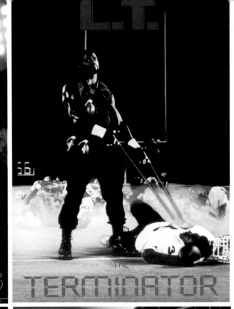

L.T.
TERMINATOR

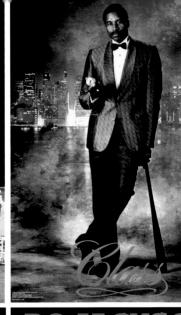

CHICAGO
VICE

DOMINIQUE WILKINS

21 DUNK ST

NIQUE

DOMINATION ALLEY

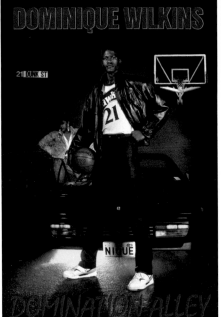

ANDRE DAWSON

WRIGLEY F
HOME OF
CHICAGO C
PORTS SH

THE
HAWK

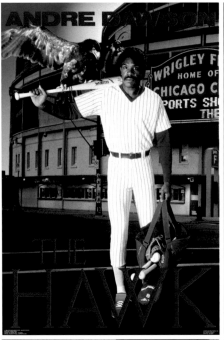

BO JACKSO

JACKSON

34

BLACK & BL

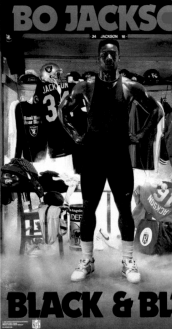

S P A C E
THE FINAL FRONTIER

MICHAEL JORDAN

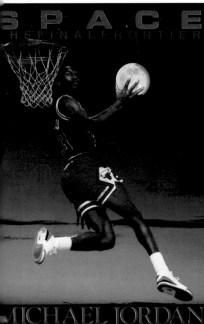

THE LAND OF
BOZ

MONSTER D.B
44

BOZKIN
44

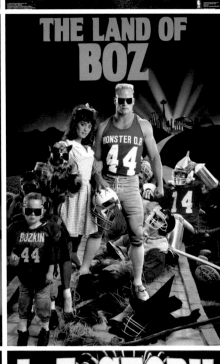

ERIC DAVIS

44
MAGNUM

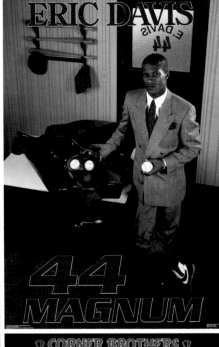

JOSE
CANSECO M
McGW

THE
BASH BROTHE

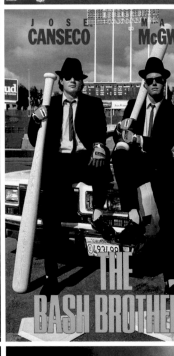

THE
FAMILY BUSINESS

GRIFFEY
SON

L.A. STORY

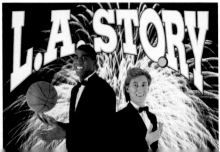

CORNER BROTHERS
PRESENTS
Frank Minnifield and Hanford Dixon as

MM

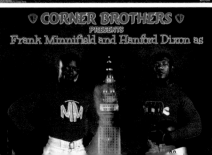

34

The Unforgettable Sports Posters of the Costacos Brothers

WALLS
of
FAME

John and Tock Costacos

Foreword by Chris Berman

TABLE
of
CONTENTS

You start with a wall. It's blank. Maybe two walls, or even three. They're all blank, or at least barren. Now what?

If it was the mid- to late '80s through the early '90s and you were a sports fan, you knew exactly what to do. If you were, say, 12 years old, maybe these are the walls of your bedroom. If you're 20, maybe they're the walls of your college dorm or your college apartment's living room (if you could really call it that). If you're older, maybe it's indeed your den, where you might watch the games on television. Maybe it's your garage.

Wherever it is, it's *your* space. You're not painting. You sure as hell aren't wallpapering. Maybe some curtains. But again the question: *Now what?*

The answer: Costacos Brothers posters. They weren't just any sports posters. We all love game-action shots, but we had *those*. What we didn't have was *these*.

Posters of the biggest sports stars, from all the sports. Appearing bold. Appearing brash. Maybe appearing funny. Appearing away from the field, at least for the most part. But appearing as you might imagine they could. Or maybe appearing as the athletes wish they could. Complete with a nickname of sorts—so you *know* that got my immediate seal of approval back in the day. And to this day.

In the '80s and the '90s, your wall dilemmas were now solved, in an instant. Colorful, with an attitude. With a statement. Voilá!—we were now our own wall artists. Thanks to the Costacos Brothers posters.

We could group them by sports. We could mix our sports. We could have just one or two, as if we installed our own spotlights and track lighting to highlight a certain painting. We could have a six-pack—of posters, I mean. We could do all the walls, or just one. More than one room, or just one. It wasn't like there were just several posters a year to choose from. Once they started rolling, these posters were like the singles of the early rock 'n' rollers of the '50s and '60s, who churned out hit record after hit record on the AM radio charts seemingly every month. Or maybe a better analogy: Selecting your Costacos Brothers posters was literally like going to a paint store, where there are so many hues to choose from.

Oh, and by the way, they were so affordable. Nobody minded standing on a chair, however precariously, or even on a three-step ladder to put the posters up. They were *our* statements. They were *our* artwork. And all of our friends complimented us on it, because they had their own versions of a theme.

The Costacos boys are from Seattle, so there were plenty to choose from with a Pacific Northwest theme. Steve Largent, Kenny Easley, Curt Warner—yes, *that* Curt Warner—and, of course, the Boz from the Seahawks. Junior Griffey and Randy Johnson from the Mariners. Shawn Kemp, Dale Ellis, and Xavier McDaniel from the then-sky-high SuperSonics.

The greatest players of that era all thought it was cool to have their own poster. Joe Montana, Jerry Rice, Walter Payton, Barry Sanders, Junior Seau, Ronnie Lott, and John Elway. These and so many more who would be future pro football Hall of Famers. They were already your Wall of Famers.

Kirby Puckett and Rickey Henderson. Michael Jordan and Magic Johnson. Wayne Gretzky. They are all poster children of their sport. They were already your posters.

Some had players with their own nicknames. Deion Sanders: Prime Time. Reggie White: the Minister of Defense. Roger Clemens: the Rocket. Andre Dawson: the Hawk. Larry Bird: the Legend.

Others were a play on their nicknames or their real names: Jim Kelly: Machine Gun Kelly. Warren Moon: Moonlighting. Karl Malone: Special Delivery. Dominique Wilkins: the Highlight Zone.

Others had monikers that were just perfect. Lawrence Taylor: the Terminator. Rickey Henderson: the Man of Steal. Jackie Joyner-Kersee: Quantum Leap. Jim McMahon was a Costacos favorite and appeared several times. What was better for Jimmy Mac than "I Shall Return"?

I was 31 when the first of these brilliant posters came out in 1986, so I never had the chance to use them in my room as a 12-year-old. I had magazine cutouts back in the days of Willie Mays, Joe Namath, and many others on my walls,

along with a *National Geographic* map of the United States. (After all, it's always good to know where you are.)

I never had the chance to use them in my college room. They would've looked great with my lava lamp, little fridge, and Farrah Fawcett poster. (Aw, c'mon, we *all* owned that one.)

I did have the chance, as a young man at ESPN, to see them take over sports fans' personal decorating preferences by storm. Just like when we started as an interesting concept and a "who knows—let's hope" idea on primitive cable television in 1979, I could recognize this being a similar venture. Maybe somewhat like us, this "Little Engine That Could" poster idea grew by leaps and bounds right in front of our very eyes. Very much wanted, and even *needed*.

The phone rang in the early '90s, and it was John Costacos, pitching an idea—for me! After I told him he was crazy, he said he had visions of a poster called "The Bermanator." I was honored and awed. And, boy, did we have a great time shooting it. I even got to wear those hot sunglasses of the day, Gargoyles, huge in the Seattle area mainly because the Boz thought they were cool. It was to promote *ESPN Sunday Night Football* and the shows that I hosted. Budweiser, behind Paul Stoddart, jumped aboard, and soon this poster was everywhere.

A decade later, John called me again. This wasn't as much of a surprise, because we had long since become great friends and stayed in touch. What he said on the phone was a surprise. "I want to come out of poster retirement," he said, "even if it's just for one. It's not to launch anything again, or even about making money. It's really just for fun." Which, of course, it had been all along for them. So? Who is it? "It's you," he said. "I have this great idea that you're the Gridfather, dressed like Al Pacino in *The Godfather*, right down to the knuckle ring. We could do it with ESPN to promote all of your football shows—*NFL Countdown, NFL PrimeTime*, and, of course, 'The Swami.'" Humbled again, I called our ESPN marketing guru, Aaron Taylor, who was

involved with the "Bermanator." He jumped at it, so we all jumped at it. I can't take a lot of credit, but like all the other Costacos posters, it was pure genius.

I have plenty of them left to this day, which I readily sign for all sorts of charities. They all look as good today as they did 25 or 30 years ago. No matter how things change, they remain the same. That's why new posters with Russell Wilson and Aaron Judge are just as inspiring. That's why this trip down memory lane in the following pages will hit you like it was just yesterday. After all, they still build rooms with walls, don't they?

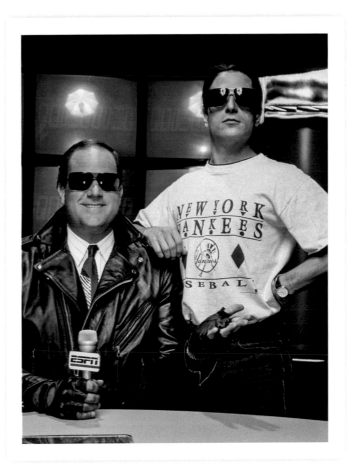

INTRODUCTION BY JOHN AND TOCK COSTACOS

In March 2017, when we were going through some old boxes, we found an unopened letter to us that had been

postmarked in 1999. It read: "My son has had a 'Bash Brothers' poster of Jose Canseco & Mark McGwire since 1990. It accidentally got destroyed today and my son is very upset. Could you please tell me if there are any of these posters still available and how I might get a replacement. Thank you, Tim."

Through the magic of internet searches, we found Tim and his son Sean, who was now all grown up. We sent him a "Bash Brothers" poster with a note: "Sorry to hear your poster got

destroyed. Here's a new one. Sorry it's 18 years late. —Tock and John." It was always about the kids.

Making these posters was a ton of fun. And it was a lot of work. For the first three years, we were working 60 hours a week, 7 days a week. There were a lot of challenges, and we fought and argued plenty, but in the end, it was the posters that mattered. Somehow, we never forgot what it was like to see the iconic heroes of our childhood as the real-life superheroes they had been to us, and we were able to connect another generation of kids with their sports heroes through the images we created.

Grown-ups bought them, too, and from the letters we received, we learned that they enjoyed the creativity of our posters and appreciated that they were different than what else was out there. When it comes to sports, you can always be a kid, no matter how old you are.

There were a lot of people who didn't think our posters would connect with customers, but they did, and it exploded into something beyond any expectations we had. It wasn't so much a roller-coaster ride as it was a feeling like we were in the Indy 500, because it all came so fast. There seemed to be a whole culture created around our work that we couldn't have expected or planned. It just happened. As with anything in life, luck played a big part, and we had more than our share. And we always felt lucky to do work that never felt like a job. It was like playtime with our friends.

We didn't set out to be in the sports business. We liked sports but weren't bigger sports fans than anybody else. We had had a basketball hoop in the driveway. We'd count down 3 . . . 2 . . . 1 . . . and launch the game winner at the buzzer. And if it didn't go in, we'd do it again.

In grade school, we played a few other sports and read stories about sports legends—and a lot of them had cool nicknames. Babe Ruth was the Great Bambino. Willie Mays was the Say Hey Kid. And the great Bears running back Red Grange may have had the coolest nickname of all time: the

Galloping Ghost. We knew they were great athletes. But it was the names that made them mythical—even more so because we had never gotten to see them play.

Then came the athletes we actually did get to watch: Wilt Chamberlain was Wilt the Stilt. O. J. Simpson was the Juice. The Buffalo Bills offensive line was the Electric Company. Baseball had Al "the Mad Hungarian" Hrabosky, and Mark "the Bird" Fidrych, and the Cincinnati Reds were the Big Red Machine—and, of course, there was Mr. October, Reggie Jackson. And we had a hometown hero from our only professional team—Sonics sharpshooter Fred Brown became Downtown Freddie Brown.

As we became teenagers in the '70s, Seattle got the Seahawks and the Mariners, and that gave us more heroes to watch. Warren Moon led the Washington Huskies to a Rose Bowl victory in 1978. And then, in 1979, the Sonics won it all. Car horns were honking at Alki Beach in our neighborhood throughout the night, and nobody cared. It didn't matter what anybody's age, gender, race, or religion was. It didn't matter if you were rich or poor or what neighborhood you were from. It felt like we were having a party with a few hundred thousand of our best friends. A sporting event can bring people together like nothing else.

We found ourselves in the poster business because of two events: The first was when we asked a clerk at the Locker Room sporting goods store in downtown Seattle what customers asked for that they didn't have, and she immediately said, "A poster of Kenny Easley." The second is that Kenny Easley said yes. These events enabled two guys in their early 20s, with no experience in art, design, photography, or business, to give it a go. And within two years, we had shot posters of more than 20 players who would eventually be enshrined in their sport's Hall of Fame. And it just kept going.

If two events led to our entering that business, two things gave us the fuel to grow: the players' interest in working with us, and the kids' and fans' response to what we were doing.

People ask what we miss about it, and there are a few things. It was nice to get free tickets to any game we wanted. It was fun working with the players on set and creating with them. The big parties the leagues threw at events were good fun. It was exhilarating to go to the office and work with our team to solve all challenges. But above all else, the thing we miss most is letting our friends' children or some kids from a youth group come into our warehouse, giving each of them a box, and saying, "Fill it up," and seeing the looks on their faces.

More than 100 of the players we made posters of ended up in the Hall of Fame, but every athlete we ever worked with was memorable to us. Each one had a story. Looking at these images, it takes us back to that time before the internet, smartphones, and social media, when fans didn't have access inside their sports heroes' lives.

The players didn't have many ways to market themselves or have some fun with their fans. Someone told us that our posters were popular because the fans felt like the players were letting them into the studio so they could all have some fun together. We just did the best we could to let the players have some fun and turn them into the kind of superheroes that we had seen our sports heroes as when we were kids. Great athletes doing the impossible at the moment their fans need them to is like Superman coming to the rescue.

We couldn't have lucked out any more than to have been in this fun business at the right time. We had a great group of people working with us to create the images we made and to join us in hoping the fans would respond to them. The '80s were a different era, and when we look at these posters, it takes us back to a time when we allowed ourselves to see the beauty in their subjects' athleticism and talents, when we didn't have access to every aspect of their lives, when we didn't amplify their mistakes. In our posters, we wanted to make it personal for the fans, to take who the player was and amplify the good stuff a little bit, and make them the heroes we wanted them to be.

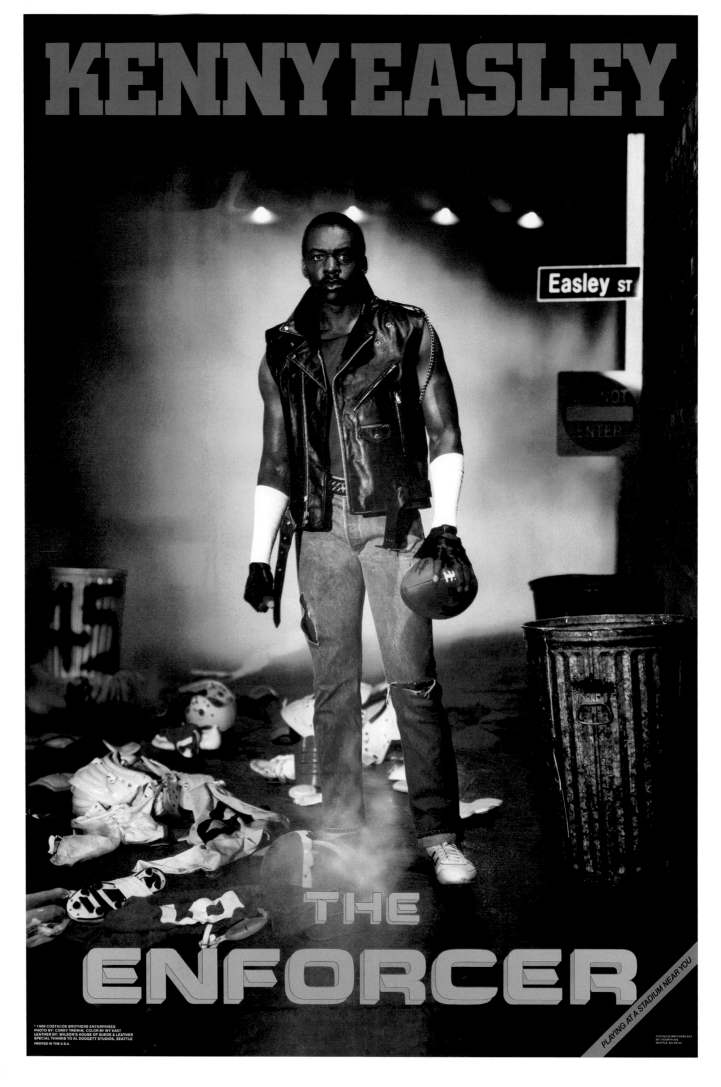

Kenny Easley

Seattle Seahawks
NFL 1980s All-Decade Team

We had our friend
Keilan Matthews
pose as Kenny for the
early test shots.

The NFL said no, but Kenny Easley said yes. The reigning NFL Defensive Player of the Year said yes to making a poster with a couple of guys who had never made a poster before, who had no experience in photography, design, art, or printing.

We had some success selling T-shirts, and one of our customers was a small, local chain of five or six stores called the Locker Room. In November 1985, while checking on how the shirts were selling, we asked a woman working in the downtown Seattle store, "What do your customers ask for that you don't have?" She immediately replied, "A poster of Kenny Easley."

A few days later, we placed a phone call to the office of Leigh Steinberg, Kenny's agent. Jeff Moorad, a brand-new agent in Leigh's office, called us back and said Kenny wanted to meet in person. We met for breakfast at Hector's restaurant in Kirkland, Washington, and Kenny agreed to work with us.

Although this was our first poster, we knew the people at NFL Properties because we had worked with them on a licensed Raiders shirt we were selling with the phrase "Real Men Wear Black," which we had trademarked. But the NFL gave us a flat "no" when we asked for a poster license, so we couldn't shoot Kenny in his uniform, and we couldn't use any NFL or Seahawks trademarks or logos. It forced us to get creative.

We knew we wanted to do something that made Kenny look tough, and part of our research was going to the downtown Seattle Public Library to look through microfilm of old sports articles. Kenny had a reputation as a guy that nobody wanted to get hit by, and one story about him from his college years used the word enforcer, which we loved. Kenny liked it, too.

Kenny asked for Seahawks team photographer Corky Trewin to shoot it, and we had a full six months to plan everything. In May 1986, we set up in an alley in downtown Pioneer Square so we could have the Kingdome in the background. We didn't have wardrobe or production people—mostly because we couldn't afford it—so we did everything ourselves with some help from friends. Corky wanted to make sure we had the highest resolution possible, so he shot on 8" x 10" film.

Once Kenny got there, we realized we needed more rips in his jeans. When we told him we needed the pants off so we could tear them some more, he said to just do it while he wore them. We didn't have a scissors, only an X-Acto knife. "Be careful" is all he said as we started slashing denim inches from his bare legs.

After the shoot, we went to F. X. McRory's restaurant and had a beer. We still remember looking at each other in disbelief and saying, "We just shot a poster with Kenny Easley!" We had just done something that seemed impossible.

Whenever we're asked which posters are our favorites, "The Enforcer" is always one we name—partly because it was our first but also because it just may well be our best. We often joke about topping out with the first poster and never equaling it. You never like to admit that sort of thing, but in this case, it might be true.

To this day, we still wonder why Kenny said yes. We've never asked him, but we have always been grateful he took a chance on us. It changed our lives and was the beginning of the most fun work we could have imagined.

Lester Hayes

Los Angeles Raiders
NFL 1980s All-Decade Team

We proposed a poster featuring Raiders owner Al Davis, but it didn't go anywhere.

We *hated* Lester Hayes. The Raiders were in the same division as our hometown Seahawks, and they were our nemesis. We hated Lester because he was a Raider, but we also hated him because he was *so good*. He and Mike Haynes were a great cornerback tandem, considered by many to be the best.

We would have loved him if he was a Seahawk, but because he was a Raider, it was quite the opposite. Whenever he got burned for a touchdown—which wasn't often—we'd taunt him on the TV. In case we're not making ourselves clear, let us repeat, we HATED Lester Hayes. And then we met him and instantly loved the guy.

Our poster with Lester originated from a complete coincidence. We had just finished a meeting at Los Angeles Raiders headquarters, in El Segundo, regarding our "Real Men Wear Black" Raider T-shirts we had made under a team license. As we were walking back to our car, we noticed Lester, who must have just finished practice, in the parking lot. We introduced ourselves, and he said he knew about our shirts and loved them but didn't know where to get one, so we gave him a couple of the shirts we had brought for the meeting. After we told him about the poster we were doing with Kenny Easley, we asked if he'd also be interested in doing one with us. He said yes and gave us his phone number.

Lester already had a nickname, the Judge, which he had earned during his Texas A&M days, when he had "sentenced" Texas Longhorns star running back Earl Campbell to a bad game. But we decided it was too easy to just use that nickname, and instead we ran with the judicial theme. *The People's Court* was a popular TV show at the time, so we went with "Lester's Court."

When we started scouting locations, we couldn't get into the King County Superior Courthouse, which was a block from our office. But we called the Washington Supreme Court in Olympia and explained how we were looking to do a photo shoot with the Lester Hayes of the Los Angeles Raiders, and the person who had answered the phone said to come on over. A lot of doors opened up for us when sports fans were in positions to help us out, whether with locations, props, or just access.

We ran into Chief Justice James Dolliver while we were looking at his courtroom, which was slightly disorienting—he wasn't in his judicial robe, and he seemed like just a regular guy despite being one of the most respected and influential people in the state. We ended up talking football with him, and since he seemed curious about what we were planning, we invited him to the shoot.

We flew Lester to Seattle in June 1986. Although you can't tell from the shot, Tock is the player dressed in the 49ers colors, and he's kneeling to help make the bench look taller—the bench wasn't very high, and we wanted Lester to be looming over the court to create a sense of authority and power. And the dates on the footballs? Those correspond to actual games when Lester made his interceptions.

The biggest challenge of the entire shoot was how Lester was so funny and animated that we had a hard time getting him to keep a straight face. Justice Dolliver did indeed come to the shoot, and when we introduced him to Lester, he jokingly asked, "Is that my robe?"

LESTER'S COURT

W. RECEIVER: Sentenced to four quarters of relentless intimidation, bone-jarring hits, and masterful interceptions. So be it.

Judge Lester Hayes

Jim McMahon

Chicago Bears
1985 NFL Pro Bowl

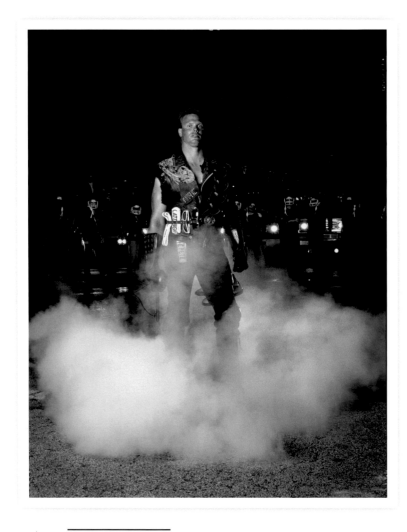

Jim simply looked
cooler wearing his
signature sunglasses.

I t was crazy to think we could get Jim McMahon, the superstar quarterback who had just won a championship with the Chicago Bears in Super Bowl XX. It was doubly crazy to add another poster to the mix in late June 1986, when we hadn't even completed the poster designs from our first photo shoots and had to start selling them by the start of football season in September. So, of course, we went for it.

It actually wasn't a decision we made lightly. We had a long debate about whether we should send the proposal, because we already had two big superstars in Kenny Easley and Lester Hayes, and there was a lot of work ahead if we were going to do right by them. But our "Mad Mac" concept seemed so perfect for McMahon and his rebellious image.

We went to a store called Golden Age Collectibles at Seattle's Pike Place Market and bought the movie posters for *Mad Max* and *The Road Warrior,* hired our friend Gary Smoot to draw the concept sketch, and sent the pitch letter. Then we left for a pre-booked Greek convention in Dallas, part of a series of conventions sponsored by the Greek Orthodox Church that Greek parents sent their kids to meet other Greeks.

When we returned, the phone rang: "This is Steve Zucker, Jim McMahon's agent. Jim loves it, and he wants to do it." But we had to get it done in the next nine days, because Jim had to report to training camp in 10 days, and we had to do it in Chicago—a city where we had no photography or production contacts.

We had coincidentally met Bill Conopeotis in Dallas, and he happened to be from Chicago. So we called Bill, who said he'd be happy to help get what we needed: a photographer, permission to shoot in the parking lot at Soldier Field, a power source or generator truck, 30 extras that could bring their own leather jackets, five large trucks, a fog machine, a makeup artist, and a live bear cub. Within 24 hours, Bill and his brother, George, had found everything on the list except the bear cub—but had a lead on one in Milwaukee.

Sure enough, the Conopeotis brothers delivered huge for the Costacos Brothers: They got everything, including an actual bear cub. We found Jim's leather jacket at a motorcycle store that had skull-and-crossbones buttons and sleeves that zipped off, and outfitted a utility belt with his signature sunglasses and headbands. Jim always wore sunglasses because one of his eyes was sensitive to light, and had previously been fined $5,000 by NFL Commissioner Pete Rozelle for wearing an Adidas headband when wearing anything with a logo was prohibited by the league.

Everything looked like it was going to work—until we saw that the weather forecast predicted thunderstorms on all three days that Jim was available before he had to report for training camp. It rained all day Monday and all day Wednesday, but on Tuesday—the day we had scheduled the shoot—the rain miraculously stopped during the three hours when we were setting up and shooting.

There was one tense moment when the bear snapped at Jim's left knee, but thankfully, it didn't bite him. The set came together, Jim looked awesome, and we got the shots.

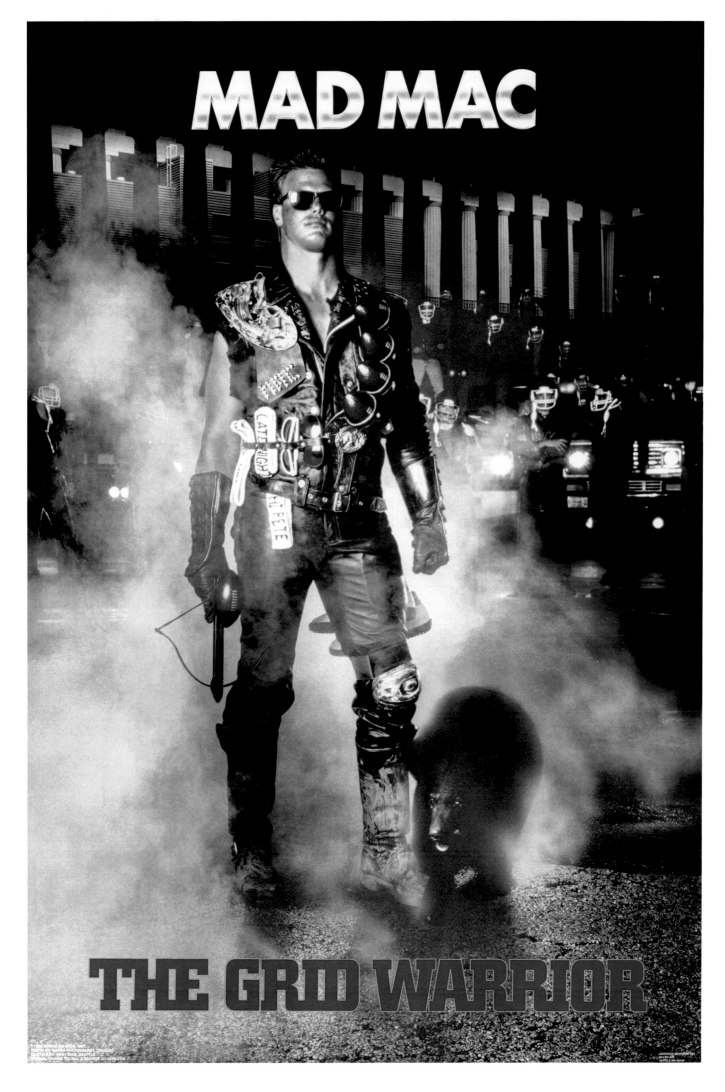

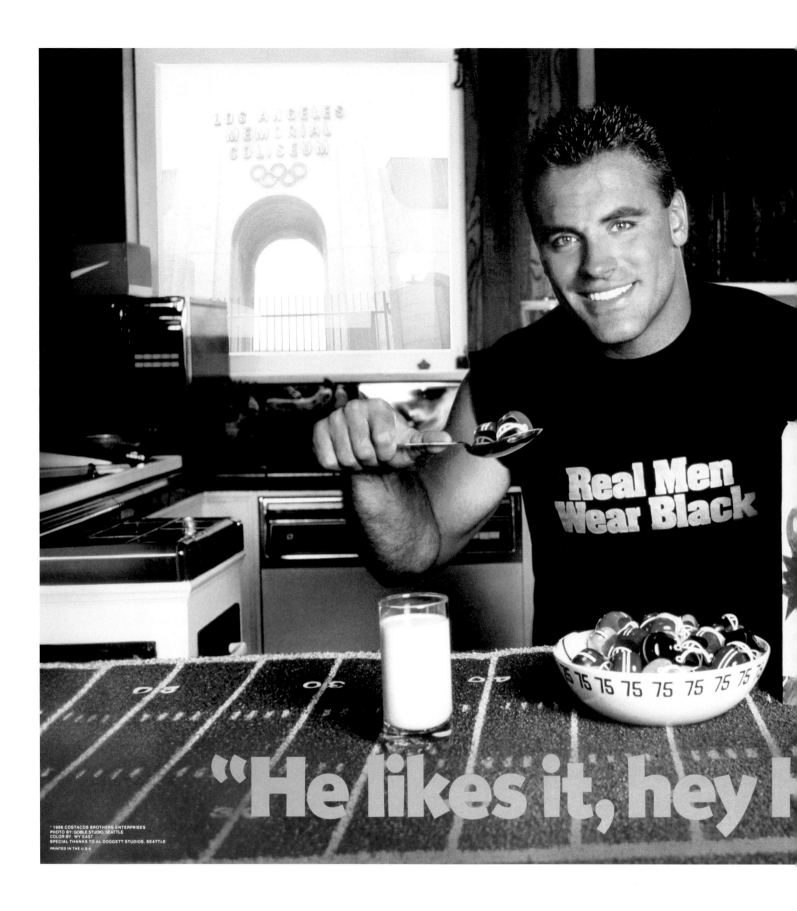

Real Men Wear Black

"He likes it, hey h

Howie Long

Los Angeles Raiders
NFL 1980s All-Decade Team

Early in the 1985 season, we were watching a Raiders game at the office, and Howie Long had just gone right through a blocker to make a tackle. One of the announcers said, "Howie Long just ate him for lunch," and that metaphor stuck with us.

After the game, we were walking out of a Safeway supermarket and noticed one of the vending machines had small NFL helmets in it, and an idea was born: A breakfast-cereal theme with Howie eating the other teams for breakfast. Howie had at that point been chosen for the Pro Bowl every year he'd been in the league and just been named the Defensive Player of the Year. We asked fellow Raider Lester Hayes to put in a good word for us, called Howie's agent, and made the deal.

"Breakfast of Champions" was our original title, but we had learned quite a bit about trademark law, and our trademark attorney, Mike Folise, recommended against it: While Jim McMahon's "Mad Mac" poster was a clear parody, the makers of Wheaties cereal owned the "Breakfast of Champions" trademark, and someone could think we were promoting a real cereal.

But then we saw the "Mikey" Life cereal commercial, which was massively popular: Two young kids have a bowl of cereal, and they know it's supposed to be good for them and neither wants to taste it, so they give it to little Mikey. Mikey eats it, prompting another kid to say, "He likes it—hey, Mikey!" Everyone knew this commercial. And it was clear from Howie's interviews that he still had a lot of little kid in him.

We went back to Safeway with a couple of rolls of quarters and emptied the vending machine of all the helmets. We still didn't get a full set, so we went to another Safeway and emptied that machine, too. Then we had to peel off all of the stickers from the helmets, just in case the tiny team logos were visible in the shot.

This poster was shot in Howie's house at his own kitchen table. His wife, Diane, was there, along with their new little son, Chris, who was a year and a half old then. Diane was always a favorite of ours and our production people. We'd see them from time to time during Pro Bowl week, and she was always especially nice and warm toward us.

The tablecloth was made from a piece of artificial turf to which we added hash marks and numbers, and we had the L.A. Coliseum (the Raiders' home stadium when they played in Los Angeles) added to the view from the windows by our photo lab. Tom Roberts—who designed our early "Purple Reign" and "Real Men Wear Black" T-shirts—created the "Quarterback Crunch" artwork for the cereal box. Corky was busy with the Seahawks, so we hired studio photographer Jay Goble to do the shoot.

Howie was particularly fun to work with because he was so at ease in front of the camera, as comfortable and confident as any player we ever shot. A couple of years later, when it came to choosing a Raiders player for our "Real Men Wear Black" poster, there was no question who we wanted.

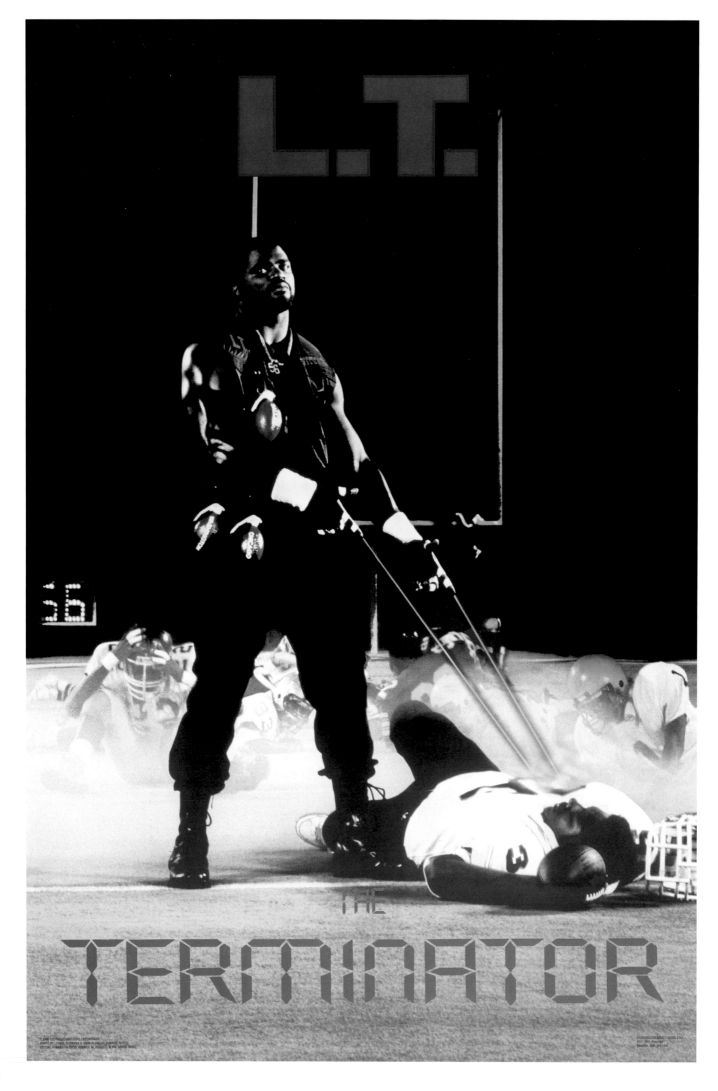

Lawrence Taylor

New York Giants
1986 NFL Most Valuable Player

(opposite) The title type here is in blue, but most people have the version in red.

(above) The assault rifle may have been a little much.

We worked seven days a week and most nights through the summer of '86 to have posters ready for football season, and by September they were really selling. Our staff had all the work they could handle, and any additional posters would have to wait for the following season.

But then the Associated Press's Barry Sweet wrote a story about our business, and suddenly our phone started ringing off the hook. *Sports Illustrated* and *USA Today* ran stories on us, and a lot of regional news reporters got in touch.

When we were asked by a *Newsday* writer in New York what other players we wanted, it just made sense to name some of the biggest New York athletes in the hope that the players would read it, so we answered, "Lawrence Taylor, Mark Gastineau, and Ken O'Brien."

A day later, the phone rang: "My name is Steve Rosner, and I represent Lawrence Taylor . . ." Could we really get this lucky?

The 1984 *Terminator* movie with Arnold Schwarzenegger had been a massive hit, and that's what we suggested, because Lawrence played football like the Terminator: He was an unstoppable force. We described the poster to Steve, and he and Lawrence both loved it. We were still working at least 12 hours a day, seven days a week, but we couldn't turn down LT!

When we went to an army-surplus store in New Jersey to get the costume, we grabbed some empty pineapple grenades—we planned to unscrew their handles and put them on little plastic footballs as props. At the counter, we had this exchange:

REGISTER GUY: You want 'em filled?
US: You mean the grenades?
REGISTER GUY: Yeah.
US: You mean so they'll blow up?
REGISTER GUY: Shhh . . . yeah.
US: Um . . . no, thanks.

We did the photo shoot in Giants Stadium, which cost us $600 for each hour we had the lights on. The extras in the background were our crazy New York buddies that we call the Bronx Brothers and the Rockland County students our cousin, Ina, recruited from the high school where she taught. The photo lab added the lasers shooting from Lawrence's fingers, and darkened the background to obscure the stadium seats and keep the focus on the field.

Afterward, Lawrence threw passes to the kids and at one point bet his agent that he could throw a football into the stadium's upper deck. Steve shook his head, and Lawrence tossed it well into the third deck and declared, "You owe me $100."

Lawrence couldn't stop laughing at all the postshoot chaos, and before he left, he came over and hugged us and said, "I'm a guy who has lots of fun, but this was a *great* time tonight. Anything else you want to do, let's talk about it." That meant a lot to us—and taught us the value of making the shoots fun for the players.

Ken O'Brien

New York Jets
1985 AFC Player of the Year

From the start, we had roles that reflected our personalities. A couple of years after we took this marketing photo, our sister Marianne and publicity person Kim secretly sent a letter and this photo to *Cosmopolitan* magazine, and we ended up being Bachelors of the Month in 1989.

Since we were going to New York for the Lawrence Taylor shoot during the first week of October, we called sports agent Jeff Moorad, who we knew from the Kenny Easley poster. Not only did he and Leigh Steinberg represent Kenny, they also had a large stable of NFL clients that included New York Jets quarterback Ken O'Brien. Ken and the Jets had a hot start at the time, and had generated a lot of buzz.

"Born to Gun" came from Bruce Springsteen's *Born to Run* album. We were (and still are) huge Springsteen fans, and we had a *Born to Run* promo poster of Springsteen in a leather jacket standing in front of an empty street, with his guitar slung over his shoulder and a pair of shoes hanging from the neck of the guitar. With Springsteen looking back over his shoulder at the camera, it had a "Have guitar, will travel" feel to it.

We had planned to shoot on a door stoop somewhere in New York City with a football in Ken's hand and a pair of cleats over his shoulder. But during the Lawrence Taylor shoot at Giants Stadium (where the Jets and the Giants played home games), we thought it would be cool to shoot it from the tunnel where the players come out, with the interior of the stadium in the background.

We walked around to different areas of the field and liked the look from the corner near the players' entrance tunnel. There was something about how massive the stadium looked from that point of view. Photographer Chris Schwenk came over and put the camera on a tripod so we could look through the viewfinder and see what it would look like, and even took some Polaroids. We decided then and there that if Ken liked the idea, this is where we'd shoot.

Jeff arranged for us to meet with Ken at the Jets' facility the day after Lawrence's shoot, and we showed him the other posters we'd made and told him what we wanted to do. We said we wanted to photograph it after a home game because we liked the idea of an empty, messy stadium as the background, as if it was the scene of a big game Ken had had. He said yes.

When we got home, we worked it all out with Jeff but were having trouble finding a time we could get to New York, and since we were already six games into the season, we needed to shoot it fast. We called Chris Schwenk and asked if he could do exactly what we'd previously talked about—without us there—and he said, "No problem—I'll get it for you."

We arranged for the shoot the following week, and some kids from the Lawrence Taylor shoot agreed to help Chris as production assistants.

Ken went on that season to achieve the NFL's first perfect 158.3 quarterback rating, coincidentally in a 38-7 win over the Seahawks in our own backyard.

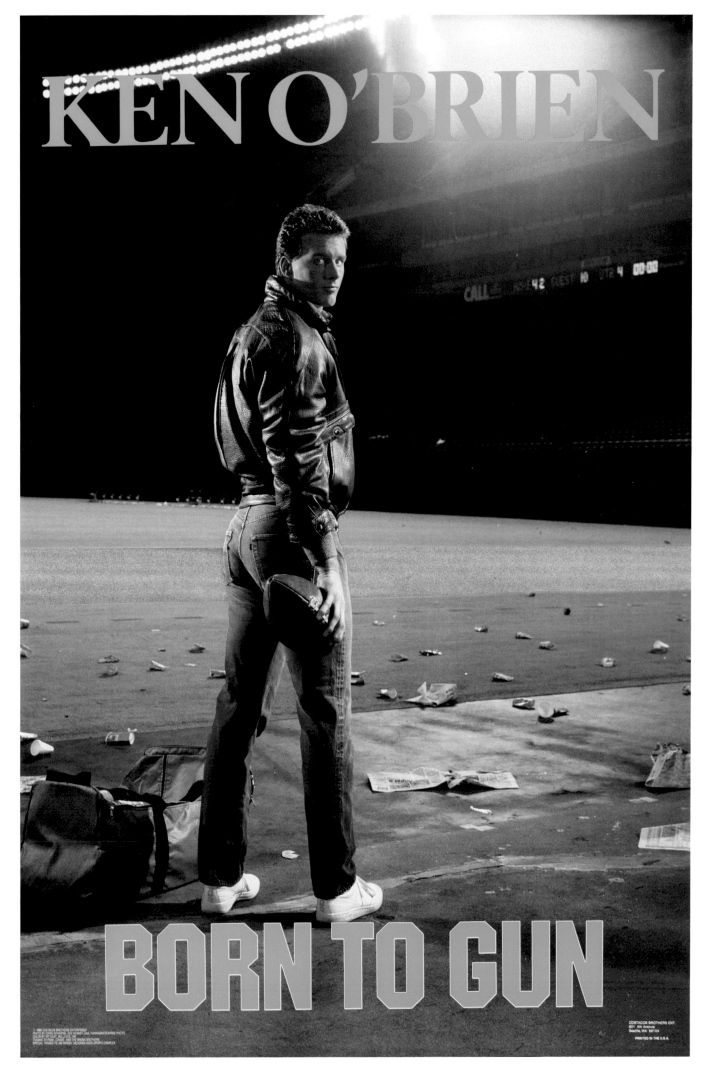

Mark Gastineau

New York Jets
Jets All-Time Four Decade Team

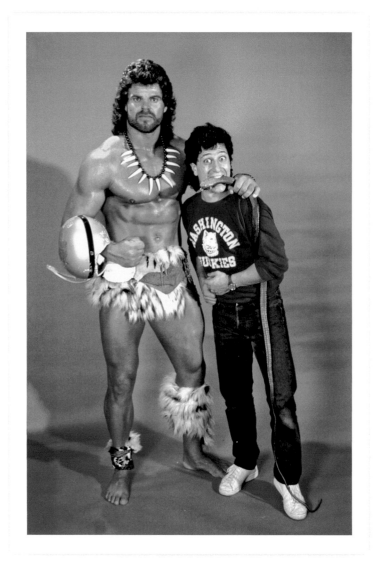

Here's Mark, John, and the rubber snake we planned to have wrapped around Mark's arm, but it covered up his muscles too much.

After our meeting with Ken O'Brien in the New York Jets locker room, we were walking out and noticed Mark Gastineau at his locker. Mark had been named All-Pro for the last five seasons and had just been on the cover of Sports Illustrated with Lawrence Taylor of the New York Giants a couple of weeks earlier. And there he was, across the room from us—there was no way we were going to pass this opportunity up! We went back to Ken and asked if he could introduce us to Mark, which he did.

We told Mark we'd like to make a poster with him and showed him our posters of Kenny Easley, Lester Hayes, and Jim McMahon, and he liked them. He asked what we wanted to do, and we started discussing ideas then and there. It felt like Mark really understood our approach, and he went right through the creative process with us.

Mark was known for his strong pass rush and for sacking quarterbacks—he led the league in sacks in 1983 and 1984. "Sackman" was a good play on the title of the videogame Pac-Man, but what could we do visually with that? We asked what nicknames he had or liked. We thought about ideas based on his number or his initials. We went through the alphabet to find any good rhymes or wordplay. Nothing clicked.

But the thing was, Mark looked like a wild man. He had long hair and, as you can see from the poster, was very muscular, especially for a guy weighing 270 pounds. Most linemen carrying that much weight had some belly fat on them, but Mark looked like he was chiseled out of marble. We suggested we do something in the direction of the Arnold Schwarzenegger movie *Conan the Barbarian* and started spitting out every word combination we could, like "The New Yorkian" and "Sackman the Markbarian." When he heard "Markan the Barbarian," he said, "Let's do something with that. My agent is Mike Sullivan, and here's his number. If you want to call him now, there's a pay phone right over there." So we went over to the phone and called his agent and set things up.

We shot the background in the Kodiak bear enclosure at the Woodland Park Zoo in Seattle. The head zookeeper came to the shoot and got the bear out of the walking area and into the caged area in the back.

We enjoyed adding cartoonlike things in our poster backgrounds, like the pair of shoes at the top of the burlap bag on the right side of the frame, as if a quarterback had been literally "sacked." The player on the ground in the red jersey with "Q. Back" written on it was one of our production assistants. The "No Dancing" sign on the left is a reference to how the NFL made postsack celebrations illegal in 1984 primarily because of Mark's signature "sack dance."

Mark's costume was easy, mostly because there wasn't much of a costume. Chris Schwenk, who was proving to be a very valuable asset for us in New York, shot him in a studio, and once again the Bronx Brothers and Sisters were our production assistants. We felt Mark would feel a lot more comfortable having females do any wardrobe adjustments—and we felt more comfortable, too.

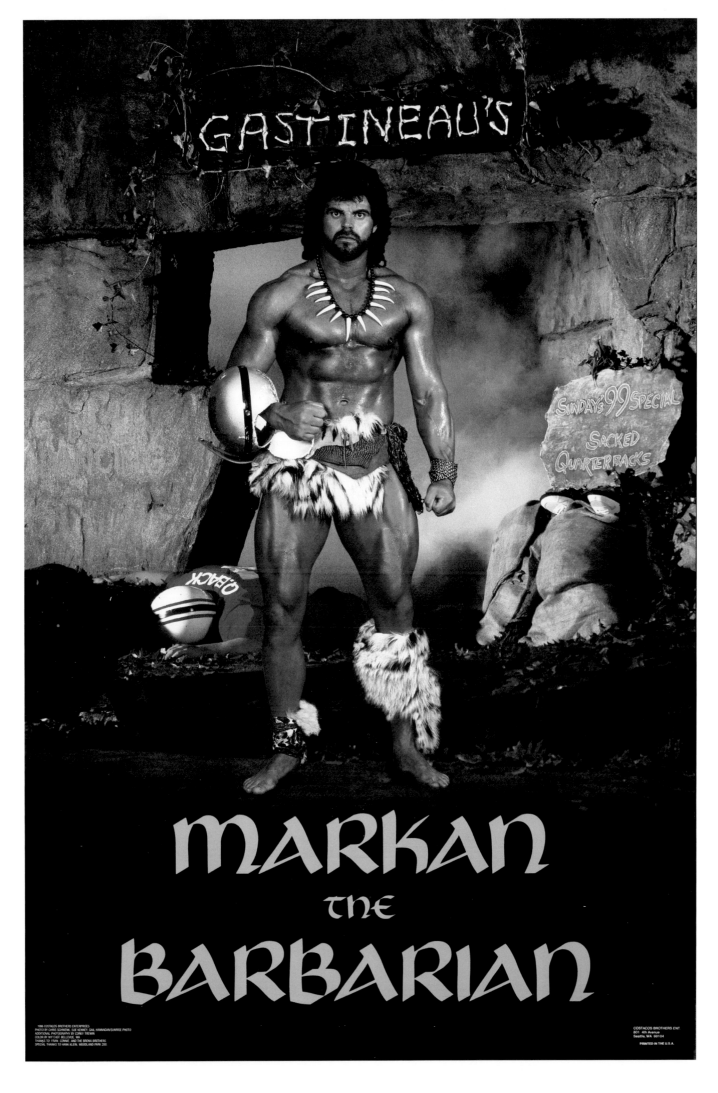

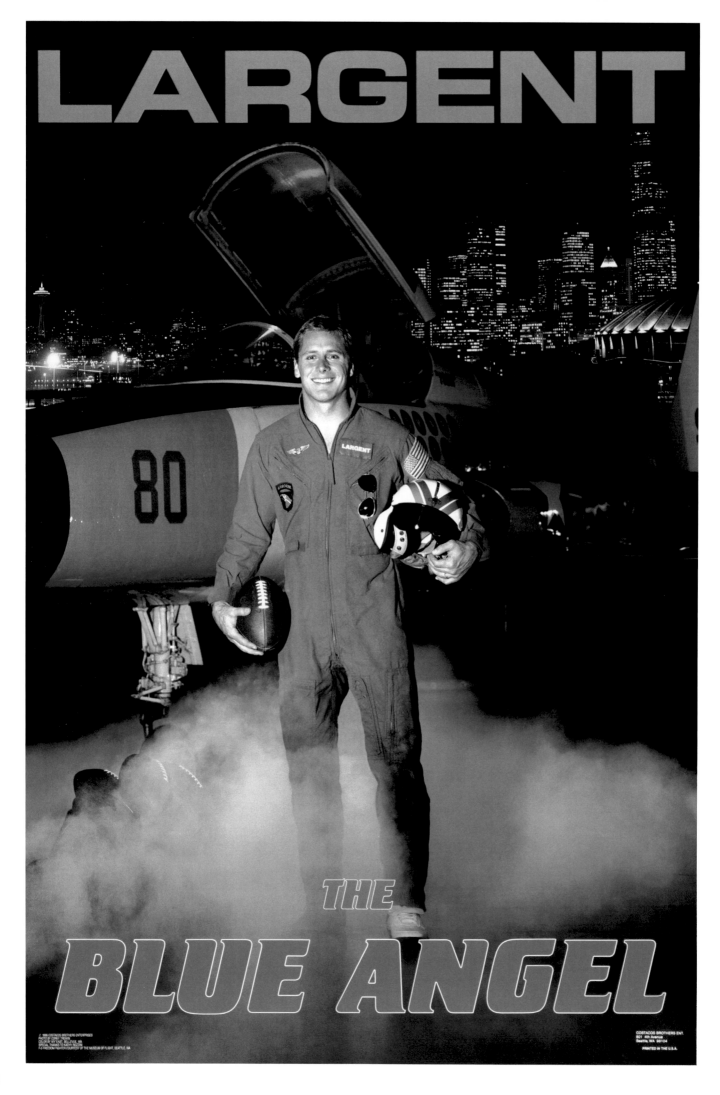

Steve Largent

Seattle Seahawks
NFL 1980s All-Decade Team

The flight suit was stiff as a board from the paint we used to change its color.

Steve Largent presented a real challenge for two reasons: He was squeaky clean, and he didn't have an agent. In a league of macho warriors, "squeaky clean" made it hard to come up with a concept that worked. And Largent's lack of an agent shut off our usual channel to even start a conversation.

We'd already shot Kenny Easley, Lester Hayes, and Jim McMahon, who were tough guys and bad boys. Steve was as tough as they came, but he was also a good-looking, blond-haired, blue-eyed, religious family man with four children and an all-American image that he didn't work to cultivate—it was genuine.

It was easier to create concepts for the guys with badass images. With Steve, we couldn't do a Mad Max or gladiator-type theme because it wouldn't make sense to his fans, and he didn't have any established nicknames from college or the pros. But we kept banging our heads against the wall because he was *so good:* Steve led the entire NFL in receiving. Twice.

Frustration built up as we tried every angle: Maybe something with his No. 80 uniform number? Something about his hands, as he caught every pass thrown near him? A rhyme with *Largent*? (We quickly—and wisely—killed a "Sergeant Largent" idea.)

After 10 months of trying, inspiration came from a faded bumper sticker on a car parked on the north side of downtown Seattle: Blue Angels. Boom. That was it. The Navy's Blue Angels flight team was very popular in Seattle because of its annual summer air show. The Seahawks' main color was royal blue, and Largent was an angel of a guy. Steve Largent: the Blue Angel. Perfect.

But we still had an equally vexing problem: how to get ahold of him to even pitch the idea. We tried sending a message to him through the Seahawks organization, but it didn't work. Getting desperate, we traded a Kenny Easley poster to a media person in exchange for a press pass, and John went undercover into the Seahawks locker room after a game to find Steve. Instead, John immediately spotted Seahawks VP of Marketing Gary Wright, who knew John—and knew he shouldn't be in there. So, like something out of a TV sitcom, John had to hide from Gary while searching for Steve's locker.

John found it just as Steve came back from the showers, and with Gary roaming the locker room, he was faced with a choice: Wait until Steve got dressed, and risk getting caught and kicked out, or introduce himself to a naked man. He went with the naked man.

John introduced himself to (naked) Steve and explained how he and Tock wanted to make the Blue Angel poster of him. Seconds after Steve gave him his home phone number, John heard a voice from behind: "Costacos, what are you doing in here? C'mon, you gotta go." But it didn't matter, because John had gotten what he came for!

The only flight suit we could find was green, and after unsuccessfully trying to bleach out the color, we just spray painted it blue. The fighter jet was borrowed from Boeing and we did the shoot in a hangar next to Boeing Field. And true to his all-American image, Steve arrived in his Chevy Suburban with his wife, Terry, and all four of their four children—that's truly who he is!

More from the Archives

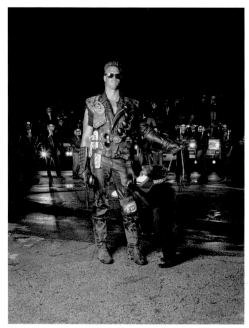

The bear cub got a little frisky with Jim McMahon and raised up on his leg during the "Mad Mac" shoot.

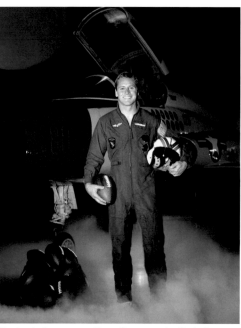

The footballs are actually spilling out of a flight bag, but it's obscured by the fog in the final poster shot.

We added this shot of the Los Angeles Raiders' stadium to the window in Howie Long's poster.

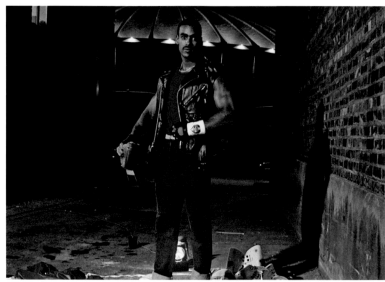

Our Kenny Easley stand-in, Keilan Matthews, has the physique of a football player because he was one—in college, as a safety at the University of Washington.

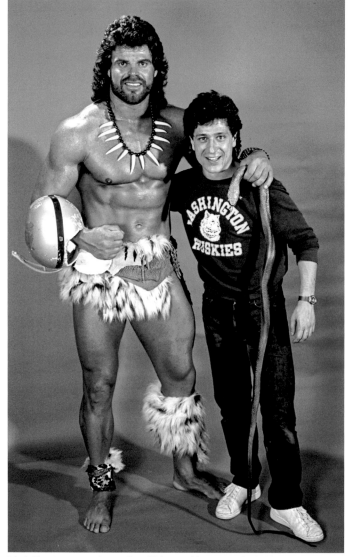

It's hard to believe professional athletes and their agents were willing to take a chance working with us, two recent college graduates without any art experience.

Mark Gastineau may have played like a wild man on the field, but he was a nice guy at our shoot. He poses here with John and an unused prop snake.

Lawrence Taylor and our New York crew, including George Germanakos in the orange jersey who ends up hanging off the background goal post.

The empty stadium at the Lawrence Taylor shoot inspired us to also shoot Ken O'Brien there, since the Giants and Jets played in the same stadium.

Public relations maven Kim Foster, production and design guy John Santos, and John with a mounted "Mad Mac" poster outside our first warehouse.

Here's our "delivery man" on his bike with a valuable box of Costacos Brothers posters. Something about those sunglasses makes him look familiar . . .

Carl Banks

New York Giants
NFL 1980s All-Decade Team

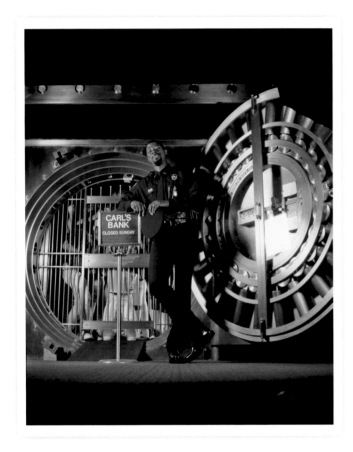

Carl wore his Super
Bowl XXI championship
ring for the shoot.

Ever since the New York Giants had won the Super Bowl in our first year of making posters, we looked to expand on the one Giants poster we had (Lawrence Taylor, see page 20) due to the team's success as well as the size of the New York market. We wanted Carl Banks because he was a great linebacker and had a huge game in Super Bowl XXI that year, making 14 tackles. Carl didn't have a nickname that we knew of, but his last name had a lot of potential with some kind of bank imagery.

Our poster themes always took a player's image or notoriety and amplified it, sometimes subtly and sometimes loudly, depending on his personality and the concept. We thought the right bank-vault door would convey the idea that as a defensive player, Carl Banks puts offensive players away and locks them up.

You can't just walk into a bank and ask, "Can you open your vault so we can see inside?" That sounds like the plot point of a ridiculous heist movie. We figured that calling on the phone was a less suspicious way to ask, so we started phoning banks in New York and New Jersey. Most wouldn't even consider it, but we had a few that softened up when they heard we were location scouting for a photo shoot with the New York Giants' Carl Banks. After all, Carl was part of the Big Blue Wrecking Crew, the defensive unit that held teams to just 80.2 rushing yards per game and powered the Giants to a 14-2 regular-season record.

The vault we found was even better than what we had imagined. The door was big and menacing, and it had a round opening with a cage door. It was perfect. The manager was willing to let us shoot after hours as long as we had extra security guards there. We got some generic football uniforms and invited our crazy Greek friends from New York (the Bronx Brothers, who had also been some of the extras on Lawrence Taylor's poster) to come and get locked in the bank's vault.

When Carl arrived, he took one look and smiled—he instantly got it. Carl looked great in the security uniform, and the only problem we had was that the guys in the vault were cracking jokes and making him laugh.

While we were at the bank, we noticed a sign mounted on a stand that read Please Wait Here for Next Teller and decided to put it on the poster with a custom message. We went to an art store and got letters to stick on the back side that read Carl's Bank: Closed Sundays, suggesting that he's out playing football on Sundays. After the shoot, we thought maybe it should actually have read Open Sundays because that's when he's putting guys away.

Reassessing was always good when we were creating concepts but painful after shooting was over and we couldn't do anything about it. We were hard on ourselves because we wanted everything to be just right. (Luckily, nobody has ever mentioned it, although maybe we shouldn't have pointed it out here . . .)

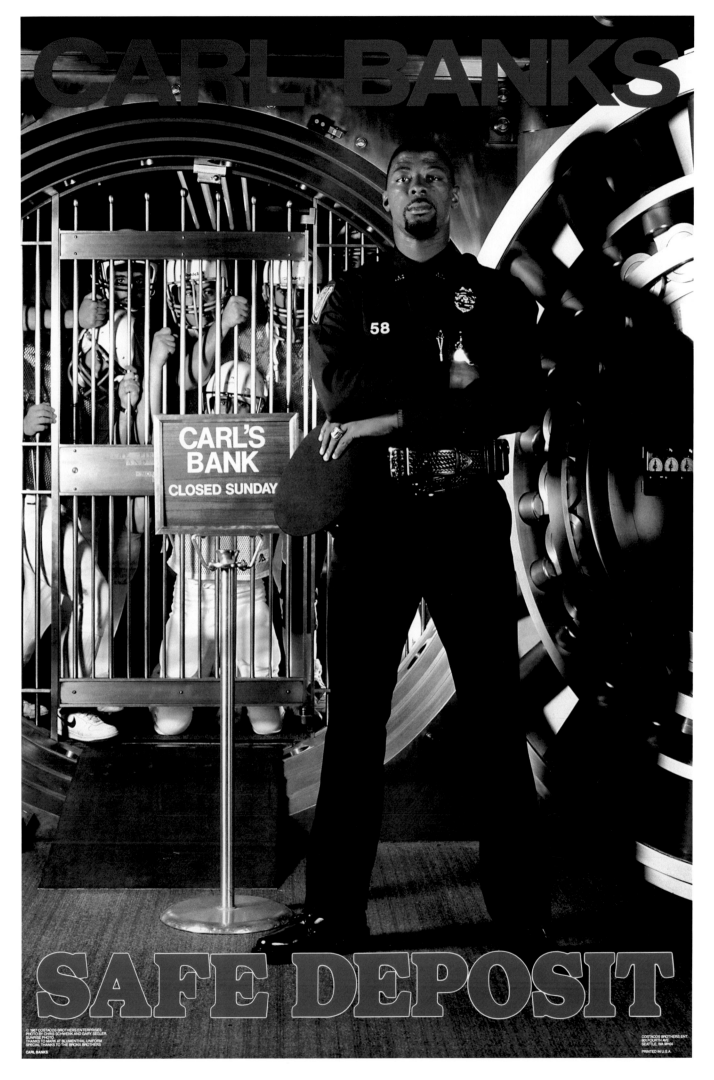

Brian Bosworth

Seattle Seahawks
Sports Illustrated NCAA Football All-Century Team

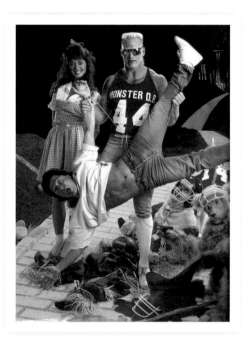

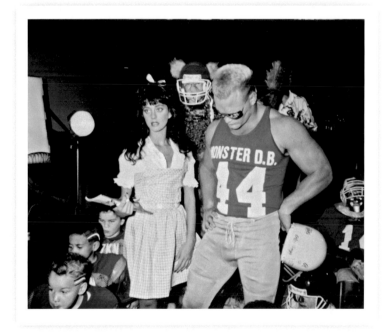

In 1987, Brian Bosworth was the Jim McMahon of college football: brash, colorful, outspoken, and a very good player on a very good Oklahoma Sooners team. He was a two-time Butkus Award winner as the best linebacker in college football, and he had just been drafted by our hometown Seattle Seahawks.

But Brian said he wouldn't play for the Seahawks, so with his NFL future uncertain, we weren't sure how to reach him. We ended up taking a shot in the dark and wrote him a letter addressed to the University of Oklahoma's athletic department. A week later, we received a call from his agent, Gary Wichard, who was familiar with our posters and interested in working with us. Gary said that, despite the public posturing around the draft, Brian would definitely sign with Seattle, and we could factor the team into a poster idea.

Since Brian was already known as "the Boz," we easily chose a *Wizard of Oz* theme. We watched the movie and made notes on the world of Oz, and worked out the production design with Mike Dillon of Dillon Works!, a local design and fabrication company: a yellow-brick road, with the downtown Seattle skyline and the Seahawks' Kingdome home stadium in the background.

This was the most elaborate and expensive set we had ever made. Dillon Works did an amazing job with the set and the costumes. Our in-house artist, Chuck Doyle, wore the Cowardly Lion outfit, and our favorite radio personalities, Gary Crowe and Mike West from Seattle's KXRX 96.5 FM, were the Scarecrow and the Tin Man, and they promoted the poster on the air. Speaking of our Scarecrow, we had Gary stand in a hidden hole in the yellow-brick road so that only his top half is visible, with the rest of his body hidden under the set and a pair of empty pants giving the illusion that Brian has stomped his legs flat. We came up with There's No Place Like Dome while we were setting up, and had someone write it on one of the background rocks.

For Dorothy, we cast Ava Fabian, who had recently been *Playboy* magazine's Playmate of the Month for August 1986. She not only made a great Dorothy but also helped attract a lot of attention: We invited a bunch of sports reporters to cover the poster shoot, mentioning Ava's participation, and ended up with a packed set. Ava also signed copies of the posters for us at sporting goods trade shows, drawing longer lines than the shoe companies and equipment manufacturers that brought in big-name athletes.

Brian's agent came up with a creative way for Brian to wear his college No. 44, since NFL uniform rules at the time did not allow linebackers to wear numbers in the 40s: Invent a new position called monster defensive back. As an afterthought, we enlisted our friends' children as his Bozkins, complete with Brian's signature shades and Mohawk hairdo with stripes on the side of their heads. (It's tough to see, but Toto the dog also has a Mohawk!)

(opposite) Seattle is known as the Emerald City, which is why we put it in the background.

(top and above) Despite this being such a complex shoot, we tried to keep things light.

Todd Christensen

Los Angeles Raiders
1986 NFL Receptions Leader

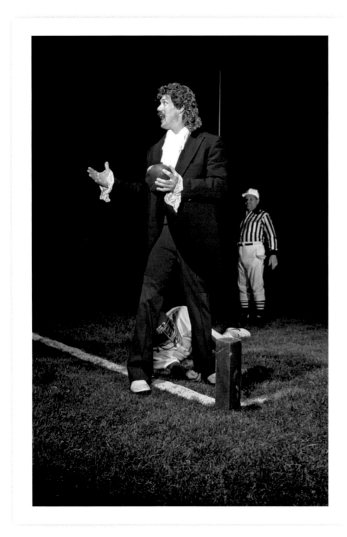

We got Todd's tuxedo
and old-timey shirt from
a local costume shop.

We met Todd at the Raiders facility, and he had seen our other posters and was up for working for us. Todd, a tight end for the Raiders and as reliable a receiver as there was in the league, was always open and always made the catch. He won two Super Bowls with the Raiders, was named All-Pro for the past four seasons, and his 95 catches in 1986 marked the second time in his career that he lead the entire league in receptions. Yeah, Todd could play a little.

He told us a story about playing in the Pro Bowl with the Buffalo Bills' Jim Kelly as his quarterback: They got in the huddle, and Jim called the play and looked across at Todd and said, "You get open."

"Jim knew he was going to get the ball to me," said Todd. "Everybody knew Jim was going to get the ball to me. So, if something went wrong, it was going to be my fault. No way am I *not* getting open."

Todd said that if he could be known for one thing, being consistent and reliable was what it would be. We made a list of words to describe how reliable he was and "trust" was one of them, and that's where "In Todd We Trust" came from.

Corky Trewin shot it in the end zone of a local high school football field in the suburb of Bellevue, and our dad dressed as the background referee. We had a fog machine for atmosphere, but it stopped working right at the beginning of the shoot, so we had to go without it. The only other problem we had was that Todd and our dad hit it off so well that we could barely shut them up long enough to get any shots in.

For the design, we debated going with his jersey No. 46 up in the corners, but a 46-dollar bill seemed weird, so we figured 6—as in 6 points for a touchdown—would be better. We thought about making a horizontal poster and framing him in in an oval from the chest up, like George Washington in the one-dollar bill, but we liked making the players as big in the posters as possible, so we went with a vertical format. Besides, Todd nixed that idea because it would have meant taking our dad out of the poster, and he thought that was the most fun part.

After the posters were printed, we sent a big box of them to his house, and Todd called immediately to thank us and said this would be one of the things he would remember most fondly from his football career. He signed one to our dad that reads, "To Jerry, thanks for letting me be in your poster," which our dad still has framed in his office today.

We stayed in contact with Todd over the years after he retired, and he was always happy to catch up, and often brought up his poster and how much he enjoyed it. He loved talking football and never failed to ask how our dad was doing. We were saddened to hear about his passing in 2013, and we keep in touch with his family through his son Toby.

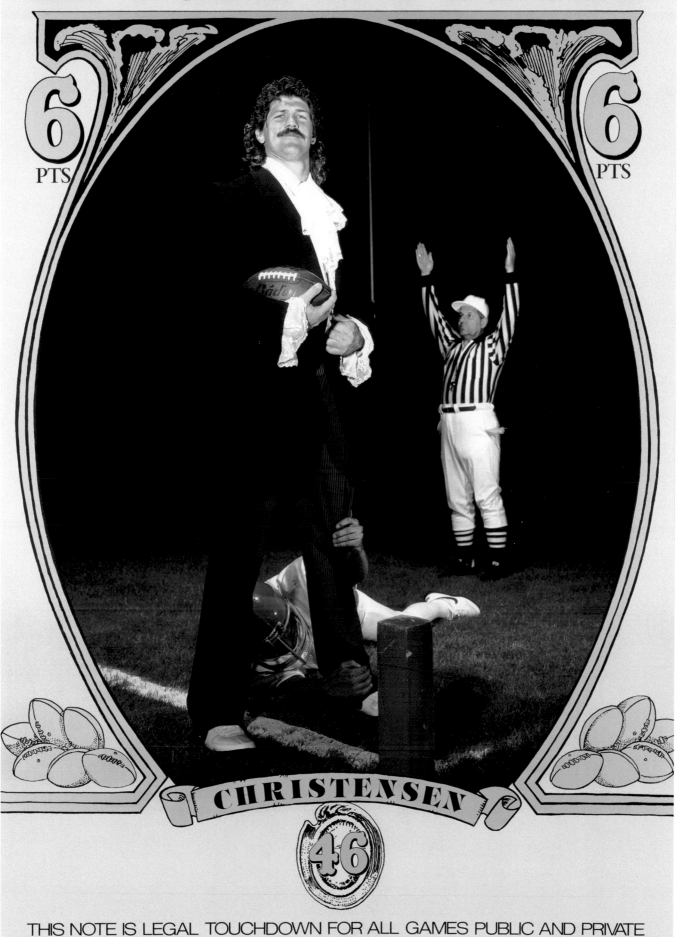

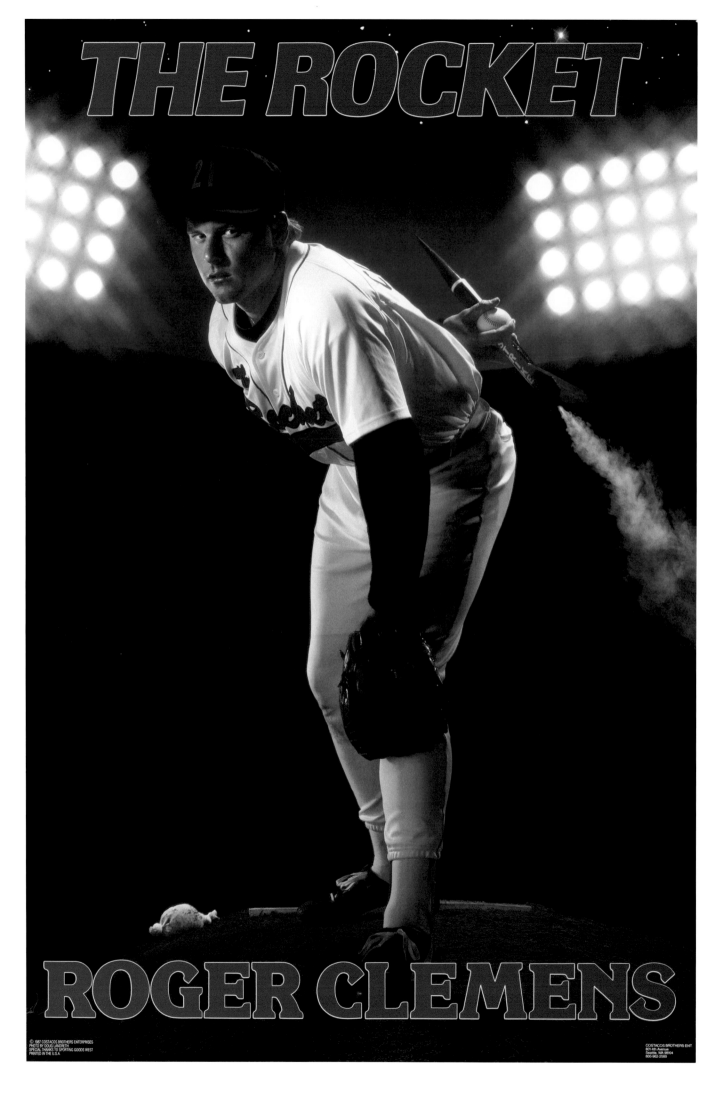

Roger Clemens

Boston Red Sox
MLB All-Century Team

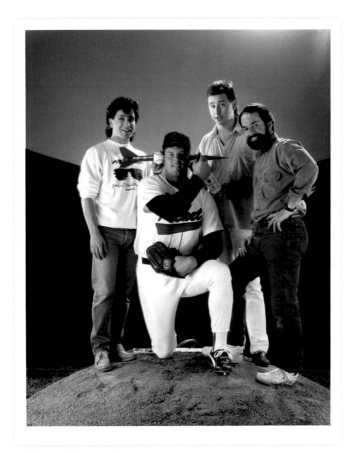

(l to r) John, Roger, production guy Ray Carr, and photographer Doug Landreth.

Roger Clemens made nationwide headlines in the spring of 1986 when he set an MLB record by striking out 20 batters in one game and went on to win 24 games, the Cy Young Award, and MVP that year. This guy was the real deal, and we were happy to get a chance to work with him.

Fans called him "Rocket Roger," and a rocket theme was a great visual for a hard-throwing pitcher like him. In a way, this poster created itself: The guy throws heat. Have him about to throw a rocket—or a baseball rocket. Conceptually, we knew we wanted him on a mound with a baseball rocket in his hand that had smoke coming out of it.

With each poster, we learned a little more about building sets and props, as well as photography limits and possibilities. We knew getting the rocket baseball to look right was key, so we bought a number of model rockets to see what size would look best and played around with the different sizes for about a week, shooting Polaroids to see how they looked in the frame.

Our plan was to connect surgical tubing to a fog machine and run it under the dirt, then hide it by running it up behind Roger and into the side of the rocket so it blew out from the end. We experimented with different fog machines, different kinds of fog, and different sizes of tubing in order to get it right. It was pretty tricky: The glue we were initially using wasn't fastening the rockets to the baseballs well enough, so they kept coming apart, and the fog was either a tiny trickle or way too much, but we eventually figured out the right glue and tube size.

Doug Landreth was the photographer for this shoot, and built the set at his studio. It consisted of a pitcher's mound, grass, and a wall that would look like a stadium. We simulated stadium lights by just cutting round holes in covers and placing them over lightboxes.

We shot it when the Red Sox were in Seattle to play the Mariners, and luckily it was on a day when Roger wasn't pitching, so he wasn't in a big hurry. Despite him being between starts, we wanted to be respectful of Roger's time and explained the progression of how we wanted to shoot and how we'd get him out as quickly as possible. He told us not to worry about time and to take as long as we needed to get it right.

His normal stance was standing straight up, with the ball in his right hand down by his side. Roger looked great, but we weren't sure the rocket did, so we improvised with the crouch stance, which is not a stance he ever used. (To be fair, he also never held a rocket with smoke coming out if it out on the mound.)

After the shoot, we had to take Roger directly to the stadium, but he was hungry, so we stopped by BurgerMaster, one of our local favorites. We tried to buy, but Roger wouldn't let us: "You guys did a great job for me today—and I just signed a new contract." He liked the burger so much that he ordered 30 more to bring to his teammates at the stadium.

Eric Davis

Cincinnati Reds
1987 Gold Glove Award, Silver Slugger Award,
MLB All-Star

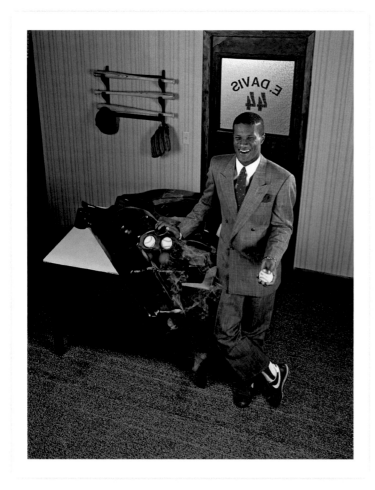

Pay no attention to how
Eric would be sitting
behind that desk with
his back to the door.

This is one of a number of posters we could never do now due to concerns about the gun—it would be a big no-no. Even though there was increased scrutiny about violence on television in 1987, nobody complained about this poster. But it would likely cause a lot of controversy today even though the poster is obviously about a baseball player and the *gun shoots baseballs.*

Eric Davis played center field and could do it all: He hit for power, was a great fielder, was fast on the bases, and had an excellent arm. Because he played for the Cincinnati Reds, one of his nicknames was Eric the Red—like the Viking hero—but we decided there were potential trademark problems with the team name.

In some ways, we loved not having official league licenses, because we had to be more creative. We tried to come up with something using the name "Cincinnati" but came up empty. John Fogerty had had a hit song called "Centerfield" a couple of years earlier, and we tried some ideas based on that but couldn't figure out what to dress him in.

The idea of "44 Magnum" came from hearing an announcer say Eric had a cannon of an arm after an amazing throw from the outfield. We didn't know anything about guns, but anyone who had ever seen the Clint Eastwood's *Dirty Harry* movies knew that a .44 magnum was a powerful gun, and Eric happened to wear No. 44. Eric was an understated guy who did spectacular things on a baseball diamond but didn't bask in the spotlight and draw a lot of attention to himself. We pictured an old-school private detective theme centered around a big gun with his bats and glove in the office, like he's a private eye who quietly sneaks around and does big things.

One thing we liked about working with photographer Chris Savas was how he loved building sets and props. When we proposed a giant gun that looked like it shot baseballs, he proclaimed, "I'll make it!" He started with a baseball and built the gun around it so that a standard-size baseball would fit in the cylinder chambers and barrel. Chris built the gun in three days out of plywood and Bondo, and it weighed almost 300 pounds. Eric had the same reaction we did when he saw the gun: He *loved* it.

Chris built the rest of the set at his Atlanta studio, and instead of ordering a suit to be made, we had Eric bring three of his own to make sure they'd fit perfectly and he'd look good in them. This shoot was unique in that we would normally place the camera at waist level or lower and shoot upward in order to make the player appear bigger. But the low point of view made the gun look terrible, so we shot it from up high, and it looked a lot better. Eric was gracious and comfortable in front of the camera, and he seemed to genuinely enjoy the shoot.

Ever since the poster first came out, people have always asked what we did with the gun. We wanted to keep it, but the gun was too big and too heavy to ship anywhere, so, sadly, we put it in a dumpster!

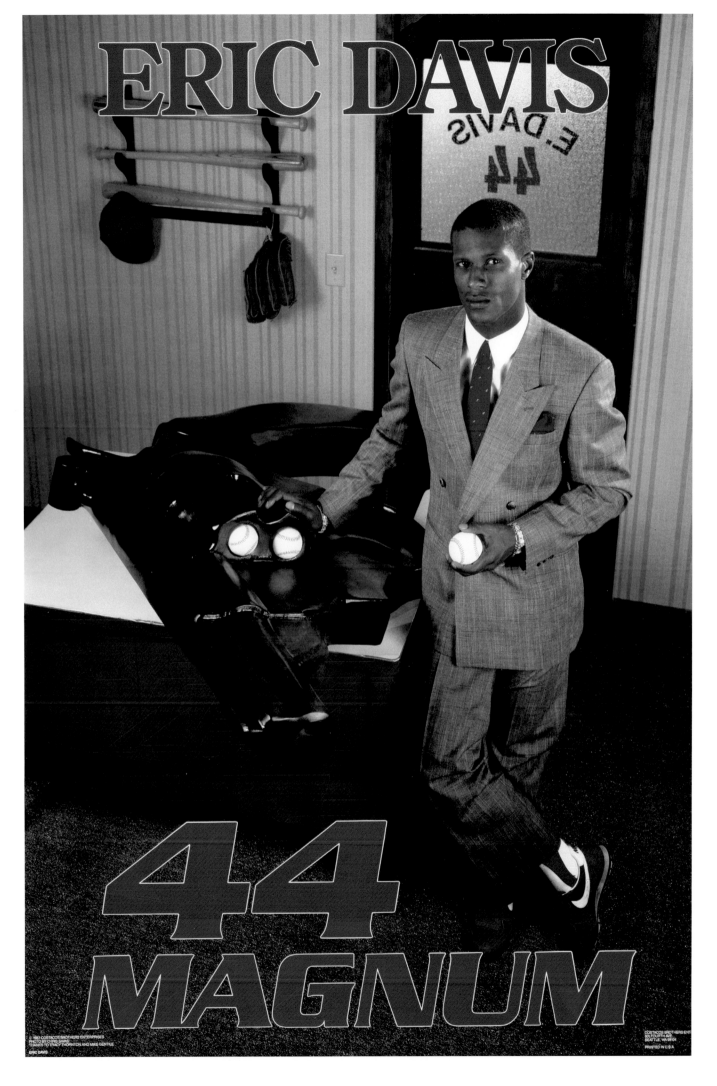

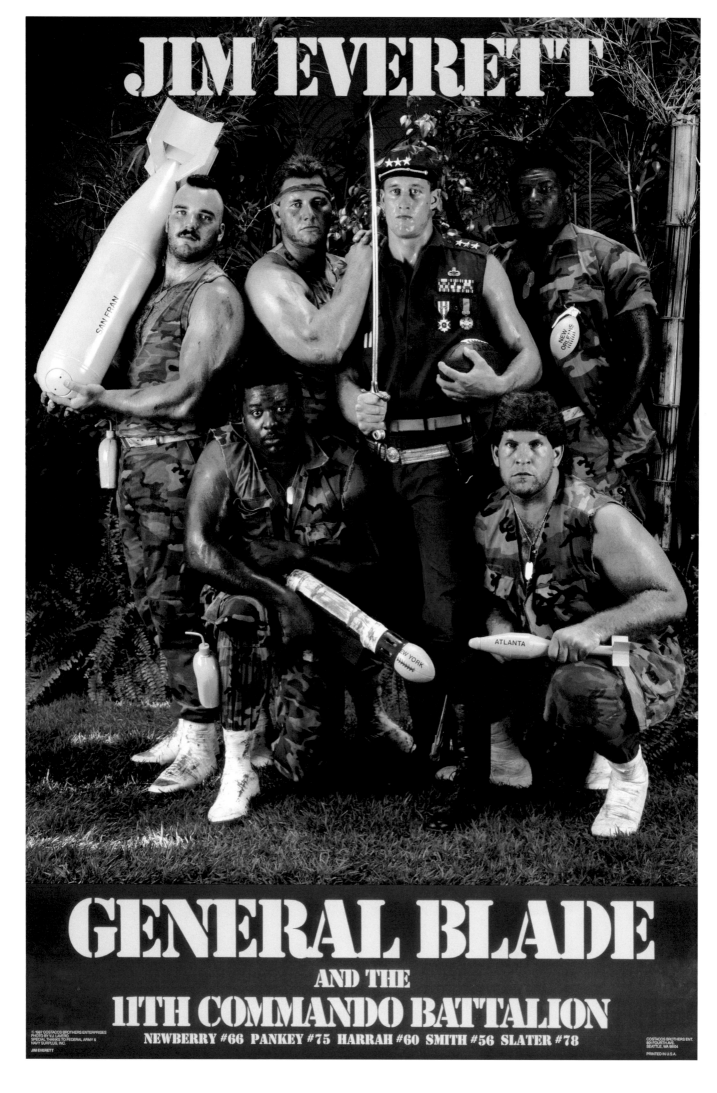

Jim Everett, Tom Newberry, Irvin Pankey, Dennis Harrah, Doug Smith & Jackie Slater

Los Angeles Rams
22 Combined Career Pro Bowls

The props have the cities of NFC West foes Atlanta, New Orleans, and San Francisco, as well as the defending Super Bowl champs, New York.

We love this one. It was supposed to be over-the-top and campy, and that's exactly how it turned out—like so many of the action-movie posters of the '80s. That campiness made it one of the most fun posters to create and shoot, as well as the fact that all the guys in it were great.

Jim Everett's nickname was Blade, which we assumed had to do with him cutting defenses to pieces, so our first ideas were "Blade Gunner" and "Air Blade." Visually, the idea was to feature him with a football that had a knife blade sticking out of each end and then have defensive playbooks from all the other teams cut and shredded and strewn around on the field around him.

But when we spoke with Jim, he only agreed to work with us on one condition: "My offensive linemen are in the poster with me." He had us write down their names: Tom Newberry, Irv Pankey, Dennis Harrah, Doug Smith, and Jackie Slater. We had seen him in interviews talking about these guys and how much he appreciated them—whenever he was asked about his accomplishments on the field, he always gave them credit. (We also found out that the origin of the "Blade" nickname didn't have to do with him cutting up defenses—Harrah had given it to him because of his thin face! Still, we thought it was such a good nickname that we wanted to use it.)

We hadn't done a group poster before, and we weren't sure if we should use one nickname for all of them combined or something that referenced Jim and the offensive linemen separately. We thought about the "Magnificent Six" or "The Blade Brothers." We even considered "General Blade and the Battering Rammers," but didn't feel legally safe using something so close to their actual team name. Our process involved keeping all ideas on the table because sometimes even risky ideas would lead to something that worked. When we asked Jim how he would describe the group, he said, "They fight. They fight and they never let up. They go to war for me on every play."

There's a scene in one of our favorite movies, *Trading Places*, where Eddie Murphy's character is making up which military unit he was in and says, "I was with the Green Berets, Special Unit Battalions . . . Commando Airborne Tactics . . . Specialist Tactics Unit Battalion. It was real hush-hush." We played with every combination of those kinds of military words and settled on one that incorporated Jim's No. 11.

While shopping for props at an army surplus store, we just grabbed bombs, grenades, rocket launchers, and anything else that looked fun. We thought we were all set until we noticed something in the front window that made us go back and ask, "Can we have that big bomb, too?" (Tom Newberry is holding that one.)

This is one we get ribbed for today, but in the context of the macho action movies of that era like *Commando* and *Predator*, "General Blade and the 11th Commando Battalion" put a smile on everyone's face.

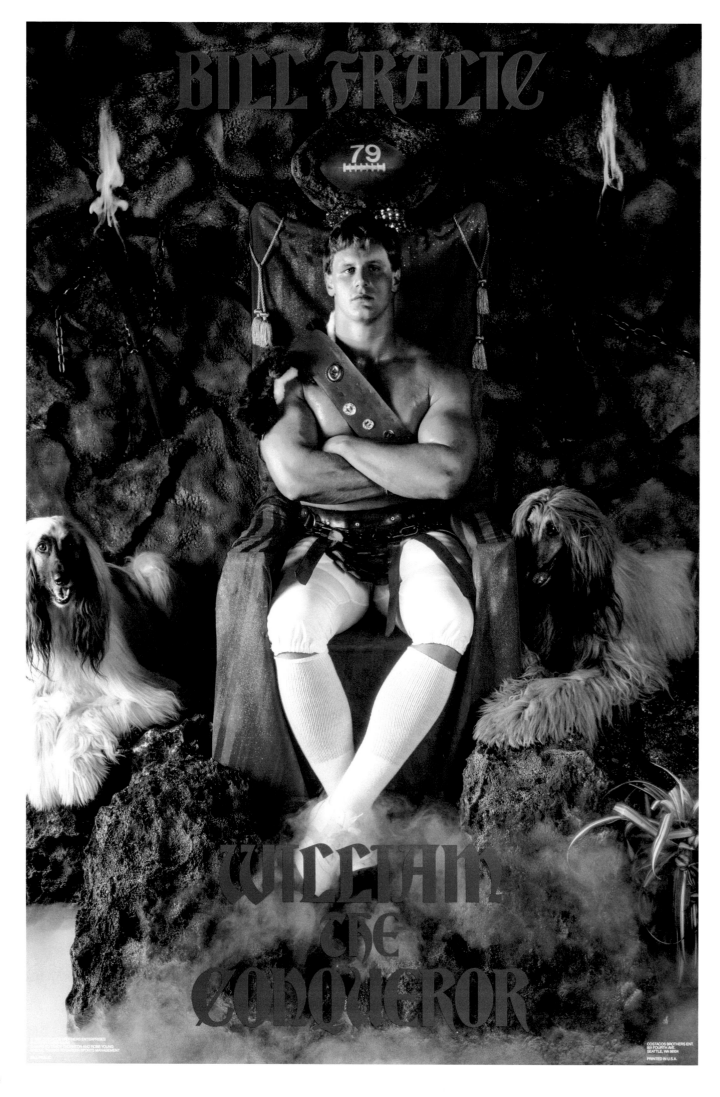

Bill Fralic

Atlanta Falcons
NFL 1980s All-Decade Team

Bill didn't pet the
dog anymore after it
pooped on the set.

This is an instance where having a great high school history teacher helped shape a poster.

We were watching the Atlanta Falcons on TV, and the announcers talked about how Bill Fralic was "dominating" his opponents. Bill was one of the best offensive linemen in the NFL, and we had met his agents at a sporting goods show in Atlanta. The concept of "dominate" didn't seem to work, so we considered every similar word we could come up with, and *conquer* was one we liked.

One of the things that made Bill Pearson, our high school history teacher, such a good educator is that he made history fun and come alive. He had explained that England's William I was generally known as William the Conqueror, but to those who didn't like him he was known as William the Bastard. That unusual point of reference made it memorable, and writing down the word *conquer* triggered the idea for "William the Conqueror." (We doubted that Bill would have gone for "William the Bastard.")

We worked through the basic concept with Bill's agents and then talked with photographer Chris Savas about how to make it look. We wanted a throne but didn't want it or the setting to look too regal. Bill's a football player, so we went for a tougher, barbaric-looking set and a simple throne. We flew to Atlanta a few days early and constructed the set with Chris at his studio. The set was made from Styrofoam blocks that were first cut, then melted and shaped with blowtorches, and then spray-painted. It was fairly simple work, but took a lot of time to finish.

We thought about renting a live falcon, but we surprisingly weren't able to find one for rent, so we rented the two Afghan hounds instead. When Bill arrived, we explained it all, got him in costume, and went to work.

He was easygoing and went right along with us, but at one point he started to look uncomfortable. We asked what was wrong, and he said, "Come here, and you'll find out." As we got a little closer, we could smell what Bill had been smelling: The dog on the left had taken a dump right in the middle of the shoot. Chris was confused because he hadn't seen the dog even stand up, and its owner explained that the hounds were trained to sit still and not move.

We did a quick cleanup as best we could, but we could still smell it, so we got an electric fan to blow the smell away from Bill and finished the shoot.

We were plenty happy with how the poster turned out and it sold fine, but it also taught us a lesson: No matter how good an offensive lineman may be, his poster won't sell as well as those of guys who run, throw, or catch the ball, or the guys who hit and tackle people. This was part of our learning experience in our second NFL season of making posters—the players whose names are called most often during broadcasts simply sell the most posters.

Jim Kelly

Buffalo Bills
1987 NFL Pro Bowl

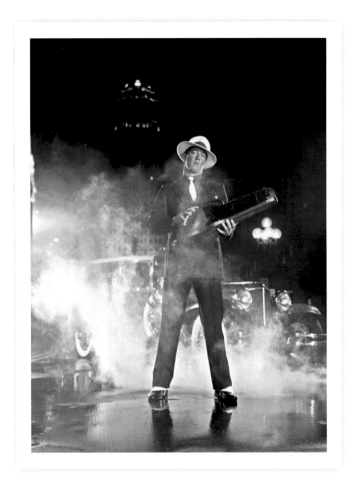

We loved using fog for
lighting effects and
atmosphere, but it was
a little unpredictable.

J im spent his first two professional seasons lighting up defenses with the Houston Gamblers of the USFL. He often made the TV highlights while he set the USFL record for passing yards and touchdowns in 1984 and as he shattered those records in 1985.

During this time, the Buffalo Bills were one of the worst teams in the NFL, going 2-14 in consecutive seasons. The Bills signed Jim to a contract in 1986 that made him the highest-paid player in the NFL, but the Bills nevertheless went 4-12 in his first NFL season. Still, we wanted to do a poster of him because he was such a great player and had a certain swagger to his personality.

We didn't know anything about the real Machine Gun Kelly except that he was a gangster from a previous era. We went to the library to learn about him and found out he was notorious for his criminal activities in the '20s and '30s. We liked the nickname so much for Jim that it was the only concept we presented to his agent, and we hoped Jim would go for it—and he did.

We watched old gangster movies and saw a number of them that featured guys who carried their machine guns around in violin cases, so we liked the idea of putting Jim's weapon of choice—a football—in a violin case. We figured an old classic car, a double-breasted gangster-looking suit, and white spats to go over Jim's shoes would complete the look we wanted.

The only trouble we had was finding a violin case with red lining, which is one of the Bills' team colors. Despite going to several music stores, every violin case we found had burgundy interiors. Luckily, while at our parents' house, we opened our sister's old viola case and there it was: a perfect bright-red interior.

We shot the poster in downtown Buffalo during the summer, and the Buffalo city employees weren't just cooperative, they were enthusiastically helpful—the police blocked the streets off for the shoot, and the fire department opened up a hydrant so we could wet down the street. The only problem was the bugs: From the moment Jim stepped in to shoot, large insects flew out of nowhere and landed all over his suit, and their white wings were really noticeable in the shot. They didn't land on anything else, just Jim. Every few frames we had to jump in, sweep the bugs off with our hands, and quickly jump back out so we could keep shooting.

One memorable moment happened when we first met Jim to try on the gangster suit. We asked him how he liked the NFL, and he stopped what he was doing, looked at us closely, and said, "Let me tell ya something: Losing sucks. I hate it, and we're not gonna lose anymore. I told everyone here—*everyone*—that last season is the end of us losing."

We could tell how much of a leader he was by the way he said that and how he acted around us; he was confident in a very likeable way. We weren't at all surprised when Jim turned the Bills into winners and led them to four straight Super Bowls.

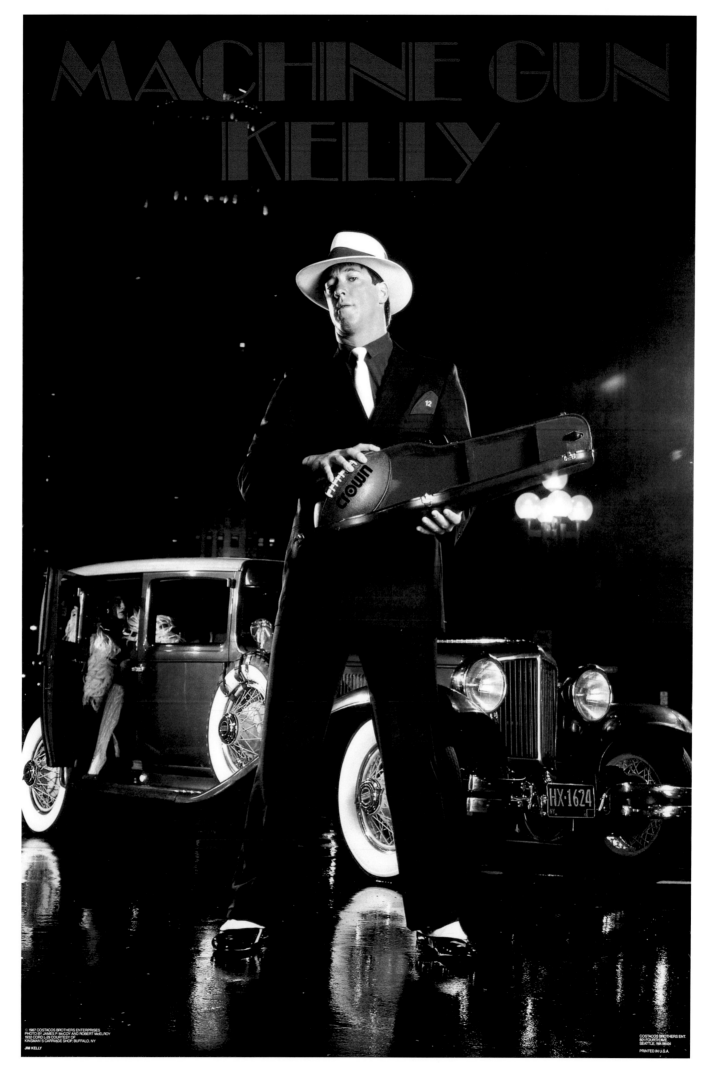

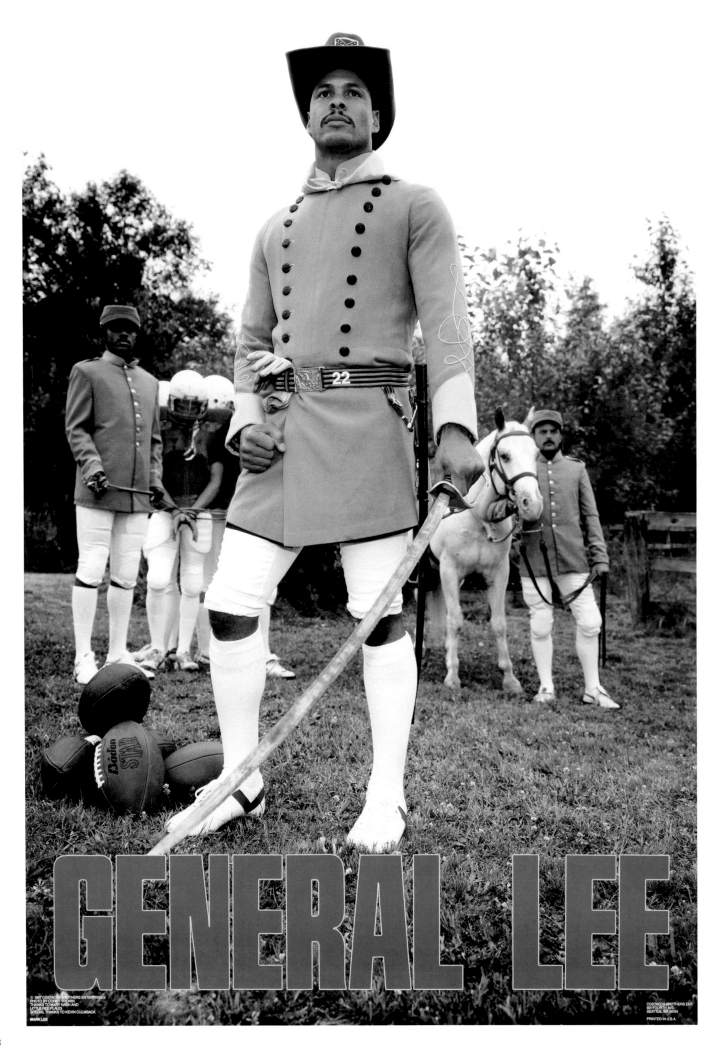

Mark Lee

Green Bay Packers
Green Bay Packers Hall of Fame

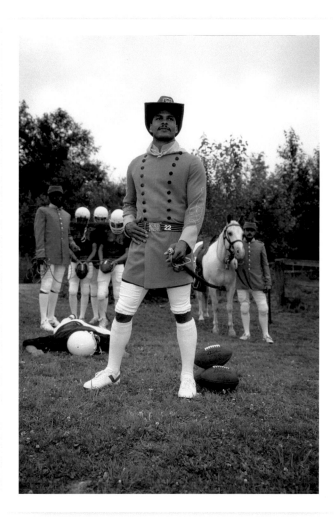

On second thought, we decided having a dead body on the ground was going overboard.

When we ask ourselves whether we would shoot this poster today, the answer is a big, fat no. An African American in a Confederate Army jacket? We wouldn't even consider it. But back then, it didn't dawn on anyone that it could be offensive. Some of Mark's teammates called him "General Lee," or just "General" for short, and Mark and his agent didn't have any hesitation about the idea.

We had known about Mark from his college days because he had played cornerback at our alma mater, the University of Washington. He was a great cornerback, but he had also returned three punts for touchdowns in his senior year, and two of them were last-minute game winners. Those moments are things you remember, so, as a couple of guys who grew up watching Huskies football, we jumped at the chance to work with him.

Mark had been drafted by the Green Bay Packers, and we also liked the idea of working with a Packers player because, well, it was the Packers. They were kind of mythical to us as the team of legendary coach Vince Lombardi, and were part of that old-school football lore in Green Bay, where the Ice Bowl had been played in below-zero temperatures. The Packers didn't have one of their best teams that year, and it wasn't a large market, but Mark was our fellow Husky and was one of Green Bay's better players.

We knew his agent from some of our previous posters, and Mark was in Seattle a lot, so we were able to talk directly with him to toss a lot of ideas around. Among others were "The Green Hornet," "Mean & Green," "Mark of Excellence," and "The Rambo of Lambeau"—a nod to Green Bay's Lambeau Field. (Yeah, that made us laugh, too.) But "General Lee" was a name that everyone had heard of, and Mark was good with it, so we were a go.

We had good luck with weather on our other outdoor shoots, but this time we got a cloudy day, although it did eliminate the need to work around harsh shadows. We tried changing the sky to blue in postproduction, but we ultimately liked the gray sky better.

When the poster came out in 1987, it didn't receive one bit of flak from anyone in sports or the media, and we didn't receive any complaints despite there being plenty of racial issues in sports that needed to be written about, and were written about. If we heard "General Lee" was someone's nickname today, we wouldn't even consider using it. And if we did, we would all be deservedly in big trouble. A number of years ago we looked at this poster and it made us uncomfortable because we realized that it probably would be considered offensive by today's standards. But we still wanted to include it because it shows how much our society has changed and become more cognizant of such issues. And Mark belong here with the other stars in this book.

A few years ago, we were interviewed about our Kenny Easley poster, and the interviewer told us he felt we were among the first to "elevate the black athletes to superstar status." We thought that was crazy, because race never came into it for us. We grew up loving our sports heroes because of how they played, and color had nothing to do with it. It was the same with our posters. We simply never thought about it, because to us, heroes are heroes.

But when we look at it now, maybe we should have gone with "The Rambo of Lambeau" . . .

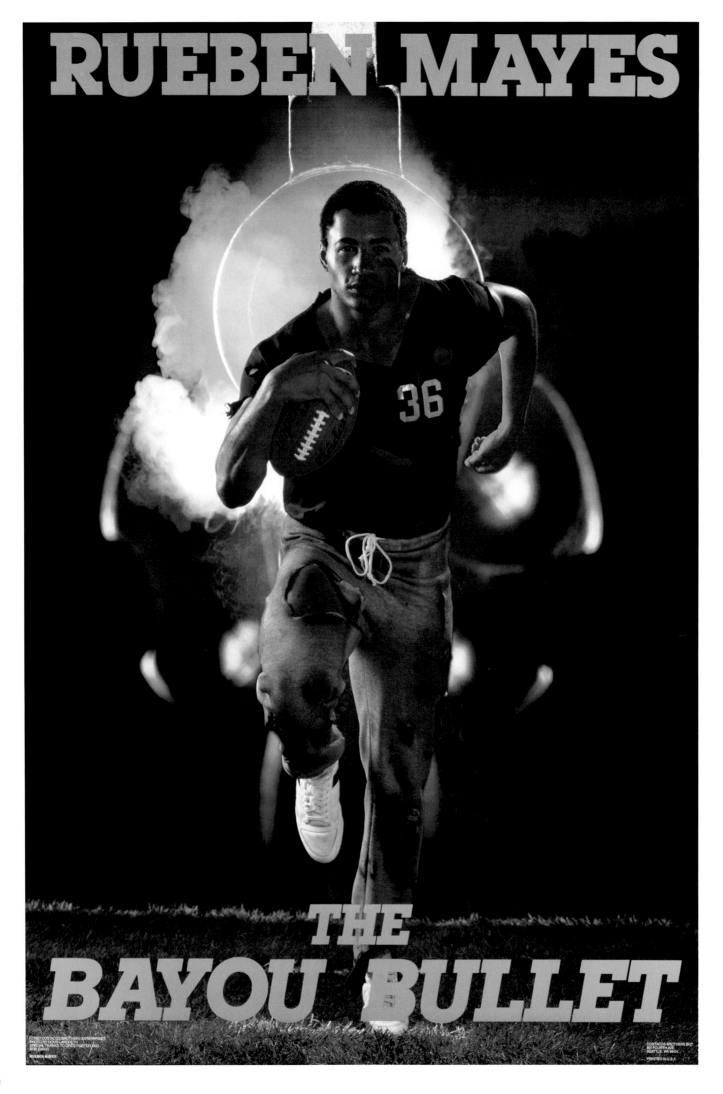

Rueben Mayes

New Orleans Saints
1986 NFL Offensive Rookie of the Year

Rueben and John
looking at a test shot.

Rueben had played college football in our backyard at Washington State University, so we knew who he was before his pro career. He made big headlines at WSU when he broke Eddie Lee Ivery's NCAA single-game rushing record by running for 357 yards in a 1984 game against Oregon.

Fast-forward two years to his 1986 rookie season with the New Orleans Saints during our first year making posters. The eight posters we had made during our own rookie season had generated a bit of a buzz in the industry. We received phone calls from various teams, a number of agents, and a representative from Nike. And we went home with the personal phone numbers of a dozen of the best players in the NFL, all of whom were interested in working with us for the following season. One of those players was Rueben.

We always worked through agents, but direct contact with the players made a huge difference in being able to talk about ideas and go through a progression of concepts. We could tell by their reactions which ones they liked and didn't like. It was the best way to narrow down an idea we thought worked and they genuinely liked.

Although there aren't a lot of words that rhyme with *Rueben*, there are plenty that rhyme with *Mayes*, but we couldn't find a rhyme that made sense. We focused on the Saints' team colors of black and gold, and as we went down a list of movies and television shows, *The Black Stallion* caught our eye.

It had been a critical and commercial hit and had become part of pop culture, and we liked this idea a lot because Rueben was fast and ran beautifully like a stallion. But even though it was a play on the Saints' team color and had nothing to do with Rueben's skin color, we realized it would likely be misconstrued. The racial implications of Mark Lee's "General Lee" poster (see page 48) had never crossed our minds, but we saw the potential problem here.

So, after nixing "The Black Stallion," we went to Rueben's roots for inspiration. He was Canadian, so we tried "Canadian Bacon" and "The Speedy Saskatchewanian," but those obviously weren't going to work. (We always verbalized things like this as part of the progression. And for laughs.) So, we focused on the city of New Orleans itself and associated words like *delta* and *bayou*, and that's where "The Bayou Bullet" came from.

We shot it in Seattle on turf with a fog machine and strobe directly behind Rueben so we could capture a burst of light like he was being shot out of a gun. We photographed the gun afterward with gold footballs in the chambers and put it all together in the photo lab, and even printed the poster with metallic gold as a fifth color to make it look especially good. Rueben was tremendous to work with, and it felt like he was really participating in the process, trying different poses and positions to get the right look and collaborating with us rather than just being a subject.

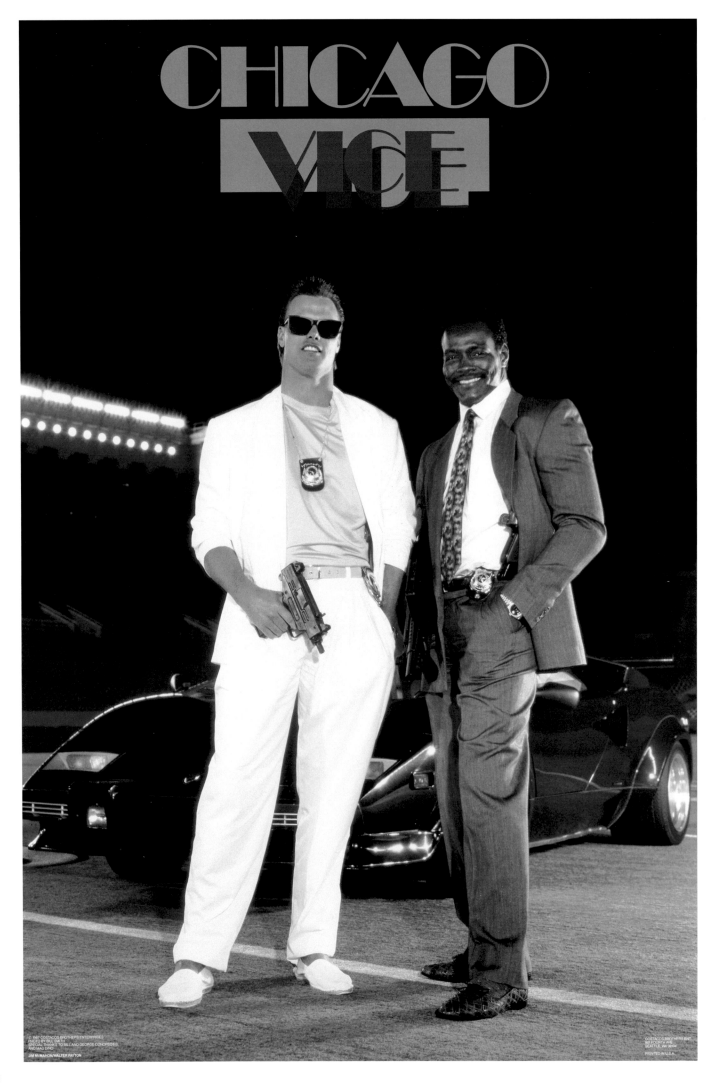

CHICAGO VICE

Jim McMahon & Walter Payton

Chicago Bears
Super Bowl XX Champions

We managed to talk Jim and Walter into letting us shoot them holding footballs after we took some shots of them holding guns, but they seemed to screw up those takes on purpose.

The Bears were so hot in 1987—and we had done so well with Jim McMahon's Mad Mac poster the previous year—that we naturally wanted to do more Chicago football posters. We asked Jim if he thought we could do something together with him and teammate Walter Payton, and Jim loved the idea. They were friends, and if you ever saw them together, they were quite a pair.

Miami Vice, a massive hit television show at the time, had become a part of pop culture. While the show was on TV one night, we joked, "Crockett and Tubbs . . . *Miami Vice* . . . McMahon and Payton . . . *Chicago Vice*." We had a little laugh about it but then thought, "Wait, this could work." We figured we'd dress them up like Crockett and Tubbs and put footballs in their hands instead of guns. We called Jim, and he talked to Walter, and they were in.

We shot it at night on the turf at Soldier Field. Walter sent his Lamborghini ahead of our 6 pm scheduled start so we could do some test shots. Jim got to the stadium early and hung out in the locker room eating pizza and drinking Moosehead beer. (He was really easy that way; when asked what he wanted us to bring, he simply said, "Pizza and beer. Moosehead, if you can get it.")

So, while Jim was eating, we were out on the field doing test shots, but we had a problem: Photographer Bill Smith, the Bears' team photographer, figured the cold weather had frozen something inside his lens, so he had to run out and get a different one. It was 5:30 pm, and Bill figured he'd be back and ready to shoot at 6:30 pm.

Walter showed up at 6 pm. This guy was NFL royalty, and we had never met him before. We introduced ourselves and explained to him about having to shoot at 6:30 pm, which led to this exchange:

WALTER: We're supposed to shoot at 6 pm, right?
US: Yes.
WALTER: It's 6 pm and I'm here, but you're not ready to shoot. Is that right?
US: Yes.
WALTER: I don't do business like that. If you say 6 o'clock, it's supposed to be 6 o'clock. I'm holding up my end of the bargain, and you're not. I'm not doing this. I'm leaving.

And then he walked out the door. We were only going to be 30 minutes late! We stood there in complete silence as panic started to hit us. We looked over at Jim for help, but he just sat there stuffing another slice of pizza into his mouth. We had everything set up, and Walter Payton had just walked out the door.

All of a sudden, the door opened back up and Walter stuck his head through the doorway and said, "I'm just messing with you." He had a big smile on his face, and when he saw the near hysteria in our faces, he came over and hugged us.

When we were finally ready to shoot, we gave them each a football to hold. Walter said, "I have a better idea." He led us out to his Mercedes and opened the trunk, which was loaded with a very large assortment of guns. We explained that we had told their agents we were going to use footballs, and he said to Jim, "Footballs or guns?" Jim said, "Guns."

Jim McMahon

Chicago Bears
25 Consecutive Wins as a Starting QB (1984–87)

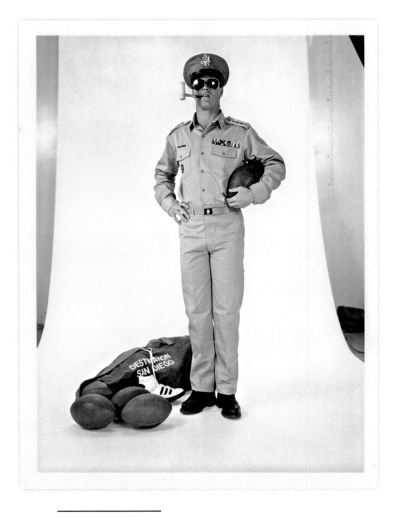

Test shot from the
shoot, with Jim in
one of many poses.

It was really one of the worst cheap shots we'd ever seen. In the 12th game of the 1986 season against Green Bay, one of Jim's passes was intercepted (by our client-to-be Mark Lee). After the play was over and Jim was walking back to the sideline, Packers defensive lineman Charles Martin wrapped his arms around Jim from behind and body-slammed him to the turf on his shoulder. Martin was ejected, but the damage was done: The injury to his shoulder ended Jim's season, and he had to have rotator cuff surgery a few weeks later.

After the season, we talked with Jim's agent, Steve Zucker, and got the ball rolling on getting Walter Payton together with Jim for "Chicago Vice" (see page 53), but we also told Steve that we wanted to shoot a new individual poster with Jim as well. The Bears were still popular, and his "Mad Mac" poster was flying off the shelves.

Jim called us, and we tossed a few ideas around, and he said his surgeon told him that he'd make a full recovery. The doctor had said that with the surgery Jim had, it would have been a different story if he was a baseball pitcher, but with his football-throwing motion, he was sure he'd be 100 percent back. Jim was annoyed that there were some sports people suggesting he may not ever play again, and he said, "I'll be back. You can count on that. I'll be back." So that was our starting point, and we thought of the famous World War II quote by General Douglas MacArthur, "I shall return." If dressing Jim up like Mad Max was perfect because of his tough image, General MacArthur was equally fitting because of his resiliency and leadership.

The main costume was easy to find at Federal Army Navy Surplus in Seattle, although the pipe was a bit of a problem. MacArthur had always had a corncob pipe, so we checked every cigar, pipe, and smoke shop in Seattle to find one, but surprisingly, we couldn't find one that worked. Two stores had corncob pipes about half the size we wanted and wouldn't have looked right at all. Then, one of our friends told us he knew of a place that had them: Dr. Feelgood's. Sure enough, all the smoke shops failed us, but a head shop came through with the perfect corncob pipe.

Jim looked great in the MacArthur getup. As soon as we saw him in it, we knew it was going to work. We shot the poster in a studio against a seamless backdrop and the background at a beach with friends, relatives, and neighbors as General Jim's soldiers. We decided to make this a door poster and printed it 80 inches tall, and it looked great all put together.

The duffel bag on the ground reads "Destination San Diego" because that's where the Super Bowl was going to be that year. The Bears had the second-best record in the conference that season but lost in the playoffs, yet Jim did end up in San Diego—two years later—in a trade to the Chargers.

Having had success with the Joe Morris door poster (see page 60), followed by having even better success with this one, made us realize the higher-priced larger posters could do well in the marketplace. This influenced our decision to create more, starting the following year, when we got an NBA license and started with Michael Jordan, Magic Johnson, and Larry Bird.

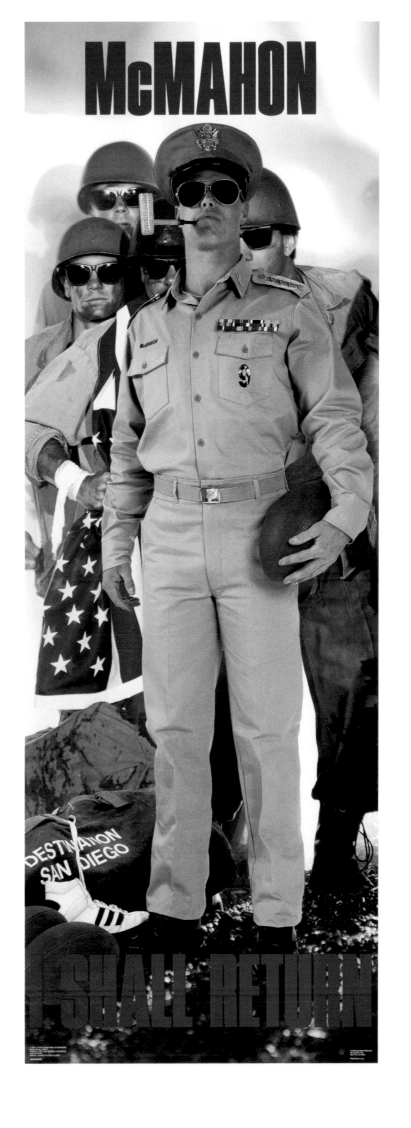

Frank Minnifield & Hanford Dixon

Cleveland Browns
NFL.com's #2-Ranked All-Time Cornerback Tandem

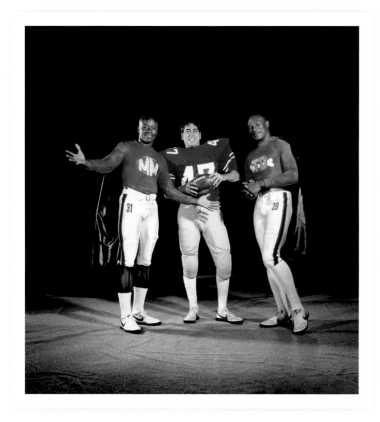

Frank and Hanford, along with their vanquished foe, our buddy and Ohio State alum Craig Foglietti.

This is still one of our favorites, and we didn't even come up with the title. We usually created the title, nickname, or theme for the posters, but this wasn't always the case, and the first poster where someone else came up with the idea was with the Cleveland Browns' Frank Minnifield and Hanford Dixon.

We met with Frank and Hanford during Pro Bowl week in Hawaii, and these guys were characters. They were very, very funny and good friends—and one of the best cornerback tandems in the league. Frank and Hanford had been instrumental in creating the "Dawgs" nickname for the Cleveland Browns' defense in 1985, when they'd bark at their defensive line whenever a lineman or linebacker got a sack, to recognize their play.

We'd been selling posters for less than six months and didn't have any Browns players, but Frank and Hanford were aware of our work, and as soon as we told them we wanted to work with them, they said yes to making some kind of poster.

The idea we had for them was the Corner Brothers. We thought we'd parody the famous Warner Bros. logo and go from there. They stopped us on the spot and had their own idea. Hanford simply said, "Mighty Minni and Top Dawg." We understood it immediately, and we were all in on their idea.

After half an hour tossing around ideas and details and what we could do visually, we agreed that Mighty Minni and Top Dawg sounded like cartoon or comic book superheroes and decided to go with capes and superhero logos on their chests. Hanford was one of the leaders of the Dawgs' defense, and his nickname for Frank was Mighty Minni, so it had some personal meaning to them, too.

Since they were going to be superheroes, we wanted them up on a roof like they were protecting their city, and we needed a background that was distinctively Cleveland. The Terminal Tower is a historic landmark in Cleveland, so we chose that building to appear in the background. We learned we could have a nice view of the tower from the top of Cleveland's City Hall, and when we checked with the city to see if they would actually let us set up and shoot on the roof of City Hall, they were very accommodating.

We made the shirts and capes ourselves because we were trying to keep our budgets as low as possible. There was no way to prevent the glitter from falling off their chest logos, no matter how well we put it on, so we just had to add the glitter as late as possible. The night before the shoot, we were like kids in grade school art class, adding glue and glitter to the costumes.

Because every superhero needs a villain, we added a defeated villain under Hanford's foot. We always put our friends in the posters whenever we needed extras, and for Mighty Minni and Top Dawg, we chose Craig Foglietti, who is a gigantic Browns fan.

This remains one of our favorite posters because these guys had an idea of their own that they wanted us to make, and because they were just the funniest guys you could ever want to be around. And when we look at the poster now, we can't keep from smiling, because it works despite being so over-the-top. And it didn't hurt that the Browns' defense was ranked second in the NFL that year.

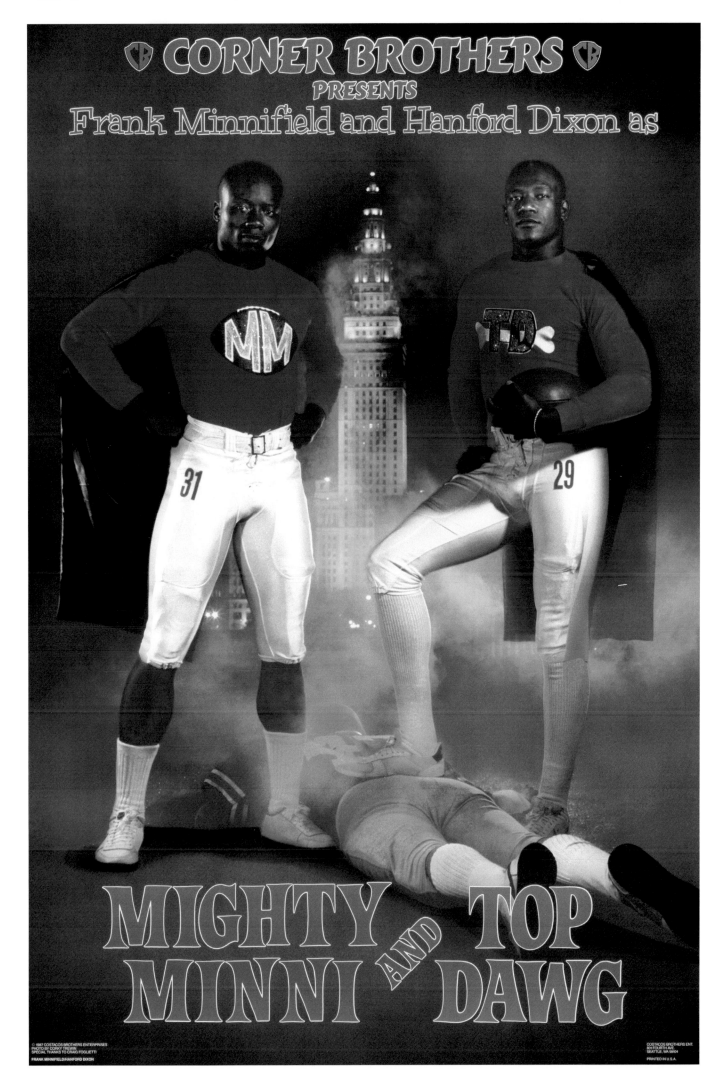

Joe Montana

San Francisco 49ers
NFL 75th Anniversary All-Time Team

It was a typical
chilly San Francisco
day when we shot.

After our first season of selling posters, we were building a good distribution network and solid customer base and were getting a lot of feedback from our sales reps and the store buyers across the country. The two players most often requested were Joe Montana of the San Francisco 49ers and Walter Payton of the Chicago Bears.

Joe had already established himself as one of the great quarterbacks in the game, winning two Super Bowls—and being named Super Bowl MVP in both. (He eventually was named MVP three times out of four Super Bowl victories.) He was so popular that he had hosted *Saturday Night Live* (coincidentally, with Walter) early in 1987. Joe had been injured for much of the 1986 season, but he finished with a flurry when he came back in Week 10 and threw for 270 yards and three touchdowns en route to being named co–Comeback Player of the Year. Heading into the 1987 season, Joe's 49ers were Super Bowl contenders once again, so we went to work on a concept.

Despite having been football fans for most of our lives, we had never really thought about what exactly a "49er" was, so we looked up the term and discovered it was the nickname given to prospectors going to California in the 1849 gold rush. When we went to the library to look for pictures from that time, though, most of the people depicted were filthy-looking miners. Nothing in any of the photos inspired anything with the San Francisco 49ers team name, so we focused on the words: What rhymes with *Joe*? What rhymes with *Montana*? What acronyms work with his initials, what can we do with the team's Candlestick Park home stadium name, what street is the stadium on? We would write every word down. Everything that rhymed with the words for the team colors, *gold* and *red*. We looked at lists of popular TV shows and movies from that time and wrote it all down. Finally, we listed things San Francisco was known for, like the Golden Gate Bridge. Golden Gate . . . Golden Gate . . . Golden *Great*—that was it.

Now, if the poster's theme was going to be "The Golden Great," we needed the bridge in the background and wanted the city behind that. We played with a number of costume ideas but ultimately decided on street clothes. San Francisco was Joe's town, and we wanted to portray him with a very clean and casual look: jeans, sneakers, and a jacket with his city in the background.

Joe liked the 49ers team photographer, Michael Zagaris, so we called and worked out the details with him. We flew down and shot at the Marin Headlands, at the north end of the Golden Gate Bridge, so we could have the bridge behind Joe and the San Francisco skyline behind the bridge. Michael was great and remains one of the most fun people we've ever been around.

Instead of using a standard four-color press, we had to print this with a fifth color to get the gold we wanted, and we were happy with the way it came out—and even happier with the way it sold across the country. It didn't hurt that the 49ers finished with a league-best 13-2 record and Joe led the NFL in touchdown passes, passer rating, and completion percentage.

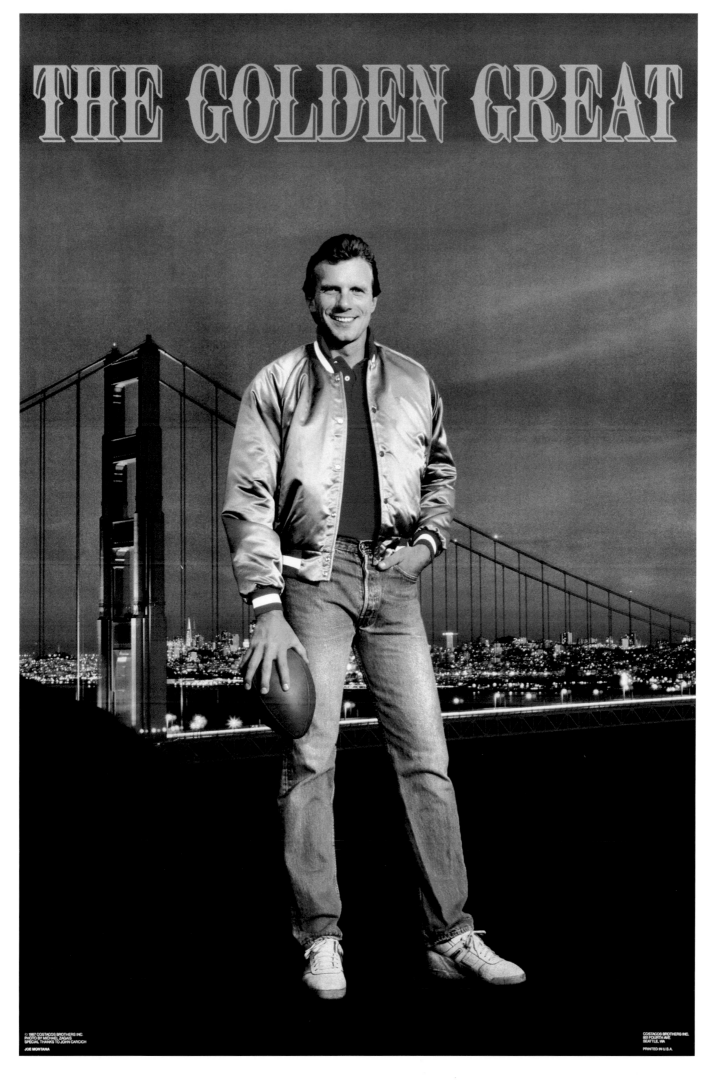

THE GOLDEN GREAT

JOE MORRIS
GROWTH CHART

5'7" Look Mom, I'm taller than Joe Morris!

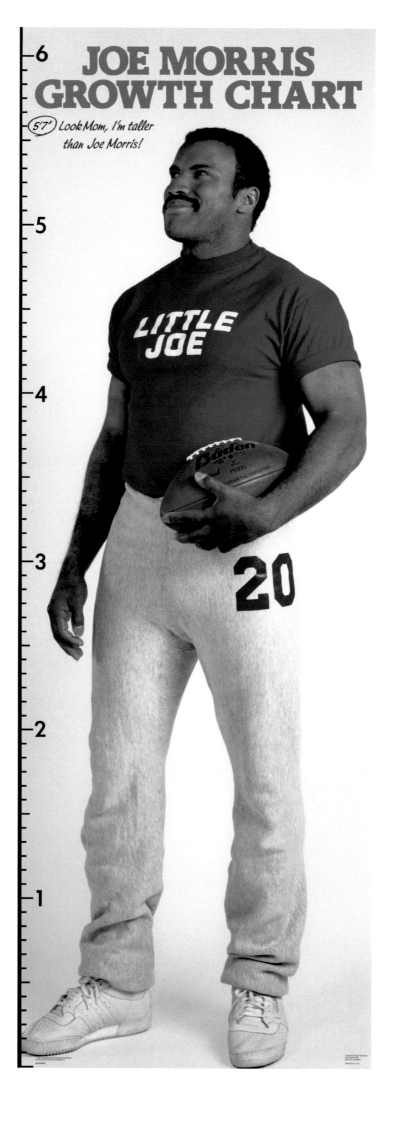

60

Joe Morris

New York Giants
Super Bowl XXI Champion

John is totally (not)
taller than Joe.

Anybody who is 5-foot-7 and playing in the NFL is a guy we love. That guy was Joe Morris, running back for the New York Giants.

The one thing announcers always mentioned about Joe was how he was undersized, but he made up for a lack of height with immense strength that powered him onto the 1986 All-Pro First Team and enabled him to set a team single-season record of 21 touchdowns that stands to this day. Still, in a league of giants, his height made him an underdog, and we knew that fans love underdogs.

We tried to brainstorm nicknames for him but couldn't come up with anything we liked. So we thought it would be fun to do something ironic like making a growth chart with the shortest guy in the NFL. Since we made posters for kids, we figured they would understand and parents would like the idea of having something to measure the height of their children as they grew. We presented the idea to Joe, and he loved it.

Very few printers in the United States had a press capable of printing posters large enough to show a person full-size, but we had found one in California by accident the year before. That printer had a press that could accomodate 80-inch posters pretty cost-effectively. Now, we wanted to try a larger poster, and this was the perfect opportunity.

Watching Joe play was one thing, but meeting a guy his size in person and knowing that he went up against guys who weighed 300 pounds was even more impressive. The shoot itself was easy: We still weren't licensed by the NFL, and since the fun in the poster was that it was a growth chart with a short guy, we didn't need a fancy costume, complicated props, or any special effects. Simplicity was the key.

But the larger poster size also meant a higher price tag, and we weren't sure it would sell. Joe wasn't an enormous star, but he was plenty big in New York and the poster sold very well. Having a good first experience with a poster this size opened up a new avenue for us the following year.

For each poster we made, we framed one and put it in the office. Joe's poster was unique because it was life-size, and it kept startling us—when you walk into a room that you assume is empty, it can freak you out, because for a split second it looks like there's someone standing there. Even though we saw it every day on our wall, it took a couple of months to get used to seeing Joe's poster. It constantly startled people who visited the office, and we had a lot of good laughs about it.

A few months after the poster came out, we got a phone call in the middle of the night that our office's alarm had been triggered. We drove over and found the police waiting for us. We unlocked the door and the officers told us to stay outside while they checked things out. A few minutes later they came out, and we asked, "Is everything OK?" One of the cops replied, "Yeah, but I almost shot your Joe Morris poster."

John Offerdahl

Miami Dolphins
1986 NFL All-Pro

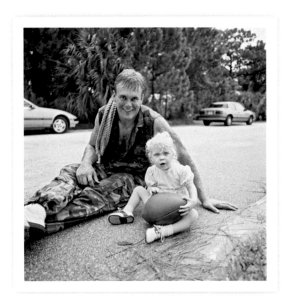

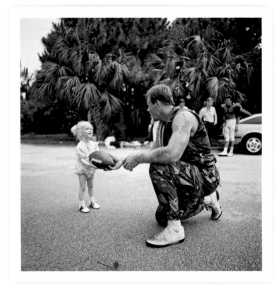

As tough as John
played, he was actually
a really sweet guy.

The more posters we produced and sold, the more we learned about the business. One such lesson was that in order to get stores in the major cities to carry our products, we had to have posters of athletes who played in their city. If we got one of their city's players, they'd carry the other posters, too.

This was roughly ten years before even slow dial-up internet access started to make its way into homes and offices, so getting information about a city, the sporting goods chain stores there, and the popular individual fan shops that we'd need to target was difficult. So was identifying local fan favorites that flew under the national radar.

For Miami, we had our eye on Dan Marino and the receiver duo of Mark Clayton and Mark Duper. We didn't have a concept we liked enough for Marino yet, and—for some reason we can't recall—we weren't able to make a deal to do "The Marks Brothers." But we just kept getting lucky. Maybe doing some good work was part of it, but good things kept happening, like meeting John Offerdahl at the Pro Bowl.

John was a linebacker from a university we had barely heard of, Western Michigan. He had made a lot of news at the 1986 Senior Bowl game when he did something most linebackers couldn't do: stop Bo Jackson. And John didn't just stop Bo Jackson on a goal line stand, he did it *twice*. He was then drafted by the Dolphins and made an immediate impact, earning NFL Defensive Rookie of the Year honors and a trip to the Pro Bowl.

Some guys are known for hitting hard or for their speed, but the thing about John was that he seemed to be in on every tackle. He had a great knack for getting locked in on whoever had the ball and getting there to make the tackle, so we were looking for a concept along those lines. The title came a few months later from a new Arnold Schwarzenegger movie called *Predator*, where an alien hunts and kills a team of Special Forces soldiers in the jungle. (Spoiler: except for Arnold.)

For the shoot, we went to Miami and found an outdoor jungle-like location and had extras dressed as downed football players (the victims of the Predator), some of which were hanging from the trees like in the movie. John wore military-style camouflage like Schwarzenegger's character, but after we started shooting for a few minutes, we realized that John didn't look like he was in the middle of a battle.

"You're too clean," we told him. "We need to get some dirt on you." As we were getting some dirt to rub on his clothes, John said, "You want dirt? I'll get you all the dirt you want." He then got flat on the ground and started to roll around to dirty himself up. The Defensive Rookie of the Year and All-Pro heard us say "dirt" and rolled on the ground to grind dirt into his clothes for our poster.

It's every kid's dream to get as dirty as he wants and not get in trouble, and we loved how John still had that bit of kid in him and we appreciated his willingness to give us the look we wanted. Whenever we're asked about John's poster, we always think about that moment.

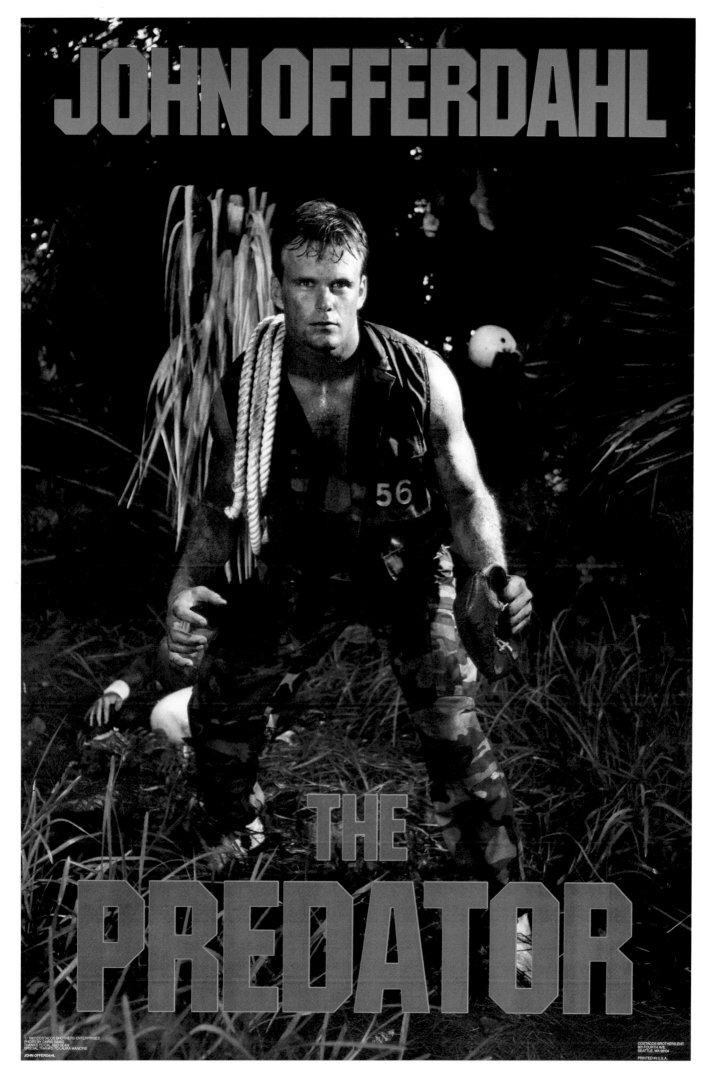

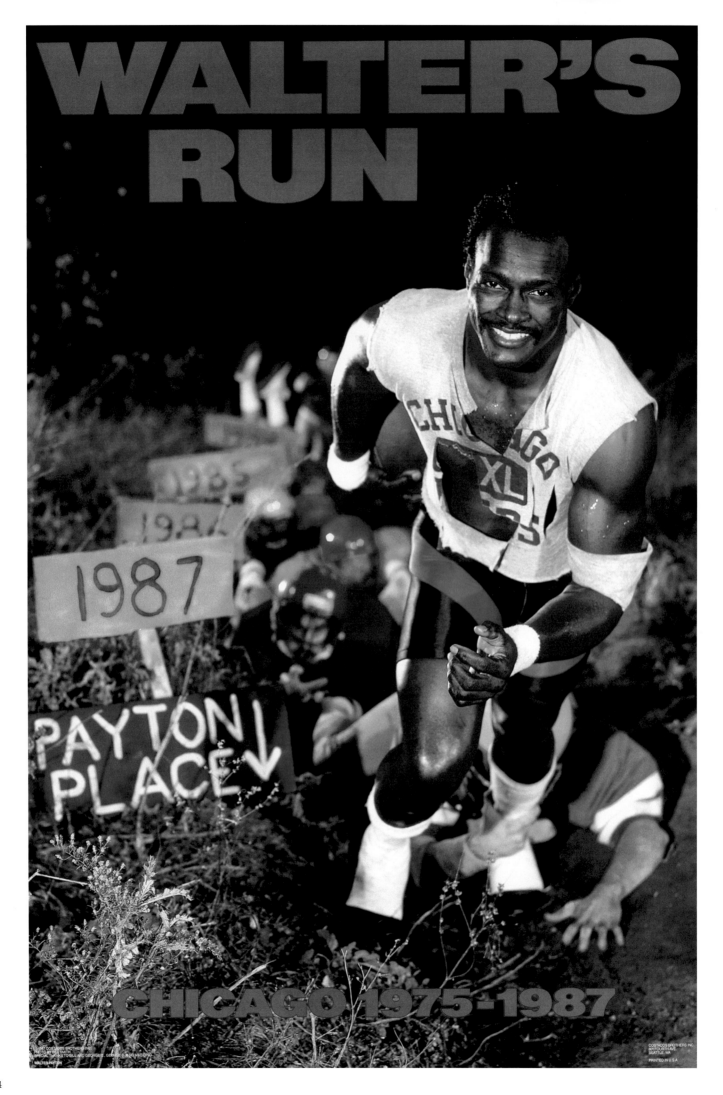

Walter Payton

Chicago Bears
NFL 75th Anniversary All-Time Team

The sports scene in Chicago couldn't have been better in 1987. The Bears were one of the very best teams in football, and the city was still basking in the glow of their team's Super Bowl XX victory. The Bulls had Michael Jordan, and the Blackhawks, the Cubs, and the White Sox had great followings. We had exceptional sales reps there, and our posters were popular, and Chicago had quickly become our favorite city.

There was no Chicago sports figure more beloved than Walter Payton. He had been drafted by the Bears in 1975 with the fourth overall pick, and after a pedestrian rookie season where he had "only" led the league in yards per kickoff return, he was named First Team All-Pro in 1976. Walter was even better the next year, leading the league in rushing yards and rushing touchdowns, setting an NFL single-game record with 275 yards rushing that stood for 23 years, and being named the NFL MVP. And the accolades kept piling up through his 13 seasons, all with Chicago: seven total First Team All-Pro selections, nine Pro Bowls, and two NFC Offensive Player of the Year awards.

But Walter was more than just a great player on the local team. Sure, he had already broken Jim Brown's record for career rushing yards, but he was also the soul of the city and one of the most cherished athletes in the country. People saw him not only as a great athlete but also as a great man. In 1977, he won the NFL Man of the Year Award, honoring his volunteer and charity work. (Years later, the award would be renamed the Walter Payton NFL Man of the Year award in his honor.) He was a true sports icon.

We had already shot "Chicago Vice" with him and Jim McMahon, so when Walter announced that he would retire after the 1987 season, we wanted to do something for him. His nickname was Sweetness, but we called him Uncle Wally because he was like the fun, smart-aleck uncle you always love hanging out with.

This wasn't what we had expected from him when we met him, though. The Walter Payton we saw interviewed on television was thoughtful and serious and soft-spoken; he seemed kind of introverted. But he was completely different once you got to know him—he was actually extroverted and lively and fun. He had the traits we had seen in the interviews, but there was a lot more to him, including a great sense of teenage-style mischief that made him fun. From the time we met and he scared us half to death (see page 52), we loved being around Uncle Wally. And the few times we saw his wife, Connie, she was really warm and nice toward us.

Walter was a fierce running back whose motto was "Never die easy," which exemplified his running style of always trying to pick up extra yards and not take the easy way out by running out of bounds. We thought of using that motto, but although it would've been perfect for the middle of his career, it didn't seem like the right way to commemorate what he had accomplished during his playing days.

Walter liked the idea of doing something based around his hill, an embankment near his home that he ran up during the offseason. It was a very steep incline that stretched fifty yards or so, and tales of him running up that hill to increase his stamina were legendary. He liked to run the hill repeatedly to complete exhaustion, to push himself and challenge his capabilities. It seemed like a nice idea to incorporate into the poster, because training on that hill was symbolic of how he tried to outwork everyone in games.

We shot it from the top of the actual hill in Arlington Heights, Illinois, and it was a sight to behold. John couldn't resist giving it a shot, and he started to run up the hill. About halfway up, his "running" downgraded to "trudging along." It looked steep from the bottom, but it was somehow steeper than it looked.

The shot was set up with Walter running upward toward the camera with a bunch of our friends dressed in rival team uniform colors strewn behind him, as if they couldn't catch him. Of course, we had to have someone wearing division rival Green Bay's green and yellow, and there's someone dressed in Kansas City red to symbolize Walter's amazing 1977 run against the Chiefs, when he had seemed to spin, fake, and overpower their entire defense. Signposts with the years he had played marked the journey of his career, finishing at "Payton Place." Walter said he wanted to be smiling on the poster, because "I want my fans to know I'm happy. I'm retiring, but they were with me every time I ran up here, and I want them to remember me smiling."

He kept in touch with us after his retirement. We occasionally saw Walter in Chicago, and he would call to get together with us when he visited Seattle. He always asked about our family, our business, and what we were up to and was genuinely interested. We really loved Uncle Wally and were deeply saddened when he passed in 1999.

The hill was flattened in the mid-'90s to make way for the par 3 Nickol Knoll Golf Club. After Walter's passing, there was a movement to create a memorial at the golf course, and visitors today can see Walter's No. 34 painted on a retention wall near the third hole—the area where Walter once put in the offseason work that enabled him to break Jim Brown's all-time rushing record—and a bronze plaque marking "Peyton's Hill."

John Rienstra

Pittsburgh Steelers
Ninth Overall Pick, 1986 NFL Draft

Here's the original concept sketch, which had a much more modest rhino costume.

When John came out of Temple University, he was a monster offensive lineman who won the 1986 super-heavyweight title at the National Collegiate Power Lifting championships. He was a big boy, and the Pittsburgh Steelers drafted him in the first round of the 1986 NFL Draft. Peter Johnson of IMG, his agent (who also worked with us on the Herschel Walker poster), told us his nickname was, fittingly, "Rhino." Peter arranged a phone call between us and we made the deal.

We didn't know how to make a costume that remotely resembled a rhinoceros, but someone referred us to a local design and fabrication company called Dillon Works! This turned out to be a great find for us, because we learned that the owner, Mike Dillon, and his crew can build anything. Mike had learned to build sets, props, and costumes while working as one of Disney's famous Imagineers, and he had founded his own shop a year earlier. Mike got John's measurements and made the rhinoceros costume, which we loved—the helmet in particular.

For the location, we used the Woodland Park Zoo, whose zookeeper we knew from when we had photographed the background for Mark Gastineau's poster there. We had thought about building a set and shooting indoors, but we liked shooting on location for the authenticity, even though it was a little unpredictable and we had less control over how everything would look. It may not have been the best idea to take chances, since we were still pretty inexperienced, but our photographers knew what they were doing and always had a backup plan.

John flew in from Pittsburgh, and we went straight to the zoo. When he saw the costume, John got a big smile on his face. These kinds of moments were always great for us, because we liked giving the athletes a chance to have some fun.

We shot it on a flat hilltop with the African savanna area of the zoo in the background, and we were hoping to get some lions in the shot—remember that part about "less control"?—but the giraffes wandered in, and that added something nice.

The original title was going to simply be "Rhino," but at one point during the shoot, we asked him for a nasty, mean look: "You're in a rage. You're the—the raging rhino!" At that moment, we all looked at each other, and the poster title changed to "The Raging Rhino" right then and there. We finished the shoot, took John out to eat, then drove him to the airport so he could catch his flight back to Pittsburgh.

While reminiscing about the shoot with John for this book, he told us that the Rhino nickname was given to him by one of his college teammates, who said John played football like the supervillain Rhino from the *Spider-Man* comics, who had super strength, speed, and stamina. Imagine how the poster would've turned out if we had known that 30 years ago!

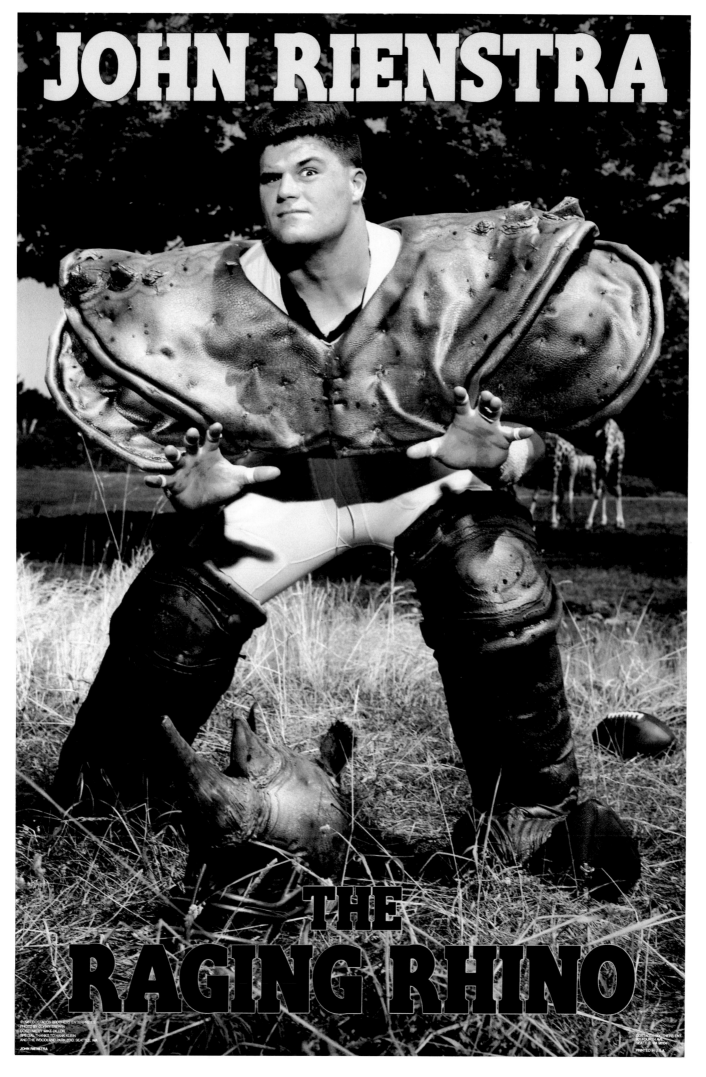

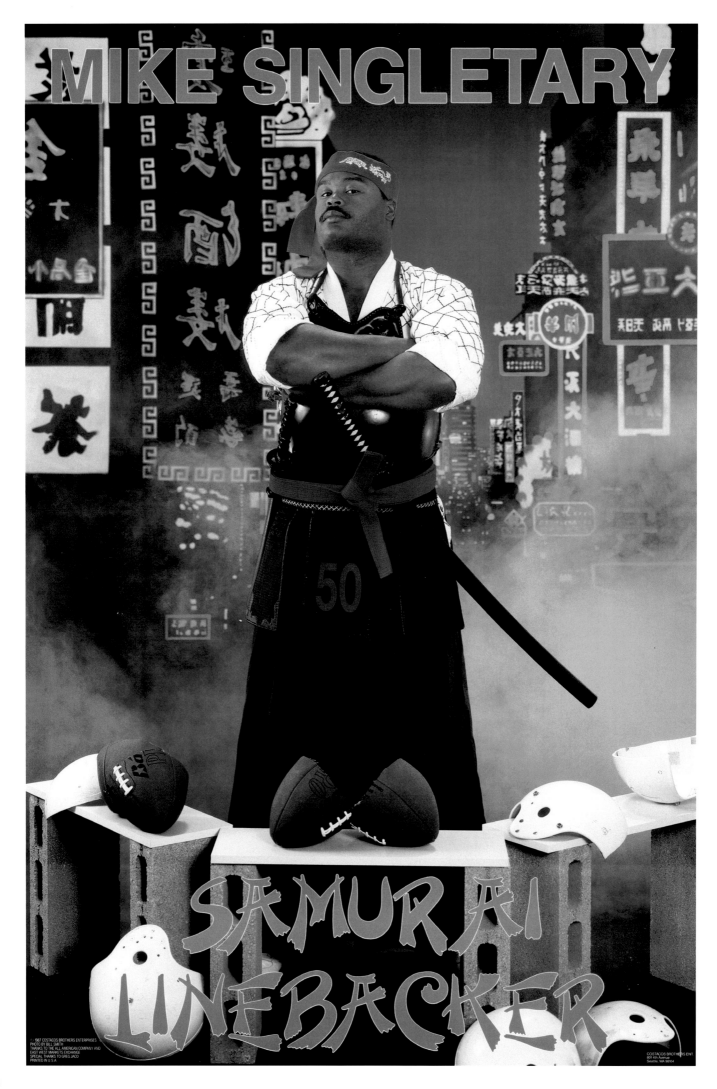

Mike Singletary

Chicago Bears
NFL 1980s All-Decade Team

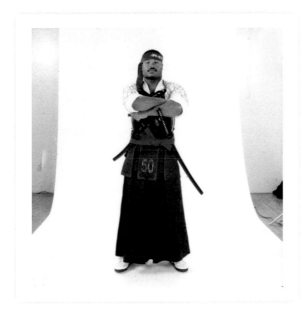

Test shots helped us
adjust lighting and
frame the shot.

"On the outside, he's a warrior, but on the inside, he's controlled and focused" is how one of Mike Singletary's teammates described him to us. Mike was the leader of the great Bears defenses from that era and had already earned 1985 Defensive Player of the Year honors and been named First Team All-Pro for the fourth consecutive year (which would happen another four times). His teammates called him Samurai Mike, and a Japanese-warrior theme sounded great to us.

We had talked about just labeling the poster "Samurai Mike," which would have been fine, but we wanted our poster title to be a little less . . . obvious. John Belushi had played a recurring role as a samurai on *Saturday Night Live* in the '70s that had become one of his iconic characters. Belushi depicts the character as a traditional samurai encompassing honor and mastery of craft, but in unexpected jobs, like in the sketches "Samurai Optometrist," "Samurai Stockbroker," and "Samurai Tailor." So, we thought about "Samurai Linebacker" and went back and forth between that idea and "Samurai Mike." After getting the opinions of our friends, family members, and employees (and sales reps), we decided on "Samurai Linebacker" because it seemed to have a little more fun to it.

To execute the idea, we first needed a samurai costume. We found a few around Seattle, but they either didn't look right or were way too small for a big, muscular guy like Mike. But our friends the Conopeotis brothers—the same guys who had helped us stage Jim McMahon's "Mad Mac" poster (see page 16)—had done some research around Chicago and had some leads when we got there.

The one we used was loaned to us by a martial arts instructor named Greg Jaco. He devoted most of his time to teaching karate to kids in very tough and dangerous neighborhoods in the hopes of keeping them involved in martial arts as an alternative to gangs and drugs. (You may have heard of Greg's son, who was five years old at the time: Grammy Award–winning rapper Lupe Fiasco.) We met Greg in the scariest neighborhood we had ever been through, much rougher than anything we had experienced in Seattle. Greg gave us the outfit and said we'd be safer if he walked us back to our car—which was thankfully still there—then gave us directions on the best way out of the area.

For the background, we rented a painted backdrop that was the closest thing we could find to make him seem like he was in Japan. We didn't envision Mike holding a sword as if he's going to attack someone with it—our idea centered around his warrior spirit, but we also wanted to have fun with it. In the *Saturday Night Live* sketches, Belushi was always pulling his sword out and slicing things up, so we sliced up some footballs and helmets as props. We wanted to create an image of Mike Singletary as the badass linebacker—but with a little John Belushi sprinkled in.

Mike was quiet and observant, and was one of those people who have an air about them that just commands respect. The samurai outfit fit him perfectly, although he didn't seem into it at first. But as soon as he saw himself in the first test Polaroid, a big smile appeared on his face, and he said, "OK—let's go!"

After it printed, we sent a box of the posters to him, and he called us personally to thank us. That meant a lot to us.

Mike Singletary, Wilbur Marshall & Otis Wilson

Chicago Bears
100 Combined Career Sacks

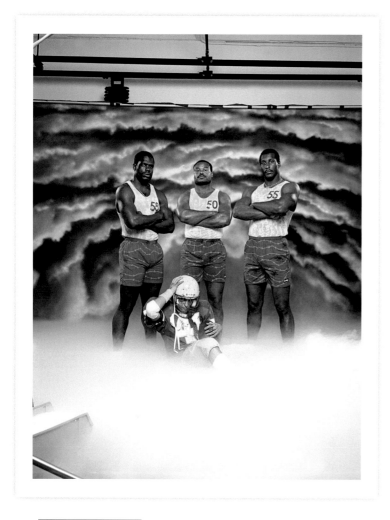

This shot exposes the secrets behind "The Bermuda Triangle."

Chicago, Chicago, and more Chicago. We kept worrying that we were saturating the market with posters and eventually it would be too many in that city, but our customers wanted more. Chicago fans couldn't get enough posters of their Bears.

The Chicago linebacker corps of Wilber Marshall, Mike Singletary, and Otis Wilson was one of the very best in the league, and they helped form one of the NFL's best defenses. At that time, Wilbur had been named All-Pro for the first of three times, Otis had already been named All-Pro twice, and Mike had made the All-Pro team four times. All three had been part of the great defense that propelled the Bears to a Super Bowl championship during the 1985 season, when it held opponents to 12.4 points per game, and then kept them to just 11.7 points in 1986.

We knew Mike from the "Samurai Linebacker" poster and had met Otis when Jim McMahon and Walter Payton took us to his locker during training camp and suggested we do one with him. (We can't disclose the proposed title in mixed company.) We don't recall if "The Bermuda Triangle" was their idea or ours, but we all liked it. The Bermuda Triangle was already known as a place ships and planes went into, never to be heard from again, and these three defensive players were so good that they often made their opponents' offense disappear.

Making these posters today would've been so much easier—back in the '80s, we had to shoot on film, which meant we were never completely sure if we got a good shot until after the film was developed. And programs like Photoshop would enable us to change colors, remove trademarks, or digitally add elements to an image. Without the licensing rights to put them in their actual uniforms, we found shorts in Chicago's team colors, orange and blue, and tank tops. (That's what someone would wear in Bermuda, right?) A painted background with an ominous cloudy sky blended nicely with the mysterious artificial fog.

We needed a player in the shot who had come into this Bermuda Triangle and not gotten out, and of course we chose to dress him in a uniform of green and yellow, the team colors of Chicago's archrivals, the Green Bay Packers. In our Lester Hayes poster (see page 14), we did a little Alfred Hitchcock move and put Tock in the poster, and we did the same thing here—that's John holding his head at their feet. (Those were the only posters we put ourselves in; we usually used our friends or family as background extras.)

There are several posters we made 30 years ago that we would not be able to make today, and this is one of them. Wilber, Mike, and Otis's costumes aren't the problem here; rather, it's how John is portraying the offensive player. The concept of having three defensive players standing over an opponent who's just had his bell rung (notice John's crossed eyes?) is problematic, similar to the old VHS compilations of the NFL's hardest hits—we now realize those dazed players had concussions, which is no joke. But in the '80s, fans thought football players were indestructible and could just shake it off.

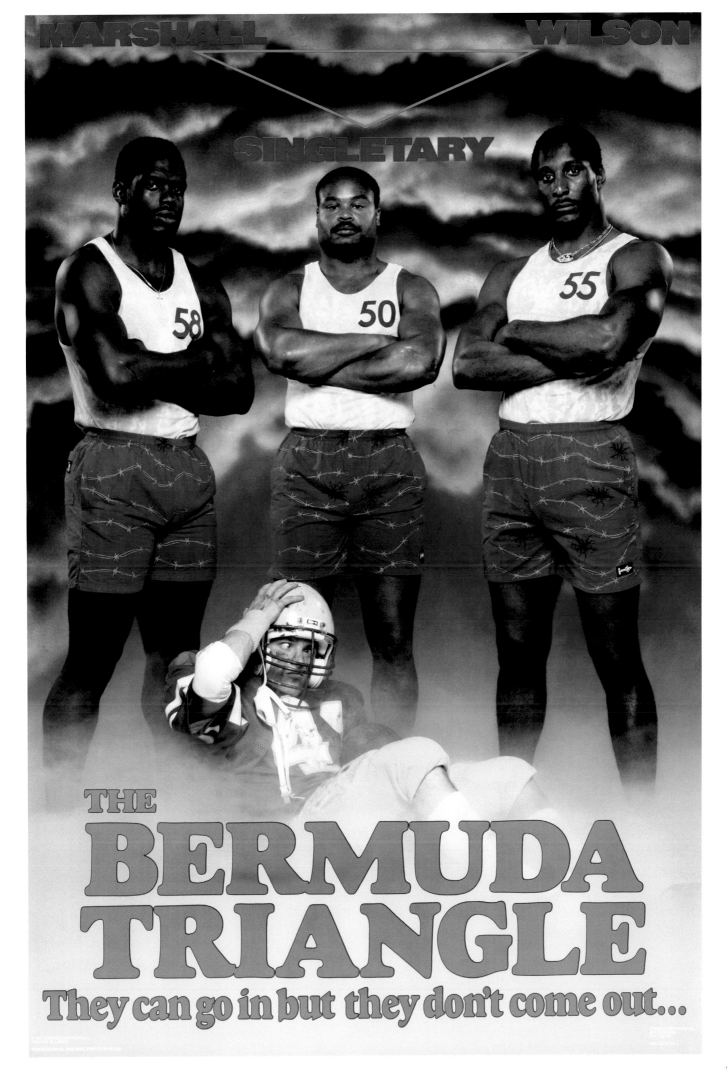

Herschel Walker

Dallas Cowboys
1987 NFL All-Pro

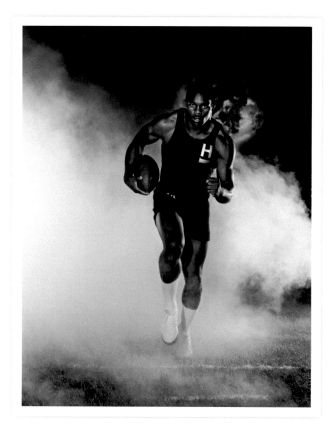

Here's the unaltered
shot of Hershel.

The answer is, yes, it's all real: We actually detonated live bombs behind an NFL superstar to make this poster.

If you were a sports fan during the eighties, you knew who Herschel was, because he had been doing amazing things on TV ever since his freshman year at the University of Georgia. He set the NCAA freshman rushing record and led that team to the 1980 national championship and earned the Heisman Trophy in 1982. He played his first three professional seasons with the USFL's New Jersey Generals but signed with the Dallas Cowboys in 1986—perfect timing for us.

We always kept notepads nearby and wrote down every work-related idea that came to us. During highlights of a game where Herschel put up big numbers, the announcer said, "Herschel Walker exploded today," so we wrote that down. That led us to words like *explode*, *explosion*, *explosive*, *bomb*, and, for a guy named Herschel, *H-Bomb*.

His agent, Peter Johnson of IMG, made the deal with us on the condition that we also make a poster for one of his other clients, John Rienstra of the Pittsburgh Steelers (see p. 66). We made the two-poster deal and called photographer Chris Savas in Atlanta, who knew a guy who did pyrotechnic work for television and films. He assured us this guy knew what he was doing and could make the bombs we envisioned for the shot.

We found an outdoor location and didn't need a permit or anything (at least, we didn't *think* we needed a permit). The bombs were soft and inside green plastic garbage bags. The bomb guy explained that he used mothball shavings in them to get a large fireball effect. They were expensive, so we only had five made, and the bombs were hung by horizontal wires so they'd be suspended above the ground.

Herschel met us for the first time when he showed up for the shoot, and he is simply one of the nicest people we have ever met—gentle, relaxed, kind, and personable. We hit it off instantly.

The bomb guy had plenty of experience and his references checked out, but when you're about to detonate bombs, you start wondering, "What if . . .?" So we decided to have him detonate the first one by itself—when we were all very safely away. This test explosion would show where Herschel should be to get the right perspective for the shot (and to make sure we didn't blow him up).

It took precise timing to get Herschel in the right spot as the ball of flames hit its peak, but Chris and the bomb guy had it precisely coordinated so Herschel was running at the perfect moment during the explosions. The bombs were loud and warm, but also very contained and consistent—the bomb guy did indeed know what he was doing!

Because we were shooting on film, we couldn't know for sure if we had gotten a good live shot until we got the film developed the next day, but we nailed it.

It's hard to imagine doing something like this today.

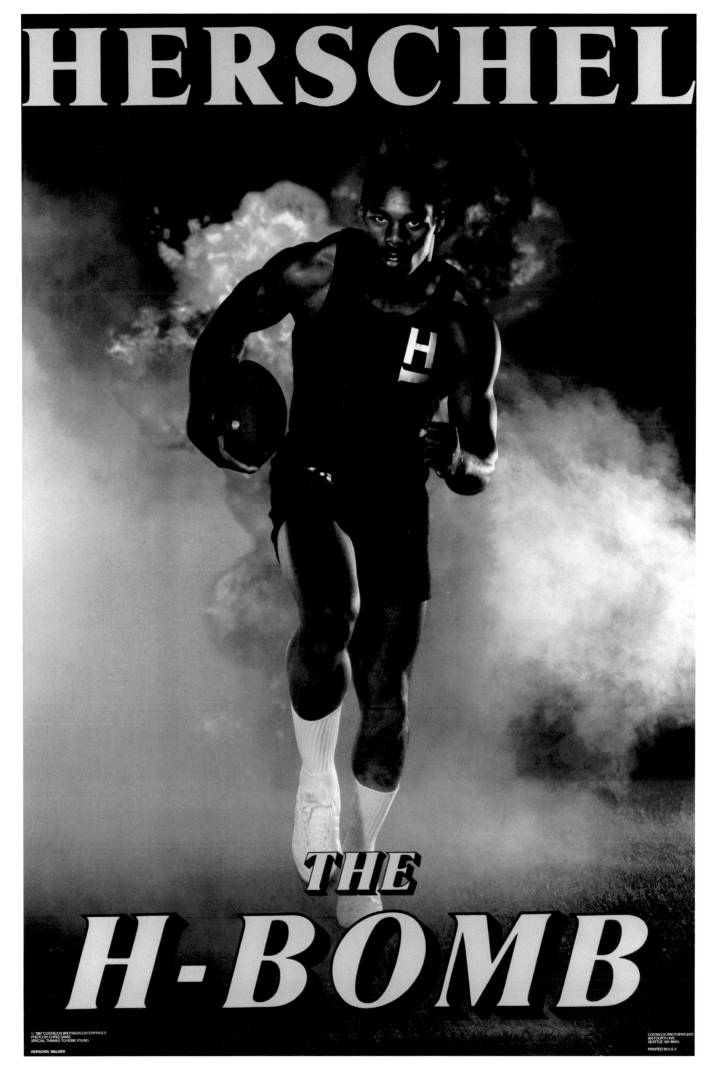

DOMINIQUE

NIQUE

THE HIGHLIGHT ZONE

Dominique Wilkins

Atlanta Hawks
1985–86 All-NBA First Team

Dominique Wilkins was the subject of our first basketball poster simply because he was the first player for whom we had an idea we genuinely liked: People called the 1986 NBA Scoring Champion "the Human Highlight Film" because of his otherworldly athleticism and skills, so we thought "The Highlight Zone" was a fitting theme.

This was one of many times we consulted our intellectual-property attorney, Mike Folise, to make sure we didn't infringe on someone's trademark. Part of our concern was that we wanted to use a font like the lettering from the *Twilight Zone* television series logo. Mike explained to us that our poster had to be an "obvious parody" and that there should be "no likelihood of confusion" for us to be legally safe. That meant that it had to be unmistakable that we were doing a parody of the *Twilight Zone* series, and that nobody would be confused and think Dominique Wilkins had anything to do with that television show.

We had met Dominique's agents, Lonnie Cooper and Roger Kirschenbaum, at the big Super Show sporting-goods trade show in Atlanta, and we called them when we came up with the concept. A few months later, we were back in Atlanta to photograph him in Chris Savas' studio against a seamless backdrop.

Without an NBA license, we had to shoot him in an original uniform sufficiently different from the Atlanta Hawks' jerseys and without team and league logos to keep us out of trouble with any trademark issues. We took turns jumping in the air for test shots—not quite as high as Dominique, but close. (It wasn't close.)

We thought about photographing Dominique dunking the ball, because he was an awe-inspiring dunker. He had won the 1985 NBA Slam Dunk Contest, beating a field that included Michael Jordan, Clyde Drexler, and Dr. J, and narrowly lost in the 1986 finals to teammate Spud Webb. But we ultimately preferred the idea of him floating in space. We explained this to Dominique and told him to really just do whatever felt natural—we wanted him to be comfortable and to have fun with it all. He understood perfectly and gave us a number of different looks, leaping impossibly high for each shot. It was amazing to see his athleticism up close.

Believe it or not, Chris simply took a black piece of paper and poked holes in it with a pin, put a light behind it, and shot that for the starry-sky background. And we took a reel of film, spray-painted the reel and film gold, and shot that, then sent everything to the photo lab to compose them together and add the glow.

Shortly after its release, we got a "cease and desist" letter from attorneys at CBS—which owns the rights to the *Twilight Zone* name—saying we were infringing on their trademark. Mike Folise explained that the attorneys were just doing their job and wrote a response explaining why the poster was an obvious parody and there would be no likelihood of confusion that the 1985 NBA Slam Dunk Contest winner was connected with a sci-fi/fantasy show about airplane gremlins and human cookbooks.

(top) We shot this poster for Reebok, which came out in 1992.

(above) Production guy Ray Carr creating his own highlight on set.

Dexter Manley

Washington Redskins
1986 NFL All-Pro

This pose would show
off Dexter's bicep,
but we wanted a more
compact pose so we
could zoom in closer.

(clockwise from top left)
Artist Chuck Doyle,
Dexter, production guys
Ricardo Galindez and
Scott Figueroa, and John.

Dexter was a defensive end for the Washington Redskins and one of the best pass rushers in the game. He had had 18 sacks the previous season and had made the Pro Bowl. And he is one of the nicest and warmest of all the athletes we worked with. We were often surprised when guys who played hard in a violent game were gentle and kind when off the field. Dexter liked our posters and took a particular interest in them, identifying the parts he liked the most and asking questions about them. We told him we didn't have a good enough concept for him yet, but we would call when we did.

After brainstorming concepts, it came down to two ideas. One was "The Dexterminator," but we decided against it because we'd done "The Terminator" for Lawrence Taylor the previous year. The other finalist was based on the children's cartoon *He-Man and the Masters of the Universe,* which was hugely popular at the time. Even though it was a children's show, we were familiar with it and always thought it was fun that the big, muscular star was called He-Man. In the cartoon, Prince Adam would raise his sword and say, "By the power of Grayskull," evoking the name of the magical fortress that bestowed superhuman strength on him. After mystic energies transformed him into He-Man, he would declare, "I have the powerrrrrr!" Or something like that.

So, we pitched "D-Man: Master of the Gridiron" to Dexter, and he liked it. We were making the posters primarily for kids, and they'd understand his reference. It seemed like kids appreciated our creativity, and from what we were reading in our fan mail, they seemed to feel like we were letting them in on the fun. (It wasn't all positive, and one negative letter was actually our all-time favorite. A kid wrote it on wide-lined newsprint, the kind used in grade school, and from the look of it he couldn't have been older than nine. It had five words on it: "Hey, you guys suck.—Jimmy." To this day, we have no idea why Jimmy thought we sucked, but he was probably right.)

We watched a few episodes of *He-Man* to get ideas for the costume and set. Though we were working nonstop every day, we were having the time of our lives. It didn't seem like work, and we felt really lucky. Whenever we would dive into projects like this, one of us would inevitably say to the other, "We have three college degrees between us—and we're watching cartoons for work." We couldn't believe we were allowed to have this much fun and get paid for it.

Our friends at Dillonworks!, the company that also created the set for "The Land of Boz" and John Rienstra's rhinoceros costume (see pages 34 and 66), built the ruptured football field Dexter stands on, as well as the armor costume and sword. Though we enjoyed building props and costumes ourselves, we were getting busier, and working with experts like Dillonworks! was a nice relief.

Dexter came to Seattle in early summer for the shoot and brought his son. He was just so gracious and kind and so willing to work with us until we got it right. Maybe it was because Dexter's son helped us imagine the excited reactions other kids would have when they saw the poster, but we really enjoyed having him on the set. Or maybe it was because it reminded us we were still kids at heart.

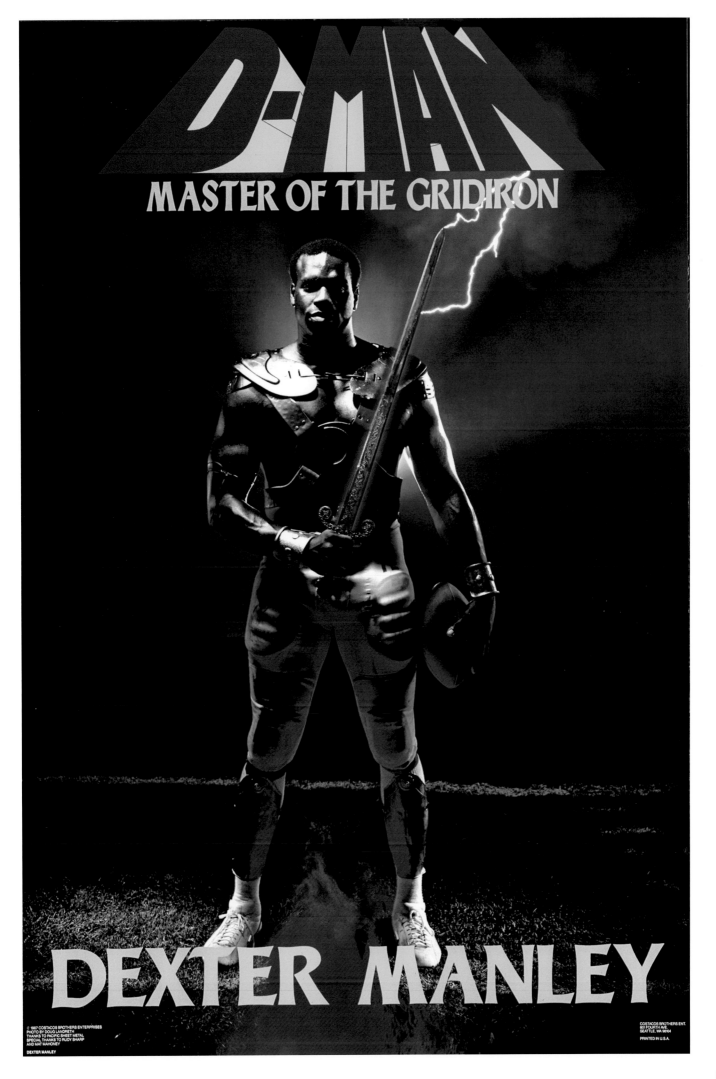

More from the Archives

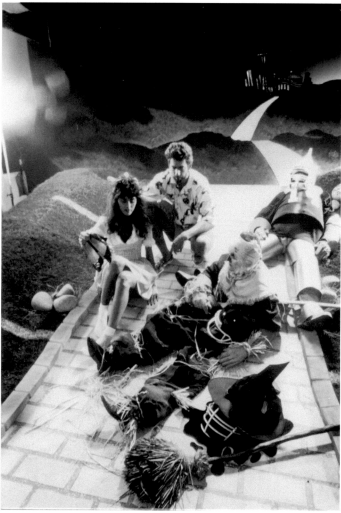

Ava Fabian as Dorothy, costume and set creator Mike Dillon, and local radio personalities Gary Crowe as the Scarecrow and Mike West as the Tin Man.

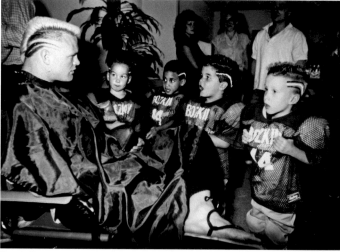

Here's Brian Bosworth in the makeup chair chatting with his Bozkins. Everyone looks less fantastical without their sunglasses on.

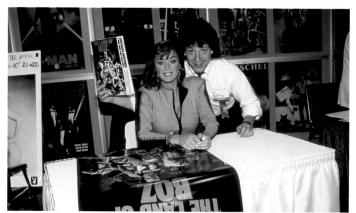

Ava and John at a sports tradeshow in Chicago, where long lines waited for her to autograph the "Land of Boz" poster.

(from top left) Frank Minnifield, Craig Foglietti, Hanford Dixon, and John, showing the collective might of this photoshoot.

It was amazing to see how effortlessly Dominique could leap in the air. You could say he was really . . . one of a kind.

We shot John Rienstra for "The Raging Rhino" in the African savanna area of Seattle's Woodland Park Zoo, with zebras and giraffes roaming around.

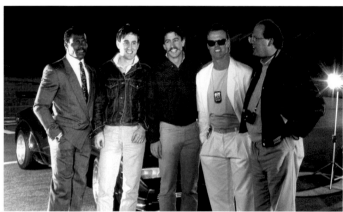

(l to r) Walter Payton, George Conopeotis, Bill Conopeotis, Jim McMahon, and Dino Alexandrou at the "Chicago Vice" shoot at Soldier Field in Chicago.

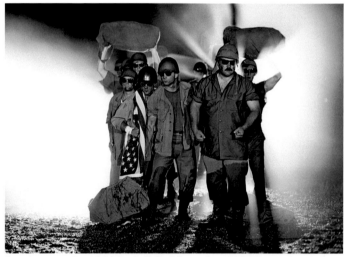

Friends were in Jim McMahon's "I Shall Return" poster background, including Mark Hoffman, John Garras, Greg Garras, Pete Prekeges, and Jim Garras.

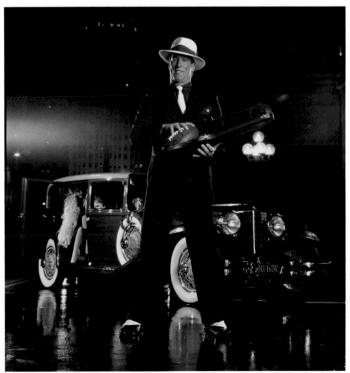

Jim Kelly was still able to crack a smile despite the humid conditions and the swarm of bugs that kept landing on him at the "Machine Gun Kelly" shoot.

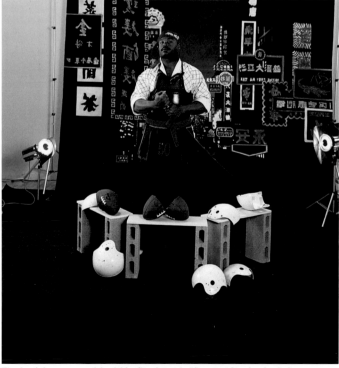

The backdrop we used for Mike Singletary's "Samurai Linebacker" shot gave a sense of the neon buzz of Tokyo. We have no idea what the signs say.

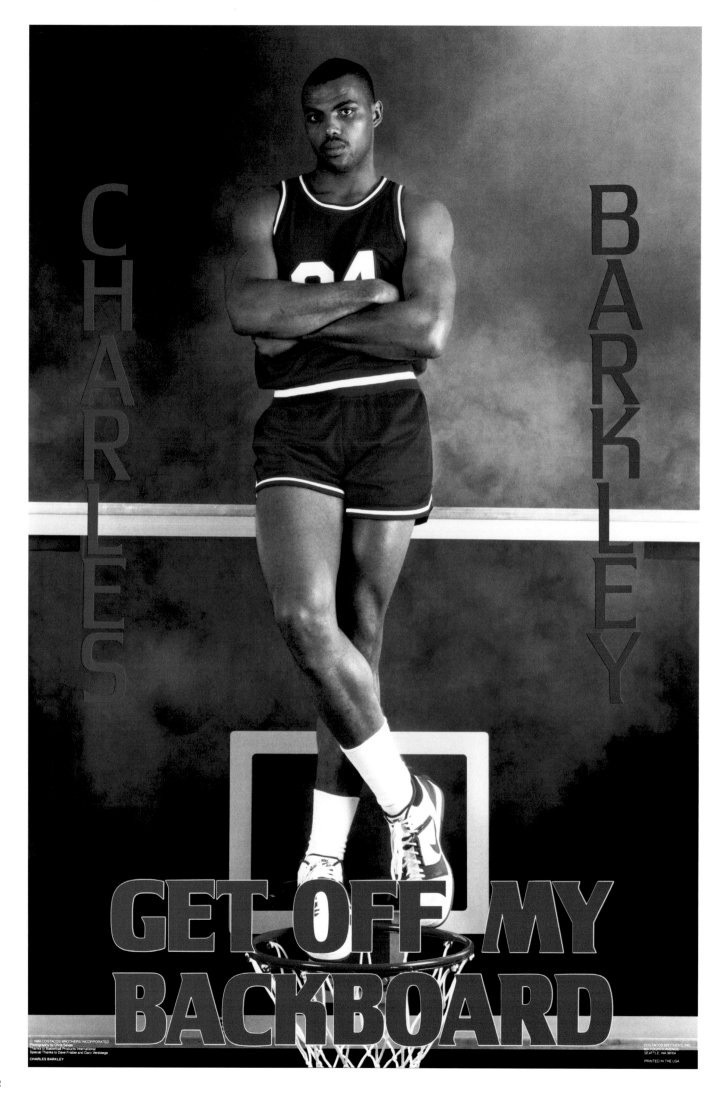

Charles Barkley

Philadelphia 76ers
NBA's 50th Anniversary All-Time Team

The one nickname Charles had was "the Round Mound of Rebound," which we'd been told he didn't particularly like. We came up with the theme "Get Off My Backboard" after Charles led the NBA in rebounds in 1987. The title was a combination of referencing the way he relentlessly attacked the boards and his overall attitude; it sounded like something he would actually say. Charles was fun, rebellious, and unpredictable—and very quotable.

The shoot was set up in Seattle, when the 76ers were in town to play the Sonics, and Charles was all business when he arrived. He asked some questions to make sure he understood what we were doing, but this was the first time we felt like a player wanted to get it done and get out the door as soon as possible.

We already had a custom-made uniform without NBA logos and asked Charles to bring his shoes, socks, and a jockstrap. For authenticity, we wanted him to wear the shoes he played in and socks of proper length that he normally wore. We figured if he was bringing those, he could just bring a jockstrap, too, because we felt a little weird asking him what size to get. When he showed up, he had the shoes and socks in his bag—but no jockstrap.

There was a sporting goods store nearby, and our sister, Marianne—who handled player relations for us—said she'd get one and be back in 10 minutes. She's all of four foot ten, and fearless and mouthy. As she was running out the door, she turned toward Charles and asked, "Small, or extra-small?"

Charles immediately burst out laughing, and that changed the entire mood of the room. It was like he instantly let his guard down and was happy to be there. When we asked if he wanted to go to the dressing room and relax while we waited for Marianne, he declined. Instead, he walked up to every person in the studio, asked their name, and shook their hand.

When Marianne returned, we proceeded with the shoot. We mounted a backboard to a frame so that it was suspended only a few feet off the ground, and our plan was to have him sitting on the rim with his arms crossed and looking tough—but it didn't look as good as we expected.

Charles worked with us as we went through a bunch of looks: fog machine, no fog machine, sunglasses, no sunglasses, and even looking like he was rejecting a shot with his foot. We thought that last pose might work if it looked like another player's shoes were upside down by the basket. Although none of those options looked right, Charles seemed to appreciate all the things we were trying in order to create the right combination. In the end, we went with the shot of him standing on the rim because it felt like that pose was Charles being Charles.

The poster turned out great, but the best thing about this shoot was that it was the beginning of a nice, long friendship between Charles and our family that has endured to this day.

(top) Patrick Trujillo drew this caricature for a potential shirt design, but it never worked out.

(above) Our attempt to make it appear Charles is rejecting opponents at the rim.

Jose Canseco & Mark McGwire

Oakland A's
80 Combined Home Runs in 1987

(top) Here's an outtake we tried with our Junior Bash Brothers.

(above) The original concept sketch of "The Blast Brothers."

We talked about new poster ideas every day, and when we came up with something that didn't quite fit a particular athlete, we still wrote it down, because it might work for another player. On this long list of TV shows, movies, and puns we liked, *The Blues Brothers* was toward the top. It was one of our favorite movies from college, and we always thought we could do something with it.

Jose Canseco won the AL Rookie of the Year award in 1986, and Mark McGwire won it in 1987, primarily because of their power hitting with the Oakland A's. Jose was coming off a season where he hit 31 home runs and drove in 113 runs, and Mark had just led the league with 49 home runs to go along with 118 RBIs. Together, they formed one of the most fearsome duos in baseball.

Our idea was to dress them up like the Blues Brothers and put giant bats in their hands and call them "The Blast Brothers." Their agents liked the concept, and we scheduled the photoshoot.

But as we got closer to the shooting date, Jose and Mark created their own version of the high-five, the "forearm bash," in which they banged their arms against each other's. This became very popular with the A's fans and the sports media, so we changed the title to "The Bash Brothers."

Having oversized bats was key, but they had to be *ridiculously* oversized. We thought about calling Louisville Slugger to see if they could make custom bats for us. Then we found a place called Think Big in New York that had 6-foot-long bats. Perfect. They even had Louisville Slugger logos on them, although we decided it was best to take those off.

We rented the suits according to Jose and Mark's measurements and had a scare when Jose tried on his pants and they only came halfway down his shins—luckily, there was enough extra material to take the hem down to a normal length. The only thing hard to find were shoes like those worn by John Belushi and Dan Aykroyd in the movie. (We finally found them, of all places, at Sears.)

The people from the A's front office helped us with everything we needed to shoot in the Oakland Coliseum, their home stadium. When we asked if they had any connections that could help us get a real police car, they simply asked when we wanted it, and one appeared on the day of the shoot.

The camera was positioned from home looking out toward centerfield. We just told Jose and Mark to position themselves and the bats in a way that felt comfortable, and they tried four or five combinations before settling on what photographer Chris Savas shot. The weather was great, Jose and Mark were easy to work with, and nearly every frame looked good. We were really happy with how it turned out, and knew we had something big. It went on to become one of our best-selling posters and remains one of the most popular posters we made.

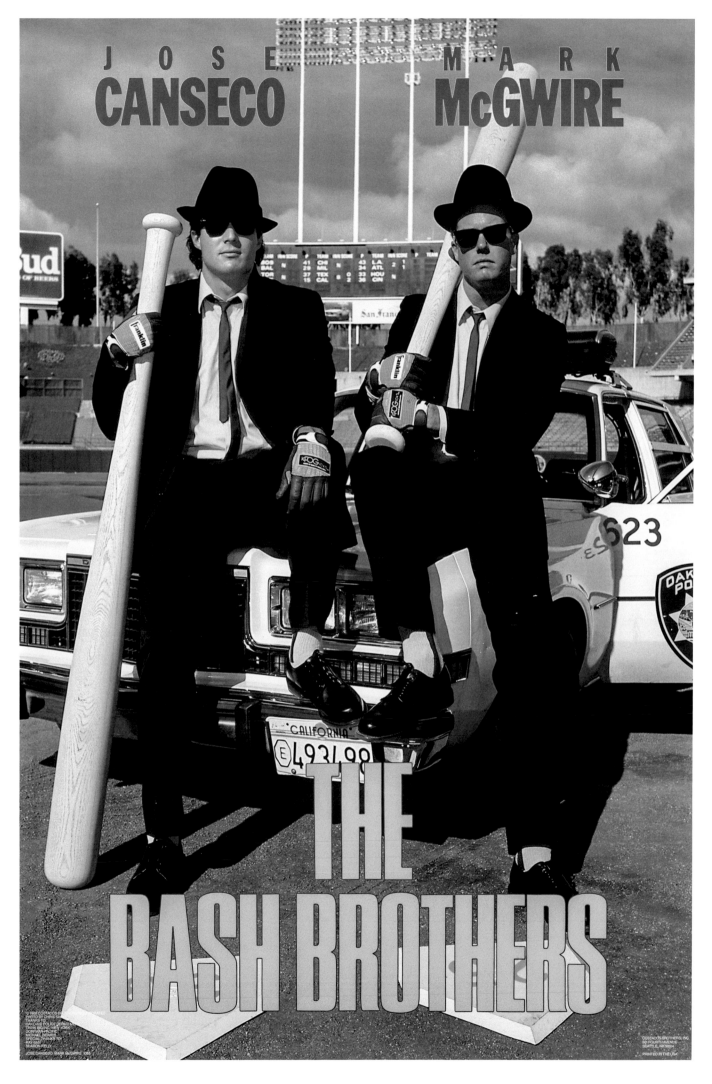

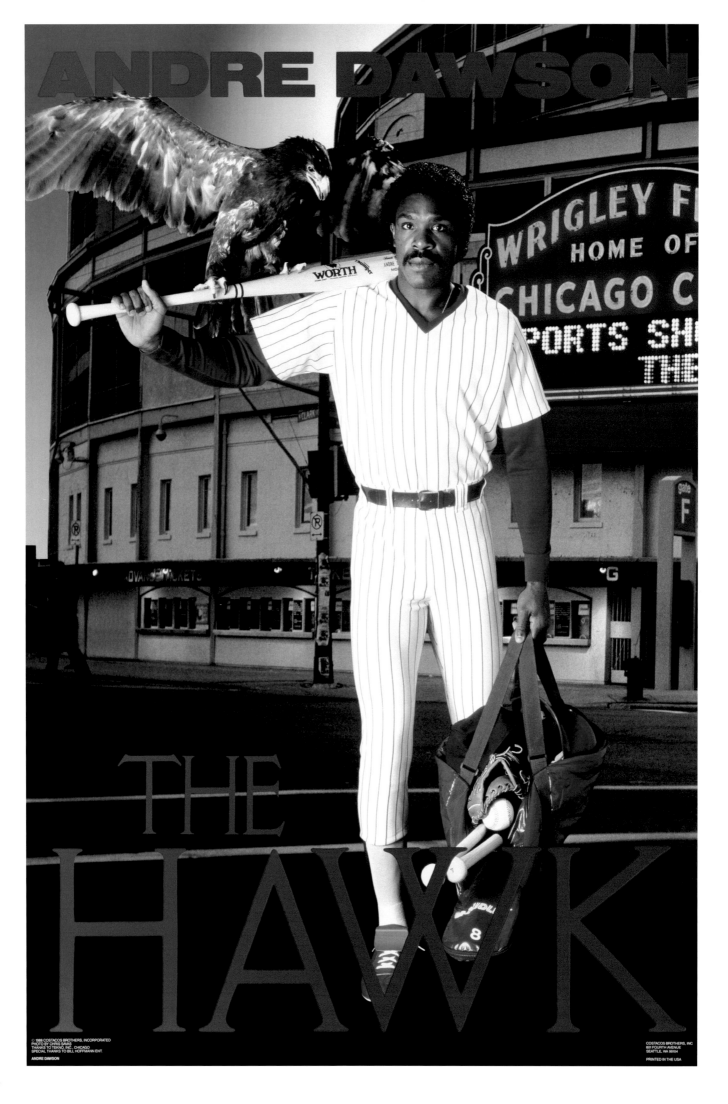

Andre Dawson

Chicago Cubs
1987 National League MVP

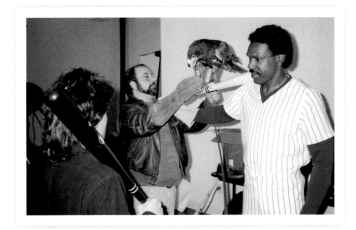

(top) The bird handler helps position the hawk for the Hawk.

(above) A concept design for the poster done in pen and ink.

By 1988, Chicago was beginning to feel like a second home to us because we were there so much, having shot half a dozen posters with Bears players. We had such great success in that market that we wanted to expand into Chicago's other teams. The popularity of the Bears pushed sales, which in turn strengthened our distribution. And each image we created gave us another example of our work to show prospective clients. What else could go right in our new favorite city?

Well, Andre Dawson had just started playing for the Cubs and had won the 1987 National League MVP award along with a Gold Glove and a Silver Slugger award, and he had led the league in home runs and RBIs. And we got a deal with him.

Andre had a very cool nickname already, the Hawk, because of the way he attacked hit balls on defense. Since we somehow safely navigated a bear cub almost slashing Jim McMahon and real bombs exploding behind Herschel Walker, we figured we'd press our luck and get a live hawk in the shot with Andre. We imagined it just as it turned out: Andre standing with a hawk on his bat, with Wrigley Field in the background. (Wrigley is like the Vatican of baseball parks and is such a landmark for Chicago and the game of baseball that we wanted it in the poster.)

For this one, we shot the background first. Wrigley has a classic lighted sign at the main entrance that we wanted to use. Without an MLB license, we couldn't have the word *Cubs* in the image, though, so we used just over half the sign but made sure to keep *Cubs* out. (We also couldn't use any Cubs logos, but we did use a uniform with the team's recognizable pinstripes.) Photographer Chris Savas suggested we have the photo lab add the glow of night-game lights to the stadium, since later that season Wrigley was going to become the last Major League Baseball ballpark to install lights and schedule games after dark.

Andre arrived and got dressed. This was another situation where we expected an intense individual and were wrong. Andre had a pretty serious game face, so we'd expected a guy with that kind of disposition, but he turned out to be as warm as anyone we worked with. And he was as game for the adventure of working with the giant bird as we were.

The hawk was both amazing and intimidating. It was a beautiful animal yet a little scary to see up close. It had a sharp beak and talons, but its eyes were the scariest part because its full-time expression seemed to say, "Where's my prey?" The handler was especially good about getting Andre acquainted and comfortable with the bird. Then the handler put the bat on his own shoulder and said a command, and the hawk flew right over to perch on the bat.

Andre took his position with the bird on the bat. He looked up and saw the hawk staring straight at him from about six inches away and nervously said to the handler, "It's not gonna go for my eyes, right?" The handler reassured him, and we started shooting.

We didn't like the look with the bird just sitting there, so the handler had Andre pump the bat up and down, which caused the hawk to put its wings up. Andre was perfect in every shot, and we added having a live hawk inches away from a superstar athlete to our growing list of crazy (but successful) ideas.

Dale Ellis

Seattle SuperSonics
1986–87 NBA Most Improved Player

Dale is 6-foot-7, and
John is . . . not.

We were especially interested in working with local players for any of our hometown Seattle teams not only because we were genuine fans but also because the production costs were generally lower and we had particularly good distribution at home. We'd recently made the poster of Xavier McDaniel of the Seattle SuperSonics, and it was a success in our local market. The feedback from our sales reps and customers was that they wanted more Sonics, and Dale was a perfect choice.

Dale was traded from the Dallas Mavericks to the Sonics in the summer of 1986, and he became an instant star. He averaged 7.1 points in his last Dallas season but a whopping 24.9 points in his first Seattle season. He had become one of the very best outside shooters in the league and was gaining popularity in Seattle despite sharing the court with Xavier and fellow 20-point scorer Tom Chambers. Dale was a fairly quiet guy who went about his game without a lot of fanfare or talking despite being a lights-out shooter.

During the 1987–1988 season, Dale went toe-to-toe with Boston Celtics legend Larry Bird in the NBA's Three-Point Shootout, finishing second as Bird hit his last attempt to pull ahead. Dale even wore No. 3. If a sharpshooter like Dale had that jersey number today, it would be natural to build a poster around the three-point shot. But 30 years ago, teams averaged just five three-point attempts per game—today's teams average more than twice that many makes. It was more of a novelty. So a great shooter was known as a shooter, not a *three-point shooter*. (Today, we'd do something like "Game of Threes," "Treymaker," or "Drainers of the Long Arc.")

The only phrase we could think of with his name was "Ellis Island," and that wouldn't work. We looked for phrases and words that rhymed with Dale but came up empty. We jokingly talked about doing a spoof on Karl Malone's "Mailman" nickname and call him the "Daleman." We still laugh about those kind of joking ideas, but usually, when we got to those, it meant we were stuck and drawing a blank on genuine ideas.

While stuck in that blank place, we got a break: We read in a Seattle newspaper that Sonics head coach Bernie Bickerstaff called Dale "the Silent Assassin" because of how he'd strike silently and quickly. That was good enough for us.

We shot Dale in a Seattle studio, and we liked the first pose he did so much that we shot that one for nearly the entire time without as many variations as we usually tried. The background photo, stripped into the window frame by a photo lab afterward, featured one of our employees dressed as an opposing player holding a doctored newspaper with the headline "Ellis Strikes Again."

After our poster came out, a newspaper wrote a nasty snippet giving us flak for calling Dale an assassin—ironically, the same newspaper where we read that Coach Bickerstaff had nicknamed Dale "the Silent Assassin" in the first place.

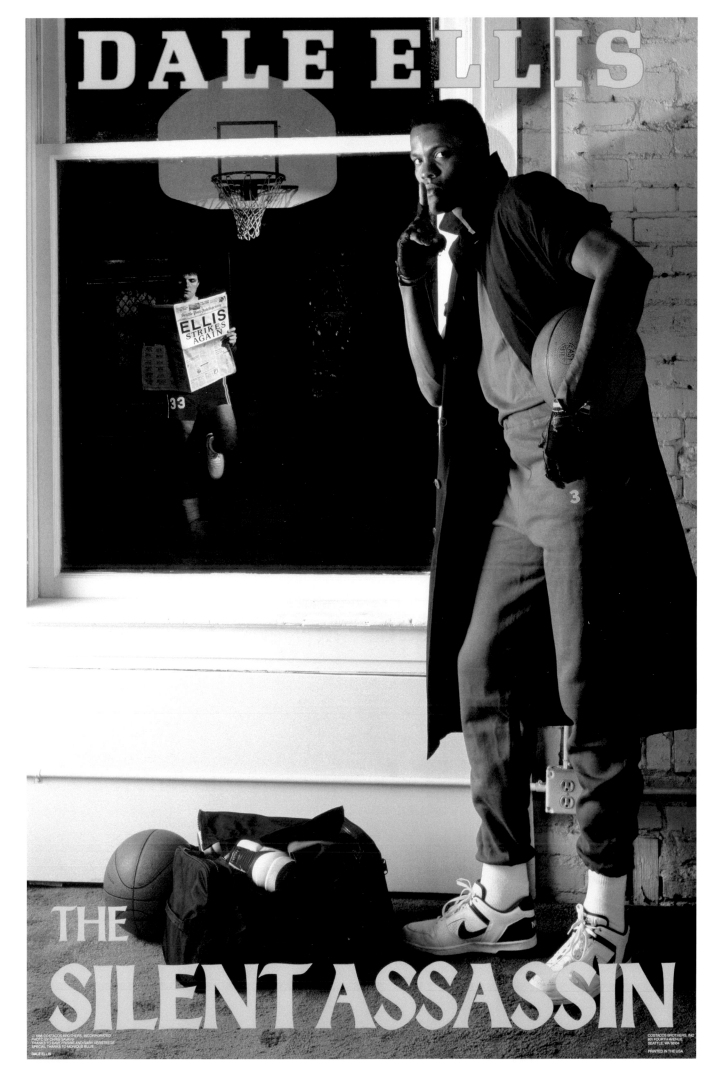

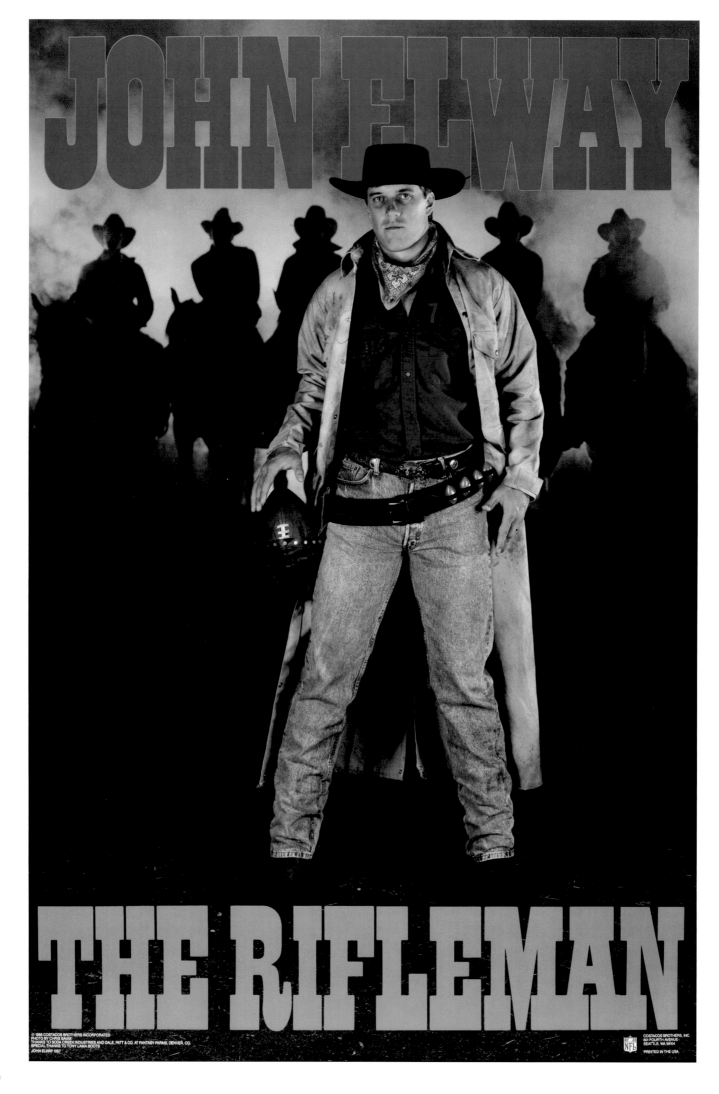

John Elway

Denver Broncos
1987 NFL MVP

If you look closely, you'll notice the little footballs in the bullet loops of John's belt.

Maybe we shouldn't be writing this part, because John Elway's always been great to us, but we hated him—but in a *good* way. It was sports hate. John was a nemesis to our Washington Huskies when he was in college at Stanford, and then he became a double nemesis in the NFL because his Denver Broncos were in the same division as our Seahawks. But we appreciated great athletes, and the guy was awesome—downright dangerous with a football in his hands—so we loved him, too. The best part about being in our business was that when it came to posters, we loved athletes, no matter what team they were on.

We had lists upon lists of concepts and titles for posters. Some were made for specific players, and some were ideas we liked but hadn't matched to a player yet. We had lists of television shows, movies, albums, bands—anything we could come up with. One list of television shows included *The Rifleman,* an old western series from the early '60s, and when we said that title out loud, we both said, "Elway"—after all, John played for a western city and had a rifle of an arm—and John liked it, too. (It was also a better nickname than the one we used for him during games against our home teams: "Smellway.")

We had the idea in 1986 but didn't make the deal with him until 1988. Before we went to Denver to shoot it, we made a reservation for a van because we had to haul a lot of equipment, but when we arrived, the rental company said they didn't have one. We told them we could wait, but they said nothing was scheduled to come in, and they didn't have a truck, either. Then we mentioned we were shooting a poster with John Elway, and somehow they had a van for us ten minutes later.

The shoot was held at a horse ranch outside of Denver, because we needed horses and riders for the background. The first thing we did when we got to the ranch was dig a big trench across the back of the set for the background lights. Photographer Chris Savas wanted them low and aimed upward through the fog. We didn't mind doing this kind of manual labor on the sets or making the props ourselves. It kept the budgets low but also made us feel that we were personally connected to the posters and that part of us was in them despite our not being in the actual photo, and this feeling was part of what fueled us.

John was really easy to work with. When he arrived, he took a walk around the set and asked questions about how we wanted it to look and made sure he understood what we wanted, then got changed. We got a lot of good shots quickly and were prepared to finish when John told us he was OK to go longer. He appreciated how far we had traveled, and he wanted to make sure we got what we needed.

It's always great to make new friends and meet nice people like John, but it also kind of sucks, because part of the fun of being a sports fan is despising your rival teams and their players. After you shoot a poster of someone you've rooted against for so long, you can't really do that anymore.

Bob Golic

Cleveland Browns
1987 Pro Bowl

Bob and John were
dogging it on set
between official takes.

We had good success with the Frank Minnifield/Hanford Dixon poster (see page 56) in 1987, and a year later we wanted to do posters with more Cleveland Browns players because not only was the team good, but they also had a lot of fun personalities.

We met Bob Golic at the Pro Bowl while talking with some of our previous clients. He's a warm and engaging guy, and it's no surprise that he has a radio show today. He knew our posters well and was not only willing to work with us but also took a real interest in our ideas for him. In fact, Bob seemed to enjoy what we were doing so much that we ran ideas for other players past him for his input and he even introduced us to some of the other Pro Bowl players we didn't know yet.

At one point, another player walked by and said something like, "What's up, bad dawg?" to Bob. We thought he had said "Mad Dawg," since the Browns's defense was called the Dawgs, and that was where we got the poster title. If you watched a Browns game on TV, you'd see Dawg shirts, signs, bones, and every conceivable reference to Dawgs. The Dawg Pound, the bleacher section on the east side of Cleveland Stadium, was as fun a place as you would ever want to sit for a sporting event. (That spirit lives on at the Dawg Pound at FirstEnergy Stadium, their current home.) It was exciting and loud and wild and fun. So anything we could do in Cleveland with "Dawgs" was going to work.

Though we knew "Mad Dawg" would work as a poster theme, we found the title to be a little ironic, because there's nothing mad about Bob. He's a naturally happy person, and there wasn't a serious tone at all to our conversations with him. He's just a big kid, and he knew we were making something fun for all the other kids.

Our best posters were usually those where the featured player spent some time with us to get the ideas flowing. Bob gave us his time, and we went through a progression of ideas and details. We could tell how great this would be because Bob was up for anything. He wanted his poster to be fun and something for the kids to enjoy, so the more over-the-top, the better.

So, what do you do with "Mad Dawg" as a theme? You build a doghouse and make Bob the dog. You get some dog biscuits in the shot, plus footballs, a Browns helmet, and Cleveland Stadium in the background. We made a "Beware of Dawg" sign for the yard but changed it to "Beware of Bob" because it just sounded funny.

To pump his arms up just before shooting, he did push-ups with one of us standing on his back. When he was in costume and all set, we just needed him to put on his socks and cleats, but he hadn't brought any. Bob said, "I'm a Mad Dawg. We don't wear shoes and socks." Duh. He was absolutely right.

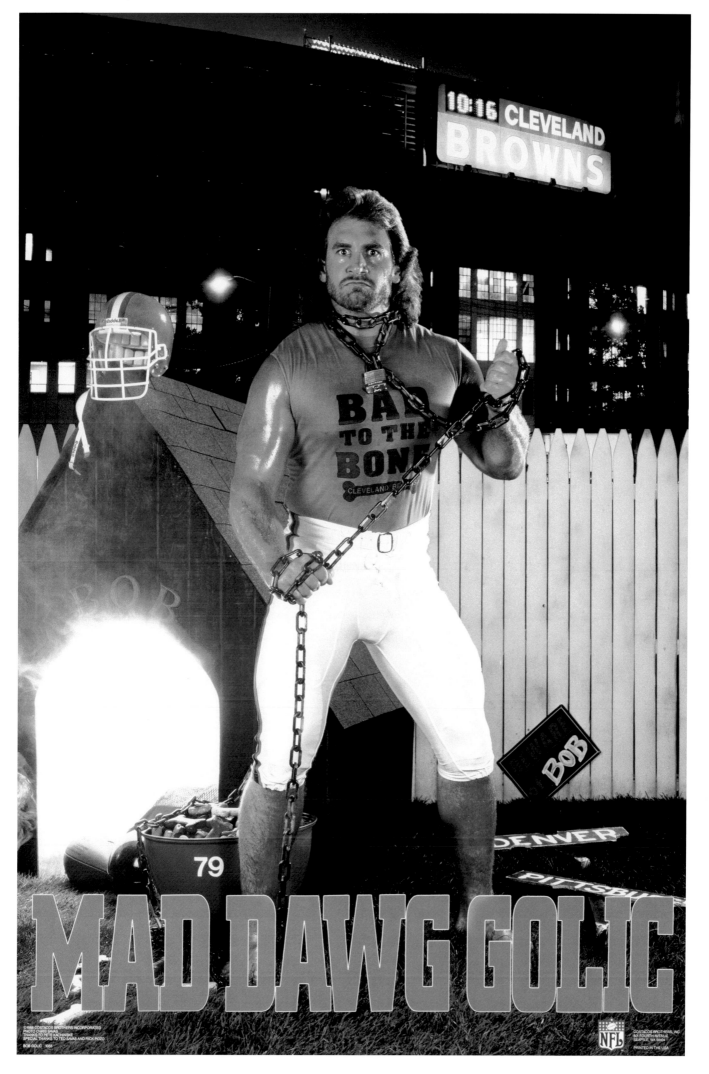

MAD DAWG GOLIC

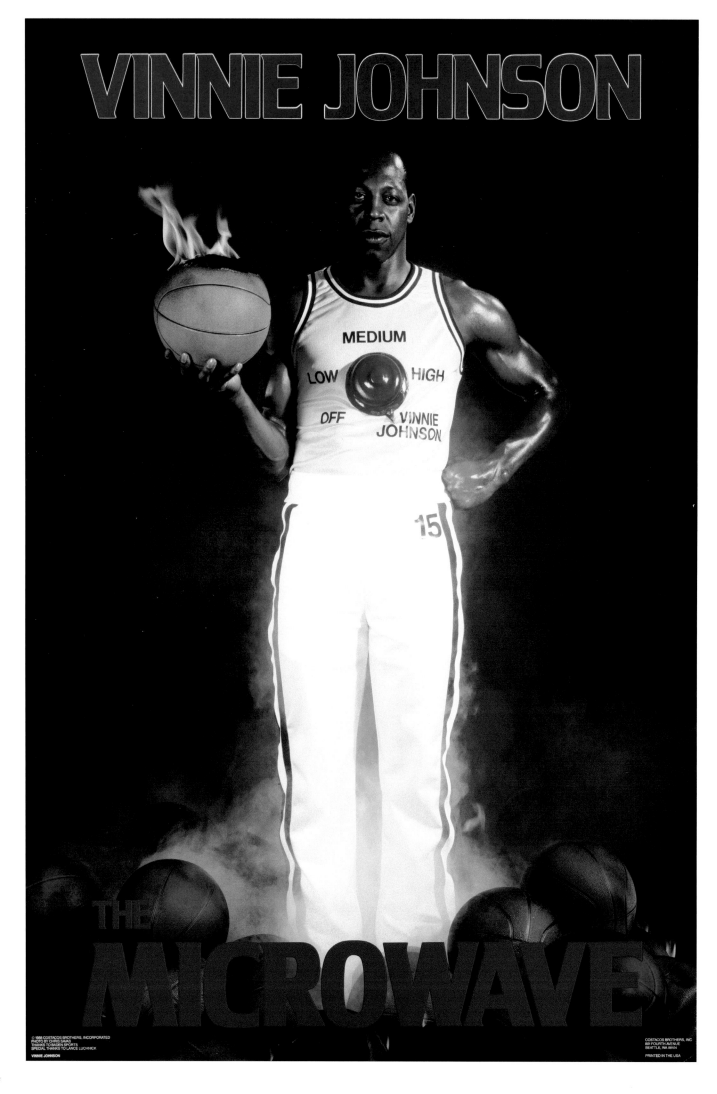

Vinnie Johnson

Detroit Pistons
1988–89 NBA Champion

(top) Vinnie was all smiles on set despite the acrid smell of burning rubber.

(above) Photographer Chris Savas setting balls on fire with a torch.

Vinnie was drafted by our Seattle SuperSonics and played his first two seasons here before being traded to the Detroit Pistons. Because of his size and skill set, he was the perfect third guard who could rotate in for point guard Isiah Thomas or shooting guard Joe Dumars, complementing either with his blend of passing, rebounding, and scoring.

And could that guy score. He earned the nickname the Microwave from Danny Ainge of the Boston Celtics after Vinnie hit 16 of 21 shots for 34 points against the Celtics, including 22 points in the fourth quarter—he got hot in a hurry. This was such a fun nickname, and as soon as we first read about it, we wanted it as his poster title. But what could we do visually for an athlete whose nickname is a kitchen appliance? It's not like we could dress him up like a microwave oven—or could we?

The poster concept came from the very funny Rob Reiner–directed mockumentary *This Is Spinal Tap,* which had come out in 1984. In one scene, Christopher Guest plays a musician named Nigel who shows the film's director his guitar amplifier. Nigel points out how his amp's volume knobs don't just go from the standard 0 to 10 settings, but instead have an extra level of 11. So, as we were talking about Vinnie, we thought, "Hey, remember the scene in *Spinal Tap* where Nigel's amps go up to 11? Let's put a dial on Vinnie's chest and make *him* the microwave."

It was a beautifully simple idea, and simple ideas are usually the best ones. We made a dial with settings marked "Low," "Medium," "High"—and "Vinnie Johnson." The idea made everyone in the room smile, and Vinnie and his agent liked it, so we arranged to shoot it when the Pistons came to Seattle.

The dial is made out of a Tupperware bowl because we needed something light that wouldn't pull down on his jersey. We burned a bunch of basketballs to put on the ground around Vinnie and arranged the fog machine directly behind where he'd be standing.

When Vinnie arrived and saw the jersey with the dial, he smiled and started laughing. He totally understood what we were doing and thought it was as fun as we did. When he walked onto the set in costume, everyone was excited, like a bunch of kids about to do something fun together.

We put a heat barrier inside the ball he's holding, filled it with crushed pieces of Duraflame logs, then lit it on fire. We just gave it to Vinnie and said, "Here, hold this" and started shooting. It didn't burn his hand or get hot to the touch (we'd tested the mechanism ourselves beforehand), but it did smell like burning rubber for the entire shoot. Vinnie was comfortable and joking around from the moment he got there. That's the kind of casual atmosphere we tried to have on our sets, because we'd learned that the usual photo shoots for pro athletes are a lot more corporate and serious (and much longer).

And the response to this one was tremendous, with fan mail revealing that a lot of kids enjoyed our way of making a nickname like the Microwave work. Kids were responding to how far out we were willing to push things, and they wanted to see what we were going to do next.

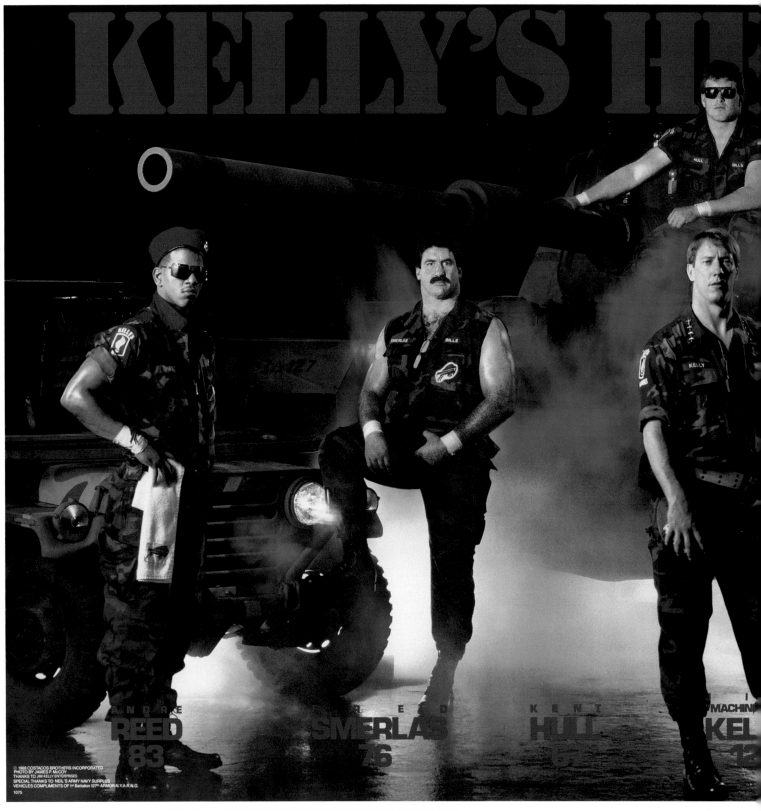

KELLY'S HE

REED 83

SMERLAS 76

HULL 67

KEL 12

The original concept sketch of "Kelly's Heroes."

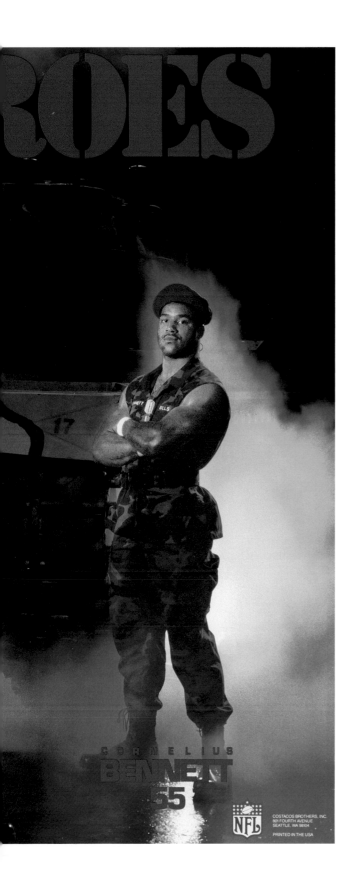

ROES

CORNELIUS
BENNETT
55

NFL

COSTACOS BROTHERS, INC.
801 FOURTH AVENUE
SEATTLE, WA 98104

PRINTED IN THE USA

Jim Kelly, Andre Reed, Fred Smerlas, Kent Hull & Cornelius Bennett

Buffalo Bills
1988 Pro Bowl

"Jim Kelly doesn't walk to the line of scrimmage. He swaggers." This was in a news story about how Jim Kelly's leadership was turning the Buffalo Bills around. We'd had good success with "Machine Gun Kelly," and, true to Jim's words, his Bills got better.

We spoke with Jim about a group poster with him, his receivers, and his running backs and calling it "Kelly's Heroes," after the 1970 WWII movie starring Clint Eastwood. He liked the idea, but he said, "We gotta have defensive guys in it, too. We win with both." We told him to choose whomever he wanted and we'd work it out. He chose defensive lineman Fred Smerlas and linebacker Cornelius Bennet from the defense, and center Kent Hull and his favorite receiver, Andre Reed, from the offense, all of whom would make the 1988 Pro Bowl. As much as "Machine Gun Kelly" seemed perfect for Jim by himself, this group shot was equally perfect, because Jim and his teammates would have walked through hell for each other.

To create a military-combat look, we wanted an army jeep and tank in the shot. We figured we could get a jeep without too much trouble, but where were we going to get an army tank? This kind of challenge made us smile, because we thrived on trying to do the impossible, especially on the limited budgets we had. Plus, it seemed fun to call someone on the phone and ask, "Do you have a tank we can borrow?"

It was even easier than we had imagined—when we asked Jim if he had any idea where we could get a tank around Buffalo, he said, "Don't worry, I'll get us the jeep and the tank." We don't know if he already had a connection, but a day later he called and, sure enough, said, "I got the jeep and the tank." We were used to many doors opening for us because of who we were shooting, but it seemed like they opened even faster if it was the player making the call. Jim had arranged for us to shoot at a National Guard armory in a large building at one of their storage facilities, and they provided the tank and jeep.

Today, you can find a lot of camouflage colors, but back in the '80s, there was only green and gray, so we bought gray uniforms and dyed them blue to match the Bills' team color. When we got to the armory and gave the guys their costumes, they immediately got into the spirit of things: Andre rolled his sleeves up. Kent cut his sleeves halfway, then rolled them up. Fred and Cornelius cut their sleeves off completely. We had dog tags, helmets, berets, canteens, sunglasses, and footballs, and each guy personalized his costume.

One of our favorite Bill Murray movies is *Stripes,* which has a scene with tanks that are backlit through fog. We really liked that effect, so we tried it here, and it worked nicely. Artificial fog can be unpredictable in the way it moves, but the guys had such great game faces that we were able to choose the shot with the fog that we liked best. We wish we had had Photoshop back then, because we didn't get quite enough light on Cornelius's arms—that guy had some serious guns!

Neil Lomax

Arizona Cardinals
1987 Pro Bowl

The Grand Canyon is so picturesque that it looks like we used a fake background, but we really did shoot Neil on location.

We knew of Neil Lomax from when he was in college at Portland State University, but we had never seen him play, because only the big football schools from the major conferences were televised back then. Despite playing for a relatively unknown football program, Neil made national headlines: He set ninety NCAA records in college and threw 7 touchdown passes in a single quarter.

Neil was drafted by the St. Louis Cardinals in 1981, and the team subsequently moved to Arizona in 1988. We had a really good relationship with Neil's agent, Jeff Moorad, because we had done a number of posters with his players and had a continual dialogue with him for ideas for other clients who were interested in working with us.

We had been working on ideas for Neil, but we hadn't come up with one we liked quite yet, and then Jeff suggested "The Grand Cannon." We both loved and hated it: We loved it because it was a great title and hated it because we weren't the ones who had come up with it. But it was exciting to get a chance to work with Neil—and to get a poster in the Arizona market.

We were newly licensed with the NFL, and this was a big change for us. The license allowed us to use league uniforms, trademarks, and logos for all the teams, which made our posters look more "official." The downside was that it required us to get approval from NFL Properties on our concepts and artwork. It was a bit funny to us because it seemed like the NFL was happy to work with us, but we also got the feeling they worried that we were going to do something way out of line.

We loved the idea of shooting "The Grand Cannon" at the Grand Canyon because it's so visually spectacular. This was going to be a fairly simple shoot, without the need to generate fog or provide artificial light—the breathtaking landmark was all the background we wanted. We didn't even need a lot of props, just Neil in his uniform and some footballs.

We flew into Phoenix and drove up to the canyon and found a location right near the rim. We set up to shoot Neil standing about 20 feet from the edge of the canyon. Neil wanted it to look right and was willing to go much closer to the edge, but we wanted no part of that.

There was really no place for him to change into his uniform on the ridge, so he just did it right there. (He thought it was funny when we jokingly started taking photos while he was changing.) It was an easy shoot, with few props and all natural lighting.

When we had finished and started packing things up, we realized we had about 20 extra footballs, so we looked over the edge to see if there were any trails that might have people down there who might like one. That part of the canyon was deserted, so one of us got a "brilliant" idea that in hindsight was probably closer to "stupid": We had Neil autograph the footballs, and we took turns throwing passes down into the canyon so that hikers might find a souvenir for themselves. We like to think all the footballs were happily found and taken home, and none are still sitting out there thirty years later.

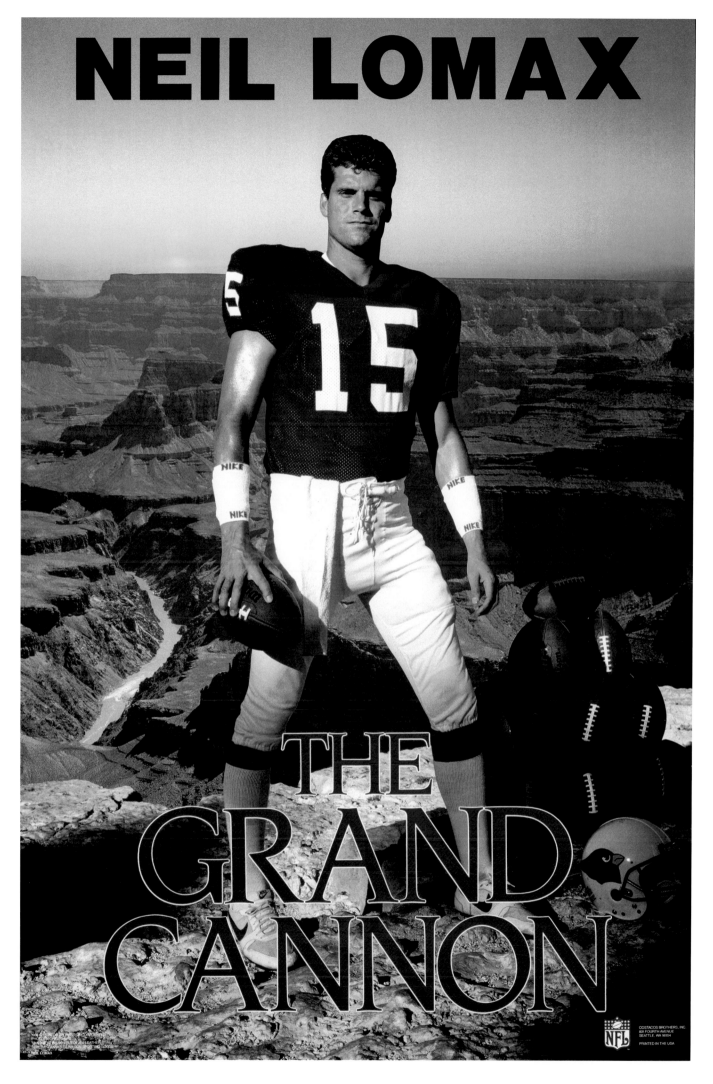

NEIL LOMAX

THE GRAND CANNON

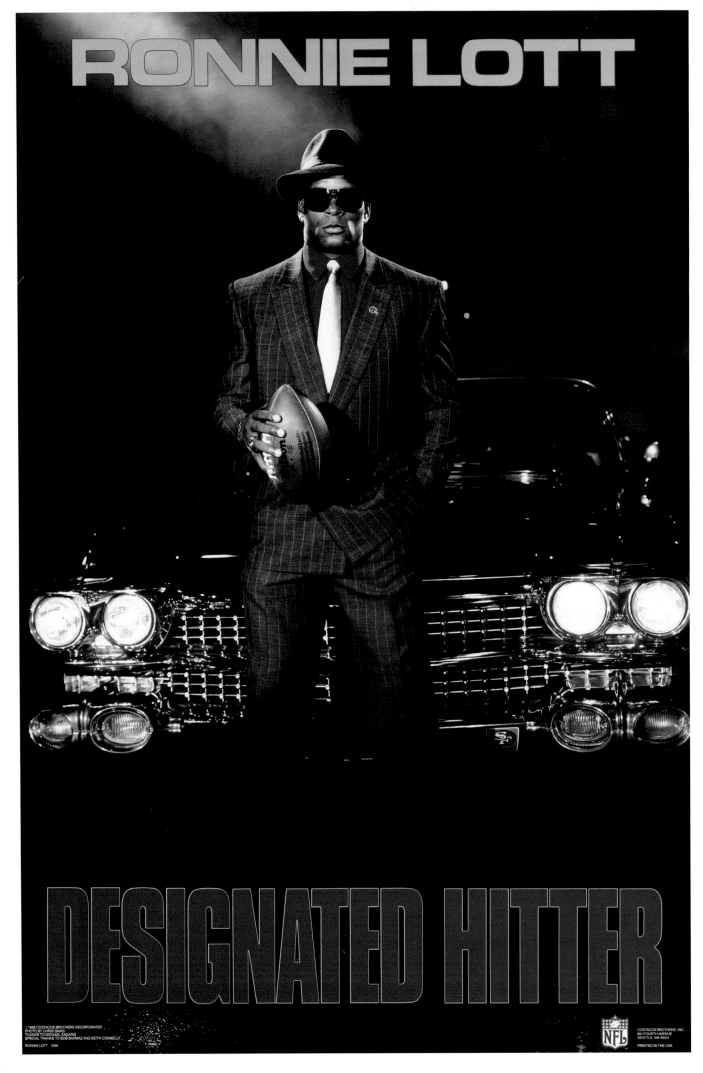

RONNIE LOTT

DESIGNATED HITTER

Ronnie Lott

San Francisco 49ers
NFL 1980s All-Decade Team

Production guy Scott Figueroa (left) and photographer Chris Savas (right) at work in San Francisco.

We were really proud of the Kenny Easley poster, and that was the first one we showed Ronnie when we approached him. Of course, we also showed him the poster of fellow 49er Joe Montana, but Ronnie had played college football at USC during the same time Kenny played at crosstown rival UCLA, and they had been the top defensive backs in the country. In fact, Kenny was drafted by the Seahawks with the No. 4 overall pick in the 1981 NFL Draft, and Ronnie was picked a few selections later at No. 8 by San Francisco, and their names continued to be linked as they dominated the NFL.

Ronnie started his pro career as a cornerback, and although he was named All-Pro as a rookie, he soon switched to safety, where his bone-jarring hits gave nightmares to anyone foolish enough to cross the line of scrimmage. He was a tough guy like Kenny—when a 1986 finger injury required surgery that would delay his return to the field, *he chose to have the damaged part of the finger amputated*—and we wanted a tough-guy poster for Ronnie, too.

Although we kept ever-changing notes on potential nicknames and titles we liked, Ronnie's poster idea was grabbed out of the air. The breakthrough came during a Seattle Mariners baseball game against the Oakland A's. The stadium announcer introduced the next batter as "designated hitterrr . . . Reggie Jackson." Designated. Hitter. Yes! That's Ronnie Lott!

We always waited a day or two to see if we still loved an idea, and for this one we did. There was no question in our minds that it was right for him, and we felt certain that he'd like it. It was perfect for him. We called Michael Zagaris, the 49ers photographer, and he said, "Oh, yeah—Ronnie will be all over that." We called Ronnie's agent and made arrangements to shoot it.

We shot the poster in a San Francisco alley, which required a city permit, plus police to block off the area for the shoot. We also needed a lot of light, so we actually rented movie lights to light up the alley, which meant we had to rent a movie truck with a generator, because those big lights required a lot of power. All that lighting equipment, plus the old classic car we rented, made for quite a production.

On the night of the shoot, it drew a big crowd that kept growing bigger as word got around that something unusual was going on. We didn't mind the onlookers, though, because we figured they would generate some word-of-mouth publicity for the poster.

Ronnie was great in front of the camera and gave us several distinct poses. He looked great in the shots without sunglasses, where you could see different expressions in his eyes, but we decided on the shot of him wearing sunglasses because we felt he looked a little more menacing. Despite his tough-guy persona—both on the field and through our camera lens—Ronnie was easy to work with and was great with his fans. After the shoot, he stuck around and signed autographs for that large crowd that had gathered.

When we got the final design with the bold title font, we were immediately happy. It remains one of our favorites. Although we often second-guess our work to this day, we wouldn't change anything with "Designated Hitter," because it's perfect.

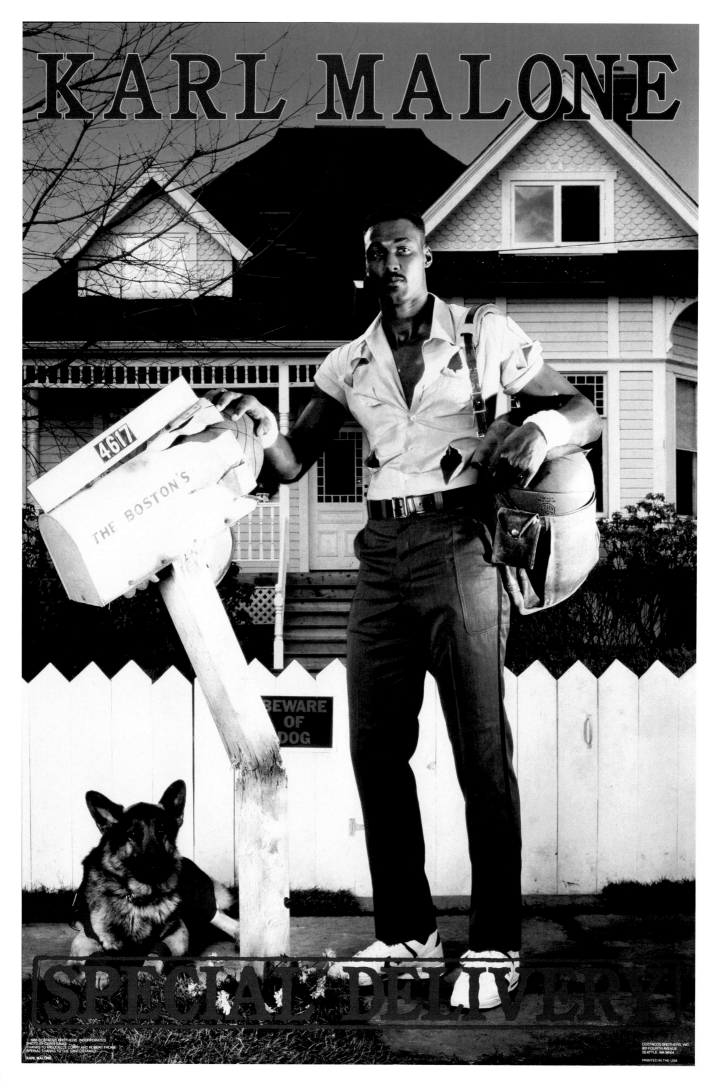

KARL MALONE

SPECIAL DELIVERY

Karl Malone

Utah Jazz

1987–88 NBA All-Star

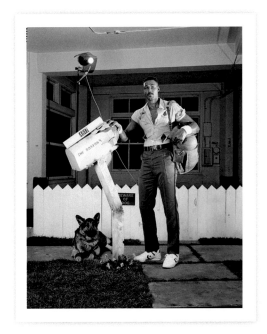

(top) It's amazing that Karl actually got even more muscular as the years went by.

(above) Here's a rare look at the *other* Karl Malone poster. Notice any similarities?

We wish we could take credit for nicknaming Karl Malone the Mailman, but fans had been calling him that since his college days at Louisiana Tech University: Like the post office, they said, he always delivered. With a nickname that strong and well-known, we felt a mailman theme was perfect.

But calling him "The Mailman" on the poster didn't exactly present much of a creative challenge for us, so we decided we wanted a variation on it. First, we thought about shipping terms like "air express," "certified mail," and "registered mail." We even thought about doing a parody of UPS and calling it "MPS," for "Malone Postal Service," but we decided to go with a full US Postal Service look and the title "Special Delivery."

When Karl arrived, he was immediately warm and comfortable with everyone—we hadn't met before, but he made us feel like we had. When he put the mailman uniform on, it looked a little too clean. If he had been a football player, we would've just rubbed dirt all over it, but that wouldn't have made sense for basketball, so we cut and ripped the shirt. We put "The Boston's" on the mailbox because using "The Lakers'" could have presented a trademark problem, and "The Los Angeles's" looked awkward.

Karl saw us working fast to get the shoot done and get him out the door as quickly as possible, and he told us to slow down. He said, "We're all here. I don't need to be anywhere. Take your time, and let's get everything we need."

The poster was very well received across the country, and we quickly realized that Karl was more popular than we had imagined. Karl did an autograph signing of the poster at the Valley Fair Mall in Salt Lake City, and the line was so long that there were still a bunch of people in line when the mall was supposed to close. Karl asked the security guards to let them stay after closing, and he signed for another hour and a half until every fan went home happy.

Shortly after the poster came out, we went to a big sporting goods trade show in Atlanta called the Supershow. A guy named Gary Stokan, who did marketing work for Converse, set up a meeting with us and the Converse people to see if we could make posters for them. Karl had an endorsement deal with Converse, and so did a lot of the NBA's best players.

The next day, we met at the Converse booth, and we were shocked at how the Converse decision-maker we met was ridiculously nasty toward us. Converse had asked for the meeting, but their representative seemed put out to meet with us and even asked why we were wasting her time. Gary was embarrassed and apologized for the way we had been treated, but we just shrugged it off and went back to work.

A few months later, one of our customers called us about a Karl Malone Converse poster nearly identical to ours and sent it to us. We were kind of flattered that a big company had obviously liked our work, but also embarrassed for them for producing such a flagrant copy. They were Converse, a huge company with vast resources. Couldn't they come up with something on their own? Our attorney sent them a cease-and-desist letter for copyright infringement, and they agreed to pull it from circulation and destroy all copies.

Xavier McDaniel

Seattle SuperSonics
1987–88 NBA All-Star

Xavier posing for
some test shots before
he changed into his
poster costume.

We loved having a chance to do anything with our hometown players. Xavier, known simply as X, had averaged 27 points and 15 rebounds as a senior at Wichita State University and was the first player in the history of the NCAA to lead the nation in scoring and rebounding in the same season. Our Seattle SuperSonics made him the fourth overall pick in the 1985 NBA Draft.

X had started as a rookie and averaged 17.1 points and 8 rebounds, and he was even better during the 1986–87 season, when he increased his output to 23 points and 8.6 boards per game. But as good as he was, X was equally known as an intimidating figure because of his chiseled 6-foot-7, 200-pound body, physical style, and emotional play. Plus, he had a great game face. We'd heard the reason he shaved his head and eyebrows was to look meaner, and this was way before shaving your head was cool.

With a nickname as cool and mysterious as X, it seemed like coming up with a concept for him would be an easy task because there are so many things that go with it. We played around with ideas like "Xceptional," "Xtraordinary," and "Xcellence." (We even joked about doing a nude and calling it "X-Rated," which is one of the kinds of silly ideas that kept the creative process fun.)

Then we focused on "X-Man," which led to "Ice Man" and then "The Iceman Cometh." Neither of us had ever seen the Eugene O'Neill play with that title—and to be honest, we still don't know what it's about—but we had heard of the title, and it just sounded cool.

We set up in a Seattle studio, and X came in. We used a lot of spray paint for the costume. We don't remember whose idea it was or why we chose the Doberman, but it just seemed that it would make X look more badass, though it was the dog that was the real badass. X is a pretty fearless guy, but he was a little nervous around the dog and its sharp teeth. The handler brought the dog around X to familiarize him with it, but the dog was a pretty darn scary. We asked X if he'd prefer to shoot without the dog, and he said, "No—but let's get going."

The fog machine worked perfectly for this one and gave it a mystical appearance, and the only problem we had was that the dog kept looking around instead of forward toward the camera. The handler told X to pull the leash up to get the dog's head in position. X looked at the guy like he was crazy—we all did. The handler came over and showed him how to do it, and the dog seemed fine, and sure enough, the big Doberman was also fine when X pulled his leash, and we got the shots we needed.

We loved the way this one turned out. The fog was great, the colors turned out really nice, and the dog was perfect. Having the photo lab add the yellow background X and the green glow in the dog's eyes were afterthoughts that worked nicely. We couldn't have been happier with the way it turned out.

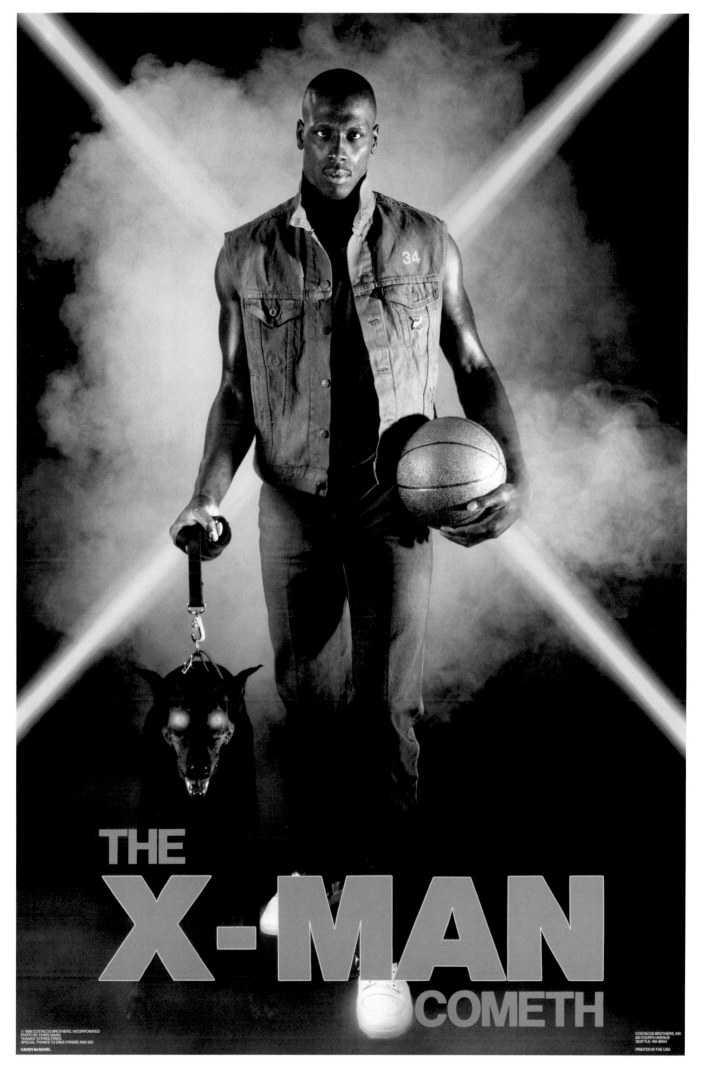

Chuck Person

Indiana Pacers

1986–87 NBA Rookie of the Year

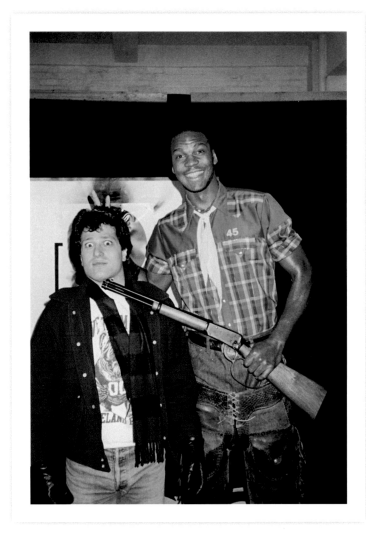

John and Chuck joking
around on the set.

Chuck Person was drafted by the Indiana Pacers with the fourth overall pick in the 1986 NBA Draft. He was a good shooter who had set the single-season and career scoring records for Auburn University, records he still holds today. Chuck also still holds the Auburn single-season and career record for most made 3-pointers, which is remarkable considering how prolific outside shooting has become at all basketball levels. With the Pacers, he made an immediate impact, averaging 18.8 points and winning the NBA Rookie of the Year award.

We thought we could come up with a play on *person* or *personal* because those words are used in a lot of common phrases, including "first person," "up close and personal," and "missing person." (One idea was "Non-Missing Person," which referenced his sharpshooting skills. OK—it was a stretch, but we still wrote it down.) None of it really clicked. There were lots of words and phrases that rhyme with *Chuck*, but again, nothing we liked.

While we were speaking with his agent, we learned that he had a nickname: *the Rifleman*. We'd never heard this, which seemed strange to us, because we always researched and studied athlete nicknames. It was the pre-internet era, but we were still surprised that we hadn't heard him called "the Rifleman" anywhere. It turned out, though, that the nickname didn't originate from his basketball-shooting proficiency, even though it coincidentally made sense. It went all the way back to his childhood.

His mother had named him Chuck Connors Person after Chuck Connors, who starred in the 1960s television western *The Rifleman*. We learned that some of his teammates called him this, and his agent really thought this was the best idea for his poster.

This presented a dilemma for us. "The Rifleman" was a concept we had come up with for Denver Broncos quarterback John Elway a year earlier, and we felt it was perfect for John, with his rifle-like arm. We hadn't made a deal with John yet, though, so the poster wasn't in the works, but we felt we had a good chance to get John to work with us. But if Chuck liked "the Rifleman" and we could come up with a visual theme we all liked, we thought we should go for it.

If we did "the Rifleman" for Chuck and John later said he wanted to do a poster, too, we decided we could do both—since Chuck's nickname was due to his birth name, we didn't feel we were creating the same thing twice. Also, they were in different sports and different markets, and we would make sure they were plenty different visually. (And when it did eventually happen, nobody gave us any grief about it.)

We got his costume, made up the targets, secured the firearm, and set up the backboard and hoop. Chuck and his agent were cool with him holding a rifle in the poster—remember, it was a different era, and gun violence wasn't uppermost in people's minds, as it is today.

One particular thing we remember about the shoot was how the extra heater we had on the set to keep the studio warm stopped working. It made us panic a little, because we always tried to keep things as comfortable as possible for the athletes, and Chuck had been born and raised in the Alabama heat. But Chuck shrugged it off and said, "It's not as cold as Indy."

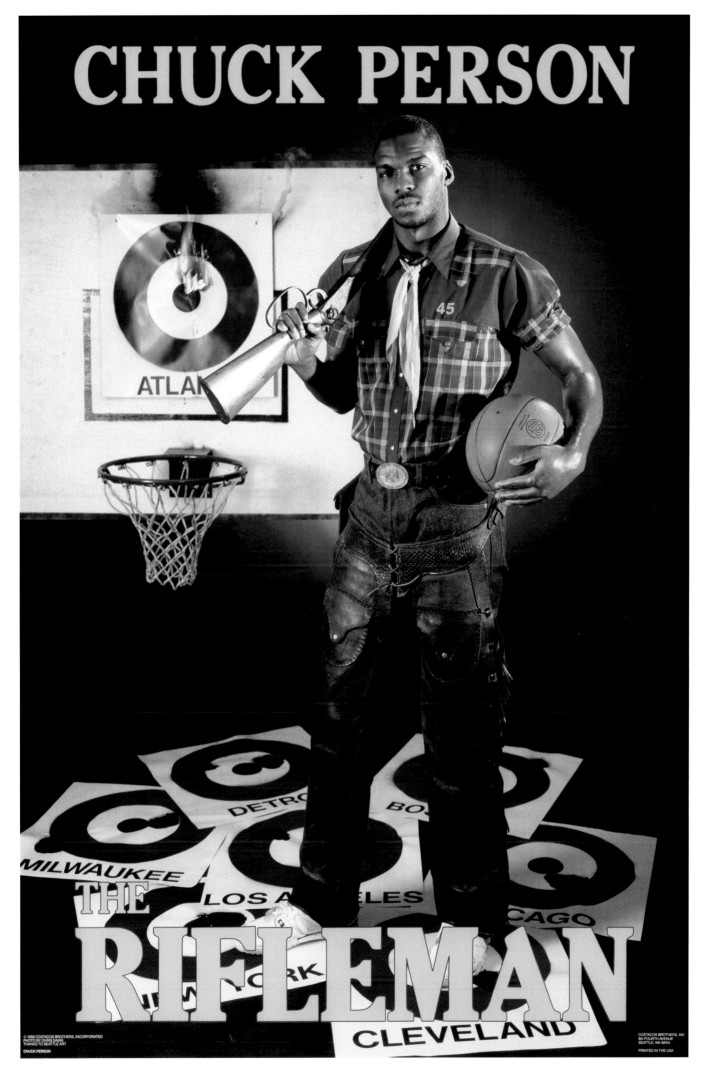

THE DOME PA

PAT SWILLING
56

VAUGHAN JOHNSON
53

SAM MIL
51

Sam Mills brought
his kids to the set,
something we always
encouraged to make
the shoots more fun
for the players.

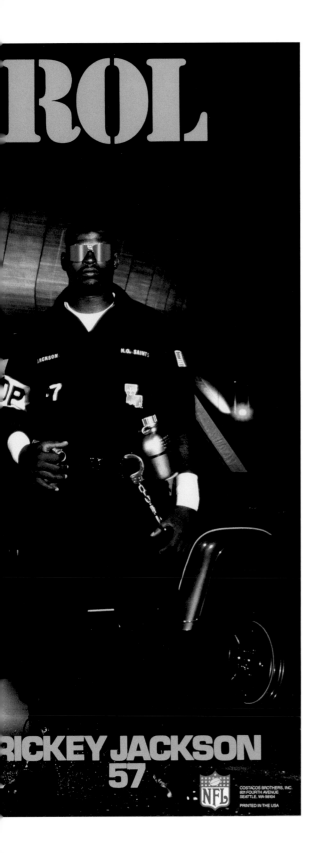

Pat Swilling, Vaughan Johnson, Sam Mills & Rickey Jackson

New Orleans Saints
New Orleans Saints Hall of Fame

We love this poster. We loved the guys in it. For the first twenty years of their existence, the New Orleans Saints didn't have a winning season, but in 1987, that changed. The team went 12-3 and made the playoffs, and the city was in love with the team. The Saints had one of the best linebacker corps in the history of the NFL: Pat Swilling, Sam Mills, Vaughan Johnson, and Rickey Jackson. We had met Sam Mills at the Pro Bowl and talked with him about doing something. He called us a few months later and said he—and his teammates—were in.

One of the great things about creating a look for NFL defensive players is that they're so easy to make look like badasses because that's who they are and how they like being portrayed. You can do it with the offensive guys, too, but it's not quite the same.

Our company was quickly growing at about the time of this project, and we needed more help. When a guy named Tom Rees, right out of college, came to interview for a job with us, he showed up in a suit. Tom had no experience in art, graphic design, or photography, but he liked sports. He was just like us. We told him, "You're hired. Lose the suit, and we'll see you on Monday."

His first assignment was a calendar featuring a number of Seattle Seahawks players that we did for a company in Chicago. It was a lot of work, and Tom did a great job, and it gave us enough confidence in him that we had him go to New Orleans to do the "Dome Patrol" shoot. Of course, we didn't send him to the wolves—we paired him with Seahawks team photographer Corky Trewin, who had shot a bunch of our posters already, and we created very specific storyboards for direction. We loved the Saints' black and gold team colors and went with a full military theme on this one.

When we saw the proofs a couple of days later, we couldn't have been happier. It looked just like the storyboards we provided, and the shot turned out better than our highest expectations. We consider this one of the best posters we ever did. The players looked great, and the Superdome looked better in the background than we had hoped.

A couple of years ago, while we were watching *Monday Night Football*, this "Dome Patrol" poster popped onto the screen, and the announcers talked about it. One of the best things about the work we did was hearing from people who had loved our posters when they were kids. If you watch sports long enough, there will eventually be a moment or a game or a season or an era of greatness that fills you with awe, and that feeling and inspiration stays with you. Years or even decades later, thinking about it can bring you back to that time in your life.

That's been the theme of so many letters and emails we've received from fans who had our posters thirty years ago. They'll tell us where they bought it, where they put it up, and what it meant to them as a kid. To have made something that reconnects an adult with their childhood—what could be better than that?

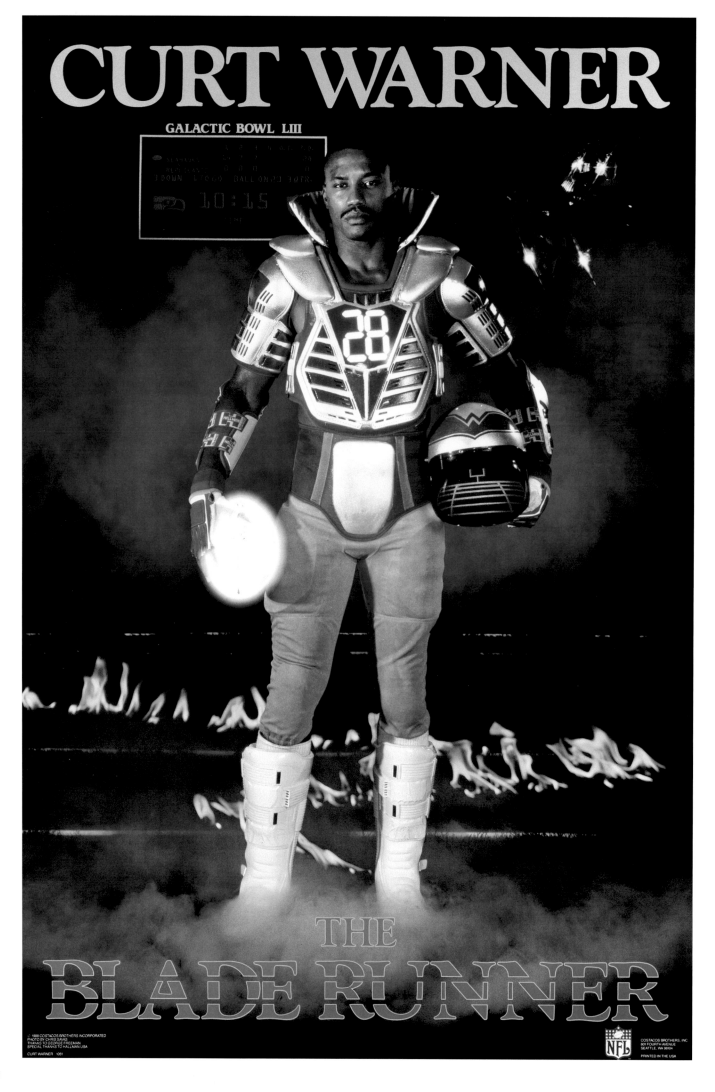

Curt Warner

Seattle Seahawks
1987 First Team All-Pro

Fans saw the serious Curt Warner during games, like in the poster. Here, we get to see the fun side of him.

C urt, a running back from Penn State, was selected by the Seahawks as the third overall pick in the draft. We loved any chance to work with our hometown players but had to wait an extra year with Curt because a couple of other Seattle guys had already made a poster of him, and he needed to be fair to them and let that poster run its course. (Over the years, a number of companies sprouted up to make player posters, but our distribution and body of work gave us a big advantage.)

Curt was especially good at cutting back on defenders. We saw replay of a long gain by Curt where he cut back twice and made the defenders look silly. The announcer said something about Curt cutting like a knife, which caught our attention. We made a list of every word we could think of related to that, including *knife, cut, cutting, saw, scissors, razor, sword, slice, scalpel, blade,* and *machete.* We kept reading down the list until one of those hit, and it was *blade*—which led to the title "Blade Runner." That was the name of a 1982 sci-fi movie starring Harrison Ford, which had somehow become increasingly popular years after its theatrical release. The movie was set in the future, so we decided to make Curt a futuristic running back playing in "Galactic Bowl LIII" who has just cut back and forth in a zigzag up the field. This poster is about as '80s as it gets and was so much fun to make and shoot—until the fire department showed up (more on that later).

Most of Curt's costume was made from motocross gear, and you can see the supposed rest of the field—and the end zone uprights—reflected on his helmet. For the fire, we used crushed Duraflame logs, and we placed neon lights down in the grass for yard-marker effects. On the right side, we even had a hovering drone referee, years before we knew what a "drone" was. There was definitely a lot going on in this one, and we took a particularly long time doing test shots before Curt arrived. He's an upbeat and happy guy, and when he arrived, Curt was ready to have some fun, so we set the Duraflames on fire and started shooting.

Only two things went wrong: First, a reporter from the local KIRO-7 television station was there covering the shoot, and he accidentally stepped on and broke one of the neon lights in the background. The second problem was a little more problematic: The Duraflames created a little more smoke than we had expected, and even though we had a giant garage door open, there was enough smoke coming out of the building that someone called the fire department. A big fire truck with a number of firefighters came in, expecting to extinguish a fire, but instead found Seattle's star running back dressed as—well, you know.

The firefighters were actually relieved to see the building wasn't on fire, and they were happy for the unexpected opportunity to meet Curt. We let the smoke clear out, put down some more Duraflames for another round of photos set them on fire, and went back to work. (The firefighters decided to hang out with us—and Curt—for the rest of the shoot as "fire control." We doubt that would happen today.)

Reggie White

Philadelphia Eagles
NFL 75th Anniversary All-Time Team

That ladder looks precariously balanced on the columns, but it was quite safe.

I f you do an internet search for "greatest defensive ends in NFL history," you'll find a lot of lists, and at the top of nearly each one is Reggie White. There aren't a whole lot of football positions where you'd find that kind of consensus, but Reggie was that good. He made the Pro Bowl 13 times and was a two-time NFL Defensive Player of the Year. His first award for this was in 1987, the year we met him at the Pro Bowl.

Reggie was a special player and an equally special person. Being around him was always a calming and soothing experience, which is surprising for someone known for his ferocity on the playing field. He gave off a sense of peace and kindness, and had a gentle and thoughtful way of speaking that made him amazing to be around. The right title for him was pretty obvious, because everyone knew him as the Minister of Defense. This was due to his deep religious faith. We'd read an article in *Sports Illustrated* about how Reggie had knocked a lineman on his butt while on his way to sack the opponent's quarterback. The guy started jawing at him after the play, but Reggie just helped him off the ground and said, "Hey—Jesus is coming." That guy was serious about his religion.

Reggie and his wife, Sara, were always warm and open toward us. We talked with them a couple of times about what we wanted to do. Reggie was an ordained minister and wasn't afraid to talk about it. We knew we wanted to title it "Minister of Defense," but for a brief moment we thought of dressing him like a military minister of defense, because we were a little concerned about whether he would look tough while wearing a minister's robe. But that was a short-lived worry—the guy was gigantic, and he still looked massive and great in the robe.

We planned to stuff burlap bags and pile them up behind him, each with a pair of shoes sticking out as if a quarterback had been literally sacked. Reggie wasn't just strong—he was also incredibly quick for someone his size. He led the league in sacks for two consecutive seasons in 1987 and 1988, and still ranks second on the NFL's all-time sacks list.

We went to Philadelphia and shot this poster in a studio. We rented the columns to give it a biblical look and stacked the bags up behind him. Reggie brought his own robe, so we didn't have to get one. In his hand, we put the two things Reggie said he read every day, his playbook and his Bible. (We suspected it was probably not in that order.) He was so unbelievably nice and warm that we wanted to do a good job for him. He was the kind of guy that you just didn't want to let down. And it wasn't because he was expecting a lot, but because of what an inspirational kind of guy he was.

The poster turned out nice, and we kept in touch with Reggie and Sara. We sent a lot of posters to them for the numerous charity auctions they were involved with, and they were always gracious and thanked us.

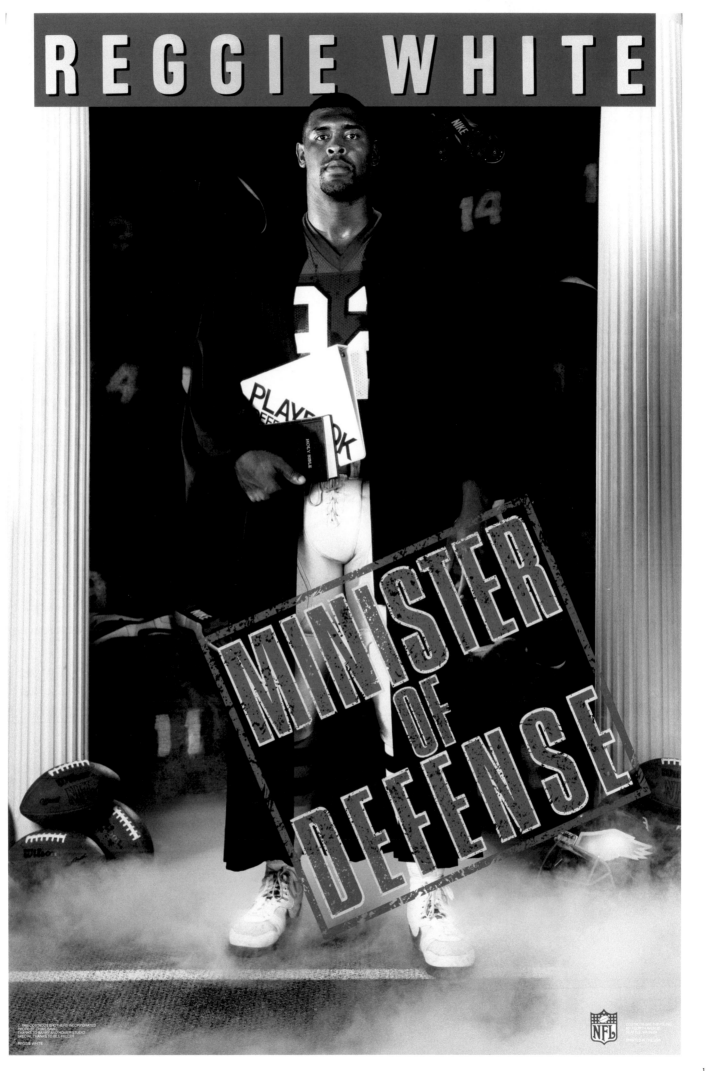

Dave Winfield

New York Yankees
1987 MLB All-Star

We had a silver glove to go with the silver ball, but we opted for the bat instead.

There have been many remarkable athletes in sports, but Dave Winfield stands out. He played basketball on the University of Minnesota 1972 Big Ten title team, averaging 10.5 points on 50.1 percent shooting and 6.1 rebounds. But that was just a hobby—his main sport was baseball, and he was voted MVP of the 1973 College World Series as a pitcher.

He started his legendary professional career when the San Diego Padres drafted him in 1973, but his athletic prowess gave him options: Dave was also drafted by the NBA's Atlanta Hawks. And the ABA's Utah Stars. And even the NFL's Minnesota Vikings, despite the fact that he had never played a down of college football.

Dave was the highest-paid player in baseball and was well on his way to the Baseball Hall of Fame when we worked with him on this poster. We had considered calling it "The Bronx Blaster" because of his talent as a hitter, but Dave was an exceptional fielder, too, winning seven Gold Gloves, and his agent thought we should do more than focus on just his bat. We considered "Super Dave," which was the name of a funny Showtime television show, but Dave Winfield didn't have the kind of personality to call himself something like that. Same with "Winnerfield"—that wasn't his style, either. We were seriously (ahem) striking out with ideas for him.

Yankees owner George Steinbrenner had been saying some nasty things about him in the media, and there were some lawsuits between them, but Dave stayed above it all and handled it with grace and class, so we suggested "Class of New York," and they liked it. (We later changed it to simply "Class" because of potential trademark issues.) The idea was to dress him in an old-fashioned suit and shoot at an old, classic location that was distinctly New York, like in some vintage photographs we had seen of Joe DiMaggio and Mickey Mantle.

We knew that the *Sporting News* had a lot of old photos, so we called them and they sent a number of Yankees photos from the previous eras (that were very, very cool), and even some of famous Brooklyn Dodgers. Then we went to New York to look for locations in Manhattan and near Yankee Stadium. We couldn't find exactly what we were looking for, though, so we decided to shoot in a studio and get a skyline shot of the city for the background.

We understood why Dave had a reputation as a gentleman and class act, because that's who he was, and we could tell from the moment we met him. He had a confident and understated way about him, and he made us all feel comfortable the moment he walked in.

Instead of a suit, Dave brought his own tuxedo, which he looked very cool in. He got in front of the camera, and we suggested he pose however he felt comfortable. We didn't have to give him much direction, because he was doing great on his own, so we just shut up and let him do his thing. And after it was over, he let our eight-year old cousin David, who lived in New York and was a huge Yankees fan, have his picture taken with him.

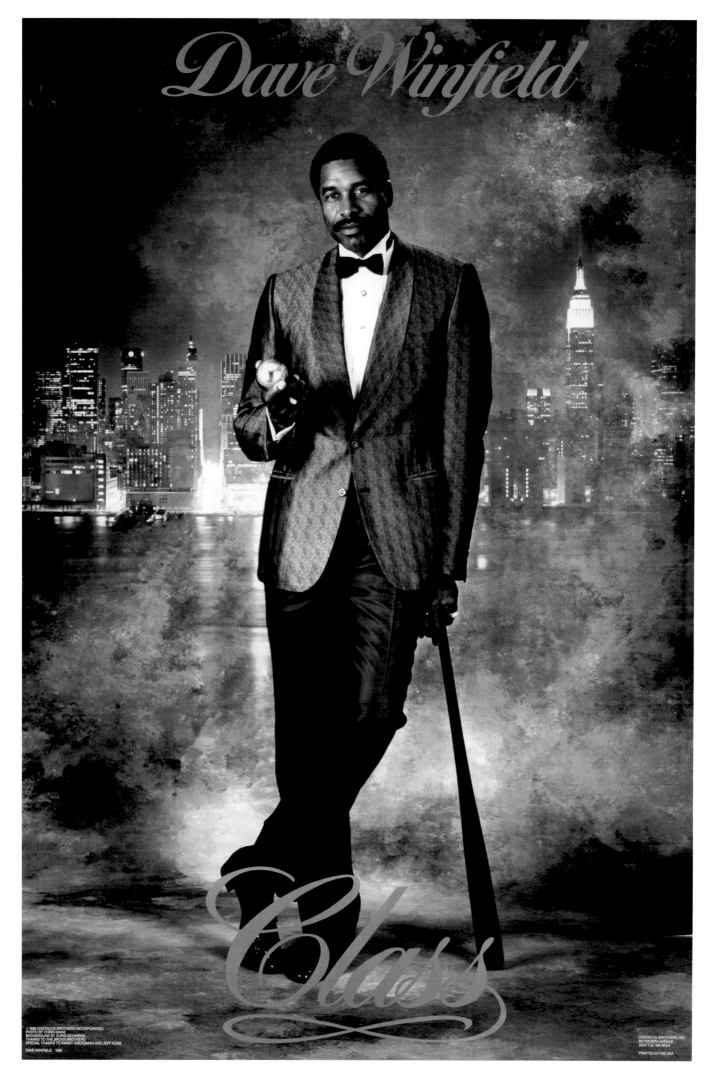

Dave Winfield

Class

JAMES WORTHY

L.A. LAW

James Worthy

Los Angeles Lakers
1987–88 NBA Finals MVP

Here's our door poster
with James wearing his
trademark goggles.

One of the reasons Coach Pat Riley's Lakers teams were called "Showtime" was their transition game. They had a fast break that was always exciting, unpredictable, and beautiful to watch. And, so many times, there was James Worthy finishing at the hoop with his cool goggles on. The ball would often get to Magic Johnson, who'd somehow send a no-look pass behind him to Worthy cruising to the hoop for one of his smooth dunks.

It was good to have a poster of James Worthy come out in 1988. The Lakers had already won the 1986–87 championship, and Riley had made his famous guarantee of winning it again before the 1987–88 season. Sure enough, Worthy's Lakers won a league-leading 62 games and finished as champions after three consecutive playoff series that each went to a seventh game, including the finals against the Detroit Pistons. And the MVP of the 1988 Finals? James Worthy, with 36 points, 16 rebounds, and 10 assists in the deciding Game 7. Wins, playoffs, championships, and personal accolades fuel the demand for posters. The most important element is the player's popularity, but the other factors give it an extra boost.

Compared to football, baseball, and hockey, basketball has significant differences that affect the relationship between fans and players. Players are much closer to fans than in football and baseball stadiums, don't wear helmets or masks, and don't have glass between them and the fans the way hockey arenas do. There's just a more intimate connection with the fans, and their faces are more familiar. This was more of a factor in the '80s than it is today, when fans have seemingly unlimited access to the players and their lives due to more televised games, social media, and all the photos and videos online. But when we were making posters, the fans' closer connection to the players helped make the NBA posters become our biggest seller.

We always thought James Worthy was a very cool basketball name. Worthy is just a great word. The dictionary defines it as "having sufficient worth or importance," and as a name it carries an air of that significance (though if he went by "Jim Worthy," it wouldn't sound quite as cool).

In looking for a poster concept for him, we tried every phrase we could using his last name: "Trustworthy," "I Am Worthy," "Net Worthy," "Newsworthy," and "Airworthy," among others. (We've often been asked why we didn't call it "Big Game James," after his nickname. It's because we didn't know about it until after the photo shoot, when James had his MVP performance in the Finals.)

"L.A. Law" came from watching a Lakers game on TV. James was having a great game, and one of the broadcasters said, ". . . and James Worthy is laying down the law tonight!" We shot it in an office in Los Angeles after putting some basketball decorations in it and adding the gavel and the briefcase with goggles, shoes, and his jersey (though we couldn't show the Lakers logo, because of trademark issues). And his assistant holding up his schedule showing his upcoming games? That's his wife, Angela.

James was so mellow and easygoing. He had a great naturally relaxed expression on his face, which is exactly what we wanted. And he gave us that look for the entire shoot. A smile would have ruined the cool.

Eric Dickerson

Baltimore Colts
NFL 1980s All-Decade Team

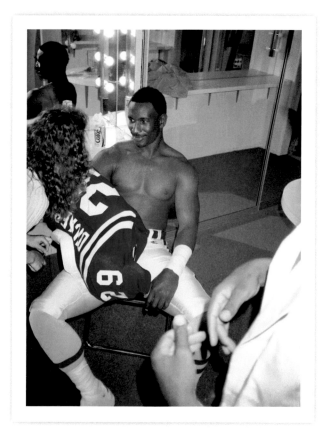

(top) This was our first poster with an official NFL license, so we could have Eric in his Colts uniform.

(above) Eric outside with his Ferarri . . . before we stole it.

The Los Angeles Rams had picked Eric with the second overall pick in the 1983 draft, and by the time we were making posters, he had already broken the NFL single-season rushing record, which still stands today. We had spoken with Eric at the Pro Bowl, and he was interested in working with us, and we wanted to increase our presence in the large Los Angeles market.

It was around this time that we had started a dialogue with the NFL, and it looked like we might get a chance to work out an official licensing agreement, which would allow us to use team names and logos. The business had started to grow, and the leagues were adding new licensees. Plus, initial skepticism from the leagues about our products was quickly dissipating because our posters sold.

But we still didn't have the NFL license, so we started writing down words that described the way Eric played and looked. The movie *Robocop* had recently been released, and it was about a police officer who was half man and half machine and—like Eric— was virtually unstoppable. We thought he looked machine-like because of the goggles and the white padded collar he wore, so we went with "Roboback" and a robotic-shop theme for the set.

Before we shot it, though, Eric was traded to the Indianapolis Colts, and we finally got an NFL license, so we were able to feature his real uniform. We built the set in a studio in Los Angeles and came up with some good wordplay with this one. Referencing the Star Wars movies and the Colts team name, we added "May the Horse Be with You." And the lab coats are printed with "See Dick Run," from the Dick and Jane books, which, back in the day, had helped teach a generation of children to read. This turned out better than we had planned, because we made and sold a lot of T-shirts with those phrases on them.

Eric arrived in a fancy white Ferrari Testarossa, which he parked on the street. We suggested he park it in the studio next door for safety, but he decided to leave it there. We talked through what we'd be doing, and he went to get into his uniform. But while he was in the dressing room, we decided to play a little joke on him and move his Ferrari so he'd think it had been stolen when he returned to where he had parked it.

As soon as Eric walked onto the set, he slipped as if he'd stepped on ice—both feet came out from under him, and he landed flat on his back. We had just tested the fog machine, and somehow it had made the floor slick. Everyone froze as Eric lay on his back. He didn't say a word, but just slowly turned his head from one side to the other like he was trying to see if he was OK.

Photographer Chris Savas was standing next to him, and he straddled Eric and yelled down at him like a coach, "Get up! Get up! I've seen you get hit harder than that!" Eric started laughing and reached out his hand for Chris to help him up. When he was back on his feet, he looked around and could tell how scared we were, so he said, "Don't worry—I'm OK. I'm fine. Let's go."

The shoot itself was easy. We played around with poses until we got the one we liked. Afterward, Eric went around the studio and thanked every person there, then walked out the door.

A minute later, he came back in and said, "All right—you got me. Where's my car?"

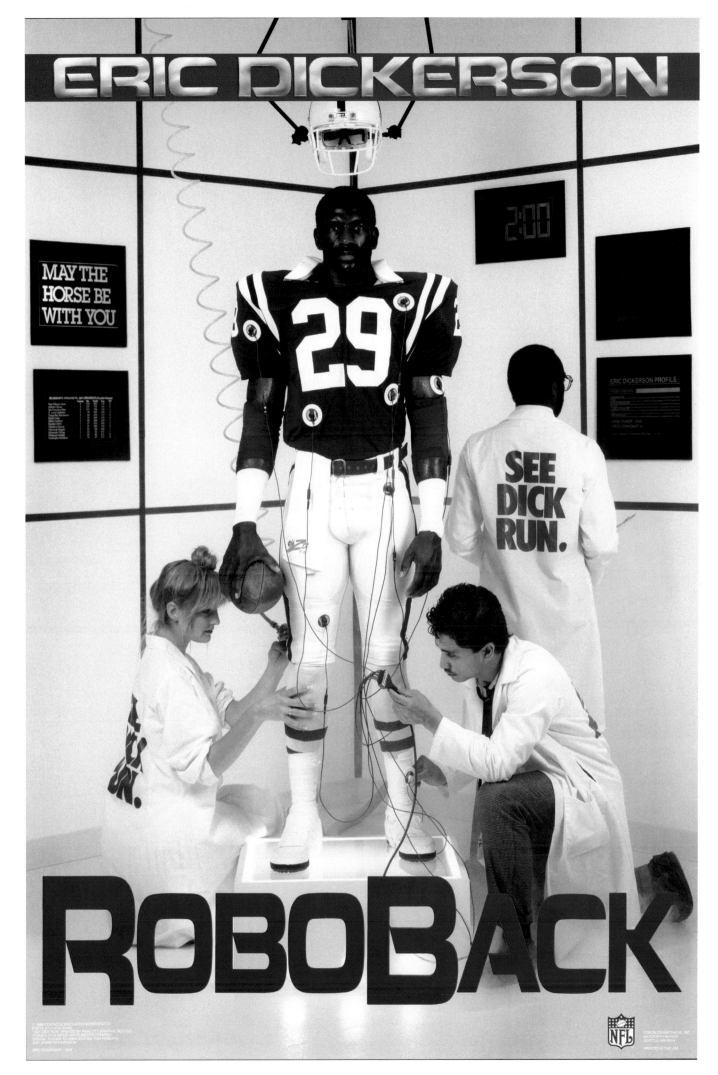

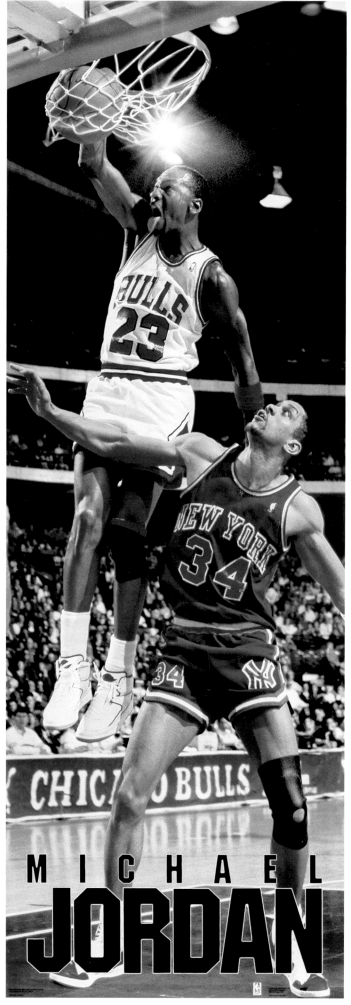

Door Posters

NBA Superstars
More Than 15 Million Sold

(above) The greatest
NBA official of all
time: our dad, Jerry
Costacos. We used him
in this shot for scale,
to show how tall the
door posters were in
brochures and ads.

Our NBA licensing started with door posters. The league liked what we were doing in the industry but didn't know how to give us a license. Our content was way different than the work from their two current poster licensees at the time, which were using game-action photographs, but they still wouldn't give us a license. So, we tried something else: oversized posters, which we called door posters.

From our experience with the Joe Morris Growth Chart, we were confident that larger-format posters would sell, and we had a relationship with one of the few printers in the country that could print 80-inch-tall posters. Basketball is a vertical game, and we'd studied NBA action photos for a while and felt the narrower format would work. What we didn't know was if 35mm slides would blow up to 80 inches tall and not be too grainy. We did some testing and felt it was doable, made the best presentation we could, and traveled to the NBA headquarters in New York. That was the beginning of our working with the NBA—they liked what they saw, so we went to work.

Of course, we immediately started annoying the league office. But it wasn't because we were being unprofessional—on the contrary, it was because we were extra professional. We were being very picky about the shots we selected. They would FedEx 20 slides at a time, and we'd send them back because they weren't good enough. We wanted each player to look spectacular in his poster, because we knew kids wanted to be proud of what they hung on their walls. Fans would see these posters every morning when they woke up and every night before they went to sleep. They had to be awesome.

There was also the problem of physical constraints. It was frustrating for us to find a great shot, only to notice that the player's elbow or foot wouldn't quite fit when cropped into the 80-inch-by-26-inch frame of the door posters.

There were also problems with hands sticking in from the side of a shot. For example, after searching through a mountain of slides, we finally found a great photo of Magic Johnson. On the slide, it looked great: He was driving past an opponent, straight at the camera and about to go up to the hoop. But when we cropped it to the poster dimensions, the defensive player's hand was still in the picture, and it looked like the hand was reaching for Magic's crotch. Within the context of the full frame it looked fine, but it was more noticeable as a disembodied hand. But the photo was so good that we kept it and paid $600 to have it digitally removed. (Today, this could be done in a few minutes for almost nothing.)

Our licensing partners started sending batches of sixty slides instead of twenty to cut down on the back-and-forth. We eventually sent our NBA reps printed door posters to help them better understand our constraints, and they totally got it and started sending us narrower shots.

The posters sold very well, especially those of Michael Jordan. He kept getting bigger and bigger, and we couldn't have enough titles of him. After the first year or two, though, we were no longer allowed to use any photo of Michael with his tongue sticking out, something he often did while dunking. It turned out that the NBA was worried that kids would try to copy that and bite their tongues.

More from the Archives

John, the non-demonic dog, Xavier McDaniel, and John's friend Angi Dutton after the photo shoot.

A particularly fun part of our work was being able to have so many members of our office help at the photo shoots. Xavier stuck around for this group shot—and eventually got comfortable with the dog.

Charles Barkley came to our office Christmas party, and was nice enough to take a picture with our dad.

One of the looks we tried was Charles wearing sunglasses and gloves, but that looked . . . weird.

Here's John and Charles posing on the rim after the "Get Off My Backboard" photo shoot was finished.

Our sister Marianne was in charge of player relations, and players like Curt Warner (usually) loved her.

Here's a close-up of the dog house and background props from Bob Golic's "Mad Dawg Golic" poster.

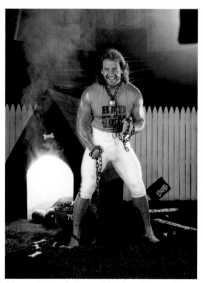

After retiring, Bob would bring that smile to *Saved by the Bell: The College Years* on TV.

This book not only provides a look back at '80s professional athletes like Eric Dickerson (right, with his pal on the left), but also '80s fashion and hair styles.

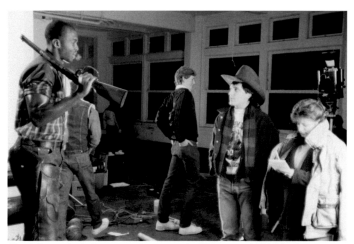

Chuck Person looked pretty cool wearing the Western outfit with leather chaps and neckerchief, but John's cowboy hat would've been a little too much.

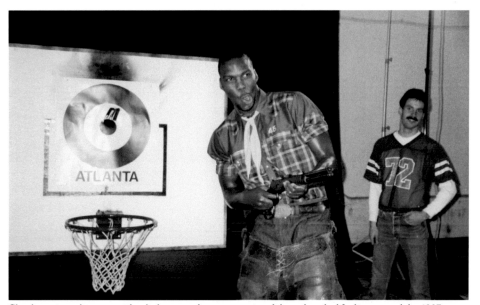

Chuck got into character with a little pretend target practice. Atlanta knocked Indiana out of the 1987 playoffs despite Chuck averaging 27.0 points, 8.3 rebounds, 5.0 assists, and 1.3 steals . . . as a rookie.

This outtake from "Designated Hitter" shows that even without the sunglasses, Ronnie Lott looks cool!

That's John adjusting Neil Lomax's wristband at the Grand Canyon for "The Grand Canon" poster.

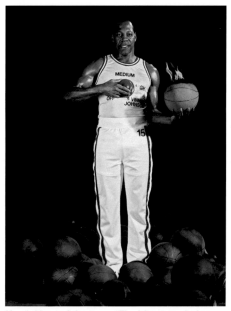

Here's Vinnie Johnson at "The Microwave" photo shoot, turning himself up to "Vinnie Johnson."

Keeping the windows open while the set was ablaze surely kept us within fire-safety regulations.

Patrick Ewing

New York Knicks

1988–89 NBA All-Star

Future Dream Teamers
can hold a pose—dogs,
not so much.

P atrick Ewing was our first licensed basketball poster. We had finally made the deal with the NBA for the license, and why not start with one of the biggest stars in one of the biggest markets?

We were familiar with Patrick from his college years at Georgetown University. The John Thompson–coached Hoyas were one of the best teams in the country. Patrick had led the team to three Final Fours and a National Championship in 1984, which we watched in person because it was in Seattle. Patrick's Hoyas beat Hakeem Olajuwon's Phi Slamma Jamma team in the final, and he was named the tournament's Most Outstanding Player. That year, the big story in the NBA Draft wasn't about who was likely to be picked first. It was about who would win the NBA's first Draft Lottery, and therefore get Patrick Ewing. And it was the New York Knicks.

We don't remember when we came up with "Madison Square Guardian," but obviously, the title comes from Madison Square Garden, the Knicks's home arena. We had developed a very good relationship with Patrick's agent and had been brainstorming ideas, but we held off to see if we were going to finalize the licensing agreement with the NBA, which would factor into what we'd have him wearing.

Patrick is another player who is just an incredibly nice person. It was super rare that we dealt with a player who was not nice. It only happened twice, and we remember those. The rest of the athletes were great, and that's the truth. But then there were the guys who were *extra* nice, and Patrick was one of them.

We shot it in a studio in New York. We had rented the fence, and the dogs were police dogs and very well behaved, but Patrick wasn't so sure. He seemed uncomfortable around them. He didn't complain or say anything, but we could tell he was a little nervous. We told him it would be OK to shoot without the dogs. He thought about it for a moment, looked at the dogs and then back at us, and finally said, "No . . . it's OK. Let's do it."

Since Patrick was already a little concerned about the dogs, we were a little anxious about how they might react to the fog machine. Their handler, a police officer, assured us they'd be fine, and they were (but we tested the fog machine with just the dogs first to be sure).

The camera loved Patrick. He's very laid-back and has a genuine and gentle smile. There were so many shots we could have used. After the shoot, we wondered whether we should have had the dogs in there at all. Looking at it today, we think the poster might have been better without them. But this is us just second-guessing ourselves, because we constantly thought about how we could make our posters the best they could be, even 30 years later.

The colors turned out great, and we were very pleased with this one, and so were Patrick and his agent. The NBA license came with certain restrictions from a content standpoint, but we generally didn't mind it, and we just had to be creative in different ways. But featuring Patrick Ewing in his actual Knicks uniform, with the team logo and the big "New York" name on his chest, made this a great debut product in the world of licensed poster publishing.

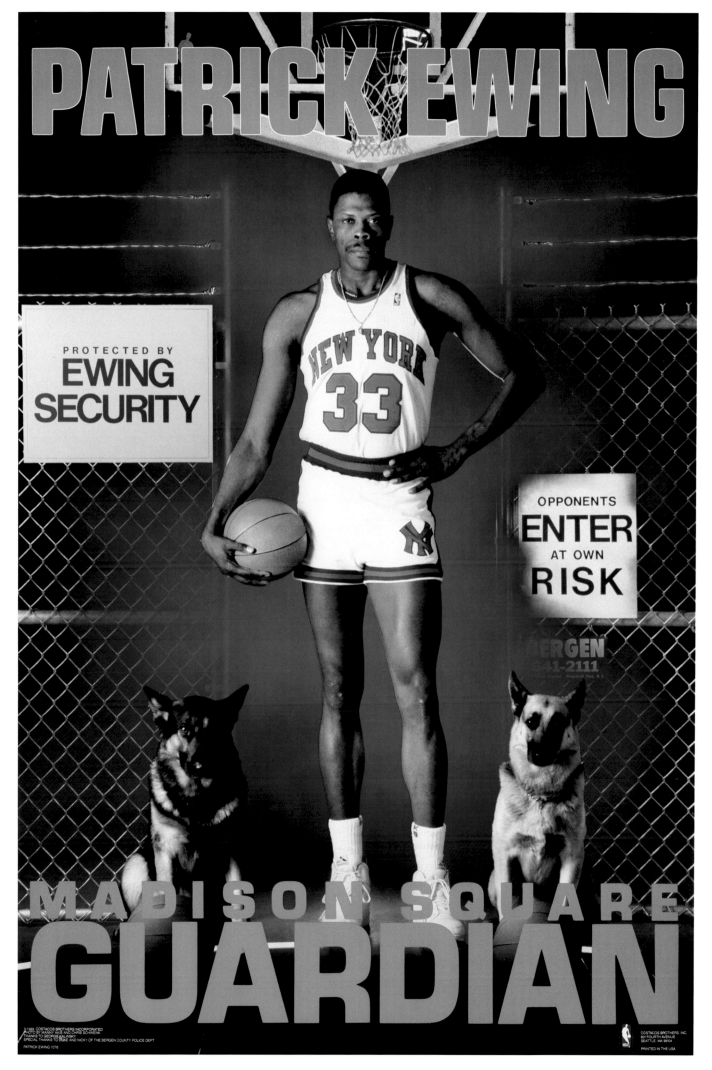

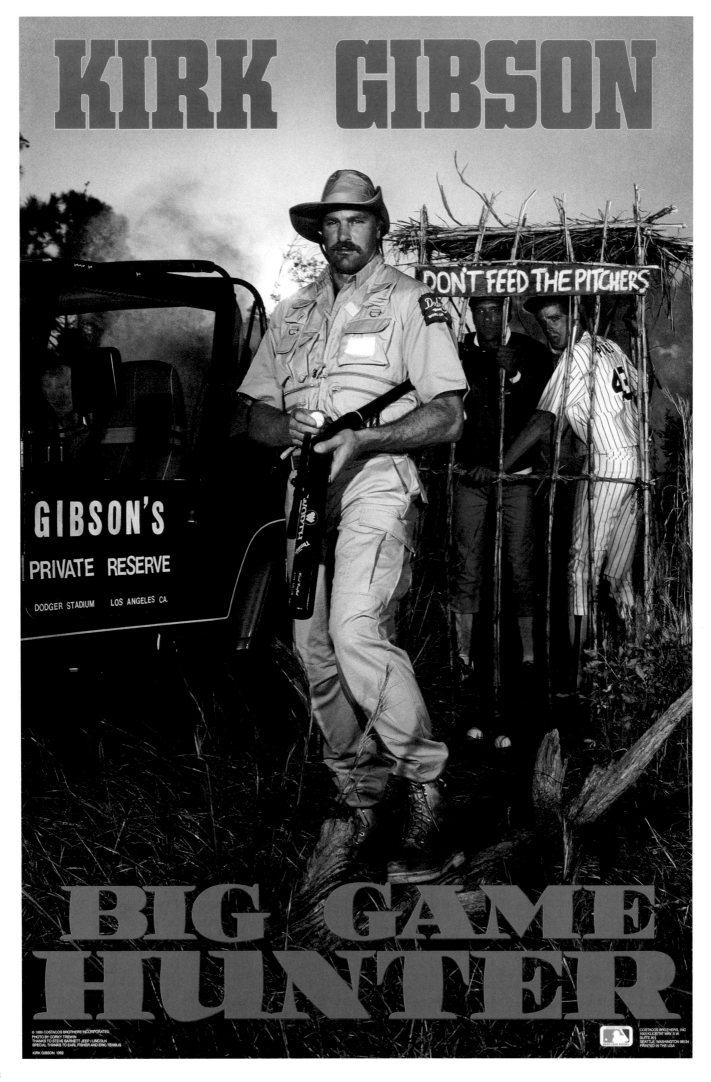

Kirk Gibson

Los Angeles Dodgers
1988 MLB National League MVP

As you can see, the
hat really completes
Kirk's safari outfit.

If you haven't seen Kirk Gibson's home run in Game 1 of the 1988 World Series, put this book down, watch it on the internet, and then come back. It's moments like this that made us love sports. His Los Angeles Dodgers were facing the favored Oakland A's in the World Series and gave baseball (and us) one of the great moments in World Series history.

We watched that game with Tom Rees in the bar at a restaurant called F. X. McRory's, near the Kingdome. In the early years, when we didn't have many posters in the market, we would root for the teams from our posters because winning made a huge difference in sales. In 1988, we had the Bash Brothers poster for the A's and no Dodgers posters, so naturally we were pulling hard for the A's.

Our Bash Brothers subject Jose Canseco had hit a grand slam earlier in the game, and the A's led 4-3 going into the bottom of the ninth. With two outs and a man on, Kirk hobbled to the plate despite having severe injuries to both legs. A crippled hero giving it a go against Dennis Eckersley, the premier closer in baseball—we all turned to each other and said, "We have to root for him, don't we?" We were fans first, so we changed our allegiance and rooted for Kirk in that moment. He slowly worked to a full count, and with the game on the line, Kirk hit a home run to win the game. It was one of the greatest clutch moments we have ever seen in sports.

Kirk's agent, Doug Baldwin, was from Seattle and actually lived in our neighborhood. When we met with him early in the 1988 season to talk about a poster of Kirk, we kicked around preliminary ideas. Doug mentioned that Kirk's nickname was Gibby, but there wasn't much we could do with that. He also told us that Kirk used visualization techniques from Lou Tice's Pacific Institute, in which the method is to visualize what you want to have happen. But Kirk was a big, strong guy, and we wanted him to have that physical presence in the poster rather than something cerebral.

We talked about titling it "Money" because he was at his best in the money moments, but we thought people could misconstrue it to mean something about the money he earned. We liked "Gamer" and "Big Gamer"—especially in light of that big home run—and then Doug said Kirk was a hunter, and "Big Game Hunter" was born.

We shot it in March 1989 during spring training and found an outdoor location that could work for our safari theme not far from the Dodgers training facility in Vero Beach, Florida. Corky Trewin built the cage, and the Dodgers arranged for some of their interns to be the background extras. We had problems with our power generator, though, so we had to scramble. Nobody was home at the house across the two-lane road from us, but we noticed an outlet on the exterior of the house and connected a long extension cord and ran it across to our set.

Tom Rees went to the Dodgers facility to pick up Kirk, and to hear him tell the story, he knocked on the door and a few seconds later found himself standing face to face with Dodgers manager Tommy Lasorda, who looked at him and said, "What the f#@* do you want?" He didn't know what to say. A baseball icon was glaring at him, demanding an answer, and Tom froze. Luckily, a voice behind Tommy Lasorda said, "It's OK—he's with me." It was Kirk, coming through in one more big moment.

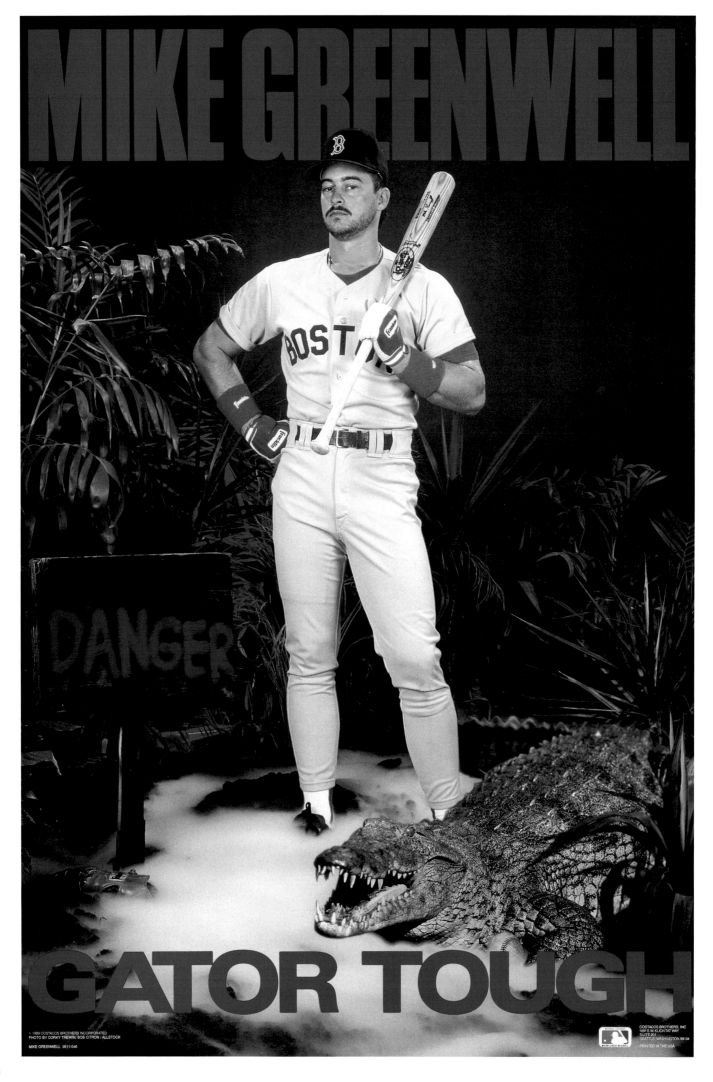

Mike Greenwell

Boston Red Sox
1988 MLB All-Star

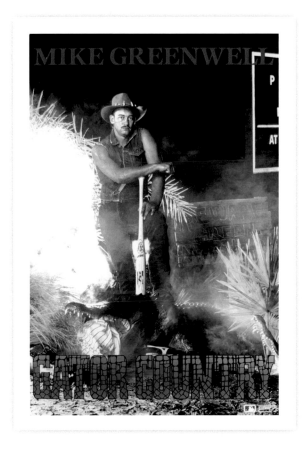

The first poster design had an alligator eating a player from an unidentified (pin-striped) team.

Mike played left field for the Boston Red Sox, and we had a good relationship with his agent. We were excited to work with him because he had just become the 17th Red Sox player to ever hit for the cycle, and he finished second in MVP voting in 1988.

Mike's friends and teammates called him Gator. We heard it was because he had grown up in an area populated with alligators, but for some reason we forgot to ask him about that. But even without know the back story, it was a strong nickname, and we thought about calling his poster "Gator," "Gator Country," or "Gator Tough." We really liked how this poster shoot came out. It's just too bad it was the second time we did it.

The first time was when we traveled down to Florida. It was always a dilemma for us whether we wanted to shoot in a studio or on location. On location was especially good because the sports media always showed up. It created awareness and anticipation—free publicity was free publicity. A studio shot was less interesting to the media, especially when we were shooting against a seamless backdrop to strip the background in later. We often had to weigh the value of the publicity against the higher cost of the location shots.

We found a location in a place that we understood wasn't far from alligator country. We weren't sure if the fake alligator we were using looked right, so Mike said, "You want a real one?" When someone says something like that and you don't know them well, it's hard to tell whether they're joking or not. So, we could only ask, "Are you serious?" Mike replied, "Yeah, I know some guys who will get us one. Do you want me to call them?" Shoot with a live alligator? When we expressed our concern, Mike said, "Don't worry, it won't be alive when it gets here." To this day, we still don't know if he was joking or not, but we used the fake alligator to make sure we didn't have any problems.

When we got the film developed, the fake alligator looked fine, but the whole shot wasn't good enough. It just wasn't. We sent some proofs to Mike and told him we wanted to make another poster and shoot it when he was in Seattle. He agreed to do another shoot the next time the Sox were in Seattle to play the Mariners.

For the second shoot, we went overboard to make sure it came out right. We built this set in a studio a few days ahead of time so we could really control it. We brought in 15 bags of peat moss, rented the plants, and took a lot of time to fine-tune everything until we liked the layout. We spent over half the previous day doing test shots to make sure we were completely prepared. We doubt the gator looked real to anybody, but Mike was the centerpiece and he looked great.

Mike came in ready to work with us and wasn't the least bit upset about the previous attempt. We didn't like it and he didn't, either, and he appreciated that we wanted to get it right for him and were spending the time and energy to do it. Mike shot for an hour and a half with us, trying several poses and looks—none with a real alligator, but with just about everything else.

Ken Griffey Jr. & Ken Griffey Sr.

Seattle Mariners & Cincinnati Reds
1976 & 1990 First-Time MLB All-Stars

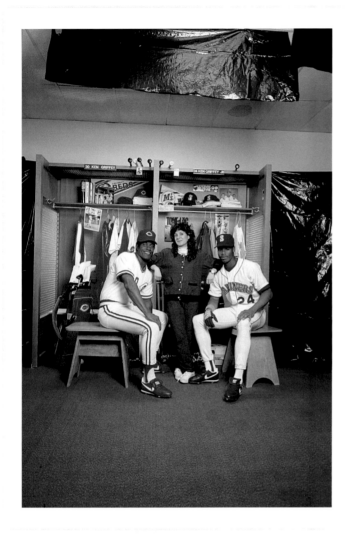

Our sister Marianne
was in charge of
player relations, and
made the athletes feel
comfortable on the set.

The Cincinnati Reds was one of our favorite teams when we were kids, and Ken Griffey Sr. played right field for the Big Red Machine teams that won two World Series in the '70s. His son was a baseball prodigy drafted by the Seattle Mariners with the first overall pick in the 1987 MLB Amateur Draft, and he flew through the minors and there was massive excitement when he was called up to the major league Mariners club in 1989.

There was a lot of buzz about this because he was expected to be one of the greatest players of his generation, and from the beginning, he didn't disappoint: We went to the Mariners home opener and watched him hit a home run in his very first at-bat in Seattle. He was a huge talent at the plate and in the field, and there was a lot of talk about how unusual it was that he and his father were playing in the majors at the same time. (His dad was back with the Reds after a few seasons with the New York Yankees and the Atlanta Braves.) That a father and son were both good enough to play Major League Baseball—and for the father to have the career longevity and the son to be ready so quickly for them to overlap—was something our dad thought was especially cool.

That Ken Griffey Jr. was poised to be a superstar was reason enough to want him for a poster, but the fact that he and his father were in the league at the same time was clearly special. And since we didn't know how long his dad would continue to play, we jumped at the chance to put them in the same poster.

We played around with every idea having to do with their names and their relationship, such as "Like Father, Like Son," "All in the Family," "Family Ties," and "Family Men." We thought about something having to do with "Passing the Torch" but couldn't work it out. We liked "Generation Next," and that led us to the title we used. The television show *Star Trek: The Next Generation* was very popular at the time, so we just changed it to "Griffey: The Next Generation" because this was really what we were shooting—the passing of the torch to the literal next generation of the Griffeys.

We shot it in the Seahawks locker room at the Kingdome and filled the lockers with their gear and a few extras. There was a Ken Griffey Jr. candy bar out at the time, so we put those in. The fan mail in Junior's locker was real, and each locker had a family photo with father and son from when Junior was a child. It seemed like they enjoyed the idea of being in this shoot together, and there was a lot of fun banter between them.

For each poster, we usually set up an autograph-signing session at a sporting goods store or a sports-card shop. We did this for Junior in Seattle and learned how big a star he was. Instead of the few hundred fans most of our signings produced, several *thousand* showed up. That gave us an immediate idea of how popular he was, which continued throughout his Hall of Fame career. The poster sold well not just in Seattle and Cincinnati but across the entire country, and it remains one of our most-requested titles.

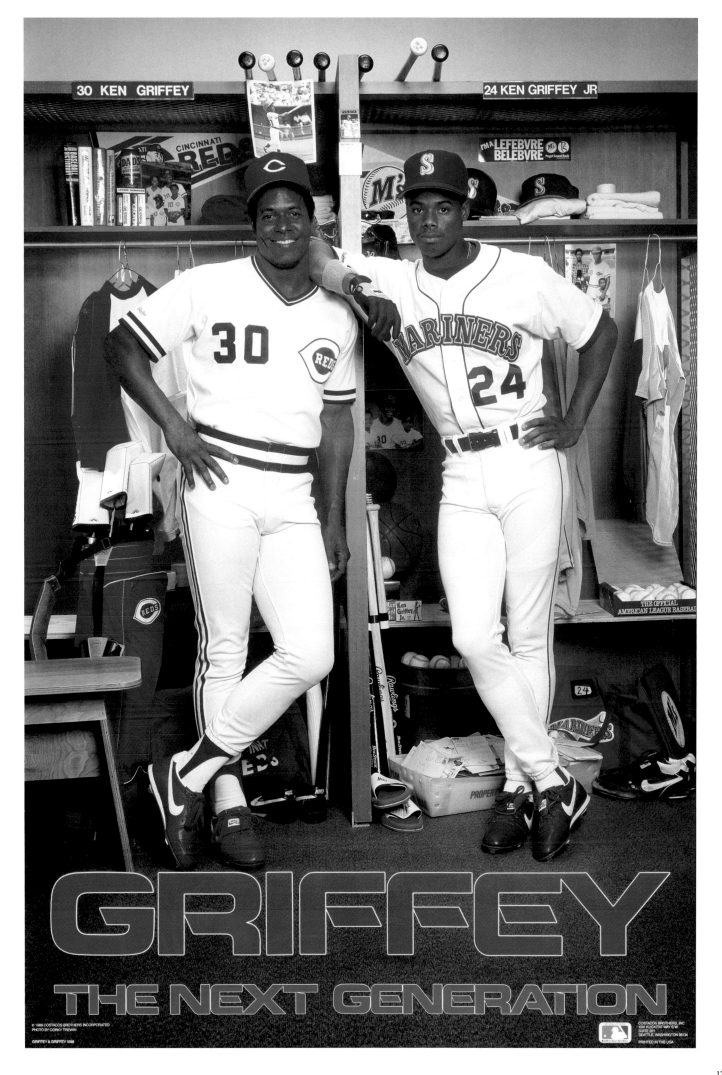

Bo Jackson

Los Angeles Raiders & Kansas City Royals
1989 MLB All-Star & 1990 NFL Pro Bowl

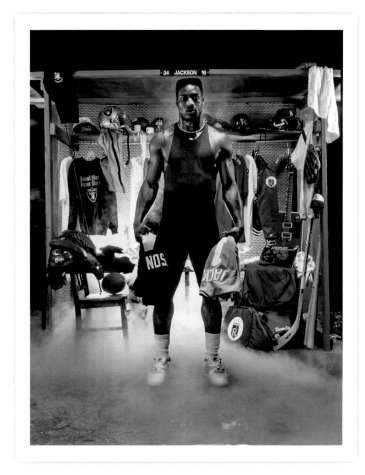

This outtake felt a little too posed, with different halves of his jerseys completing his name.

Bo Jackson was as big a sports star as there was in America. He'd won the Heisman Trophy during his senior season at Auburn University, then shocked everyone by choosing to play pro baseball instead of pro football. He played for the Kansas City Royals, and after one year, he also signed with the Los Angeles Raiders under the condition that he play football only after his baseball season ended.

Bo was great at both sports, and we had to do *something* with him. We came up with a lot of ideas, but nothing seemed to work well enough, so we decided to simplify our approach: Since he played football for the Raiders and baseball for the Royals, we worked to combine those two. But we still needed a title.

The solution actually came from Joe Montana. One of the ways we tried to get out of a creative dead end was walking through our offices for inspiration, looking at the framed posters we had on the wall. Joe Montana's "Golden Great" poster got us thinking about the teams' colors. "Black & Blue." Duh.

Nike had a gigantic ad campaign at this time called "Bo Knows," featuring commercials with clips of Bo being great at everything imaginable. A lot of the props in the poster, such as the hockey stick, the red Bo Diddley guitar, and the fishing pole, were some of the things that were part of the "Bo Knows" campaign.

We had promised Bo's agent that Bo would be walking out the door sixty minutes after he walked in. Some Nike representatives had come up to meet with us and watch the shoot. Nike was actually a competitor of ours because they had their own poster program, but they had expressed interest in working with us, so they came to see what our shoots were like. They brought the shirt, shorts, socks, and shoes Bo would be wearing.

Tom Rees was our head of production, and he went to get Bo at his hotel. The Nike people told him not to talk to Bo, which was a little strange because it was our shoot and our contract was directly with Bo. We had good relationships with our clients specifically because we *did* talk to them, and because we personally picked them up rather than sending limousines. And everyone loved Tom.

When Bo arrived, he was quite friendly but ready to get to work. He said, "You have 60 minutes," and although he was smiling, we weren't going to test him. When we gave Bo the clothes that the Nike reps provided, we noticed a 4-inch-long cut in the crotch of the shorts. While we were sewing that up, we got Bo situated for test shots, and after the shorts were fixed, he got dressed and we worked fast—and Bo was finished forty minutes after he arrived.

He asked to see our operation so we walked him through the warehouse and offices. He seemed genuinely interested in seeing how we operated and chatted with our staff. As we approached the 60-minute time limit we told Bo that *he* only got an hour with *us*, and he needed to get out. He got a serious look on his face, and we had a moment of panic that he didn't realize we were joking, but then he smiled and said, "That's a good one."

"Black & Blue" became our second-biggest seller ever and remains one of the most popular that we ever made. Turns out Bo knew posters, too.

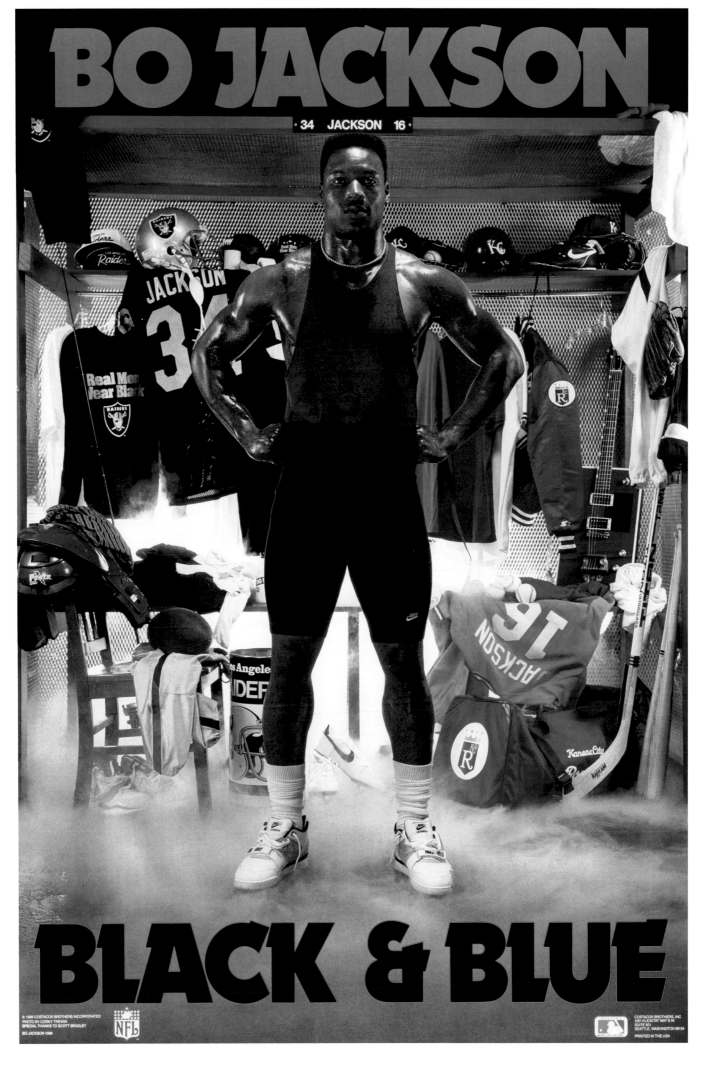

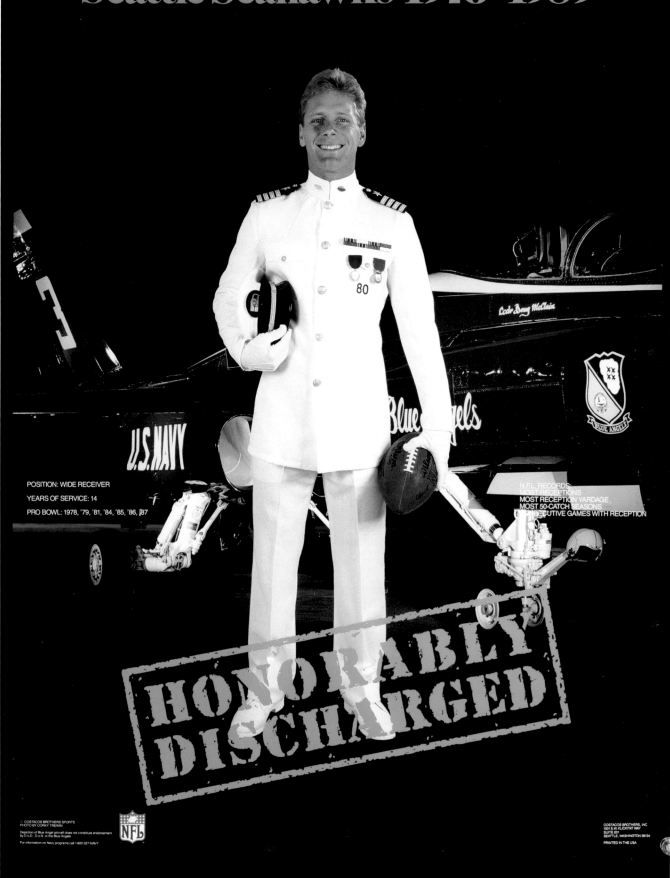

Steve Largent

Seattle Seahawks
1988 NFL Man of the Year

Steve looked great in
his dress whites, and
it all came together
with the Blue Angels
background.

It's hard to believe, but Steve Largent was traded to the Seahawks for an eighth-round draft pick. By the time he retired, he held the NFL record for receptions, receiving yards, touchdown receptions, and consecutive games with a reception. We're pretty sure the Seahawks got the better end of that deal.

But so did the city of Seattle. Steve was an original Seahawk, a rookie during the Seahawks's inaugural season in 1976, and played here for all of his fourteen seasons in the NFL. He raised his children here, and the city was in love with him. He's done work with the Seattle Children's Hospital, the Salvation Army, the United Way, the March of Dimes, the Wheelchairs for the World Foundation, and Habitat for Humanity. A lot of people still would say he's their favorite Seahawk of all time.

We wanted to do something nice for him for his retirement, and there seemed to be a lot of support for a second poster. We had many requests to do another poster of Steve in the years following 1986's "Blue Angel," but the poster sold steadily, so we stayed with it. With the end of his career approaching, though, we wanted to do something to send him off right. Since the Blue Angel nickname had stuck with him, we thought we might do something along those lines, but we had trouble coming up with a title.

We were inspired by the scene in *Top Gun* where Tom Cruise shows up at his graduation and all the pilots are wearing their white navy dress uniforms, which looked very cool. Since, in a sense, his retirement was like a graduation, we thought it would fit. We figured he'd look great in the navy dress whites and that the navy theme would be an obvious "Blue Angel" reference. We still didn't have a title, but during an unrelated conversation, our dad talked about his World War II service in the US Navy and told a story having to do with some of his shipmates and the different kind of discharges they got from the navy, and that's when it hit: "Honorably Discharged." That was such an appropriate thing to say about Steve. So we decided to put his full name in big letters at the top and the discharge stamp at the bottom.

Steve's brother's childhood best friend was a guy named Doug McClain, and at this time he was a Blue Angels pilot. He arranged for us to shoot one of their aircraft for the background photo, and due to their friendship, we made sure it was Commander McClain's plane (with his name on it) in the background—we liked touches like that. (We also liked being able to see an F/A-18 Hornet up close.)

Steve's impending retirement was a beautifully sad moment for Seahawks fans because the city loved the guy so much, and we were very happy to do something like this to commemorate his great career. We always talk about how we made the posters for kids, but this one was personal. He was our first local football hero growing up—he meant a lot to us and to our city—and this was our thank-you and farewell to him.

A few years later, in 1995, Steve Largent—the player traded for just an eighth-round draft pick—was inducted into the Pro Football Hall of Fame.

Jim McMahon

San Diego Chargers
46–15 Record as Bears Starting QB

Here's the shot Jim
said he'd send to
ex-coach Mike Ditka.

We never had a shortage of poster ideas for Jim McMahon. He was one of our favorite subjects because he was rebellious, colorful, funny, and a blast to work with. In 1989, the Bears traded Jim to the San Diego Chargers. The iconic '85 Bears had lost Walter Payton to retirement, defensive coordinator Buddy Ryan to the Eagles, and now Jim. Head Coach Mike Ditka once wrote about all the other personalities and great players on that team but said Jim was the one who made the team go.

Jim still had a national following, and his trade to San Diego created an opportunity for us because we didn't have any Chargers or Padres posters yet. We called him and asked if he was up for doing another poster, and he said yes, although we didn't have any specific ideas yet. By this time, we had obtained a license with NFL Properties, but Jim being Jim, he preferred to do something without any uniforms, logos, or trademarks.

So we went to work with his new San Diego Chargers team in mind, and played around with concepts related to electricity and lightning bolts. We did have one idea, "General Electric," we liked that felt perfect for him as the Chargers quarterback, but we decided against it because our "I Shall Return" poster had already featured him dressed like a general. So we went back to the drawing board.

The answer came from a movie, the Steven Spielberg blockbuster *Indiana Jones and the Last Crusade,* which had just come out that summer. This was the third of the massively popular Indiana Jones movies, and everyone knew the character, and we figured Jim would look great dressed up like him, so we played around with a bunch of titles, and "Jim McMahon and the Last Rebellion" won.

We built the set ourselves to replicate the opening scene in the first movie, *Raiders of the Lost Ark,* where Indy is in Peru searching for a golden idol he finds in an ancient temple. Braving a number of traps, he finally finds the bright gold statue sitting on top of a pedestal. We replicated the set from the movie—only instead of a gold figurine, we had a gold football—with Jim's signature headband and sunglasses. When we saw the finished set, we couldn't have been happier, and we all thought the golden football was a complete riot.

Jim loved it, too. He came up in the summer, just before his first training camp with San Diego, and he had a ton of fun that day. One of the things we liked about working with Jim is how much he trusted us and let us try a lot of looks. Our parents came for the shoot, and when our mom met him, she said, "You know, you and I have something in common. We graduated from the same university." Jim admitted with a smile, "I didn't graduate!" (He went back to Brigham Young University and graduated in 2014, but Mom still loves telling that story.)

After we finished, Jim grabbed a beer and put the prop gun to his head and said, "Hey, get me a shot of this," which we did. Then he said, "Can you send me a copy of this one? I'm gonna send it to [ex-Bears Coach] Ditka and tell him this is what I would have done if I had to play another season for him."

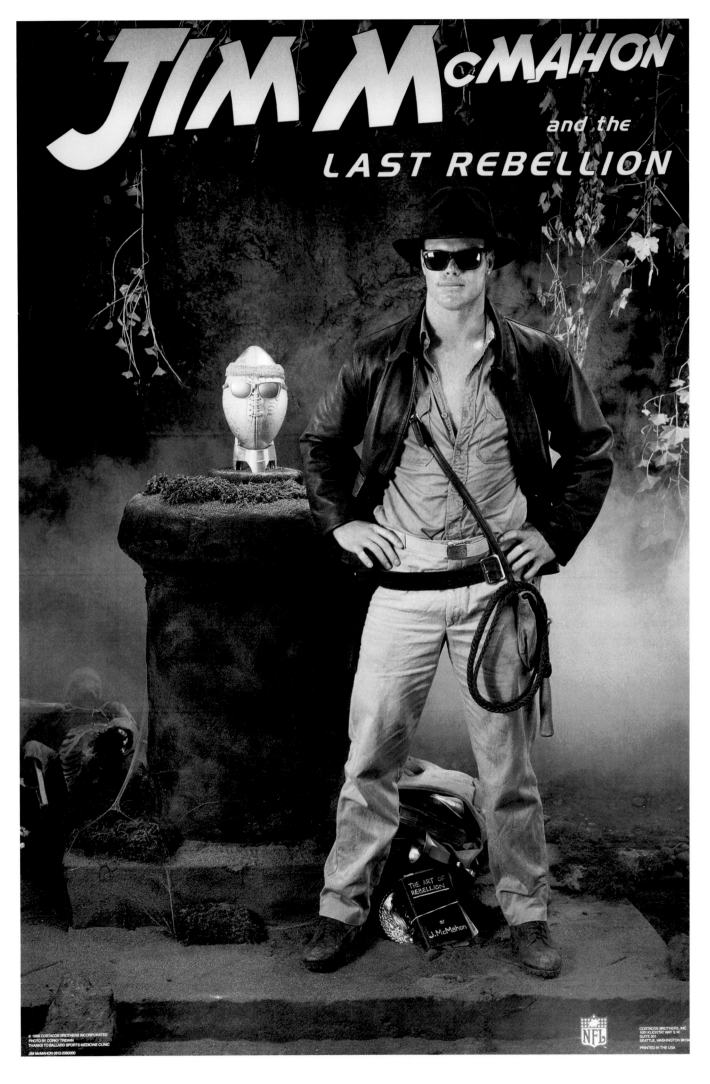

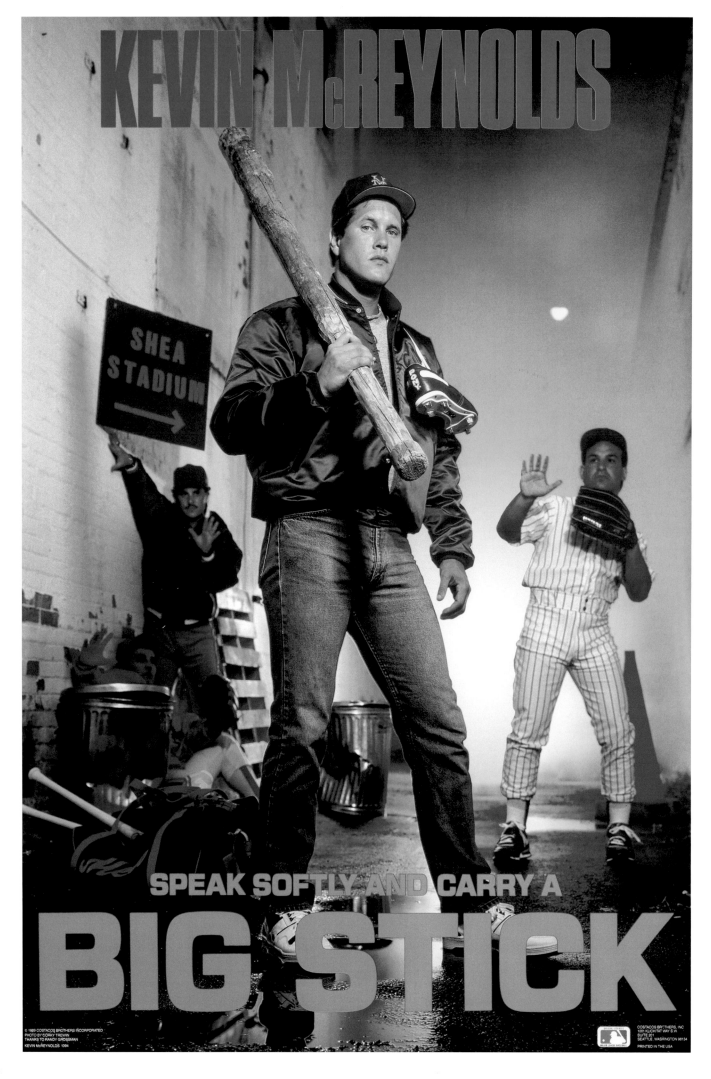

Kevin McReynolds

New York Mets
1988 Record for Most **Stolen Bases**
Without Being Caught

Here's a shot we did
before having Kevin
carry a literal big stick.

Sometimes we made posters because we had a great idea for a player, and sometimes it was because a player had a great idea or nickname. And sometimes we'd want to enter a market, and there was the right player at the right time.

This was the case with Kevin McReynolds of the Mets. The team had a number of big stars and big personalities like Dwight Gooden, Darryl Strawberry, and Gary Carter, but we wanted to work with Kevin. This quiet and understated outfielder had had a great season in 1988 and was third in MVP voting. He hit for average and power and could run the bases as well. Although he was a star, he was a private person and didn't seem to like the spotlight, which wasn't something we often encountered in sports.

Kevin's muted personality made it a challenge for us. We wrote down words like quiet and silent. We thought about "Silent Killer," but his agent didn't like it. (We knew it was probably over the line, but we gave it a try anyway.) His agent told us Kevin liked duck hunting, so "Duckhead" made the funny list, as did "Silent but Deadly" and "The Mute Met." (When we got frustrated in the creative process, we'd go to the funny ones for a while for a break in the action and then go back to it.) It just wasn't easy to come up with something for a guy this quiet!

We owe the title we ended up with to Bill Pearson, our history teacher at West Seattle High School. Mr. Pearson was one of those teachers you appreciated in school and even more later in life because he made learning relevant and fun. His classes were funny and interesting, and he had an animated way of speaking to get the material across to his students. He particularly loved famous quotes and statements, and whenever he'd recite one, he would do it slowly and emphatically, stopping at the end for emphasis to let it sink in. One of his favorites, which he said a number of times, was a well-known motto of President Theodore Roosevelt: "Speak softly, and carry a big stick."

As we were coming up empty on ideas for Kevin, we talked about him being a player who didn't speak much but let his bat do the talking, and then Mr. Pearson's history class came back to us: "Speak softly, and carry a big stick." Perfect.

This one was shot near the Mets training facility in Florida. Kevin was the quiet country boy we had expected and was the most polite and well-mannered player we worked with. We loved the big stick he held in the shot. Our guys bought the wood at a lumber yard and whittled it themselves. His agents, Randy Grossman and Seth Levinson, came to the shoot, so we decided to put them in it—they're dressed in uniforms in the background. We loved the way this one turned out because it turned out even better than we had expected. Kevin looked great, the stick looked great, and we were very happy with the colors.

(And, Mr. Pearson, if you're reading this, it was Don Sweeney and one of us that taped the naked centerfold onto the film screen in room 301 and rolled it up. And it was Mr. Hard who let us in. He's a now a deacon in a church, so you can't really get mad at him!)

Kevin Mitchell

San Francisco Giants
1989 National League MVP

Kevin posed on top
of a prop roof that we
had built for the shoot.

The first contemporary *Batman* movie was coming out in the summer of 1989, and the anticipation for it had been growing since the previous Christmas, when movie theaters ran early previews for it. It's hard to describe to younger people the hype and excitement leading up to this during the pre-internet age, when we didn't have access to any information other than that Michael Keaton was going to be Batman and Jack Nicholson was going to be the Joker.

Jack Nicholson as the Joker? Everyone wanted to see this. It was one of the most anticipated movies of its time, and as soon as we found out it would be coming out a year later, we knew that someone would be on a poster called "Batman."

Kevin Mitchell of the San Francisco Giants was that guy. He was swinging the bat well, and we also thought he'd be able to pull this one off. It had to be the right guy. We made the deal and shot this poster months before the movie was released in June. He was having a great season and would end up winning the National League MVP while hitting 47 home runs and 125 RBIs. (Plus, he had made one of the coolest catches in the history of the game—you know what we're talking about.) This was another time when we lucked out and got the right guy at precisely the right time.

We went to San Francisco for this one and shot it in a studio. It was a pretty simple image, with the shot of Kevin and the background shot, then the Giants logo up in the sky, summoning Kevin. We had the low wall built for us, and we remember it being a lot more expensive than we had expected. But it worked well for the feel we were looking to get, and it was better than having him standing on the roof of a high-rise. We had planned to shoot Kevin without his helmet or a hat on, but the helmet seemed more in line with Batman and his mask, so we went with just that and the cape. And it just worked.

The first printing was as you see this one, with *Batman* as one word. In subsequent print runs, though, MLB wanted us to separate the words as "Bat Man" so that we didn't have trademark problems. Our trademark lawyer had worked on dozens of situations like this and assured us this was an obvious parody and there would be no likelihood of confusion. But MLB wanted us to change it and break it into two words.

This was one of the issues that was different after we had the league licenses. We were in good shape legally, but MLB has deep pockets, so they're more of a target and have to be especially conservative in the way they handle such things. We understood and broke it into two words for the subsequent printings, so if you find your old copy stashed in a corner of your basement and it reads "Batman" as one word, know that you've got a bit of a collector's item on your hands.

We enjoyed working with Kevin very much, and he worked with us again on a poster called "The Master Blaster" when he was traded to the Mariners for the 1992 season.

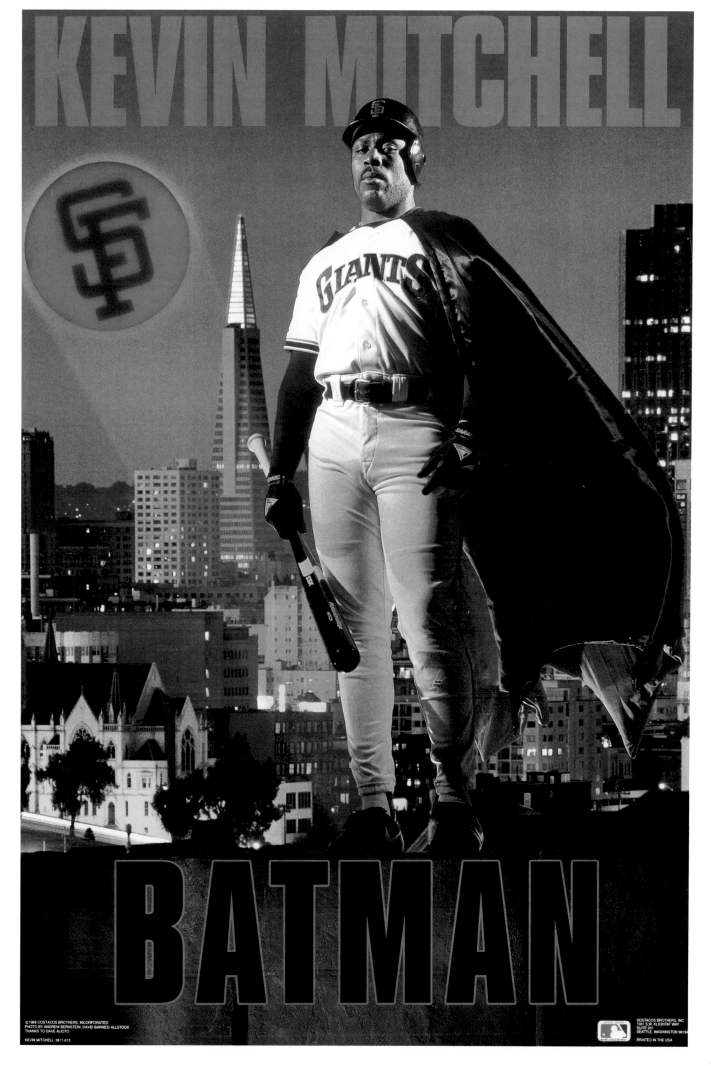

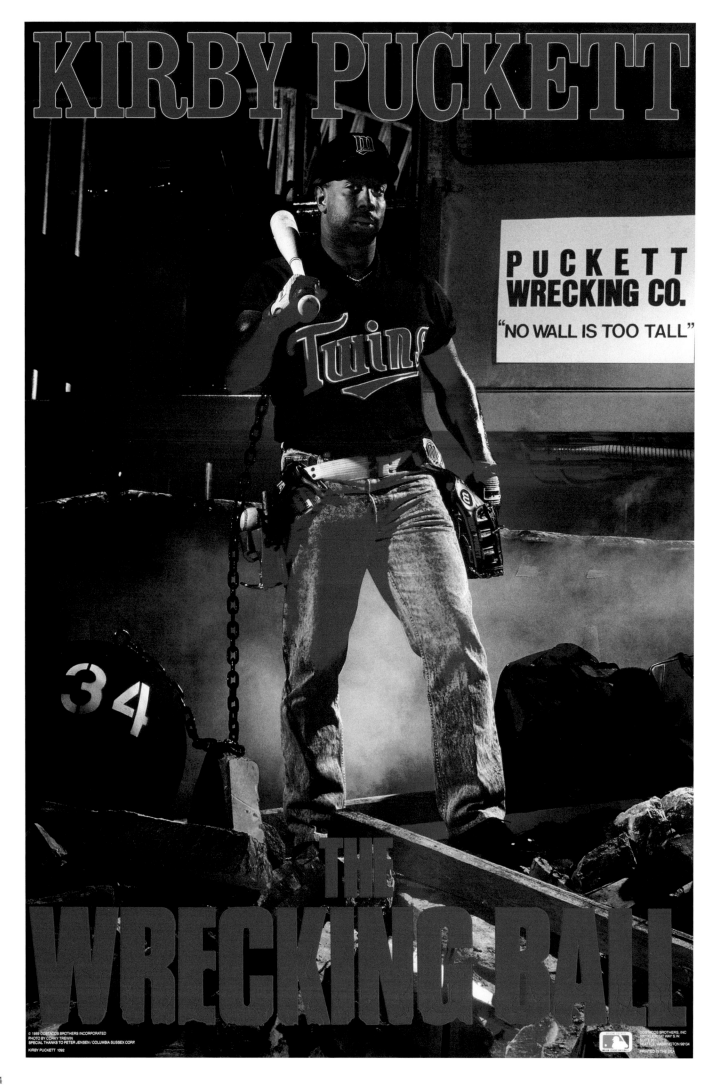

Kirby Puckett

Minnesota Twins
1989 AL Batting Champion

Here is the Kirby
that most people
recognized, with his
infectious smile.

The only words and phrases that rhyme with *Puckett* are *bucket*, "suck it," and . . . something we couldn't put on a kid's poster. Rhymes are where we started, and nothing worked. *Derby* rhymes with *Kirby*, which would have been fine if his team were the Kentucky Twins instead of the Minnesota Twins (Kentucky Kirby?).

Kirby was loved in the Twin Cities and, really, all throughout baseball. He had a likable personality and a warm smile. He was short for a baseball player, but he was strong and he could play. We shot this poster at the right time, because Kirby had won the American League batting title that year.

The name we settled on came from our production head, Tom Rees. We had gone through our normal progression of rhymes, phrases, wordplay, movie titles, his initials, his number, and the team name. (We considered "Twinner," which would have been appropriate, considering his team had just won the 1987 World Series, but we didn't feel it was strong enough.) Like we often do, we then took to tossing out words to describe him, and Tom said, "The guy's just . . . just . . . he's a wrecking ball. He's a *wrecking ball*." Kirby stood just 5-foot-8, but he was powerful and stocky, and he had just hit 28 home runs while leading the league in hits while finishing third in MVP votes. We all agreed immediately, and that was what we pitched to him. And Kirby loved it.

We shot this one on Kirby's birthday, March 14. He had just signed a big, new $3 million dollar annual contract, which was a record at that time, making him the highest-paid player in baseball. We kicked around ideas on what we would do visually for a "Wrecking Ball" title, and we decided on Kirby with a demolition theme. Wrecking balls are found on construction sites, so we went to the Twin Cities to look for one. We found a lot of building sites, but we needed one with a lot of demolition already going on, so it would look like he had done all the damage.

We found one in town but didn't know who to ask for permission— so we didn't. There were no signs of any kind that indicated who we should call. We figured if anybody complained, as soon as they saw it was Kirby, they would be OK with it—the guy was just so beloved in Minneapolis. Having found a location, we got some props, had some signs made, and of course brought in a fog machine.

Tom still says to this day that Kirby Puckett was the single nicest person he has ever met. Kirby was humble and kind and gentle, and we found him to be an amazing guy to be around. He arrived with his wife and her parents. We always encouraged the players to bring their family members, because it gave the shoots more of a comfortable family atmosphere, and we genuinely liked meeting their families. And Kirby's family were extremely nice.

We shot some with him smiling and some with a serious face. All the shots with Kirby smiling looked great. It was harder to find a good serious shot because Kirby was so enthusiastic, and looking serious just didn't come naturally to him. His presence and personality made for a warm atmosphere the whole evening.

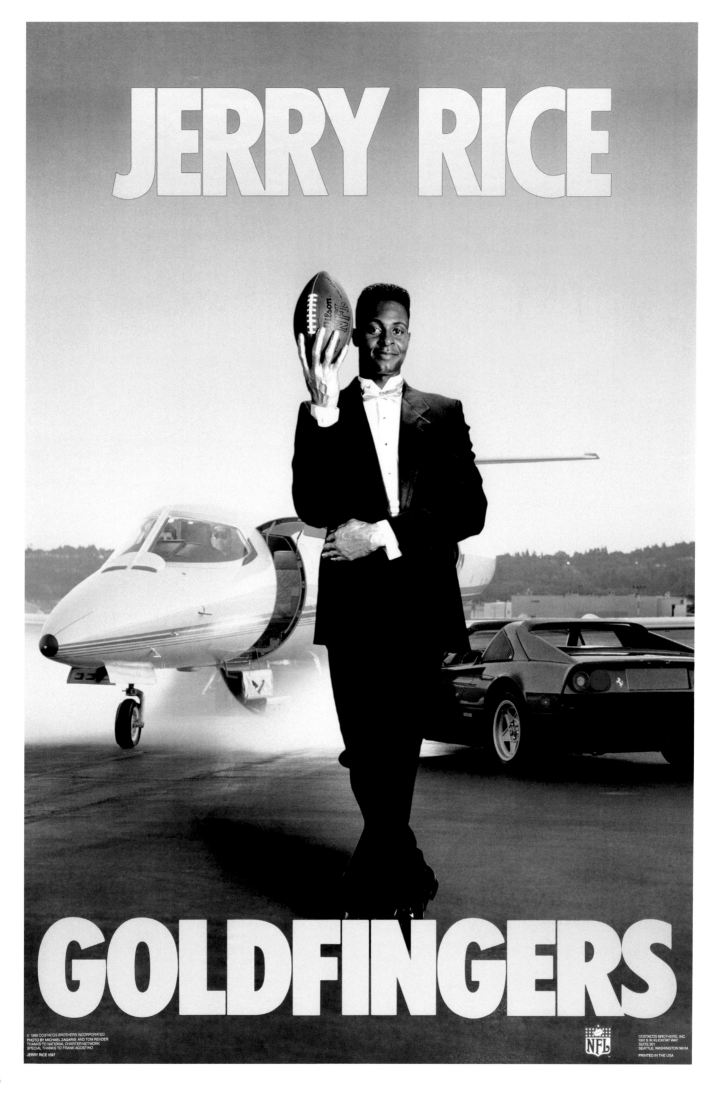

Jerry Rice

San Francisco 49ers
NFL 1980s All-Decade Team

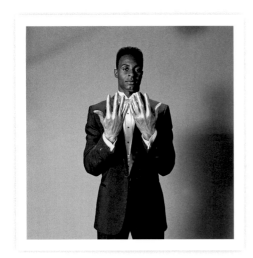

Jerry's hands were really worth their weight in gold to the San Francisco 49ers.

Ⓦe didn't just want Jerry—we needed him. We were getting to the point where we felt we were letting the kids down if we didn't get them the posters they were asking for. Requests for a Jerry poster were coming every day from customers, and tons of fan mail about him as well. It didn't hurt that he had set Super Bowl records for receptions and receiving yards the previous season.

Anybody who knows football knows his name, and any discussion of who was the greatest receiver ever has his name in it. He broke and set numerous records, and the Joe Montana–to–Jerry Rice connection was flat-out dangerous for their opponents. The San Francisco Bay Area continued to be a great market for us with our Joe Montana, Ronnie Lott, and Bash Brothers posters, and even though the Raiders were in Los Angeles at that time, the Lester Hayes and Howie Long posters were still selling well in the Bay Area due to the Raiders history in Oakland.

We loved James Bond movies, and when one of us said, "Goldfingers," there was nothing left to say. We didn't need another idea. That's what we wanted to do for Jerry. It fit perfectly, and we thought he would be very cool as a Jerry James Bond. Plus, we had high hopes for the gold hands.

We shot Jerry in a studio in San Francisco. We had always preferred to shoot on location rather than in a studio, because it was the most fun and the most real. But there were too many things that could go wrong, especially with weather. And studios were usually more convenient for the athletes, many of whom had to work around busy schedules to make time for us.

We found gold makeup for his hands and tested it on ourselves just to make sure we knew how it worked. We didn't think Jerry would be happy if the stuff didn't come off. We also needed to know if it was going to stick to the footballs or could easily come off on his fancy clothing.

Jerry was really comfortable with photographer Michael Zagaris. Actually, everybody's comfortable around Michael. He's just plain fun, and, having been the photographer for the 49ers and the Oakland A's for many years, he understands athletes very well. It helped that Jerry has an upbeat personality and was up for whatever we wanted to try. It was always fun getting athletes to understand what we were going for and seeing them get comfortable in the character we wanted them to portray.

We shot the background in Seattle near a hangar at Boeing Field. Our friend Frank Agostino let us use his Ferrari in the shoot, so we put him in the cockpit of the plane, and one of us is in there with him. We'd originally wanted a night background, but we liked the lighter near-dusk look. Also, we printed with a fifth color, which we always had to do with either silver or gold in the color scheme.

The gold on Jerry's hands looked great—we printed with a metallic ink to make sure of that—and so did he. A lot of posters ran their course in one or two seasons, but this one kept going because every year, Jerry kept breaking records. We thought about doing another with Jerry, but we felt that this one was so perfect for him that we couldn't have topped it.

Cory Snyder

Cleveland Indians
308 Putouts in 1988

Production guy Scott
Figueroa laying down
fog. We shot two
options, one with this
outfield wall and one
with the Western town.

ory Snyder could throw. He was known as a five-tool player, with the ability to play just about anywhere in the field. But he was especially known to have a cannon of an arm, and he was the regular right fielder for the Cleveland Indians when we shot this one. We had a good relationship with Cory's agent and started a dialogue with him about working together. We played with ideas having to do with his number, his name, the team colors, and everything else that we always did, but we came up empty.

When we got stuck for ideas, we always remained patient. We knew a good idea was right around the corner. We kept working and researching over a few weeks and finally got our break when the Indians were on television. Cory threw a guy out at home with a perfect throw from the outfield, and the announcer said, "He smoked that one."

That line prompted us to think that a take on the iconic television western Gunsmoke would be cool. His agent agreed. We shot it in Arizona during spring training, which was always great for us, even if just for the weather. After a typical rainy Seattle winter, we would have shot posters of anyone just to get in the sun.

We found an old western-style town that was often used for television and movie shoots and arranged to do it there. The costume was easy, and we didn't have much work to do on the set except put a "Wanted" poster up on the wall. Because we weren't in Seattle, we didn't have to worry about bad weather. In Arizona, you can generally count on blue skies, especially at that time of year.

The shoot went smoothly, except for a little wind messing with the smoke. It was a little windier than we would have liked, and we didn't quite get the effect of the smoke we had envisioned. Cory was a pleasure to work with, though, and he didn't have any problem playing cowboy for us. We hung a baseball glove from his belt, like it was a gunslinger's holster, and instead of bullets in the belt's loops, we had little baseballs. In the background, there's a base runner who had just gotten thrown out at home by Cory's "lethal" arm. Pretty cool.

Something else good happened that day—we met photographer Andy Bernstein. You might not know it, but you've see his photos everywhere. At the time, he was the team photographer for the Dodgers and the Lakers. We instantly got along so well that we knew we'd be friends for life. We got a poster we liked, we met a great guy in Cory, and we made a new friend in Andy.

Years later, when Cory signed with the Dodgers, he remembered that our dad was a big Dodgers fan, so he invited us to bring him down for a game. One of our godfathers was a big Dodgers fan, too, so we all flew down to Los Angeles and they got to go on the field and meet Cory and legendary Dodgers manager Tommy Lasorda before the game at Dodger Stadium. That was a happy day for the two lifelong Dodgers fans.

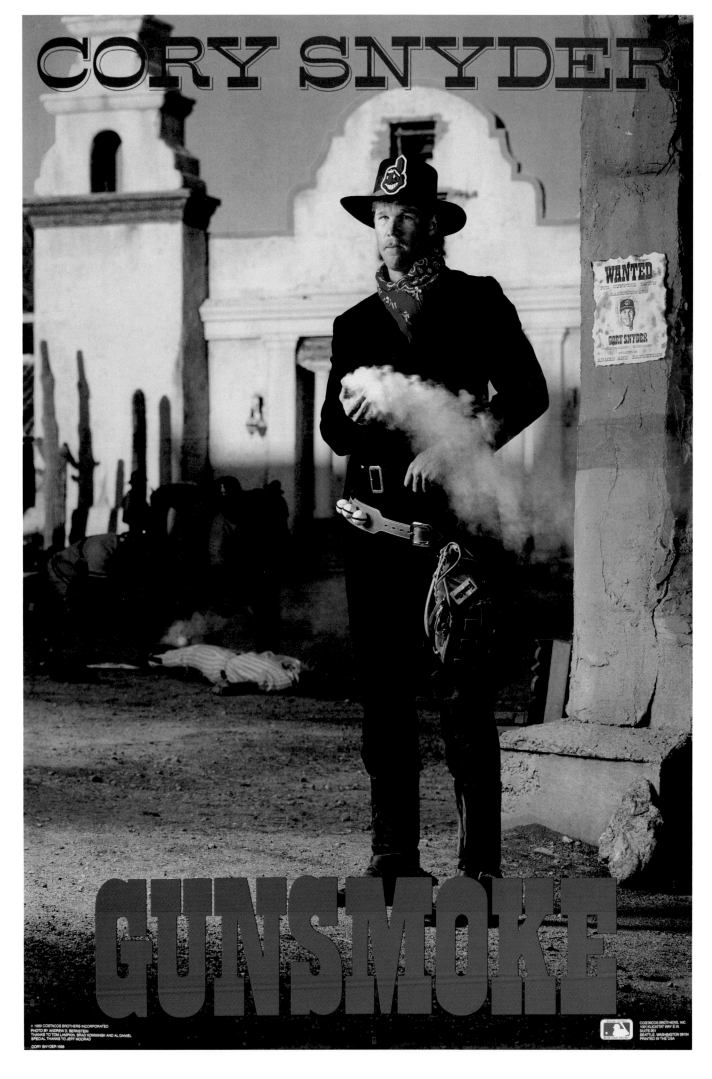

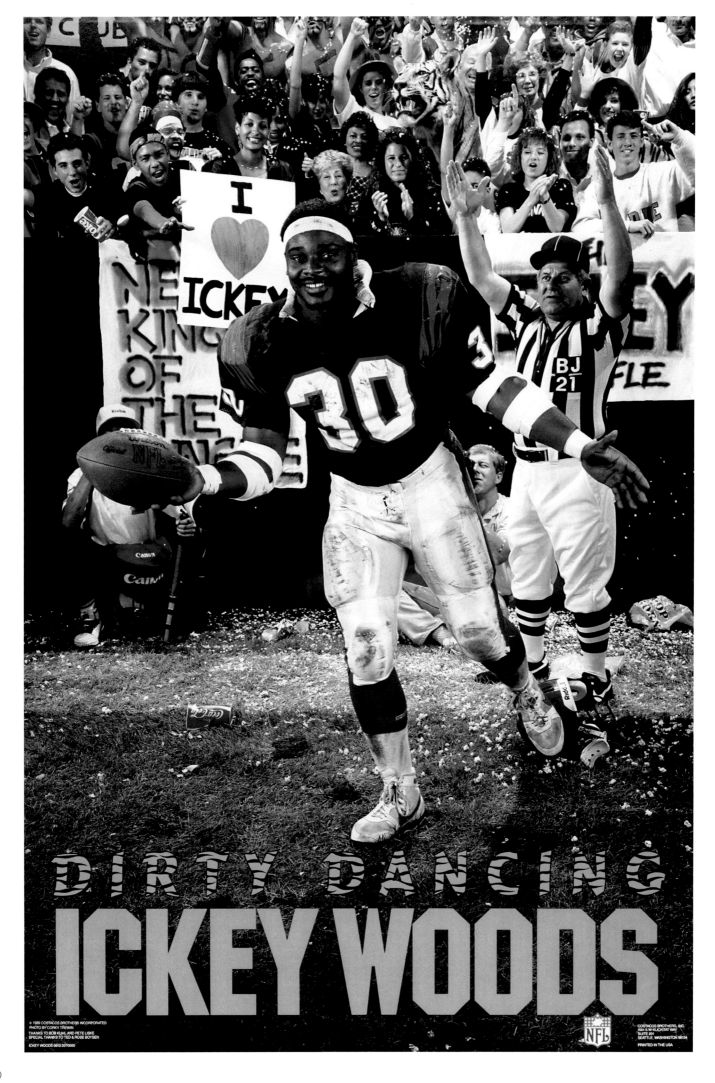

Ickey Woods

Cincinatti Bengals
1988 AFC Rushing Touchdowns Leader

(top) Our dad poses with Ickey for a quick photo.

(above) Some of our extras (and the stuffed Bengal tiger) with Ickey.

Ickey rushed for over 1,000 yards during his 1988 rookie season with the Cincinnati Bengals and helped lead them to Super Bowl XXIII, but it was the "Ickey Shuffle" dance he did in the end zone that became a national sensation. It was one of those things that couldn't be planned: His little celebratory post-touchdown dance captivated fans across the country. Even we weren't immune—we held an annual company Super Bowl party, and that year, we held an Ickey Shuffle contest at halftime (which surprisingly, was won hands down by our local KOMO-4 sports anchor, Rick Meeder).

Anything we did with Ickey had to be about the shuffle, but we couldn't come up with any phrases that worked with *shuffle,* so we focused on *dance* and *dancing,* and we decided on "Dirty Dancing," after the 1987 hit movie with that title featuring Patrick Swayze.

This was the largest set we ever built, and the poster had more going on in it than any other we made. We rented bleachers and built the wall and signs, and we brought in real grass and spray-painted it to look like an end zone. That wasn't enough, though, so we added popcorn, peanuts, and a Coca-Cola cup to make it look like a real game was going on.

We dressed our dad up as the official—his second appearance in a poster, and we got Mom in this one, too. (She's in the crowd, directly above Ickey's head.) The woman holding the "I ♥ Ickey" sign was Ickey's wife. She came with him to Seattle for the shoot, so we made the sign on the spot and put her in the front row. The rest of the fans were a mix of our employees, friends, family members, and neighbors. Near the middle at the top was a real (stuffed) Bengal tiger that belonged to one of our dad's childhood friends, a big-game hunter. We didn't think twice about including a real mounted animal at the time, but we definitely would today.

Our local KING-5 television station sent a reporter and a camera crew to do a story on the shoot, so we added their cameraman in the shot, like he was filming the game. (He's sitting on the ground between Ickey and our dad.) We just kept throwing everyone and everything in. Photographer Corky Trewin felt it needed a photographer in the end zone, and since he was taking the photos, we gave some of Corky's gear to Jason Louie, a designer in our art department, and threw him in. (Unfortunately, his face was covered with the ball in the shot we chose—but it's him, we swear).

Ickey got dressed and we dirtied him up, which we always like to do. We took a few test shots of him standing still, and then he did the dance for us, which lit up the room. There was just something extra fun about seeing him do that famous dance right in front of us. He has a great face and a genuine smile and was having fun. He didn't even seem to mind that we made him do the Ickey Shuffle over and over.

Injuries shortened his career after that amazing rookie season, but we're happy to have captured this fun piece of football nostalgia—and to have finally gotten our mom in a poster. She still reminds us that our dad was in two.

More from the Archives

Cory Snyder is 6-foot-4, which made him look great in the long duster from this alternate photo shoot.

(l to r) Our dad, godfather George Prekeges, John, and Cory Snyder at a Dodgers game after Cory signed with the Dodgers in 1993—he remembered our dad was a big Dodgers fan years after we shot his poster.

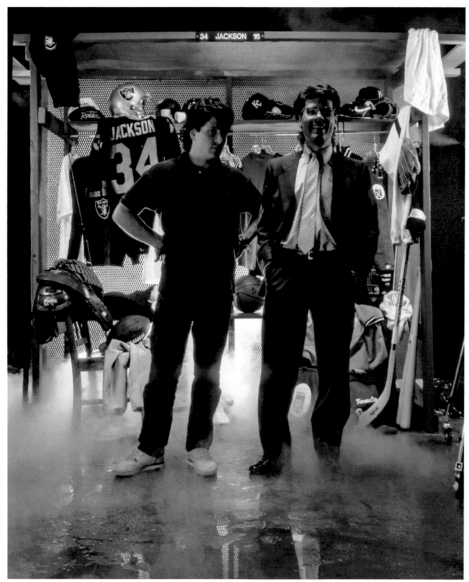

We built this locker in our warehouse, with a few hidden bits like a basketball and hockey stick. Maybe we should've added track and field gear, too—Bo was a two-time state decathlon champion in high school.

Would this version with only Patrick Ewing and not the dogs have been too plain for the poster?

With a league-leading 47 home runs during the 1989 season, Kevin Mitchell was perfect as Batman.

After the "Jim McMahon and the Last Rebellion" photo shoot, Jim McMahon posed with our entire staff wearing his trademark sunglasses and headbands with nicknames and messages written on them.

Jim does a pretty good impression of the iconic idol-swapping scene from the film *Raiders of the Lost Ark*.

Here's Ickey, his wife Chandra, and the Bengal tiger from the background of the "Dirty Dancing" poster.

Like all shirtless guys in a crowd, our friends were compelled to flex even next to an amazing physical specimen like Ickey.

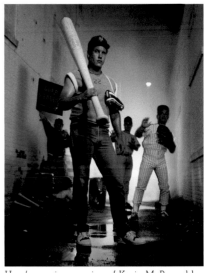

Here's a serious version of Kevin McReynolds holding our giant prop baseball bat.

Photographer Corky Trewin could almost pass for Jim, or at least pass as Jim as Indiana Jones.

Kirby Puckett's wife Tonya accompanied him to our unauthorized photo set for "Wrecking Ball."

Jerry Rice's hands are *huge*, and it's no wonder he's considered the best wide receiver in NFL history.

153

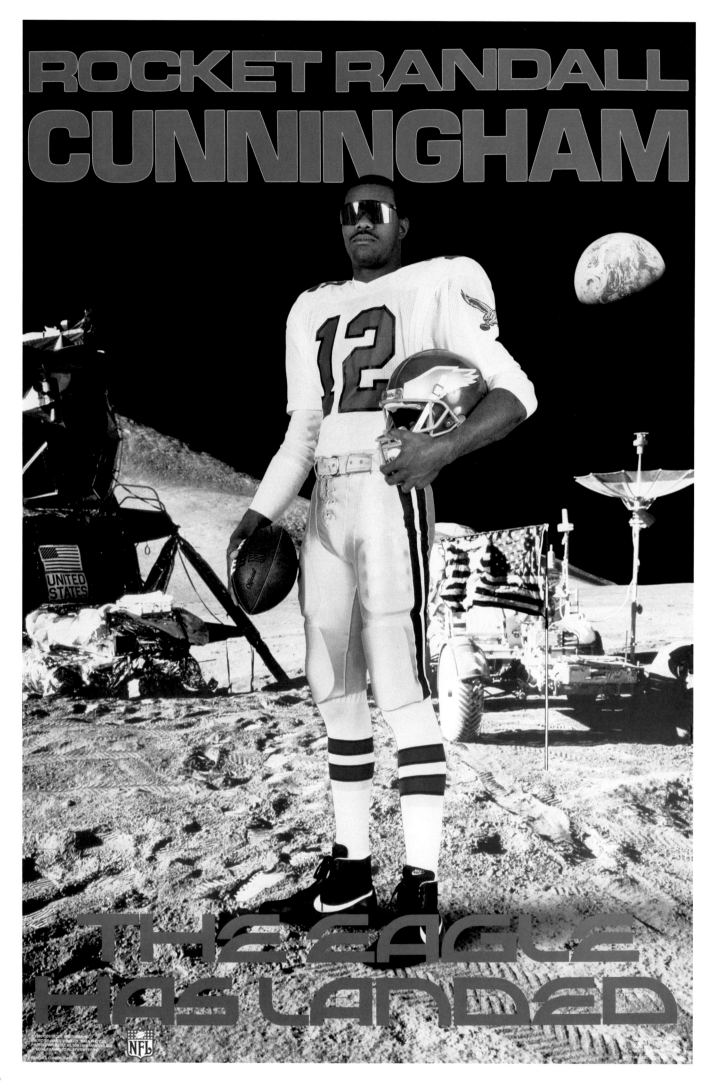

Randall Cunningham

Philadelphia Eagles
1989 NFL Pro Bowl

Randall giving us his
quarterback version of
the Heisman pose.

The University of Nevada, Las Vegas, was known for its basketball team—it's the school where Armen Gilliam, Freddie Banks, Sidney Green, and Reggie Theus played. We never saw their football team on TV. But in 1984, we saw highlights of Rebels quarterback Randall Cunningham. We'd seen more of his older brother, Sam "Bam" Cunningham, who had starred at running back for USC when we were kids, just because he went to a big-time football school. And now here was Randall, making incredible plays for this basketball school in Las Vegas.

Once he was drafted by the Philadelphia Eagles in 1985, the country started to see what he could do. He could run, and he was *fast*. Randall had a unique arm motion and could throw the ball a mile. He was one of the first quarterbacks who could beat defenses with his arm and his legs, and he was named to the 1988 All-Pro Second Team. (And he could punt, too!) We liked that he came from a school not known for its football team and then lit things up in the NFL. He was exciting to watch and dangerous for defenses.

But as amazing as he looked on the television highlights, Randall seemed like a regular guy in person. In fact, he stood out because he didn't stand out. When we spent time with him during Pro Bowl week, he didn't seem like a professional athlete to us. He could have been one of our buddies that came on the trip with us. That's how down-to-earth he was.

Our distribution in Philadelphia was getting better, thanks to our having Charles Barkley of the 76ers and Reggie White of the Eagles on posters in that market. We told Randall we were going to make a poster with him whether he liked it or not. He laughed and said, "I'm already in. What do you wanna do?"

We had several ideas: "Where Eagles Dare," "The Eagle Has Landed," "Wings," "Bold Eagle," "Just Wing It" (we're sure Nike would have loved that), and "The Philadelphia Flyer" (red alert—trademark issues). We went through each one and kicked around ideas about what we'd do visually. We liked the lunar-landing one visually because it was different, and we liked that "The eagle has landed" was a well-known quote from Neil Armstrong at the moment of the first moon landing, because Randall had landed in Philadelphia and made such an exciting impact.

We shot this poster at the Pro Bowl in Hawaii, a time when we had a whole week to schedule shoots for the players there. That was a real luxury, but we weren't able to schedule the players until we got there because even the players didn't know their schedules until then. It was usually hectic, but Randall was willing to work in whatever was best for us. For others, that wasn't the case. Some guys golfed 36 holes after practice. Others went sightseeing. Others went partying. We were lucky that we left at the end of the week having completed every photo session we had planned.

Randall was all cool on the set—cool in his pictures and cool to everyone there. It was another one of those sessions where it felt like we were hanging out with a friend instead of shooting a poster. And his Eagles helmet looked really cool in person. A lot cooler than most of the others (to us, anyway).

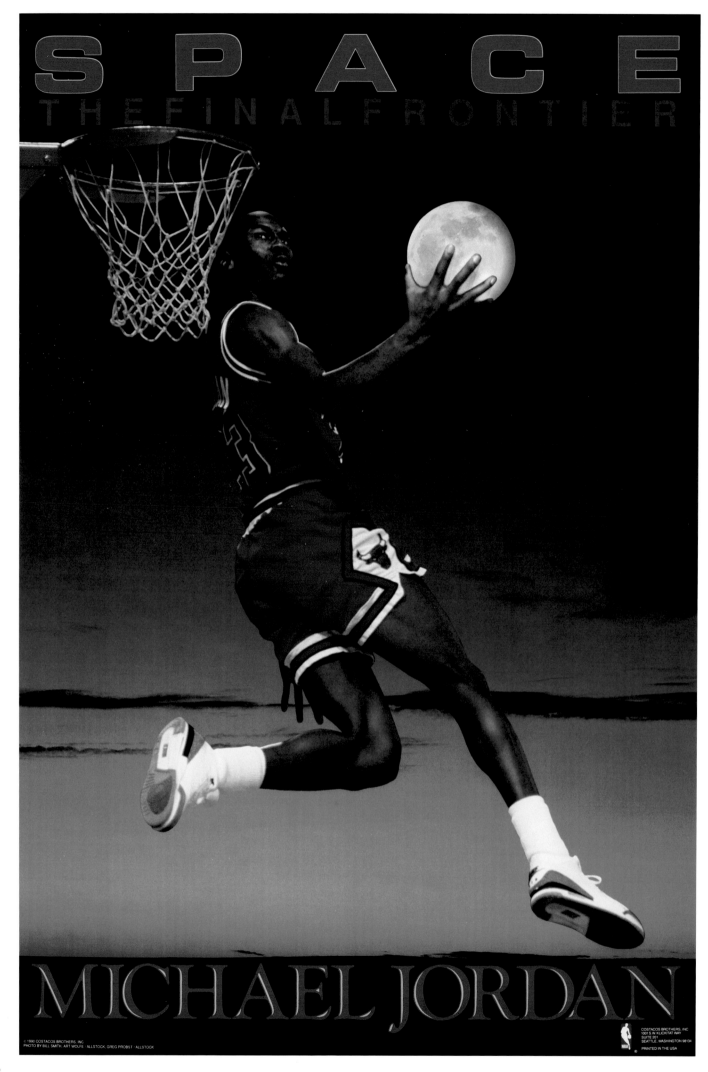

Michael Jordan

Chicago Bulls
1988–89 NBA Scoring Champion

We have Nike to thank for this one, our all-time best-selling poster. To be honest, if we could have had ten posters of Michael, they would have been our number top ten best-sellers, and eleventh place wouldn't be close. He was so popular that everyone wanted a poster of him on their walls, and this one flew off the shelves. The unfortunate aspect of it was that Michael didn't get any of the royalties for this poster, even though that was our original plan.

Our Jordan door posters were selling very well, but we badly wanted to get him in the studio. We finally made a deal with his agent for three posters, all to be shot in a 60-minute window at a studio he could walk into right after practice. It would've been challenging, but we knew how to work fast and still get the job done. The titles were "Space: The Final Frontier" a phrase from the voice-over opening of *Star Trek*, "Let There Be Flight . . .," and "The Great Chicago Flyer." But Nike nixed the deal.

Because of Nike's extensive relationship with Michael, they had some say over what his other endorsement deals could be. We didn't understand why they had blocked our poster agreement, though, so we drove down to Nike to talk with them about it. We had a relationship with a number of people at Nike dating back to our first year making posters, when a man named Harry Johnson had called us. He worked for Nike and wanted to talk with us about making their posters for them, since the great Peter Moore had left the company. (Peter, who had been Nike's creative director, designed the original Air Jordans and the Jumpman logo, and he's our hero because he made all their greatest posters, too.)

A year later, we got a letter in which Nike threatened to sue us over our Charles Barkley "Get Off My Backboard" poster because it interfered with their contract with him. We told Charles about the letter, and he took care of it. After that, we thought we had developed a good relationship, and we would even request Nike product for the shoots we had with their athletes so they would appear in Nike's gear. We even sent storyboards and descriptions to Nike so they would be OK with the posters their product was going into, and there had never been a complaint.

So, we drove to Nike and met with them about our Michael Jordan deal, and it soon became clear that they were saying no without a justifiable reason. At first, they said it's because of image. We told them they could approve the concept and final artwork, and they still said no. We asked why, and they couldn't give an answer. Finally, we said, "Look, we drove three hours down here. Why don't you man up and tell us the truth."

After looking at each other for a few seconds, one of them said, "Well, frankly, we haven't been able to get Michael for some shoots that we need to do, and there are some people here who are pretty upset that he agreed to do it for you guys." We explained it was because we had only one hour of his time—which was unusually tight for a photo shoot—and suggested that they tell Michael's

people he could do our shoot only after he'd completed the Nike shoots with their guys.

They still said no, because any time he spent with us was time he wouldn't spend for them. It was clear that they were flexing their Nike muscles because they could. One of them leaned back in his chair with a cocky look on his face and said, "Hey, if you can find a way to shoot a poster of Michael without taking any of his time, be my guest." He wasn't saying it to be helpful.

We already knew what our next step would be. After we drove home, our first call was to our NBA licensing manager to request that the league add player rights to our license. This would mean we could use photos of any player during games and it would be all part of a combined NBA and NBA Players Association license.

The benefits to us were that every player's photo would be covered by our license so we didn't have to do contracts with individual players, and using preshot photography would cost us only about twenty percent of what we spent on original photo shoots because we didn't have to travel, rent equipment, create costumes, and build sets. It also meant we could produce new titles much faster because instead of spending weeks organizing an elaborate shoot and all the related logistics, we could just get slides FedEx'd to us.

The only downside was that the royalty money wouldn't be going directly to the players, and we liked sending them checks. Instead of an athlete getting revenue from their poster, their share would instead go to the NBA and the NBA Players Association. For the athletes, poster money wasn't much compared to what they made on other marketing deals, and most of them sent the royalties to the various charities they supported, but we liked sending them the checks because their image had earned it.

So, under the new license, we made this poster, which sold 1.2 million copies. And, thanks to the guys at Nike, all the royalty money went to the NBA and the NBA Players Association instead of toMichael. (We later told another Nike athlete the story, and when we told him who Mr. Cocky was, he said, "A bunch of us got that guy fired! We all hated him.")

This new NBA license turned out to be great for us in many ways. We sometimes called the NBA "the ballet" because to us, it was this beautiful, high-flying, violent ballet with motion, speed, 3-pointers, lobs, and crazy dunks, and we got to use players captured while they did all these things. Although these posters were not as fun to produce as those we shot in the studios, many of our favorite and best-selling posters were made under the new license. And we still got the three titles we wanted for Michael.

Two years after the poster came out, we had a chat with Michael and Charles Barkley in San Diego when they were there with the Dream Team. After we shared the story with Michael, he smiled, nodded, and said, "Yeah, that figures. I like the poster, though. Good job."

Bernie Kosar

Cleveland Browns
1989 Pro Bowl

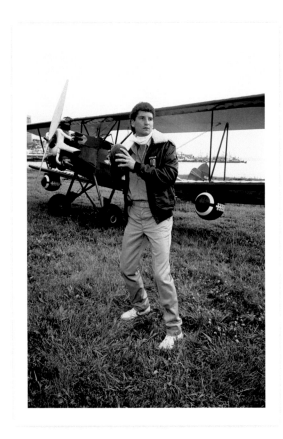

(above) Bernie looked good in our unpublished "Browns Bomber" poster, but the rest of the shot was just OK.

(below) Here's the hand-drawn lettering we used to develop the poster typography.

We first saw Bernie Kosar when he was at the University of Miami. As a freshman quarterback, he led the Hurricanes to the NCAA championship with a victory in the Orange Bowl. A year later, in a game against Boston College, when the Hurricanes and the Eagles were trading leads, Miami called a timeout with 30 seconds left and the ball on Boston's 2-yard line. The Miami coaches were talking about what play to run, and we saw Bernie caught on camera disagreeing with his coaches. "Let's play f*@%ing football!" he yelled right in the coach's face. "Let's run it right the f*@% at 'em!" We loved this guy!

(Miami did run it into the end zone and took the lead—until four plays later, when Doug Flutie threw his famous "Hail Flutie" pass to win the game for Boston. But we remembered Bernie's attitude.)

He signed with the Cleveland Browns in 1985, and the next year, he finished second in the league for passes completed while piling up 3,854 yards and orchestrated a league-leading six game-winning drives. Bernie also led the Browns to the playoffs in each of his first five seasons there.

We met Bernie at the Pro Bowl and found out we had something in common: We liked a lot of the same comedians, and we spent a lot of time recalling their routines and lines. He was open to whatever concepts we had, so we talked about different ideas. We wanted to call it "The Browns Bomber," a variation of the "Brown Bomber" nickname for heavyweight champion Joe Louis.

He liked the concept, so we made arrangements and flew out to Cleveland and shot it out on a grass airfield. Bernie was the pilot, wearing a bomber jacket, and he stood in front of a biplane with two giant football bombs suspended under each wing.

Bernie looked fine, but the plane and the background just didn't look good enough. We hated that we had to do it again, but it was better than putting into the market something we really didn't like. So, we ate the cost of the shoot (and Bernie's time, the thing we felt really bad about), and went back for another shoot.

We don't remember why we changed the title to "Air Raid." We know there was a specific reason but aren't certain about what happened. It may have been because we now had the NFL license and they had a problem with "The Browns Bomber," although that would seem weird given they were OK with "Air Raid."

What we do remember is that we got the flight suit in an army surplus store, and for some reason they had it in orange, one of the Browns's team colors. We considered spray-painting it brown but decided to stay with orange because we liked the brighter color. We customized the flight suit for Bernie, adding the patch with the dog and bone, which was a nod to the defense and the end zone superfans, affectionately known, respectively, as the Dawgs and the Dawg Pound.

The background photo of the jet was shot by John Bennet, the photographer for the US Navy's famous Blue Angels flight demonstration squadron for a number of years. Looking at this flight suit from today's perspective, doesn't it look a little like a prison costume from *Orange Is the New Black*?

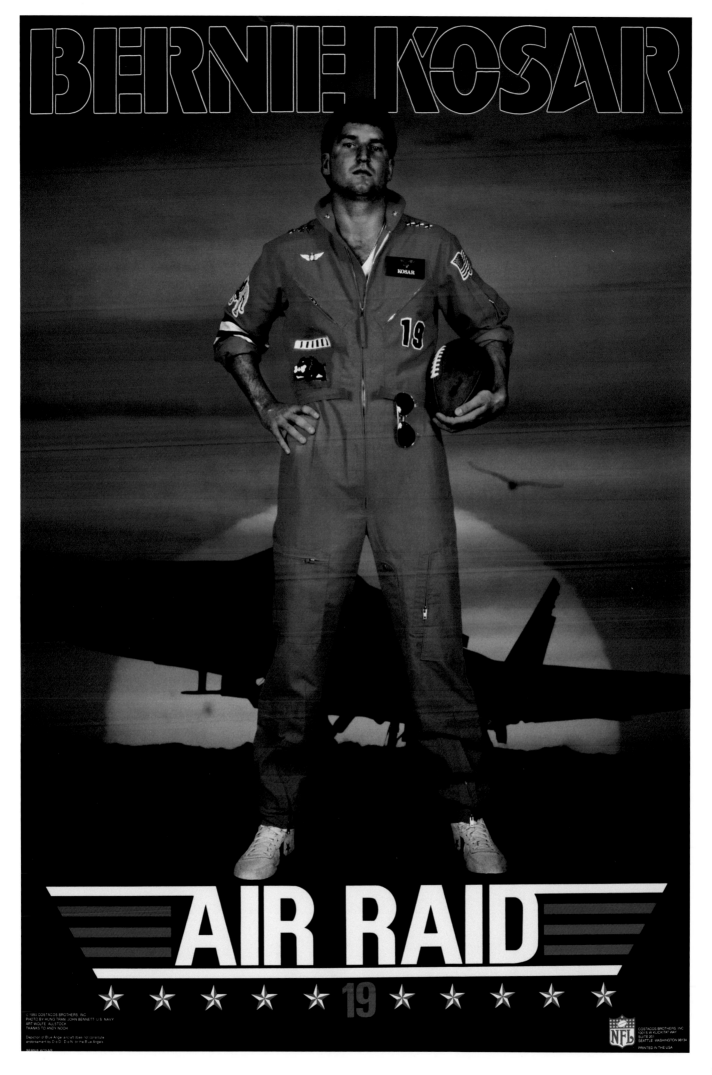

Don Majkowski

Green Bay Packers
1989 NFL Passing Yards Leader

We started doing more game-action posters, including this 1990 poster of Dan Marino, who had just finished second in completions to Don in 1989.

We badly wanted to do something with a Green Bay Packers player because, well, they're the Green Bay Packers. We were fortunate enough to work with their great cornerback Mark Lee on the "General Lee" poster back in 1987, but we wanted more. That opportunity came when a 10th-round pick became the Packers starting quarterback in 1989.

Don was a late-round pick in the 1987 NFL Draft out of Virginia University, a school better known for its basketball team than its football program. But in his first year as Virginia's starter, Don led the team to its first bowl game, a 27-24 win in the 1984 Peach Bowl against a Purdue team quarterbacked by future No. 3 overall draft pick Jim Everett.

During his first two seasons, Don split time with veteran quarterback Randy Wright. When he assumed the role of the featured quarterback in 1989, he shockingly led the NFL in passing with 4,318 yards. They called him "the Majik Man," and that sounded good to us for a quarterback. Once in a while, it was nice not to have to come up with the poster title.

We made the deal, flew to Milwaukee, and took the long drive to Green Bay. The photographer was John Biever, whose father, Vern, had been the Packers's team photographer. John had been a 16-year-old teenager working with his father and was in the end zone with him when Vern photographed Green Bay's Hall of Famer Bart Starr score the winning play in the famous 1967 Ice Bowl at Lambeau Field.

We had never seen footage of the Ice Bowl but had read about it. It was the stuff of legend—played in minus-15-degree weather for the NFL Championship. Just talking to a guy who was there was great. From when we were kids, we had read about legendary players and teams and moments. The stories made them bigger than life. We weren't able to see footage of them because it was a few decades before the internet, and that made it all more mystical.

We thought if we were going to call him "Majik Man," we might as well embrace it and dress him as a magician. We had bought a black tuxedo in Green Bay and made it look distressed, and after Don tried the tux on to make sure it fit, we had him take it off so we could rip and beat it up some more. We got a little help from the scoreboard operator (there was no Jumbotron in those days), sprayed some fog into the background, and levitated the football with a piece of string.

Walking into Lambeau Field was very cool, but walking from the Packers's locker room, through the tunnel, and onto Lambeau Field was even better! We asked John to show us where the winning play at the Ice Bowl had happened. He said, "I'll show you the exact spot" and walked us right over to it. "Right here," he said, and he pointed to a spot on the ground, and we said, "Can we shoot it here?" He smiled and nodded because he understood. And that's where we shot it.

(The story didn't quite stop there. After we'd driven all the way back to Milwaukee, Tom Rees, our production head, realized he'd left his wallet at the tuxedo store in Green Bay. He had to drive another two hours each way pick it up.)

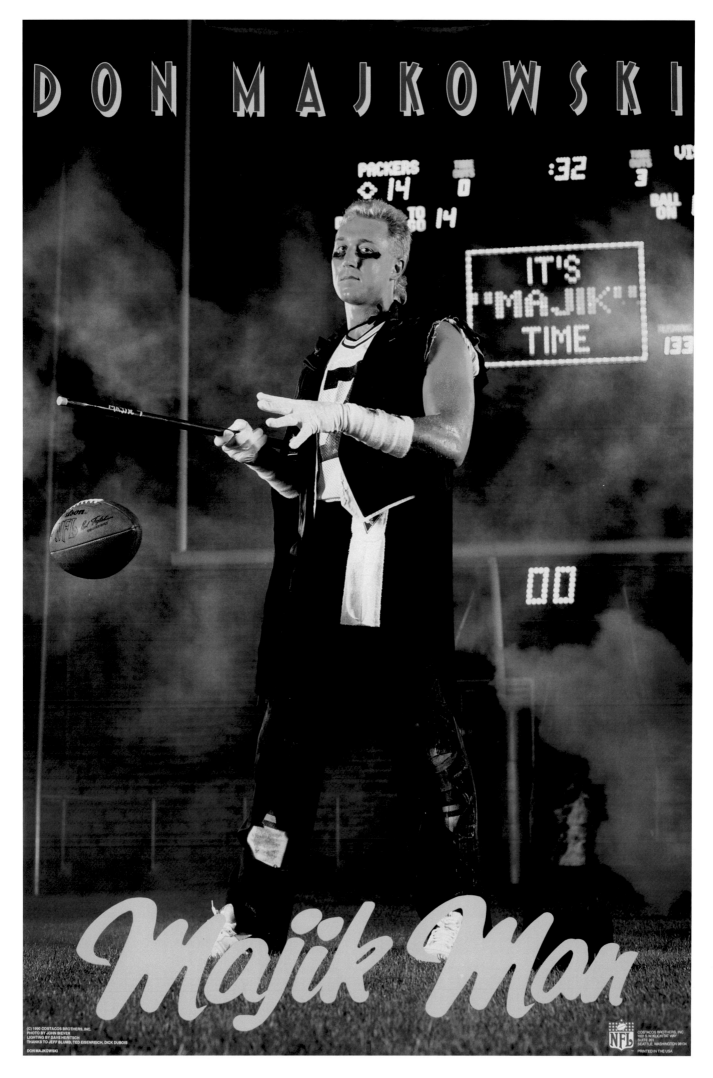

Warren Moon

Houston Oilers
1990 Pro Bowl

(top) John demonstrates his picture-(im)perfect form while Warren shows why he's not a two-way player.

(above) Warren winging a pass inside the hotel.

We loved having a chance to work with Warren. He was a big hero in Seattle because he had played for our Washington Huskies. When we were teenagers, he led the Huskies to the conference championship and their first Rose Bowl in over 15 years, resulting in a victory over a heavily favored Michigan team.

After college, he became a huge star for the Edmonton Eskimos of the Canadian Football League. Warren won the Grey Cup MVP award in 1980 and 1982 and passed for a record 5,648 yards and won the CFL's Most Outstanding Player award in 1983. When he came to Houston in 1984, he threw for a franchise-record 3,338 yards and continued to hit pass after pass, year after year.

When we thought about poster themes, we focused on his last name, since moon was such an everyday word. Some ideas included "Moonshine," "Moon Man," and "Blue Moon," which was appropriate because blue is one of the Oilers colors. There was also "Shoot the Moon," "Full Moon," and many others. We liked the idea of a moon in the shot and thought we would fill up as much of the background as we could with one. The question was what to call the poster, and the top two themes we liked were "Moonlighting" and "Moonshine." We nixed "Moonshine," though, because it refers to alcohol, and we didn't think we could get that through the NFL approval process.

We had met Warren a few times before, but it was at the Pro Bowls that we really got to know him because of the casual atmosphere—we just hung out on the beach with him. This Pro Bowl was on February 2, 1990, the second of nine times he would be voted into the game. He was very warm to us (maybe a Huskies thing?) and super helpful by introducing us to other Pro Bowlers, who would come by to talk with him. (Our favorite was Emmitt Smith, who recognized our names and said, "Costacos? Costacos *Brothers*? I love your stuff! We gotta do something." We met a lot of the guys that way.)

We shot "Moonlighting" along with about ten other posters that week. We had a studio set up in the hotel and shot against a backdrop so we could add the background later. Shots like this were especially nice because the players had their real uniforms, so we knew they'd fit. All we had to do was focus on the player. With Warren, it didn't feel as much like a photo shoot as it was just having fun and shooting some pictures with your friends. We knew that his real name was Harold Warren Moon, so we called him Harold the entire time just to make him laugh.

Back home, when we shot the background photo with the blue fog on the grass, it came out with a nice, misty look. Blue light through fog looked really good on a number of posters we did. We went big with the moon in the background as planned, and when we saw it in small format during postproduction, it looked great. After it printed and came into the warehouse, we saw it full size with the giant moon behind him and liked it even more.

This was the right year to get Warren on a poster, as he was at the height of his career. Although we shot his photo in February 1990, the designed, printed posters released in the fall in time for the next season, when Warren led the NFL in passing yards and passing touchdowns and was named the AFC Player of the Year.

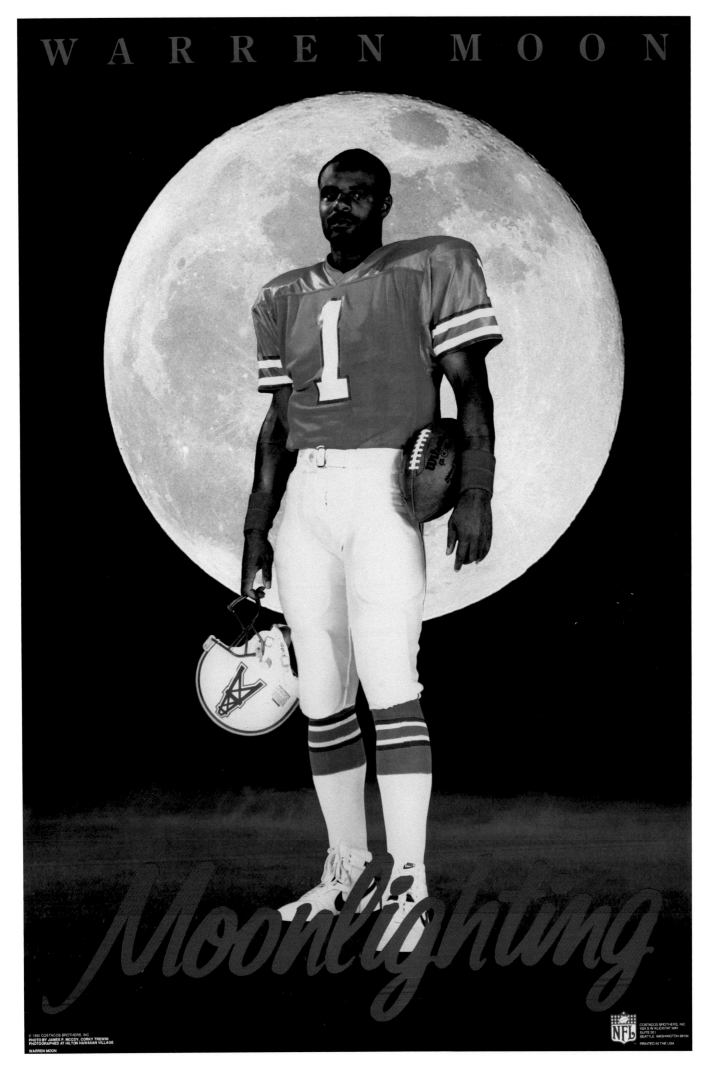

WARREN MOON

Moonlighting

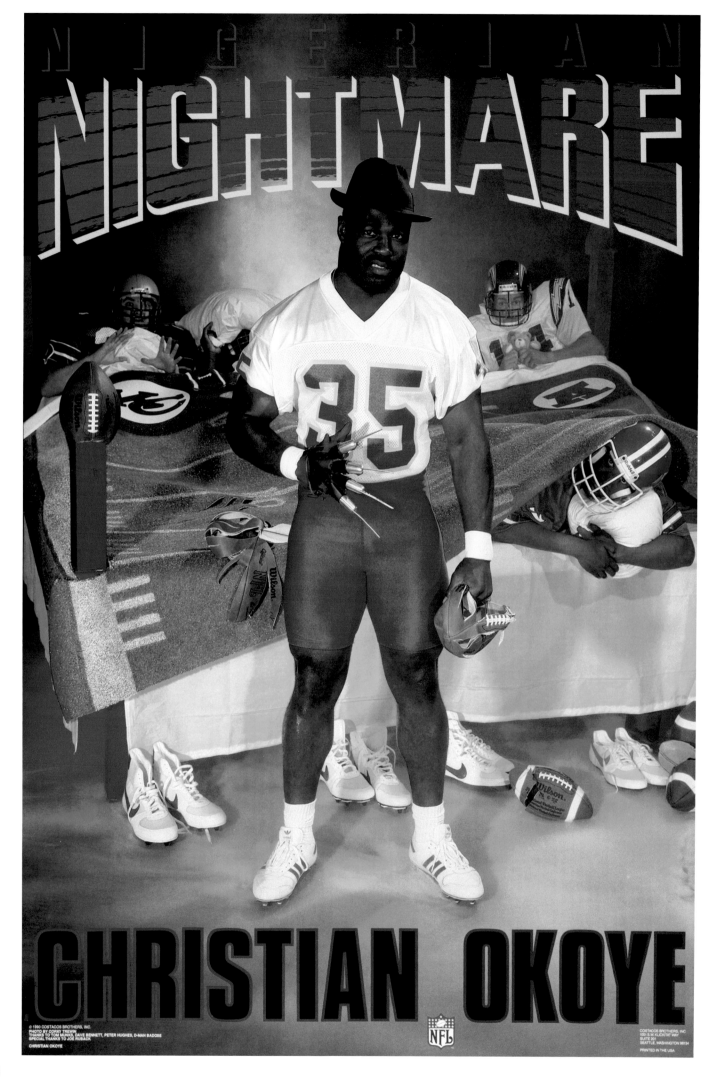

Christian Okoye

Kansas City Chiefs
1989 AFC Offensive Player of the Year

Christian looks more
surprised than scary
in this outtake.

Christian, after coming to the United States from Nigeria, competed for the track and field team in the throwing events at tiny Azusa Pacific University in California and ended up winning seven national titles in shot put, discus, and hammer. The rumor about Christian's first exposure to football is that when he was a freshman, watching football for the first time, he asked his friends, "Why does the guy with the ball fall down when the other guys run into him?"

Whether it's true or not, someone saw fit to introduce him to Azusa Pacific's football coach. And why wouldn't they? He was an exceptional track and field athlete, weighed 260 pounds, ran the 40 in 4.4 seconds, and could squat over 700 pounds. He became a running back and earned the nickname "the Nigerian Nightmare" due to the nightmare he was for other teams. He had a good college career and in his final year led the nation in average rushing yards per game, and the Kansas City Chiefs drafted him in the second round with the 35th overall pick.

Christian had had a monster season the previous year, leading the league in rushing yards and being named First Team All-Pro. And with a nickname that strong and that well-known, "Nigerian Nightmare" was a natural poster title. We did flirt with the idea of calling it "Welcome to Your Nightmare"—a play on the classic Alice Cooper album *Welcome to My Nightmare*. But "Nigerian Nightmare" was just too good.

Several of the *Nightmare on Elm Street* movies, featuring Freddy Krueger, a monster with a bladed glove who attacked people in their nightmares, had come out during the '80s. We figured we'd do a Freddy Krueger–esque Christian Okoye, which was especially fun because it's such a contrast from what a gentle and kind person he is. He's really one of the nicest people you could ever meet.

We built a bed complete with artificial-turf comforter and football players under the covers hiding from their "nightmare." Christian came to Seattle for the shoot, and the only difficult thing about working with him was that it's hard to make him look mean. Even in all the serious shots, he just doesn't look mean because, well, he's not mean. He's the complete opposite.

We tried hard to get Christian to give us a mean, nasty look, but it didn't seem to be working, and he had a hard time not smiling, so we just kept shooting as we had him try a lot of facial expressions. He had a good time doing it and was very willing to go with all our suggestions. We encouraged him to improvise and do whatever came to him, and he was like a kid making a bunch of funny faces. We had so many looks to choose from on this shoot. If Disneyland is billed as the Happiest Place on Earth, this was the happiest shoot we had ever had, because Christian is such a warm guy and he put everyone in a great mood just by his presence.

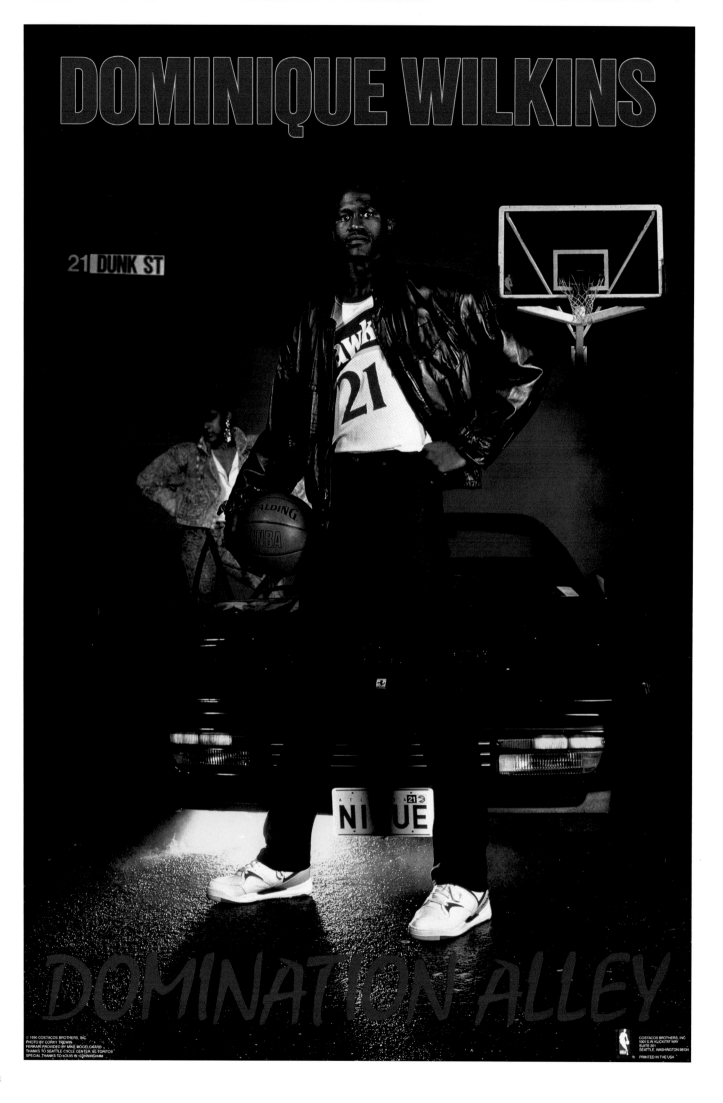

Dominique Wilkins

Atlanta Hawks

1989–90 NBA Slam Dunk Contest Champion

Shooting outside meant less control of variables, including the temperature.

Our "Highlight Zone" poster of Dominique had done well in the marketplace, and we were very happy with its performance. After three years, its sales were finally slowing down, but Dominique continued to be among the league leaders in scoring and was in the NBA highlights on television all the time. Dominique's highlights were the best advertising we could get, because he looked so cool doing his acrobatic moves.

By this time, Dominique had not only led the league in scoring but was now also a five-time All-Star and had been named to four All-NBA teams. And perhaps more important for the kids who were buying our posters, he had won his second NBA Slam Dunk Championship against a field that included Scottie Pippen, Shawn Kemp, and Kenny Smith. That kind of thing fuels demand, and we were getting lots of fan letters and customer requests for more Dominique.

He was as happy to work with us again as we were to work with him. We weren't sure if we should try to do something else with "Highlight," because it might be too close to "The Highlight Zone." We considered everything from "Highlight Reel" to "Moonlight Highlight" (which would have had him ET-style in front of a huge moon). We even created artwork for an idea called "The Skylight Zone," which would have him up in the clouds about to dunk a basketball, but we eventually dropped that because it wasn't different enough. We didn't want to follow a poster of him floating in front of a night sky with one of him floating in front of a day sky.

After playing around with a lot of words, we all agreed that we liked dominate for him. It's a good, bold word and sounds related to his first name. We played with "Dominate," "Domination," and "Dominator." "Total Domination" was another one we considered, but then someone suggested "Domination Alley," a reference to the 1977 sci-fi film *Damnation Alley* starring Jan-Michael Vincent and George Peppard, which we all liked.

We shot this in the same alley where we had shot our very first poster, with Kenny Easley, in Pioneer Square in downtown Seattle. We borrowed the Ferrari from . . . someone. We can't remember who, but we loved any chance we could get to put a Ferrari or any cool car in a poster. The Hawks had an extra day in town while they were on a West Coast road trip, so we scheduled it for his day off in Seattle.

It was cold when we shot it. Seattle's not as cold as Minneapolis in January, but it's still pretty cold. Because of this, we all loaded up on hot chocolate from an Italian restaurant named Umberto's a block away.

Dominique brought a friend with him, so we decided to put her in some of the shots. We liked the way it looked with her in the background, so we kept her in it.

This was the second of three photo sessions we had with Dominique. We genuinely loved the guy and enjoyed working with him. With him, it was like we were working on something together. It never felt like we were giving Dominique direction, and we liked that he wanted to be there and cared more about getting something we liked than being on a schedule.

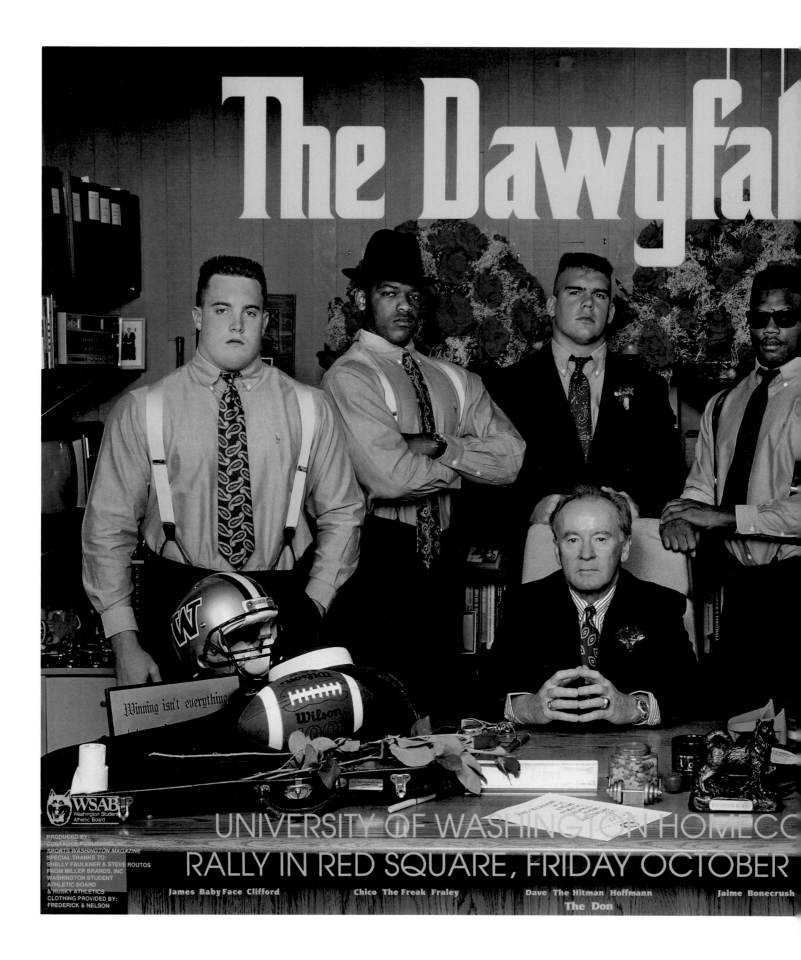

The Dawgfa...

UNIVERSITY OF WASHINGTON HOMECO
RALLY IN RED SQUARE, FRIDAY OCTOBER

James Baby Face Clifford Chico The Freak Fraley Dave The Hitman Hoffmann Jaime Bonecrush

The Don

PRODUCED BY:
COSTACOS PUBLISHING, INC
SPORTS WASHINGTON MAGAZINE
SPECIAL THANKS TO:
SHELLY FAULKNER & STEVE ROUTOS
FROM MILLER BRANDS, INC
WASHINGTON STUDENT
ATHLETIC BOARD
& HUSKY ATHLETICS
CLOTHING PROVIDED BY:
FREDERICK & NELSON

WSAB
Washington Students
Athletic Board

Winning isn't everything

Don James

University of Washington Huskies
1990 Pac-10 Coach of the Year

Don James was to Washington Huskies football what Nick Saban is to Alabama football. (In fact, while he was at Kent State, Coach James gave Saban his first coaching job.) He was successful and absolutely beloved and respected in Huskyville. His Washington football program was based on organization, fundamentals, and discipline, and you could see that on the field.

Coach James became Washington's head coach in 1975, and he led the team to a Rose Bowl win in 1977, the first of five victories in six trips when the Rose Bowl was one of the most prestigious games in sports. He was inducted into the College Football Hall of Fame as a coach based on seven league titles, a career 178-76-3 record, and setting the Pac-10 Conference record for most games won.

Although this poster came out in 1990, its inspiration dates back to 1984, two years before Tock and I ever thought of making posters. I had gone to a Huskies road game and was talking with Coach James's daughter Jill and her husband, Jeff Woodruff (who was an assistant coach for the Huskies), at the team hotel. I told them how I had been a fan since I was a kid and, as a ten-year old, would take the bus to Huskies games with tickets given to me by my dad and my godfather, George Prekeges. Jill and Jeff's son Jared was four years old at the time, and when he heard the word *godfather*, he repeated it, only he said "dogfather." Someone corrected him, but Jared repeated it a few more times as our conversation continued.

I always liked playing with words, so from then on, I referred to George as my dogfather. Fast-forward six years, and someone at the University of Washington Athletic Department asked me about doing a football poster to give away at Homecoming. We had already created "Purple Reign," "Beware of Dawgs" (as the Huskies were affectionately known), and "Bad to the Bone" among other themes for UW, but this time was different. Don James had become such an iconic figure that I wanted to do something focused on him. A couple of weeks later, George called me and I greeted him with my usual "Hello, dogfather," and the light went off in my head.

Everyone knew *The Godfather*, so it felt like the perfect play on words. It seemed like it would work, because Coach James was so well respected by his players and the Husky football community, just like the titular character from the classic film starring Marlon Brando. I felt really stupid for being in a business that was all about words without ever putting *godfather* and *dawgfather* together.

I still wasn't sure if Coach James would go for it, because he was a low-key guy that never wanted to put the spotlight on himself, but he agreed on the condition that some of his players appear in the poster, too. They chose linebackers James Clifford, Chico Fraley, Dave Hoffman, Jaime Fields, and Brett Collins, and we shot it in Coach James's office with him seated at his own desk. That's his real office, and all we added was the hit list of that season's schedule on his desk, and the violin case with roses symbolizing the Rose Bowl. (We tried a purple fedora, but it made Coach James look too much like a pimp, so we scrapped it.)

So, while people give me credit for "The Dawgfather," it was really little four-year-old Jared Woodruff who was responsible for naming his grandfather's poster.

Deion Sanders

Atlanta Falcons
NFL 1990s All-Decade Team

Deion was one of the
few people on the
planet who could pull
off that outfit.

Deion had two nicknames: Neon Deion and Prime Time. They both suited him. "Neon Deion" was good because he was like a neon sign: His on-field performance shone brightly, and you couldn't help but notice it. And "Prime Time" was fitting because he was such an amazing athlete that he was must-see viewing. Neon Deion gave way in the media to Prime Time, and that's the one he wanted to do a poster with.

We loved Deion, and Deion loved us. He had a big personality and was a tremendous athlete, accomplishing what Bo Jackson had by playing in the NFL and in Major League Baseball in the same years. A lot of people saw him as a self-promoter, but that isn't a fair term. Deion just loved his career, loved what came with it, and fully embraced it all. He knew his career in sports was going to last for a limited amount of time, and he wanted to have a blast and get as much out of it as he could. And Deion loved what we were doing and wanted to work with us as much as we wanted to work with him.

We had this one set up well in advance. Deion was playing football for the Atlanta Falcons and baseball for the New York Yankees. We went to Atlanta for the shoot and got everything set up. The Yankees sent Deion's uniform, and we were ready for him to pose in it. Having him in his actual uniform was going to be special, because they normally didn't send uniforms out for something like this.

But there was one problem: His Yankees uniform didn't show up. Whoever had sent it hadn't put it in a regular box. It was shipped in a duffel bag featuring the Yankees logo and had Deion's name printed on it! What were the chances of that bag—clearly marked with the logo of New York's favorite team and the name of a recent NCAA All-American football star, being a prime target for theft? Of course it didn't make it!

This was really a bummer, because the poster was supposed to have him in his Falcons uniform on the left and his Yankees uniform on the right. When Deion arrived and found out what had happened, he shrugged his shoulders and said, "We're here. Let's do it anyway." We hoped there might be a chance to get an appropriate shot of Deion in his Yankees uniform later so we could strip it in later, so we shot with that possibility in mind. We weren't able to do that, but he was still Deion Sanders, and we knew his poster was going to sell. It did. And we shot more with Deion in successive years.

We didn't have a better subject in front of the camera than Deion. He loved the camera, and the camera seemed to love him back. He was a guy who just seemed born to be in the spotlight. And as talented and famous as he was, he always treated us great. Whenever we saw him at any event, he would take the time to stop and say hello. We loved that about him.

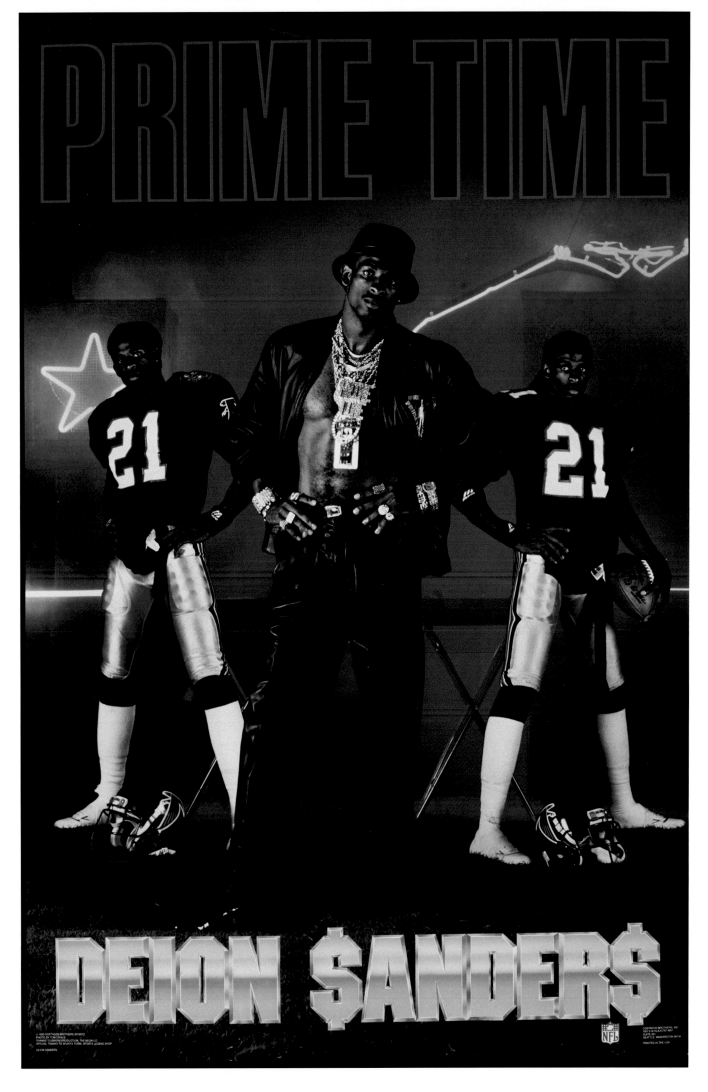

Barry Sanders

Detroit Lions
1990 NFL Rushing Leader

Sure, Barry looks taller than John in this shot, but he's wearing thick-soled shoes.

We first heard of Barry Sanders in 1988, when he averaged 238 rushing yards per game as a junior running back at Oklahoma State University. Read that again: Barry Sanders averaged 238 yards *over an entire season.* You couldn't watch college-football highlights in 1989 without seeing him running all over Creation. He set thirty-four NCAA Division I records, including most rushing yards in a season and most rushing touchdowns in a season. Add in the fact that he stood a mere 5-foot-8, and his accomplishments are almost unbelievable.

Part of the fun of Barry's story was that he had seemingly come from nowhere. For the previous two years, he had been the backup to All-American Thurman Thomas, a superstar in his own right who set the Oklahoma State career record for rushing yards. Then, as the team's featured back, Barry produced the greatest season in college football. We loved stories like this—a guy with no fanfare destroys the record books and then wins the Heisman Trophy.

Barry left college after that magical season, was drafted by the Detroit Lions with the third overall pick of the 1989 NFL Draft, and promptly earned Rookie of the Year honors and was named to the Pro Bowl. By this time, we had enough contacts with players and agents that we decided to get ahead of the game and shoot a number of posters at the Pro Bowl. It was held in Honolulu that year, and nearly every NFL player we'd be interested in was in attendance. This was a huge cost savings, because it entailed just one photography studio, one set of lights, and travel costs to one city. Even better, it meant we got all our shots months in advance. And since the various Pro Bowl activities were stretched over the preceding week, we had the first few days to talk with clients and work out any details for the shot.

To make things as easy as possible for the players, we set up our studio in the hotel where the players stayed. Having the license with the NFL in some ways may have made us less creative, but knowing we had the option of using official team uniforms instead of having to create original costumes made things easier, and we wanted to see how this new approach would work.

This poster is an example of something a little more simple than our previous work, but we still like its look and feel. The top three ideas we had for Barry were "Detroit Wheels" (from the '60s rock band Mitch Ryder and the Detroit Wheels), "General Motor" (from the Detroit-based car manufacturer General Motors), and the one we chose, "The Silver Streak" (from a 1976 comedy film we liked starring Richard Pryor and Gene Wilder).

Barry is one of the most understated guys you could ever meet. He was soft-spoken and very nice, but also quite funny, which we didn't expect. We'd met with him the day before to go over the details, but when he walked onto the set—all 5-foot-8 of him—in his uniform, he said, "You guys are short." So we spent the entire shoot insulting each other with short jokes. But Barry was focused, too. He'd wipe the smile off his face and get serious for a few shots and then start in with the short jokes again. He was wonderful to work with, warm, happy, and unbelievably humble.

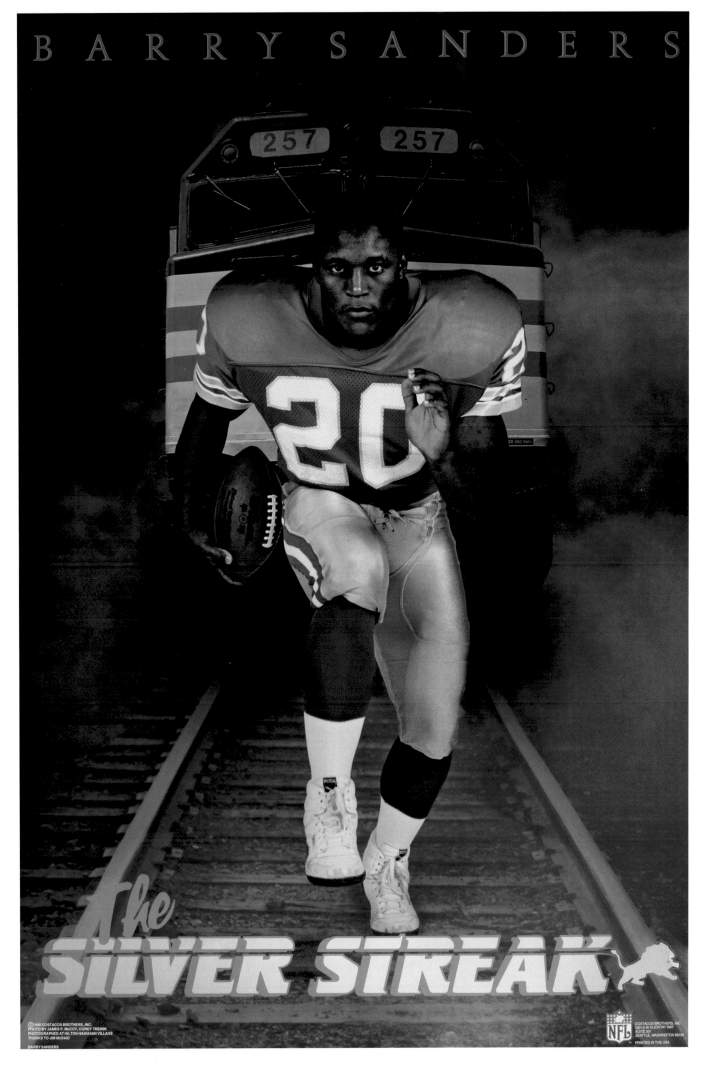

The great Barry Sanders showing some of the moves that made him one of the most elusive running backs in NFL history, for the "Silver Streak" poster.

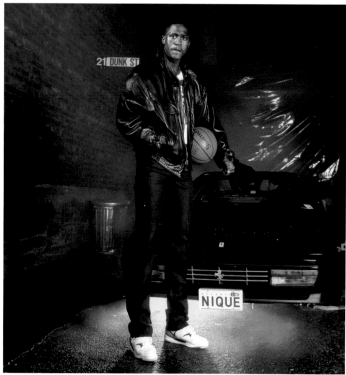

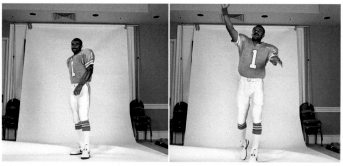

Warren Moon got on our radar back in college, when he led our beloved Washington Huskies to an upset victory over Michigan in the Rose Bowl.

Dominique doesn't really need a sports car and leather jacket to look cool, but when we added everything together, it made for an intimidating poster.

Randall Cunningham was one of the guys who made it worthwhile to set up a shoot in Hawaii, where we could work with a lot of athletes in a short timespan.

(l to r) Production head Tom Rees, John, Randall, and Tock pose during Pro Bowl week in Hawaii, so of course we all had sunglasses handy.

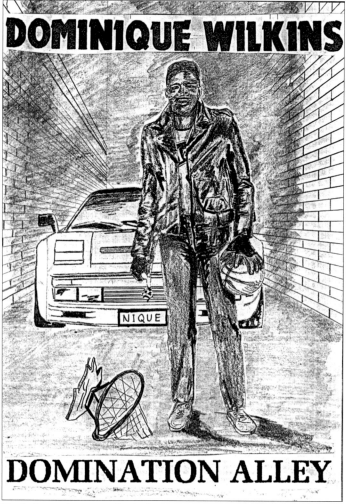

Here's the rough concept sketch of our second poster with Dominique Wilkins, which we shot in the same alley as we did our Kenny Easley poster.

Outtakes from "Prime Time"—even though we had Deion's grey away uniform, we felt like we needed the home pinstripes version because it's so iconic.

This photo of John, Christian Okoye, and production head Tom Rees is a more accurate reflection of Christian's personality than the final poster shot.

Andre Rison (left) came to the set with Deion, and one of them left the lights on in their Mercedes. It took an hour for someone to come and give them a jump.

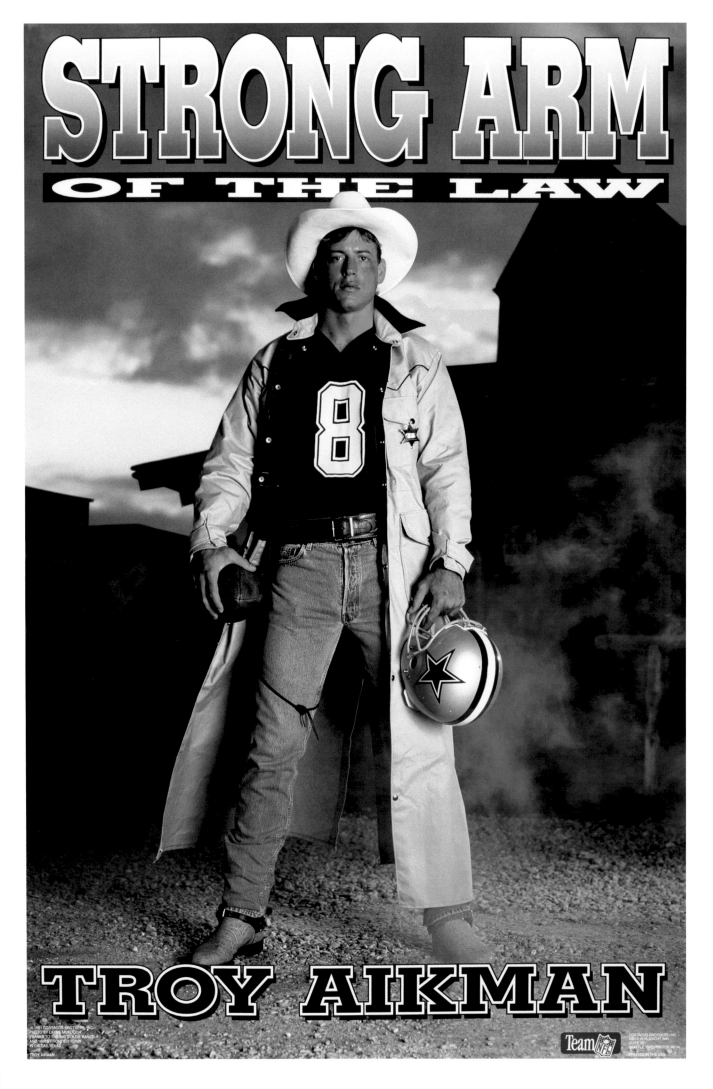

Troy Aikman

Dallas Cowboys
1991 Pro Bowl

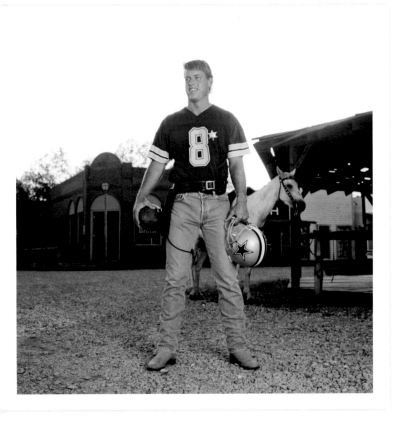

———————————

Troy looked a little too
plain without the duster
and cowboy hat.

The Dallas Cowboys were a team we liked as kids during the early '70s, when Roger Staubach was their quarterback and they were known as America's Team. The Cowboys were one of the best teams in the NFL in the '70s but had slipped by the late '80s, going 1-15 in 1989. Even though they were one of a handful of teams with a national following, there wasn't much to get excited about anymore. But things were about to change, and Troy Aikman was a big part of it, being selected by the Cowboys with the first overall pick in the 1989 NFL Draft.

We were familiar with him from his college playing days at UCLA because the Bruins had been in the same conference as our Washington Huskies. Through the course of writing this book, we've realized how many of our clients were guys we had been familiar with from the Pac-10 (now the Pac-12) Conference.

We knew Troy's agents well and had a good relationship with them, and we started talking with them about Troy during his rookie season. It seemed natural that we would do a cowboy theme with him—he was a gunslinging quarterback playing for the Dallas Cowboys. It was so obvious that we tried looking for other ideas, just to be sure we'd considered things outside of that box.

Among others, we thought of shooting him with the stadium wall rising behind him and calling it "Walls of Troy" or in the players' entrance tunnel into the stadium and going with the title "Hall of Troy." We still didn't like those as well as the cowboy theme, though. And there were the silly ones, like "Troys R Us," "Troy Will Be Troys," and "The Troy Store" with the Cowboys stadium behind him. We never got tired of the funny list. (What would we do if we were making this poster today? Well, since the main character of Woody in the Toy Story movies is a cowboy, how about "Troy Story"?)

We had given it a cowboy-free try and come up empty, which was what we had expected. It came down to "Strong Arm of the Law" or "Gunslinger," and we chose the former because, in addition to having a strong and accurate arm and a quick release, Troy was known as a good leader, so the sheriff theme seemed slightly better.

We shot this poster in Texas, and it's one of a very few that, even if we nitpick it to death, we wouldn't change anything on it. We loved the way the colors came out, the fog was a perfect light mist, and Troy looks great. His posters sold very well, and when he went on his run of six straight Pro Bowl seasons, in which he led the Cowboys to three Super Bowl victories, we were constantly calling our printer to order up more. Troy and his Cowboys winning were good for poster sales.

(Troy also helped us get national exposure, so to speak: One year, at the Pro Bowl, sports photographer Walter Iooss asked if we knew where Troy was because he needed to get a shot of Troy at the beach. We hadn't seen him, but we took him over to Troy's agent, Leigh Steinberg, and introduced him, and they worked it out. Troy came out later, and Walter told us, "I'm shooting from here. If you're there behind him, you might get in the frame." So, when *Sports Illustrated* came out a week later with Troy sitting in a chair at the beach, there was half a Costacos brother in the picture! Thanks, Troy.)

Larry Bird

Boston Celtics
NBA's 50th Anniversary All-Time Team

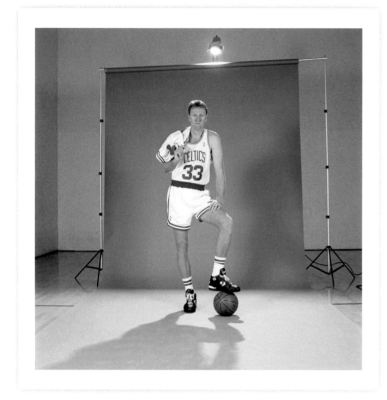

Here's a shot of Larry
getting wild and
putting his shirt over
his shoulder.

We met Larry's agent, Bob Woolf, during our second year when we were in Boston. We wanted to meet with him face-to-face so Bob would know who we were and we'd begin to build a relationship. He liked our work and gave us a lot of encouragement. He told us to feel free to call him if we ever needed advice or wanted to work with his clients. Jumping at the opportunity, we told him right then and there that we wanted to work with Larry Bird.

It took us a few years to get this one done. A lot of it had to do with Larry's schedule, and it seemed like Larry wasn't all that interested. From what we understood, Larry just wanted to be on the court playing basketball, and marketing activities didn't matter much to him. And that singular focus on basketball was reflected on the court—Larry had already been named to nine All-NBA First Teams, was a three-time league MVP, and had led the Celtics to three championships.

Surprisingly, we had a tough time coming up with ideas for him. We knew we had to come up with a simple concept because Larry wouldn't be interested in any of our over-the-top stuff. *Bird* seemed like a name we could do something with, but words that rhyme with bird are words like *curd, herd, nerd, turd,* and *word,* and none of those worked. We thought about doing "Birdman," but that didn't seem right. We had seen the Burt Lancaster movie *Birdman of Alcatraz,* where the main character is in prison for murder, so we had a good laugh about dressing Larry up in a prison uniform and having a bunch of carrier pigeons about to deliver basketballs to other teams' hoops. (And speaking of the guy being in for murder, "Mass Birderer" went on the funny list.)

We finally got a title when we had just reached a point where everybody in the room was frustrated. Someone said, "We suck—Larry Bird is a legend, and we can't come up with one good idea for him." Somebody else said, "Wait a minute. Legend . . . Larry . . . Larry Legend . . . Larry Bird . . . *The* Legend." So simple. And that was it. We made the deal and went to Boston to shoot it.

We shot Larry at Brandeis University in Waltham, Massachusetts, where the Celtics trained at the time. Larry was very polite and professional, but he was all business. He stood in, and we got the shots and then he left. It had taken several years, but we finally had Larry on film.

After he left, we went to the Boston Garden to shoot the background shot of the iconic parquet floor. We used a fog machine for atmosphere, and we were done. Art Director Bart Unger went to pack up the fog machine and said, "Uh, oh. Boston, we have a problem." His feet had nearly gone out from under him, because the fog had left a film on the wooden floor, making it slippery as ice. Luckily, we noticed and got it cleaned up, because the Celtics had a game a couple of hours later. (Plus, we didn't think we had enough insurance to cover an entire NBA team, let alone two.)

This is one of the simpler posters we made, but we think it captures his no-nonsense approach as a player.

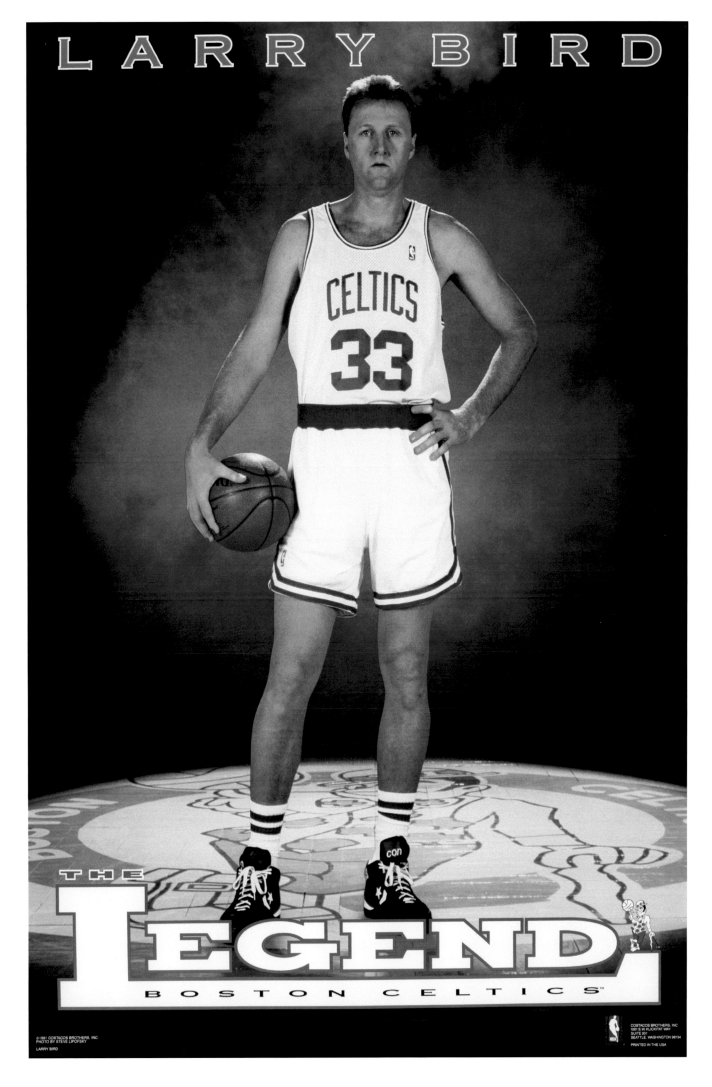

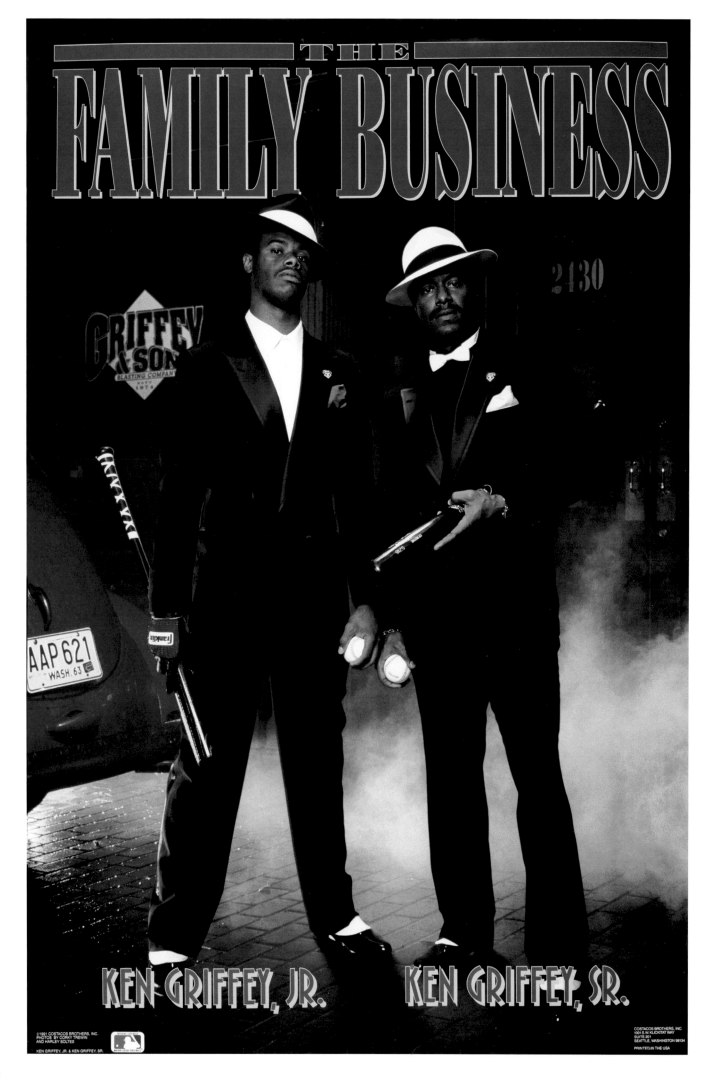

Ken Griffey Jr. & Ken Griffey Sr.

Seattle Mariners
4,924 Combined Career Hits

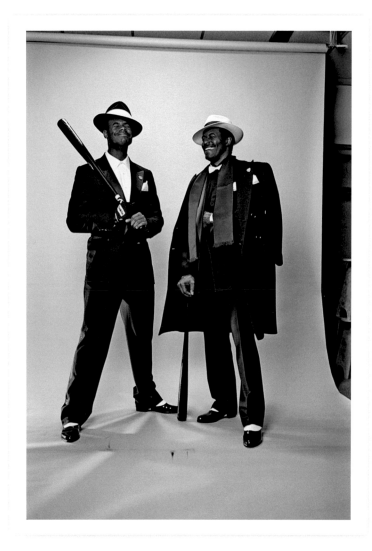

The Griffeys took care
of business, but still
had fun between takes.

We wanted to shoot something with Ken Griffey Jr. back in 1989 because, well, he was Ken Griffey Jr. But we chose to shoot him with his father, who was a three-time All-Star for the Cincinnati Reds, and call it "Griffey: The Next Generation." A father and son playing in the major leagues at the same time was extremely rare, and it was great to be able to commemorate that in a poster. But you know what's even more remarkable? For a father and son to play *on the same team,* and that happened for the first time in MLB history in 1990 with our hometown Seattle Mariners.

On August 31, 1990, in his late-season debut game as a Mariner, Senior hit a line drive up the middle for a single in his first at-bat. Junior was up next, and he hit a single of his own into right field. And a couple of weeks later, the two of them hit back-to-back home runs in the same game. Toward the end of Senior's eighteenth year in the majors, he had a resurgence batting in front of his son and hit .377 over the twenty-one games left in the season. Their story just kept getting better.

Because we'd gotten poster licenses from Major League Baseball and the MLB Players Association, we had recently done an action shot of Junior called "The Goodbye Kid" where he had just hit a home run. It was selling very well, and we had more titles in the pipeline because the demand for more Junior posters was skyrocketing. But for the upcoming 1991 season, we wanted to do another original photo shoot with the two of them. The opportunity was too good to pass up.

We dug up our creative files from "The Next Generation" and started playing around with ideas like "Family Affair," "Like Father, Like Son," and "All in the Family." We thought about "Legacy," "Legend," or "Bloodline," but "Family Business" was the winner because there was something fun about how they were indeed both in the same business. Plus, a mob theme always looked cool.

We shot them in a studio, and when Junior was a little late, his dad apologized to us for it. We found this funny because it was so real—the son was late, and his dad was a little annoyed about it. This was a father-son dynamic that could be in any family, except in this case Junior was a megastar. So, when Junior finally arrived and got in a little hot water with his dad, we couldn't help poking fun at him about it. (He was a good sport about it.) They were really patient, and we shot for a long time with this one. (We shot the background afterward at a location downtown to get the old brick street, spraying it down for effect.)

We have a good relationship with our dad, so we liked seeing the father-son duo playing together on the same team—we understood the bond between fathers and sons and how special it must have been to play on the same team. It was a pleasure for us to work with the Griffeys and to help memorialize that experience.

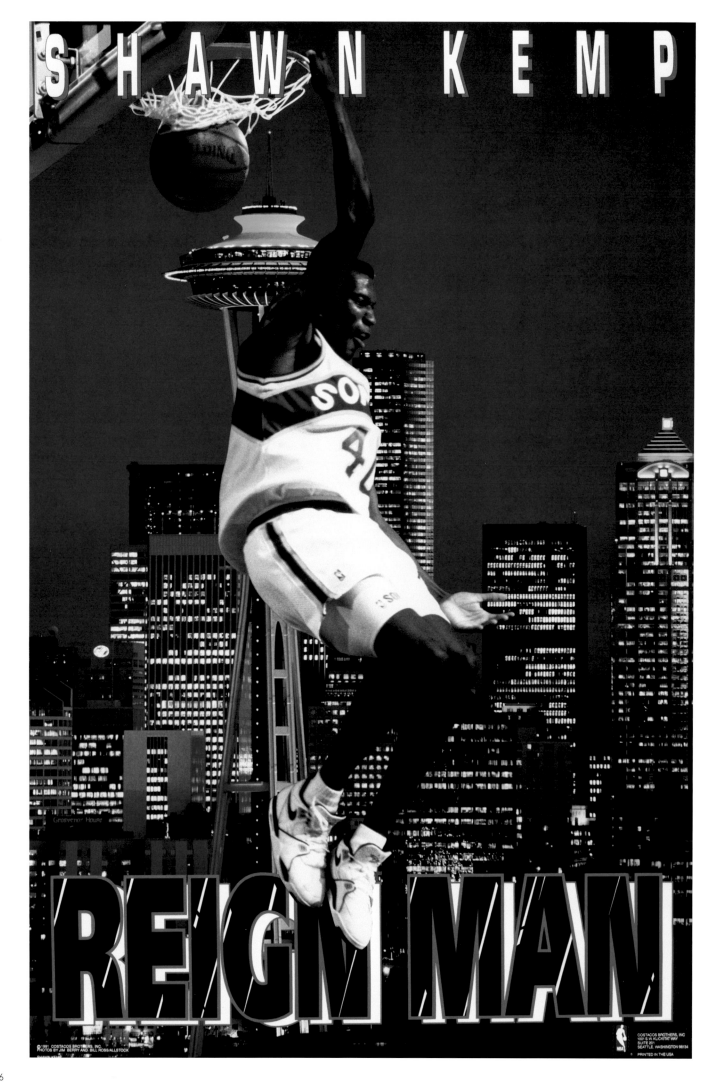

SHAWN KEMP

REIGN MAN

Shawn Kemp

Seattle SuperSonics
Future Six-Time NBA All-Star

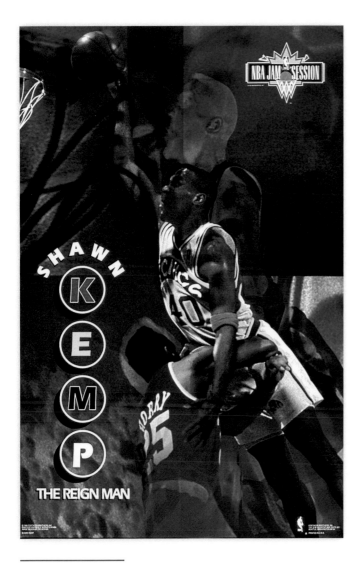

We used another
game-action shot
of Shawn for a series
we did called "NBA
Jam Session."

Shawn Kemp came to the Sonics with a different kind of fanfare and expectation than most first-round draft picks. He was a McDonald's High School All-American and originally went to the University of Kentucky but left in the fall of his freshman year before playing a game. He transferred to Trinity Valley Community College in Texas, but again left before playing in a game.

When he entered the NBA draft at nineteen years old, though, the Sonics took him in the first round. Nobody knew what to expect in Seattle because we hadn't heard about him or seen him play. But there was a buzz of hope that maybe this guy we knew nothing about might be something special.

We got a pretty good idea of what we were in store for as soon as we got to watch him play. He was an explosive player, and his dunks were powerful, violent, and primal, the kind that fans love, and whenever he threw one down during a home game, the place absolutely exploded.

The idea for "Reign Man" came from a discussion with production head Tom Rees, who suggested it in a meeting with Art Director Bart Unger. It had been a few years since the Dustin Hoffman movie *Rain Man* had come out, but it was a well-known movie that had won the Oscar for Best Picture. Plus, he played in Seattle, a city known for its wet weather. With a familiar title like that and a guy who could dunk like Shawn, it seemed like a great idea for Shawn.

Around this time, things had been changing for us. The NBA didn't want us doing original photo shoots with players in a studio anymore. Instead, they wanted us to utilize our license by purchasing photos from them, then designing our posters around those images. It wasn't the worst thing in the world. It wasn't as fun as being in the studio, but it was also a lot less complicated—we didn't have to do individual contracts with the players or deal with the logistics of sets, props, and costumes. And the high-flying, acrobatic NBA action photos gave us a lot to work with.

As soon as this poster came out, the nickname took off. Kevin Calabro, the Sonics radio play-by-play announcer, saw our poster and loved it. He immediately picked up on the catchy title and went crazy with it whenever Shawn rained down a dunk during a game. Kevin is a great announcer, and he made the games exciting with his enthusiasm and excitement. We loved hearing Kevin call out "the Reeeiiiggnn Maaaaannn!"

The Sonics even used the theme for a commercial, which we loved. Every time something like that happened, when somebody else picked up on something we had done and used it, people would ask us if we were upset about it. In most cases, we weren't—instead, we were generally flattered.

One of the most satisfying things that happened to us in our poster career was when Shawn came back from the All-Star Game and told us how a bunch of the other All-Stars had said they loved his poster. We couldn't believe this. "No, seriously—I'm not kidding," said Shawn. "We were all talking about each other's Costacos posters." And then he added, "And we were giving crap to the guys that didn't have one."

Magic Johnson

Los Angeles Lakers
1990–91 All-NBA First Team

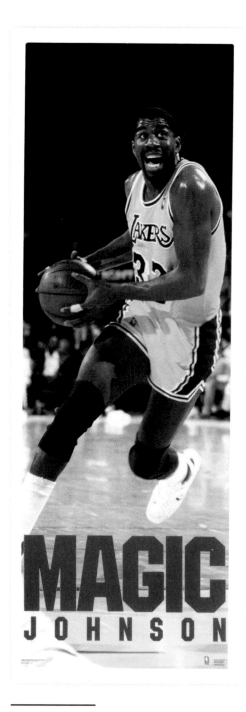

We love this door
poster of Magic!

E arvin Johnson had been a star since college. He was the perfect star with a great nickname: Magic Johnson. *Magic* and *Johnson* seem like they belong together, and they sound like a sports star's name should sound. ("Magic Costacos," on the other hand, would never fly.)

We got Larry Bird to come and shoot with us, but not Magic. Do we like this "Magic Kingdom" poster? Yes . . . and no. We love the way it looks. But we don't like what it reminds us of, that we never quite got a deal done to get Magic in the studio with us.

The Lakers were in the same division as our Sonics, so we got to see Magic play all the time. Even though the Lakers regularly beat our team, he was just plain awesome to watch. Our action-photo door posters of Magic sold well, but we wanted to do something in the studio with this amazing player.

We got far more requests for a Magic poster than for any other athlete on any other LA team. And we had a deal with his agent in 1987 for two posters that we'd shoot in one session, each for release at the beginning of successive seasons. One would be called "Showtime," and the other would be either "Magic" or "The Magic Show." All terms were agreed on, we both had the contract—and then Magic changed agents before it was signed, and his new agent wasn't interested. So, we had to go to Plan B.

The titles we liked for him were the original three titles mentioned above, and "Magic's Kingdom" or "Magic Kingdom." Which one we used would depend on the photo we found. We loved this photo of Magic seemingly floating over the city and composed it with the background.

We were starting to get used to the idea that most of our NBA posters were not going to be in studio; instead, we'd used action shots composed with background photos. It was less expensive, faster, and easier and carried less risk. And doing it this way meant we didn't have to do an individual contract with each player, which saved us time and legal expenses. And we could have a poster ready to print within a couple of weeks from the day we agreed with the NBA Players Association on the concept. With studio shots, it was at least a few weeks to get the concept agreed on and a contract signed, then a couple more months just to get on the players' schedules. Using existing photos was less exciting than being in the studio, but from a business standpoint, it made sense.

Magic was popular everywhere, even in foreign countries, as the NBA audience was growing on a global scale. We got in trouble with the NBA because this poster somehow ended up in a store in London, and our license didn't allow us to sell outside the United States and Canada. We never tried to work outside the rules, and the culprit had to be one of the distributors we sold to, but we had no way of finding out who it was.

The overreaction by the NBA was one of the most ridiculous things we'd ever seen. One store in London got one order of Magic Johnson posters, and, from the way they reacted, you would have thought we were smuggling drugs.

We might not have been able to get Magic into the studio, but we liked the way this one turned out. ("Showtime" or "The Magic Show" would have been pretty cool, though.)

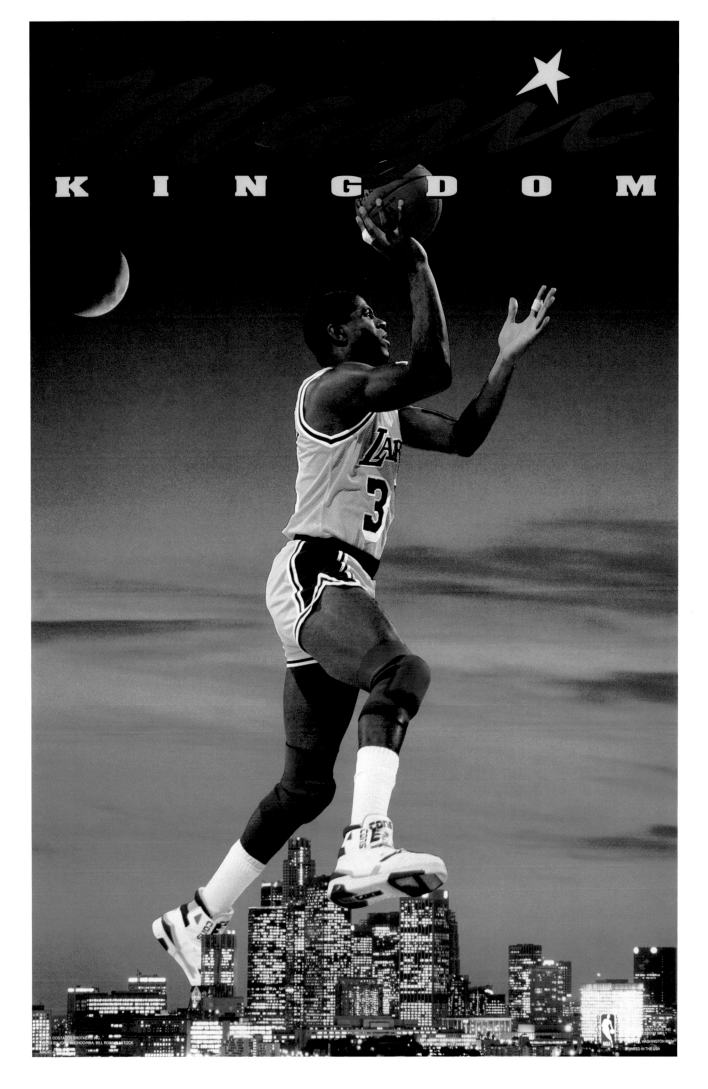

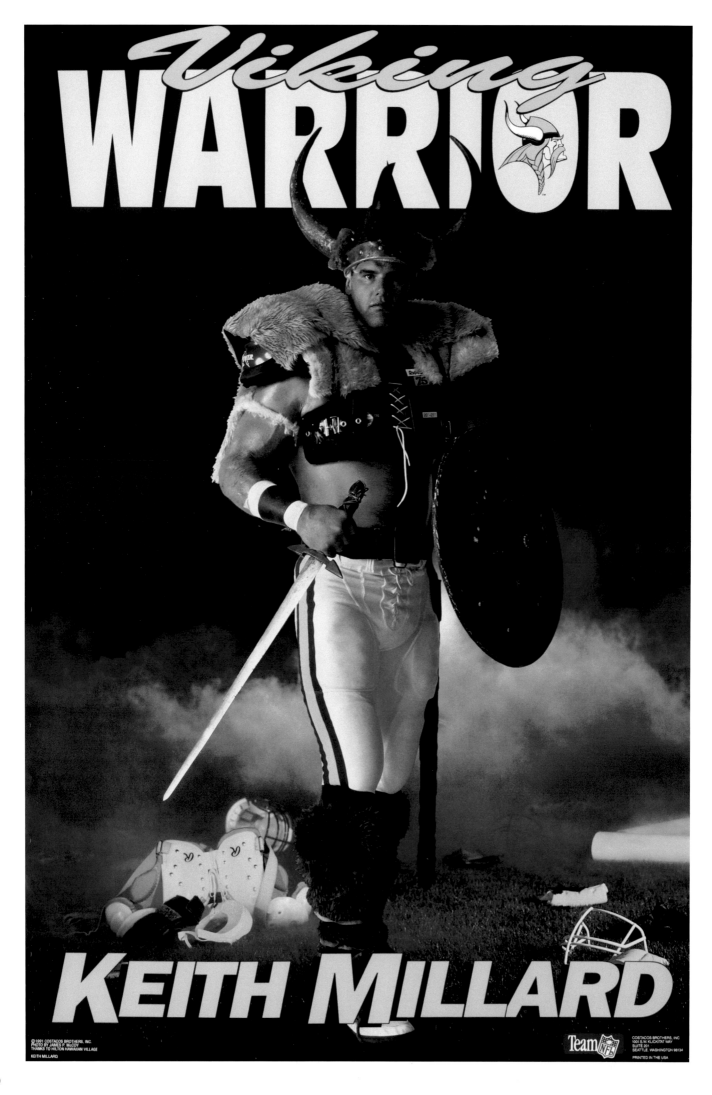

Keith Millard

Minnesota Vikings
1989 NFL First Team All-Pro

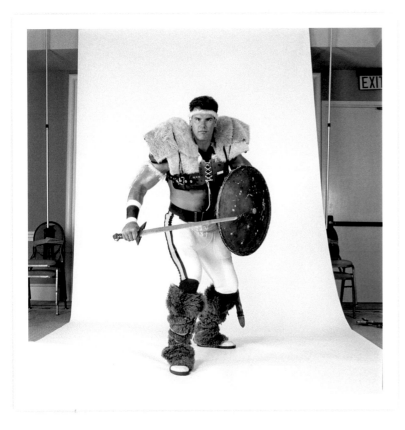

We did a few different poses with Keith, but the Viking helmet and horns really connects him with the title.

We had known all about Keith from his college days playing football for our school's rivals, the Washington State Cougars. By his senior year, he was a dominant defensive tackle and an absolute force on the field, and he had won the Miller Trophy as the Pac-10's best defensive lineman. Keith was drafted by the Vikings with the 13th overall pick in the 1984 NFL Draft, but he actually started his professional career with the Jacksonville Bulls of the US Football League.

A year later, he joined the Vikings, and a few years after that, he was in the Pro Bowl. In 1989, he was named NFL Defensive Player of the Year as well as UPI's NFC Player of the Year. To this day, he still holds the NFL record for sacks by a defensive tackle in a season, with 18, and he was named to the NFL's 1980s All-Decade Team. The guy was a heck of a player.

Getting costumes would have been so much easier if we had lived in Los Angeles, because LA has massive costume houses that serve the television and film industry and have just about any costume you could ever want. We had an idea of how to make a guy look like a Viking, but we weren't sure.

Back in that pre-internet era, we would go to the library and look through books and encyclopedias. We found a lot of reference pictures, and in fact we found too much—there were so many variations of depictions of Vikings that we didn't know which one to actually use. Then we found a couple of movies about Vikings on video and watched those. There wasn't anything exact, but we knew we wanted a helmet with horns and to try to make him look as much like a badass warrior as possible.

We rented the helmet, made the rest of the costume ourselves, and got it to Hawaii so we could shoot Keith during the 1990 Pro Bowl. This is one of about 10 posters we shot that year during Pro Bowl Week. It was shot in a studio at the players' hotel, the Hilton Hawaiian Village, and Keith rocked it.

But of course we couldn't let him get away with all the times he had lined up across from our beloved Washington Huskies, and we started telling Washington State Cougars jokes before the shoot, at which point he reminded us that serial killer Ted Bundy had gone to our university. Nothing like guys trading insults to bring them closer together. It was silly fun, but it kept us relaxed.

The University of Washington's main color was purple, which, of course, is the team color for his Minnesota Vikings, and we poked even more fun at him for playing for a purple team. He was a good sport about it all and gave it right back to us. This kept the mood of the shoot light, and Keith did a great job. (We also made a sign that read, "Cougars Suck," and at one point one of our guys quietly snuck into the frame behind Keith and held the sign up so we could get a couple of shots of it. Nothing like a little college-football rivalry.)

We still laugh about the uniform parts strewn throughout the background, because it's the same idea as the strewn parts in the Kenny Easley poster, which the NFL hated. So, now we're licensed by the NFL, and the same thing is OK? Confusing. We're happy with the way this turned out, though, especially the half–football player, half-Viking costume.

Luc Robitaille

Los Angeles Kings
1990–91 First All-Star Team

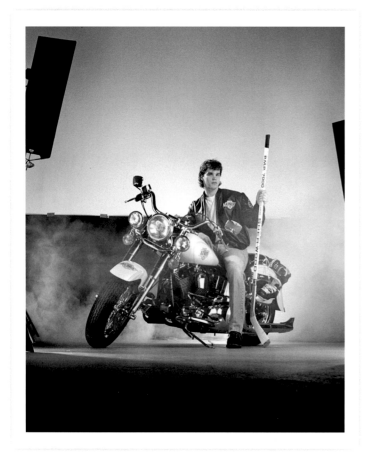

We didn't use this
outtake because we
wanted Luc to fill the
vertical poster frame.

We met so many good people, really good people, when we were making posters. We feel like we are being repetitive in telling these stories by saying what a nice person the player was, but quite honestly, most of them were that nice. And Luc is that nice, and he is that humble. Our production head, Tom Rees, said, "He's the kind of guy you want to be buddies with." Luc made enough of an impact on us that whenever we talk about him today, that's the first thing we say.

The other thing we learned that day is that nothing rhymes with *Robitaille*. Nothing. *Luc*, on the other hand, has lots of possibilities, most of which made the funny list, such as "Luc the Kook" and "Luc of Hazzard." Since he played left wing, we thought about "Stage Left" and "Left Brain." Not even close. "Deft Wing"? Nope. So, when we went to looking at movie titles, the 1967 Paul Newman movie *Cool Hand Luke* was the first one we thought of, and we thought it would work well.

We talked to Luc's agent, and he said yes. The movie takes place mostly in a prison, but we obviously couldn't do a prison scene for it. We watched the movie to get ideas for something other than a prison scene, but nothing came to mind from that. We considered shooting him on the ice at the Forum, his team's home arena, or outside and in front of the Forum. We were still working on the concept when we found out that his girlfriend was actor Steve McQueen's daughter-in-law. OK, she was technically McQueen's ex-daughter-in-law, since she had divorced his son Chad and was now with Luc. But still . . .

We loved Steve McQueen. His movies *The Great Escape*, *Papillon*, and *Bullitt*, among others, had been some of our favorites from the time we were kids. And Luc was dating his daughter-in-law? (*Ex-daughter-in-law*, blah, blah, we know, but still!) We just had to put a muscle car or a motorcycle in it. Steve McQueen was a motorhead, and he loved fast cars and motorcycles.

We love the scene in *The Great Escape* where McQueen rides a motorcycle while being chased by German soldiers, so we talked about that. Then we found out that Kings owner Bruce McNall had a custom Harley with a Kings logo on it and was willing to let us use it. And that's exactly what we did. So the motorcycle is our nod to Steve McQueen, in case he ever saw this poster.

We shot in a studio, and Luc came with his girlfriend, whom he would later marry. Luc was quiet, comfortable, and relaxed. McNall's motorcycle was beautiful. And Luc really liked the jacket. (He liked it so much that he kept it—that kind of thing tended to happen a lot.) He looked cool in it with jeans, boots, and his skates over his shoulder. And this was another great experience working with photographers Andy Bernstein and Jon SooHoo. It was a comfortable and relaxed shoot, and we got loads of good shots with Luc in various poses. We combined the shot we chose with the sunset sky for some color and loved the way it turned out, especially with our secret wink to Steve McQueen.

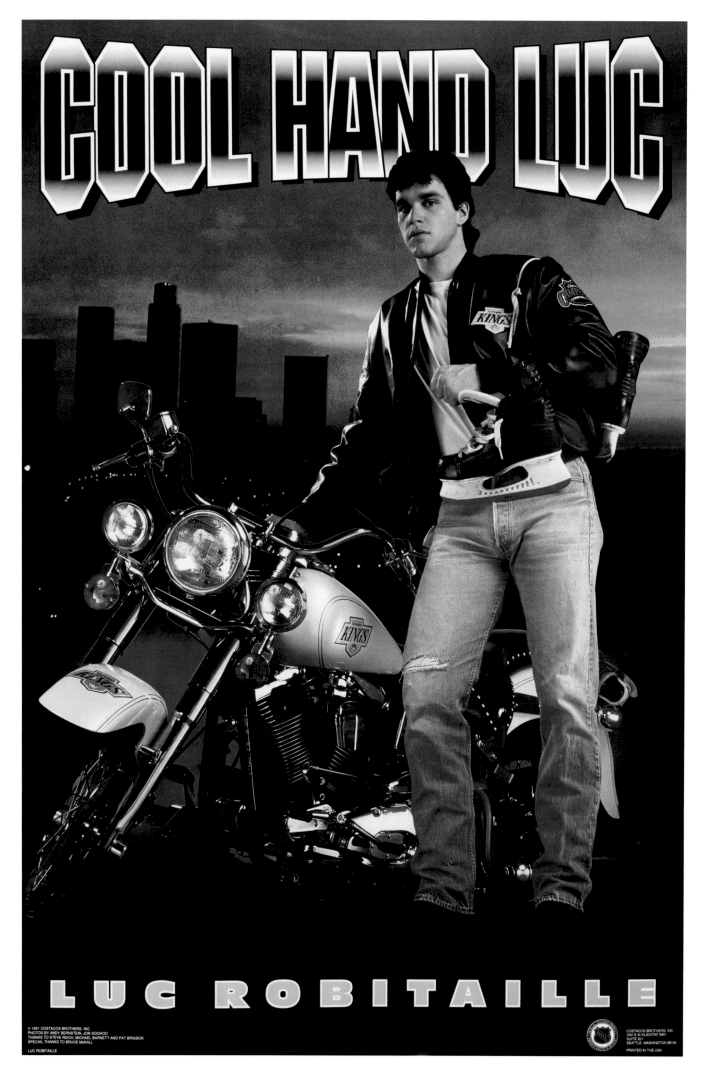

Magic Johnson & Wayne Gretzsky

Los Angeles Lakers & Los Angeles Kings
12,104 Combined Career Assists

We also produced this poster featuring Wayne. (Party time! Excellent! C'mon, it was going through your head.)

Magic and Wayne were Los Angeles royalty in 1992—and still are. Magic was huge from the moment he arrived in 1979. We nearly had a poster deal with him around 1987, but he changed agents just before we signed the deal, and Magic's new agent wasn't interested. Then, when Wayne moved to LA to play for the Kings in 1988, it rocked the hockey world. He was already a hockey legend, and playing in LA legitimized hockey in sunny California.

During this time, our business was growing up and changing. After five years of making posters, it had started to mature into more of a real business. This was good from a stability standpoint, as we employed more support people and had our production, sales, and distribution systems pretty well set up. And we had enough reps under our belt that we didn't feel like we were flying by the seat of our pants all the time.

Additionally, we had developed a network of good relationships. Poster-royalty money was quite insignificant compared to just about every other licensing deal an athlete did. Our creativity was our greatest asset, but it was our relationships with players and agents that formed the foundation that everything else was built on. Our player clients often helped us secure deals by pointing out opportunities, and this even happened with agents. We were always very grateful when this happened, and we owe this poster to Wayne Gretzky's agent, Michael Barnett.

Michael appreciated the creativity and quality of our product and was always in tune with what was going on in player marketing. He saw the value of posters as a good way to create and market a player's image, and he recognized how hard we worked for our clients. He also knew that we'd been wanting a poster with Magic Johnson and almost had a deal before it fell through.

One day, Michael called and told us about a photo that had been taken of Wayne Gretzky and Magic Johnson that he thought would make a good poster. At this point, our distribution was very good, and as much as we loved getting the players in the studio to create a poster through a shoot, it was really the player that was the key. And if there was an existing shot of these two Los Angeles icons together, we would have been stupid not to use it. A couple of years earlier, *Chicago Times* magazine had a cover with a photo of Michael Jordan, Walter Payton, and Andre Dawson and asked us to distribute a poster of it for them called "Class for All Seasons." It flew out the door, and we liked the potential for another multi-icon poster and were thankful that Michael put the deal together.

And we knew this one was going to sell. There was high demand for both players, so we worked fast to create the background and come up with a theme (inspired by the title of a recently released Steve Martin movie), and we were able to get this into the marketplace about a month after Michael's initial call.

It sold across the country, and especially in Southern California and all of Canada. Sometimes things just work out, and it's nice to have made the friends we did along the way. After all these years, we're still friends with Michael Barnett and Wayne Gretzky—and Magic Johnson's *first* agent.

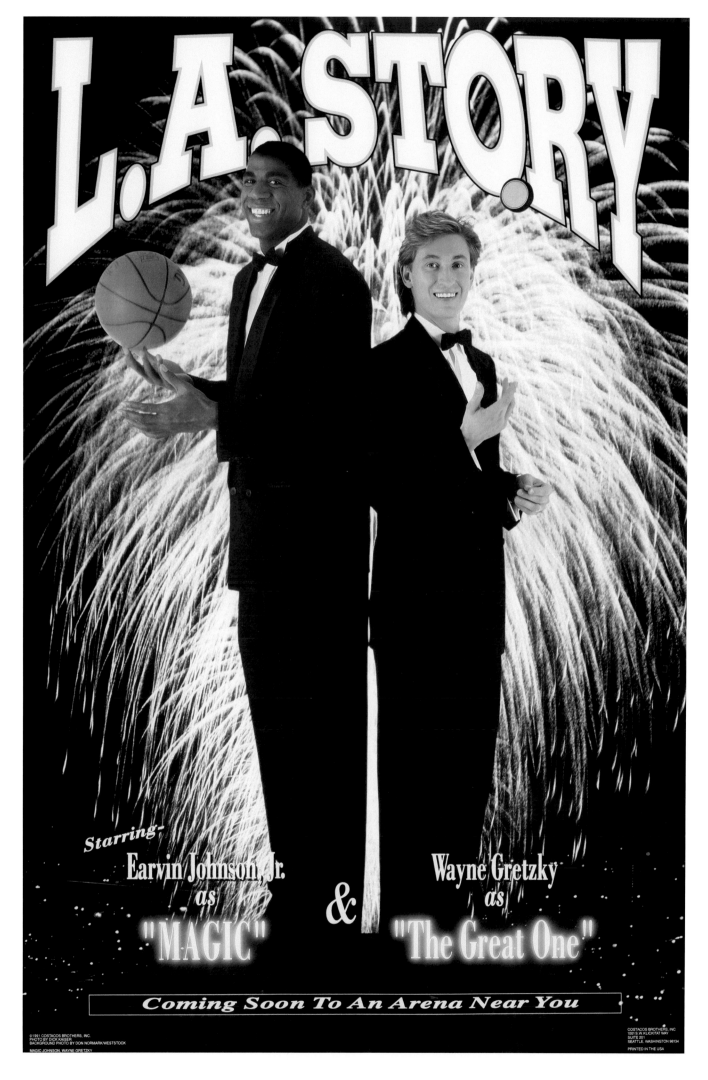

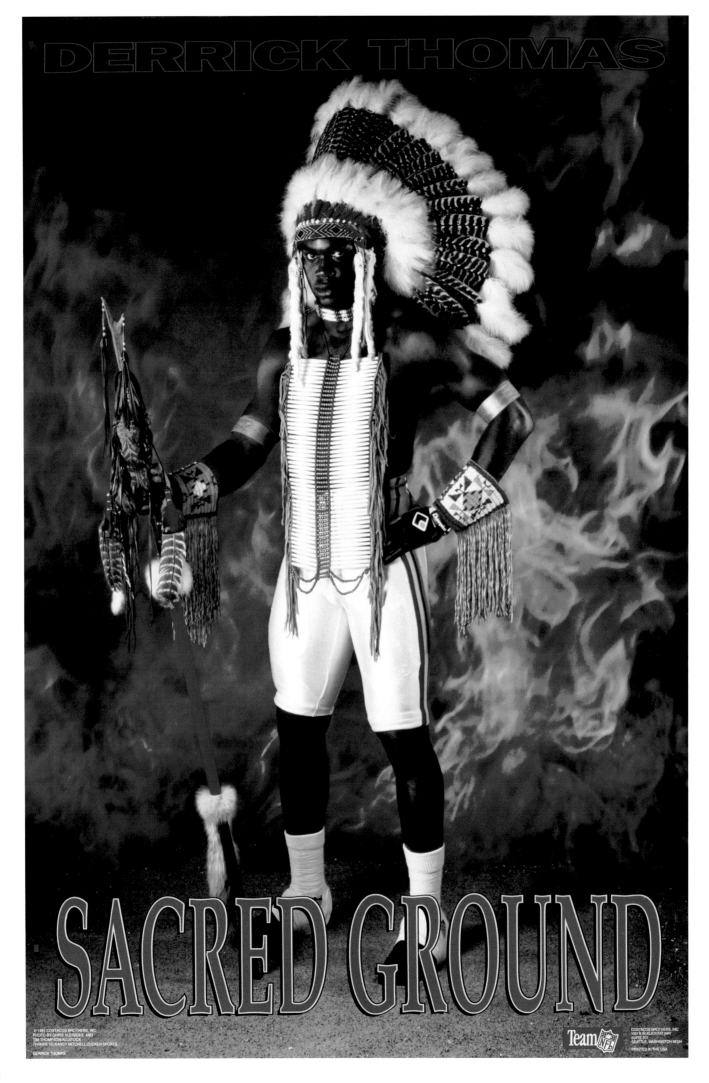

Derrick Thomas

Kansas City Chiefs
1990 NFL Sacks Leader

Here's a contact sheet from Derrick's shoot, including some of the other historic pieces brought to the set.

W e had previously worked with Derrick Thomas on a poster with his teammate Neil Smith called "Rush Hour" and had had a good time. We had enjoyed working with him, and he was up for doing an individual poster. Derrick was the 1989 NFL Defensive Rookie of the Year and had already made a Pro Bowl. He was a rising star in the league who a lot of people expected to become the next Lawrence Taylor

We arranged to shoot this in Kansas City along with another poster of the entire Chiefs starting defense, which would be called "The Tribe." The Kansas City Chiefs had a relationship with their local Native American tribes, and Derrick had a connection with an association of the tribes in that region of the country. We called the organization and told them about the posters and that we wanted their support if we were even going to do them in the first place. And if we did have that support, we needed their help to make sure we were respectful and authentic in what we did. They said we would have their support as long as we let them attend the photo shoot and approve the costumes—which they would provide. We enthusiastically agreed.

They put the word out to the tribes as far as a few hundred miles away, and the response was overwhelming. These Midwestern tribes responded unbelievably and brought us far more costumes than we could have ever asked for. Derrick's individual poster was first, and we shot it in a studio. Three or four representatives from the tribes there had brought a number of costumes, and they helped us decide which to use. They explained the history and significance of the different parts of each costume, which was really fascinating.

We tried a number of costumes, but the one in the poster was the one we all agreed looked best. Derrick was a fairly quiet guy and very accommodating. When we finished the design work at home and put the fire and the titles on, we couldn't have been happier. We were all looking at each other and thinking the same thing: This one looks *unbelievable*. We loved the colors, the font, the fire in the background, and, most of all, the authenticity.

The group poster was a bit of a problem. We had arranged to shoot on a farm. There were probably 40 to 50 representatives from Native American tribes who had come from all over Kansas, Missouri, Iowa, and Nebraska, and they all brought the most amazing costumes, packed in protective boxes, for the defensive players to wear. Some of the costumes were hundreds of years old. Our guests were also our wardrobe specialists for this shoot, and they spent a large amount of time selecting the costumes for each player, explaining its significance, and putting paint on them. It took a little longer than expected, but that wasn't a problem.

The problem was that a storm was coming, and the sky got dark quickly. We could see lightning flashes in the distance. Preparing the costumes took about 90 minutes, but we finished shooting it in about 5 minutes. With the storm getting closer, we didn't want to be responsible for the Chiefs's defense—or the history and heritage they were wearing—getting hit by lightning.

Rickey Henderson

Oakland A's
1990 American League MVP

A concept sketch
of Rickey with the
armored-car idea.

Rickey was one of our favorite players. He was colorful, and funny, and he spoke in the third person a lot. And he could flat-out play. Rickey won a Gold Glove Award and three Silver Slugger Awards, and he was a ten-time All-Star, an American League Championship Series MVP, and a two-time World Series champion. He could do it all and was the best leadoff hitter in the history of the game—Rickey still holds the MLB record for most runs scored, most unintentional walks, and most lead-off home runs.

But Rickey was best known for his base stealing. Usually, a player would win the league stolen-base title with a season total of 70 or 80 bases, and sometimes just over 100. In 1982, Rickey stole 130 bases. One hundred and thirty bases. He was so much fun to watch on the base paths, and it was particularly fun to watch this cat-and-mouse game between Rickey and the opponents' pitchers and catchers.

It was obvious to everyone that if anyone was going to break Lou Brock's all-time stolen-base record, it was going to be Rickey. He played for the Oakland A's at the time, and we had lunch with him in Seattle when the A's were in town. We only talked about the poster for about five minutes. He loved "Man of Steal" and said yes.

We spent the rest of the lunch talking about baseball and hearing many funny stories about his experiences in the game. The guy loved the game and was having the time of his life. He was quite a multitasker, too. People were continually coming to the table asking for autographs, and he didn't skip a beat, continuing to look at us and talk as he took their pens and signed every autograph he was asked for.

We shot the poster the next time he was in Seattle. Our original idea was for a thieves' hideout full of stolen bases, but we changed the setting to an armored car. That way, we could have the guards be catchers and add some "Wanted" signs. The idea for having the catchers in the background came from a TV commercial we saw on television for Rolaids antacid where a catcher is watching film of Rickey stealing and obviously getting an upset stomach over it. When the A's came back to town, we picked Rickey up for the shoot, and when he looked at the set, he immediately loved it. He hopped up into the armored car and looked around like a little kid who'd just gotten dropped off at a new playground.

We got him dressed, and he came onto the set and it took us about fifteen minutes just to get him in place to shoot because he was having such a great time with everyone. Ricky had two looks: One was a completely serious game face, and the other was a huge smile. That smile was on full display that day. He thought everything that was going on was so much fun, and that made his poster one of our favorite shoots. It didn't feel like a business deal. It felt like Rickey was part of our team, trying to make something fun for his fans. Looking back at our careers, this may have been the one time that the player had more fun than we did.

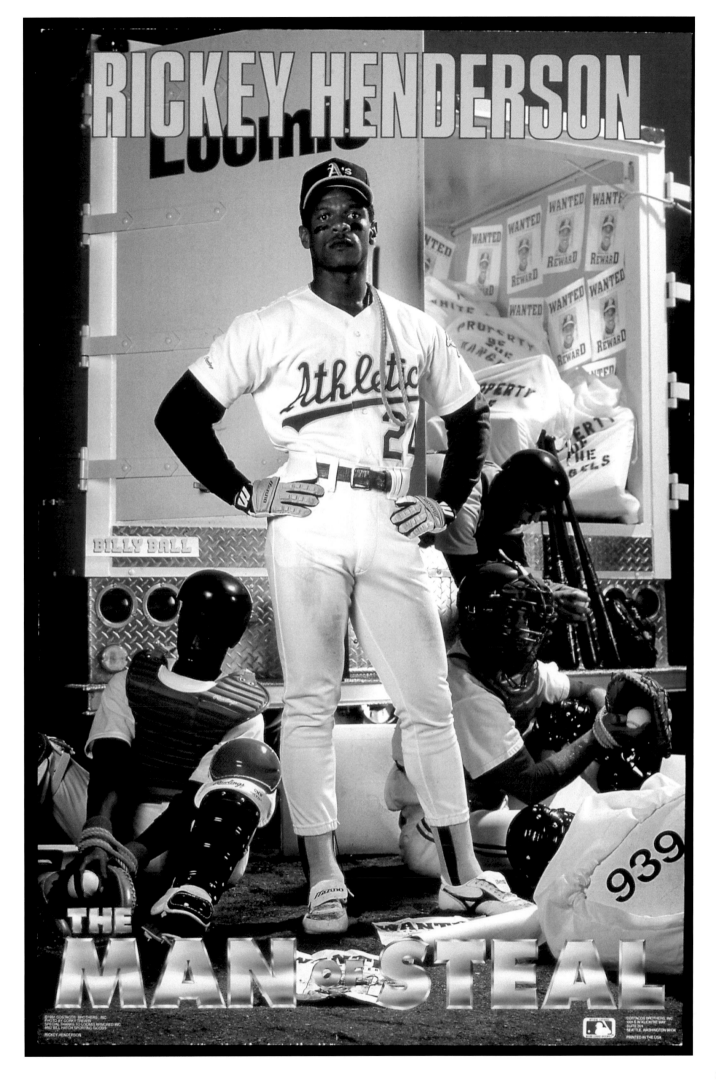

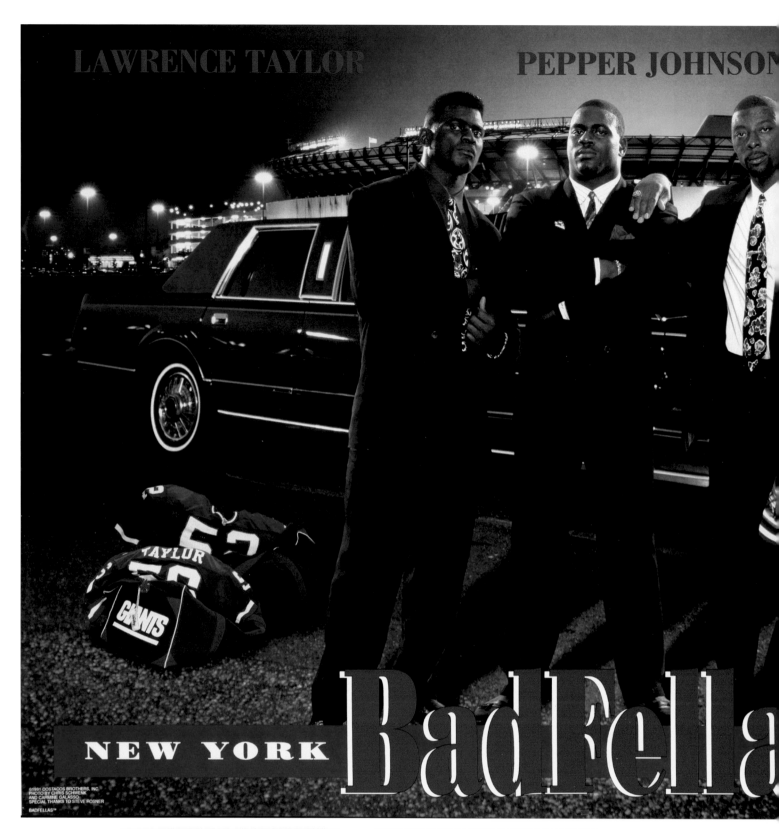

LAWRENCE TAYLOR

PEPPER JOHNSON

NEW YORK BadFella

©1991 DOSTACOS BROTHERS, INC.
PHOTO BY CHRIS SCHWENK
AND CARMINE GALASSO.
SPECIAL THANKS TO STEVE ROSNER
BADFELLAS™

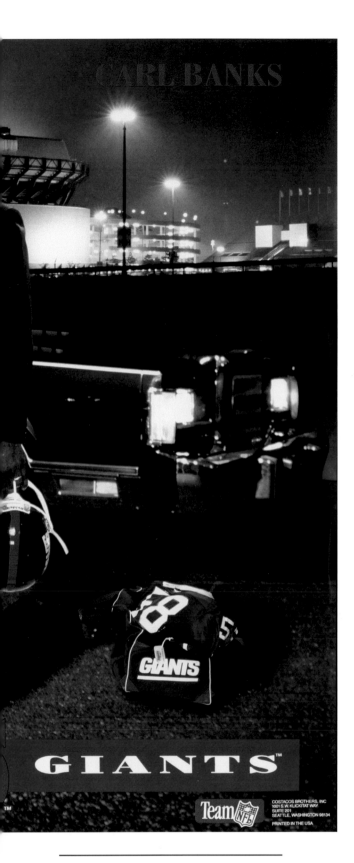

(far left) We shot the background limo in front of Giants Stadium.

(left) The guys looked both intimidating and chic in their suits.

Lawrence Taylor, Pepper Johnson & Carl Banks

New York Giants
Super Bowl XXV Champions

New York had been good to us. In our first year making posters, it gave us Lawrence Taylor and "The Terminator." The following year, it gave us Carl Banks and "Safe Deposit." In 1990, it gave us the movie setting for Martin Scorsese's mob classic *Goodfellas*, which was released around the beginning of the NFL season. We immediately thought we should do a "Badfellas" poster of . . . somebody. We just didn't know who it should be, so we filed it away on our should-do list.

Coincidentally, the New York Giants were just beginning one of their greatest seasons ever. Their linebackers, including Lawrence and Carl, were just plain awesome on the field. Kids loved these guys, and their posters continued to sell. In 1990, the Giants went 13-3 in the regular season, with one of the top ten defenses in NFL history. They defeated the defending-champion San Francisco 49ers in the playoffs, then beat the Buffalo Bills 20-19, the closest game in Super Bowl history.

After the season, we spoke with Lawrence and Carl about doing "Badfellas" with them together. They said yes but wanted to add fellow Giants linebacker Pepper Johnson. Lawrence and Carl had previously made NFL All-Pro teams, and Pepper had just added that honor to his resumé. They were a nasty group of linebackers, and the name fit them well. A *Goodfellas* parody with three badasses from a New York team? Fuhgeddaboudit.

The most memorable thing about this shoot is that we thought the guys were going to get into a fight. Carl and Pepper arrived early, but we had to wait for Lawrence. We weren't on a strict timeline, so we weren't worried. But when Lawrence showed up a half hour late, he was in a bad mood. He was always a really nice guy to us, but it was obvious he wasn't having a good day. This didn't seem to be a big problem, though—we'd shoot it and get them out of there.

We told Lawrence we'd work quickly, and he thanked us and apologized for his mood. Then, Carl came up to us and quietly said not to worry about Lawrence's sullenness—he'd handle it—so we started shooting. Pepper and Carl were totally into it and having fun. Lawrence wasn't.

Lawrence appeared to be legitimately trying but couldn't shake his bad mood, so Carl started teasing him and making fun of him, egging him on, hoping to get him out of his funk and engaged in the shoot. But Lawrence was having none of it. Carl didn't let up and kept giving him crap, and Lawrence was getting mad. Maybe Carl knew something that we didn't, but it seemed like things were just escalating and a fight could break out at any time.

Finally, Lawrence stopped in the middle of the shoot and said, "Carl?" Carl didn't even flinch. Lawrence got closer to him and said, "Shut up!" At that moment, we were looking for escape routes before a brawl broke out. Suddenly, Lawrence burst out laughing. They all did. Big sigh of relief for us. Lawrence walked a lap in a small circle and took a couple of deep breaths and got back in place. "Sorry, guys. I'm good. Let's do it."

More from the Archives

Before the Golden State Warriors had the "Hamptons 5," we shot a 1991 poster of another dynamic offense known as "Run TMC," featuring Tim Hardaway, Mitch Richmond, and Chris Mullin.

As you can see, Lawrence Taylor was not having as much fun as Pepper Johnson and Carl Banks.

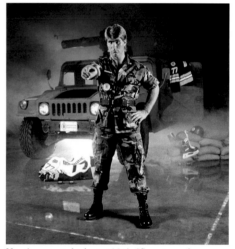

Rickey Henderson looks pretty serious in a couple of these outtakes, but in the last shot, you can see a little of the enthusiasm and excitement that he had on the set with all the props and costumes.

Here's an outtake from 1991's "Secretary of Defense," starring the Boston Bruins' Ray Bourque.

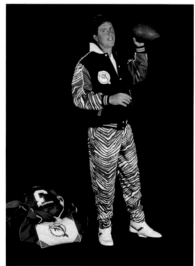

The concept for Dan Marino's "Armed & Dangerous" poster evolved quite a bit, from a Miami mafia theme to something more chic, to . . . Dan wearing Zubaz weightlifting pants, thanks to an endorsement deal he signed.

An outtake from the photos we had for the final "Armed & Dangerous" poster.

Jaromir Jagr on set for his "Czechmate" poster, which featured the superstar on a giant chess board.

It must've been pretty cool for Luc Robitaille to play for a team whose owner loved the team so much he owned a motorcycle with a custom Kings paint job—and let us borrow it for the "Cool Hand Luc" shoot.

An outtake of Dee Brown during the "Boston Dee Party" shoot, where he fit right in with all the kids.

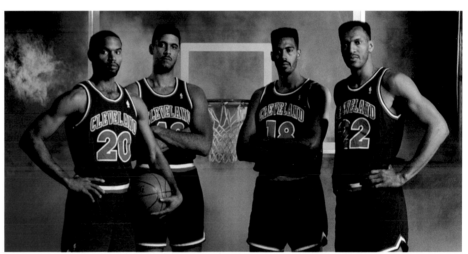

The Cleveland Cavaliers' frontcourt of Winston Bennett, Brad Daugherty, John "Hot Rod" Williams, and Larry Nance pose in this outtake shot from the "Bring It On, Baby!" poster from the 1991–92 season.

Here's the final poster for Brett Hull's "The Golden Brett" poster, alongside an outtake which shows the prop pot of golden hockey pucks. The title is a reference to his father Bobby "the Golden Jet" Hull.

It was fun to work with Troy Aikman on the eve of his dominating Super Bowl championship run.

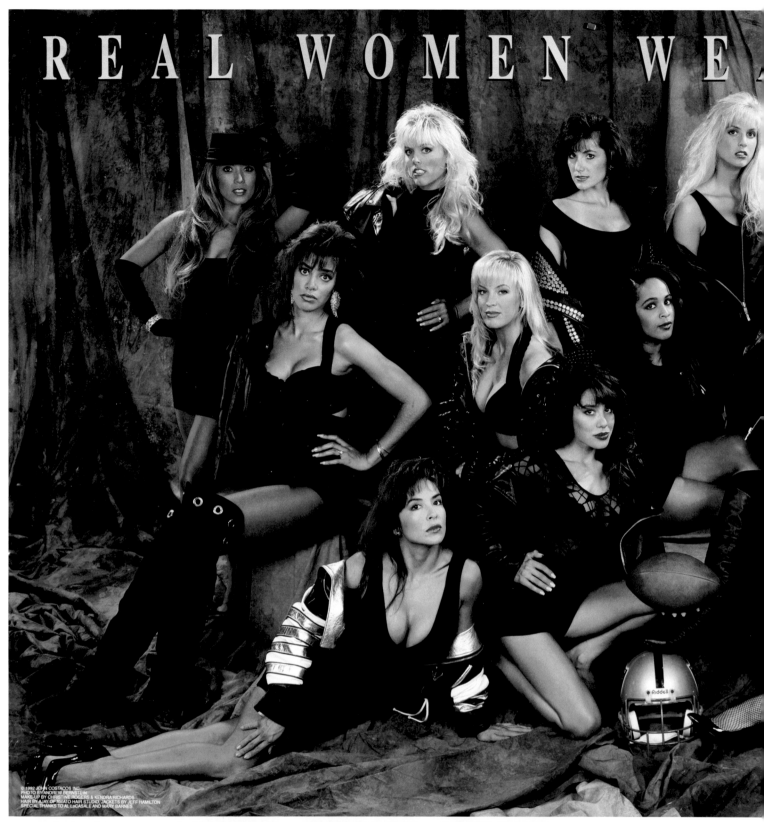

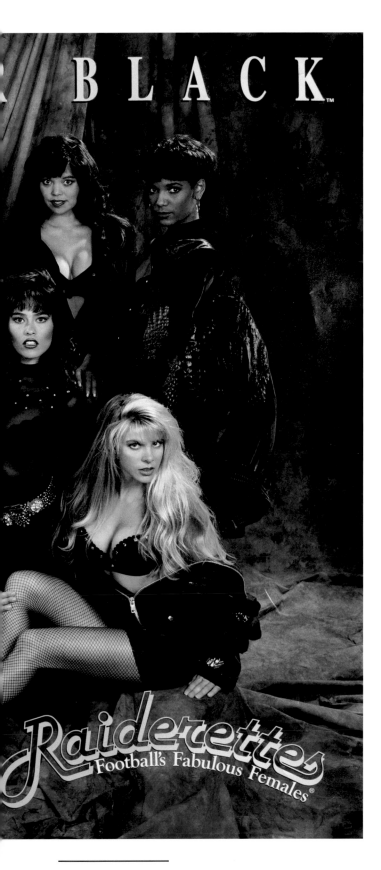

BLACK™

Raiderettes
Football's Fabulous Females®

The Raiderettes

Los Angeles Raiders
"Football's Fabulous Females"

Raiders owner Al Davis loved that we had created the team's "Real Men Wear Black" slogan, and I suspect it may be why I was hired for the first Raiderettes photo shoot (as a side project without Tock), which actually wasn't this poster.

The Los Angeles Raiders had hired me to shoot their cheerleader calendar for the first time in 1990. With a few years of photo shoots under my belt, I knew how to organize a set and have everything prepared so a subject could come in on the appointed day and get the job done. This calendar project was a little different—I had to shoot forty-eight Raiderettes, and had just two days to pull it off.

It was a little nerve-wracking to keep on schedule, but the women were great to work with. I didn't have to worry about makeup or making them look good because they did their own makeup and they were all extremely comfortable in front of the camera. Most of them had done some modeling, so they were used to it.

Al LoCasale was Al Davis's right-hand man, and one of his responsibilities was being in charge of the Raiderettes. Al was happy with how the calendars came out and brought up the idea of doing a poster of the cheerleaders. I suggested just taking the popular "Real Men Wear Black" slogan associated with the Raiders and changing it to "Real Women Wear Black." Al loved it.

I got to work with my good buddy Andy Bernstein, my favorite photographer. I enjoyed working with all the photographers we used over the years and became friends with many of them, but me and Andy had just clicked together from our first project together, Cory Snyder's "Gunsmoke" poster. I really appreciated not just Andy's photography work and professionalism, but also how thoughtful and patient he was, especially on set when things could get intense.

The Raiderettes are a big squad, and Al chose which women would be featured in the poster. The original idea was to shoot the women in their uniforms, but I pointed out that the uniforms weren't predominantly black but mostly white with black and silver accents, which would be a disconnect. Al said, "No problem. Tell the girls to wear something black that looks sexy." Problem solved.

This one was just plain easy to set up and easy to shoot compared to most others. I didn't have to worry about wardrobe, since the women wore their own clothes, which looked and fit the way they liked. And makeup wasn't a concern, because they all did their own, so they could look exactly how they wanted.

And when it came to positioning them on the set, all the women just sort of walked in and organically positioned themselves together. It was like one woman chose her place, another sat down next to her, another stood behind her, and all of a sudden, they were all in position. We did some slight fine-tuning and just started shooting. (One of the nicest things about working with the Raiderettes was developing some nice friendships. In 2012, when an art gallery in LA had an exhibit featuring our posters, Al and his wife and sons attended, along with a group of the Raiderettes.)

When we sold our company, one of the things we kept was the trademark for "Real Men Wear Black" from our T-shirt with that slogan, which was our first venture in professional sports, even before we'd made a poster. Al LoCasale and the Raiders had been so good to us that we gave that trademark to the Raiders.

Chris Berman

ESPN

Six-Time National Sportscaster of the Year

Chris looks cool wearing sunglasses even in this concept sketch.

By 1992, Tock and I had been making posters for over five years, and after all that chaos, we finally had the systems and personnel in place for Tock to run it as a proper business. We had all the league licenses, and Tock felt it best to stick to our core business, which was making and selling posters under those licenses. But since I can't sit still and am always thinking about creating new things, I pursued side projects not under the Costacos Brothers banner.

We both loved Chris Berman. He had that great "Boomer" voice and his signature catchphrases, but we especially loved the nicknames he gave players. But what if he was broadcasting highlights of a player also named Berman? What would Chris call him? "The Bermanator." Perfect.

I sent a letter to ESPN with this idea and received a phone call from Tom Hagopian, who said his company loved it. A month later I was at ESPN Studios in Bristol, Connecticut, to shoot the poster. Just seeing ESPN headquarters from the outside was like heaven to a sports fan like me. It looked like the complex of a supervillain in a James Bond movie, with huge satellite dishes all over and a number of buildings. It felt like I was in the center of the sports universe.

They took me into the studio to set up, and when Chris came in, the first thing I noticed is how his broadcast voice is just his voice—it's not amped up when he's on the air. He walked in with a jacket and tie, just like I'd always seen him on TV, and said, "OK, what are we doing here?"

I told him to lose the jacket and showed him the *Terminator*-looking biker jacket, and he smiled and said, "I like you already." Then I gave him the gloves and the Gargoyle-brand sunglasses to complete the look. When he sat behind the desk and we started test shooting, I couldn't resist saying, "Hey, do Arnold Schwarzenegger doing NFL highlights."

He stopped and thought about it for a few seconds, took a deep breath, and started into a routine in his best Arnold accent: "I'm Arnold Schwarzenegger, this is Tom Jackson, and welcome to NFL Priiiiime Tiiiiime!" and just kept on going with what a day it had been in the NFL.

We finished testing and got all the shots done without a hitch. Chris kept things lively throughout the shoot by constantly coming up with new player names that sounded fun spoken in Arnold's accent, and whenever there was a break to change film, he'd do more highlights in Arnold's voice. It was great working with a guy whose work I enjoyed so much over the yeras, and to learn he enjoyed our work, too.

A few years later, I called him with another idea: a riff on *The Godfather*, called "The Gridfather." Flip toward the end of this chapter to see how the story ends!

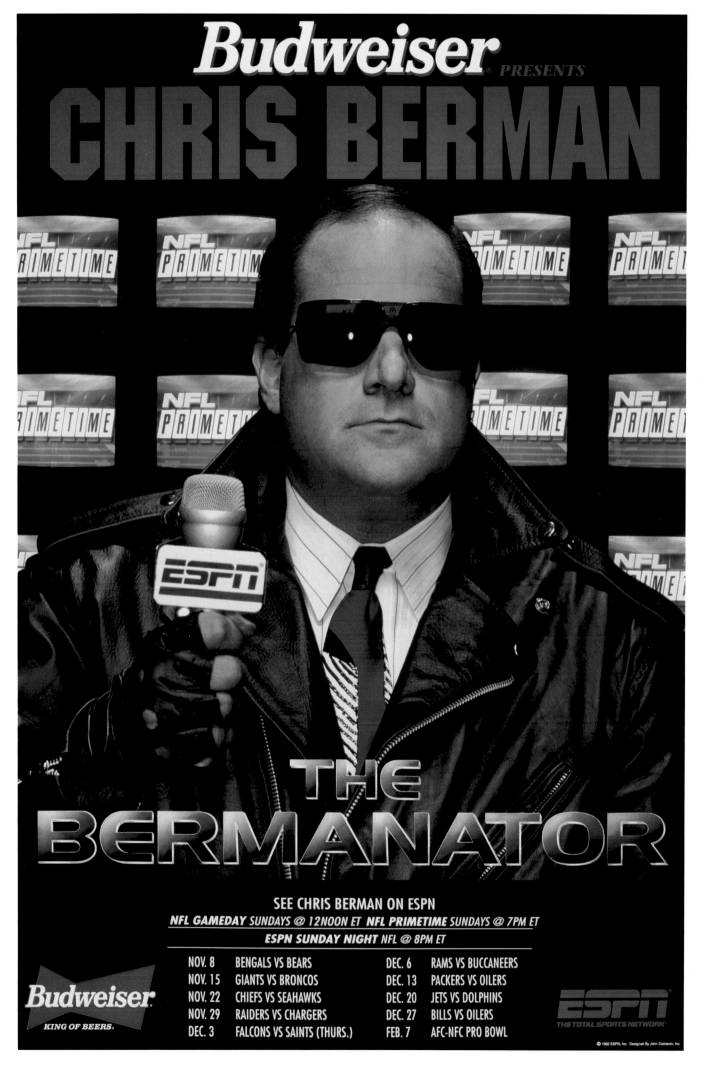

Will Clark

San Francisco Giants
1991 MLB All-Star

In 1987, we held a photo shoot for Will and produced a poster titled "Willpower." We loved the title—and loved the way the guy played. He was an amazing hitter and was known for having one of the most beautiful swings in baseball. He could hit for average and for power, the latter of which was amazing, because he wasn't a big, muscular guy like a lot of the other power hitters.

But we felt like we had let him down. There was a lot we liked about "Willpower," but we had imagined it would be . . . better. So often, when we got the film developed after a shoot, it exceeded our highest expectations. Our vision for "Willpower" was to capture the motion in his beautiful swing, with him knocking the cover off the ball. A lot turned out great in that one, but the most important element didn't: We just didn't do a good enough job capturing the power in his swing, and this bugged us. It should have been better.

Will's agent, Jeff Moorad, was always great to us. He was one of our very favorite guys to work with on deals, and we felt like we'd let down not only Will but Jeff, too. When we put together a photo shoot, we usually did a number of shots as backups so we could compose various elements together in a photo lab if our primary shots didn't work. But we didn't get any good shots of his full-speed swing that we could have used in a Plan B. In the end, the colors turned out great, Will looked great, we loved the lettering, but the execution wasn't good enough. We were disappointed in ourselves and thought that we owed it to Will to do something better.

Five years after "Willpower," Will continued to shine. He wasn't just the baseball phenom who had homered off legendary pitcher Nolan Ryan in his first at-bat. He was now a five-time All-Star, the 1988 National League RBI leader, the 1989 National League Championship Series MVP as he helped drive the Giants to the World Series, and the 1991 Gold Glove Award winner.

And we were a different company, too. We'd been successfully selling our posed studio posters and kept growing our distribution, so the leagues expanded our licenses to include action shots. Some of these were pure game action, and some featured the player in action but stripped onto a new background. We liked the action shots a lot more that we thought we would. The best part about this new process was being able to sift through frame after frame of unbelievable action shots. It was frustrating and tedious to look through that many photos, but the great photography made it worth it. And when we saw this shot, we knew it was our chance to make things right with Will.

The title is, of course, from the classic 1984 baseball movie starring Robert Redford. This photo was shot by longtime Dodgers photographer Jon SooHoo, and it perfectly showcased the perfection in Will's swing as well as the power that had been so elusive at our 1987 shoot. If you're reading this, Will, we hope you think we did right by you.

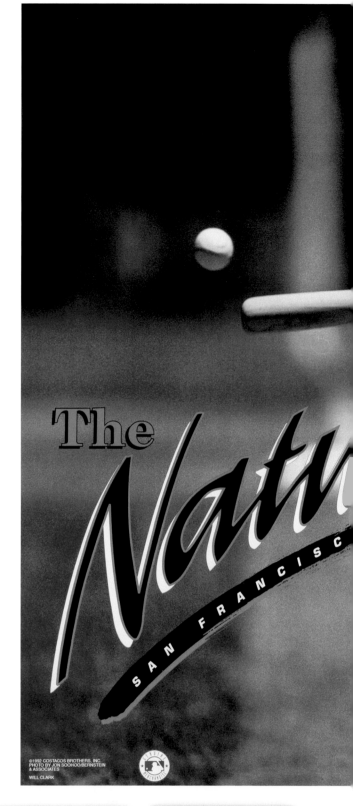

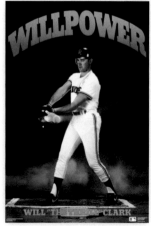

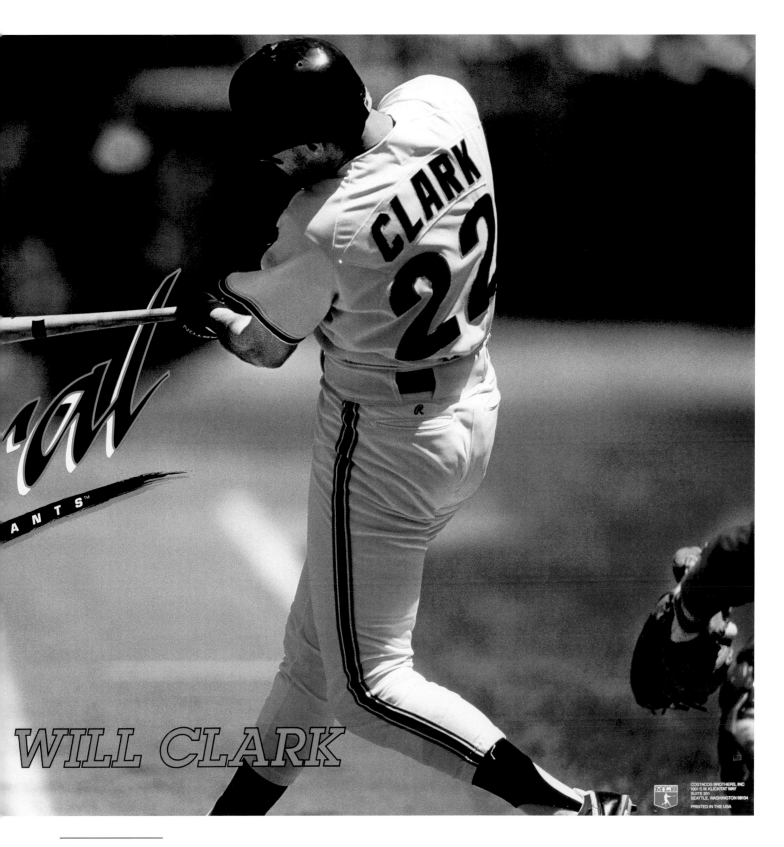

WILL CLARK

CLARK 22

Here's an outtake of
from "Willpower," along
with the final poster.

Jackie Joyner-Kersee

USA Track & Field

1992 Olympic Gold Medal in the Heptathlon

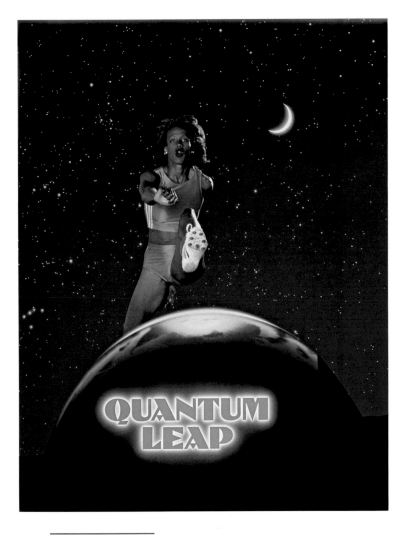

We tried a few different typefaces for "Quantum Leap," such as this variation.

Jackie Joyner-Kersee was one of the greatest track athletes of the 20th century. She competed in four Olympics, winning six medals, including two gold medals and one silver medals in the seven-event heptathlon and one gold medal and two bronze medals in the long jump. The woman's heptathlon winner is considered the world's greatest female athlete because its seven events—100-meter hurdles, high jump, shot put, 200-meter run, long jump, javelin throw, and 800-meter run—test an athlete's strength, speed, agility, and stamina.

She shattered the heptathlon world record in 1986 at the Goodwill Games in Moscow, broke that record a month later at the US Olympic Sports Festival in Houston, broke *that* record at the 1988 US Olympic Track and Field Trials in Indianapolis, and broke it once more at the 1988 Summer Olympics in Seoul, a record that still stands to this day.

We regularly talked about making posters of women athletes over the years but hadn't done it. Part of the reason was that we focused on expanding in the major team sports because that's where we'd sell the most product. But we knew that there's always a market for something that nobody has served yet. We were excited for a chance to work with Jackie. Since a lot of people aren't wholly familiar with the heptathlon, we drew up a sketch calling it "Magnificent Seven," which would have her in her uniform and surround her with props that would reference each event, with a javelin, a shot, and gym bags for the other events. Each bag would be labeled with the event names, and each bag would have its own gear and shoes. (We thought her shoe company might love that part.)

The 1992 Olympics were quickly approaching, though, and she was in heavy training, so we were unable to schedule the photo shoot. So, we went to Plan B and started looking for existing photos, and this is the one we liked best. We took the title from Quantum Leap, the popular Scott Bakula time-traveling TV show. Meanwhile, Jackie went to Barcelona and won two gold medals, in the heptathlon and the long jump.

We always knew there was a market for female athletes. In addition, we thought there were markets for men and women in tennis, golf, and a number of other sports. But we were concentrating on the big professional sports that had the largest audiences. Jackie helped us break the ice with our first female athlete's poster. Right around the time we sold the company, we signed a contract with our second female athlete, American soccer star Mia Hamm.

One amazing change from our poster days to now is the rise in popularity of female athletes. Though the major sports still draw the biggest audiences, the media landscape has changed and given far more exposure to female athletes. As boys growing up watching male athletes, we all got to see our sports heroes on TV and buy posters and endorsed gear, like their signature baseball gloves. Girls in our generation didn't have much access to female athletics on television. They do now.

Jackie Joyner-Kersee broke the ice for us. Mia Hamm built on it. And today there are a lot of posters available of women athletes. We don't know if we were the first to put a female athlete on a poster, but we were proud that Jackie was *our* first.

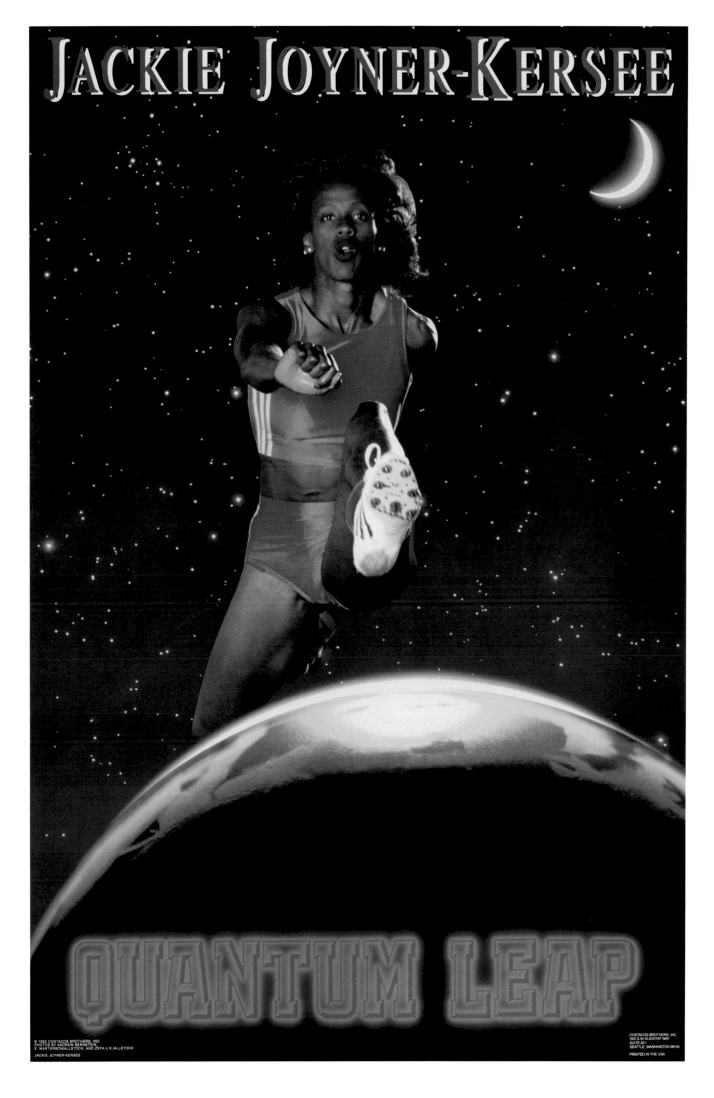

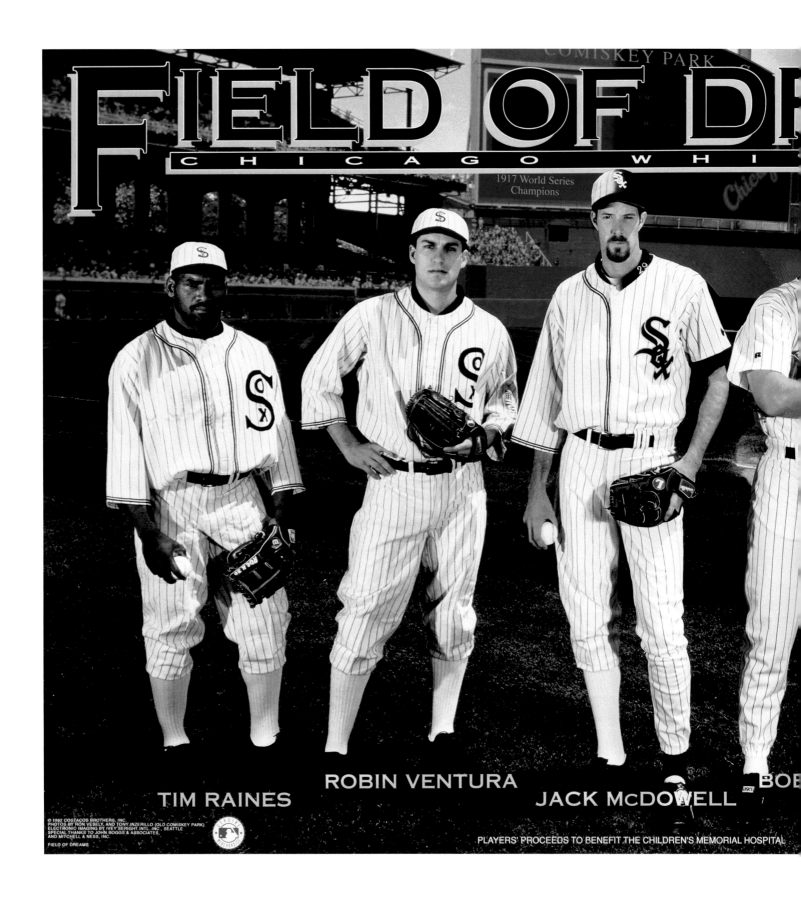

FIELD OF DREAMS

CHICAGO WHI

1917 World Series
Champions

TIM RAINES ROBIN VENTURA JACK McDOWELL BOB

Tim Raines, Robin Ventura, Jack McDowell, Bobby Thigpen & Steve Sax

Chicago White Sox
A New Tradition at New Comiskey Park

The original Comiskey Park was home to the Chicago White Sox for 81 years. They tore it down and, across the street, built the new Comiskey, which is now called Guaranteed Rate Field. When we heard the old stadium was being torn down, we had hoped to shoot something there for nostalgic reasons, but we didn't get it done before it came down. So we improvised. We didn't get to shoot in the old stadium, but we pretended to.

The Kevin Costner baseball-themed movie *Field of Dreams* had been a big hit when it came out in 1989, and we liked it a lot. We also knew it would be a good name for a poster, so that went on the to-do-someday list, and we pulled it out for this one. We had been starting to do more group shots and thought this would be a nice theme to connect the two stadium eras, especially since one of the characters in the film, Shoeless Joe Jackson, played for the White Sox at Comiskey. Now, we just had to figure out a way to blend the old and new stadiums, which was going to be a bit of a challenge given the technology limitations at the time.

We started with a photo of the old Comiskey Park, which you see on the left half in the background. Armed with a camera and the photo, we then went to the new stadium on a visual scavenger hunt, walking around the field while looking through the viewfinder to find a matching spot to shoot from. It needed to be from the same vantage point as the old photo so the backgrounds would blend together—specially the outfield fence and the scoreboard, which would be right in the center. We found just the right spot on the third base line.

We had previously worked with Tim Raines and Robin Ventura, and they helped us coordinate the participation of Jack McDowell, Bobby Thigpen, and Steve Sax, who had been traded to the White Sox for the 1992 season. We got three vintage uniforms from another licensee (in return for copies of the poster when they were printed), and the others wore their regular uniforms.

Just before they left the clubhouse to go on the field to shoot, their teammate Ozzie Guillen said something about how we had Tim Raines in the vintage uniform from early 1900s, an era when there weren't any black players in the majors. We hadn't considered this, but our art director, Bart Unger, had the best answer: "There should have been." So we kept Tim in that uniform.

The big challenge was getting Jack McDowell split down the middle in both uniforms. We shot the group photo first with him in the old uniform. Then he changed and we shot Jack by himself in the new uniform in the same pose. He memorized his position well, and we used Polaroids as a reference. We needed him to be in the exact same position so we could blend the two photos together.

He did a great job of remembering, and when we got home and put the slides of Jack on top of each other, they were a perfect match. The photo lab worked their magic to blend the photos together, and that was it.

We liked this poster because it connected the modern team with its history, as old Comiskey had been around so long that Babe Ruth and Ty Cobb had played there. And Shoeless Joe Jackson.

Sarunas Marciulionis

Golden State Warriors
1992 Olympic Bronze Medal

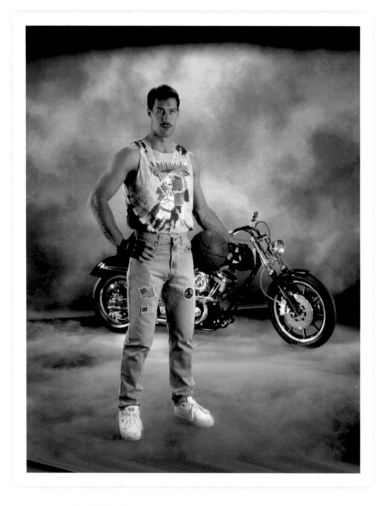

Here's a test shot we did with the black motorcycle, but we liked the red one better. Sarunas is wearing the original shirt design by artist Greg Speirs.

Sarunas was a bit of a folk hero, and not just in the San Francisco Bay Area, where he played a major role as a tough, slashing guard who averaged 18.9 points off the bench during the 1992–93 season for Don Nelson's exciting Golden State Warriors. He was part of a cool local story, which soon became a national story and eventually an international story that's still remembered decades later.

Before he was with the Warriors, Sarunas was one of the best basketball players outside the United States, and a key part of the Soviet Union national team that shockingly beat the United States and won the gold medal in the 1988 Olympics. But when Lithuania declared its independence from the Soviet Union in 1990, Sarunas and his newly resurrected Lithuanian national team found itself needing financial support to compete in the 1992 Olympics. Word got out that Lithuania needed help, and it got that help from an unlikely source: the Grateful Dead.

The legendary rock band heard about their story of freedom and donated money to the team as well as shirts tie-dyed in Lithuania's national colors. While the US Dream Team captured the world's attention in Barcelona, tiny Lithuania slowly gained national—then international—attention as they kept winning and their story got out.

In a storybook ending, in the bronze medal game, Lithuania played the Unified Team, which consisted of basketball players from the remaining countries from the dissolution of the Soviet Union, including Russia. The Unified Team had already beaten Lithuania 92-80 during pool play, despite Sarunas's 21 points, 7 rebounds, 8 assists, and 4 steals.

With the world watching and national pride at stake, Sarunas scored 29 points as Lithuania beat their former colonizers by a narrow 82-78 margin in an emotional game. After the game, the team proudly walked onto the podium in front of the world, unexpectedly wearing their wild tie-dyed shirts with a skeleton dunking a basketball as a gesture of thanks to the Grateful Dead for their support.

Following the Olympics, they sold shirts in this style to raise money for Lithuanian charities. The title for his poster had to do with Sarunas's "long, strange trip" from Lithuania to America, a nod to lyrics from the Grateful Dead song "Truckin'." If you look closely, you'll notice the white title text has a subtle drop shadow in blue and yellow, the team colors of the Warriors.

The two motorcycles for the shoot were custom-built by Arlen Ness, the famous motorcycle designer. There was a red one and a black one, and we shot with both but the red one looked better. This poster developed a cultlike following because it was so different. There's a lot of color in it, and we loved having Sarunas wear his Grateful Dead T-shirt.

What most people don't know about this poster is that Grateful Dead icon Jerry Garcia was actually going to be in it. Unfortunately, Jerry became very sick the day before the shoot and wasn't able to come that day. Since Sarunas was the main feature, we decided to still shoot it with just him. But can you imagine how cool it would've been to have Sarunas alongside Jerry—two of the driving forces behind that magical 1992 team?

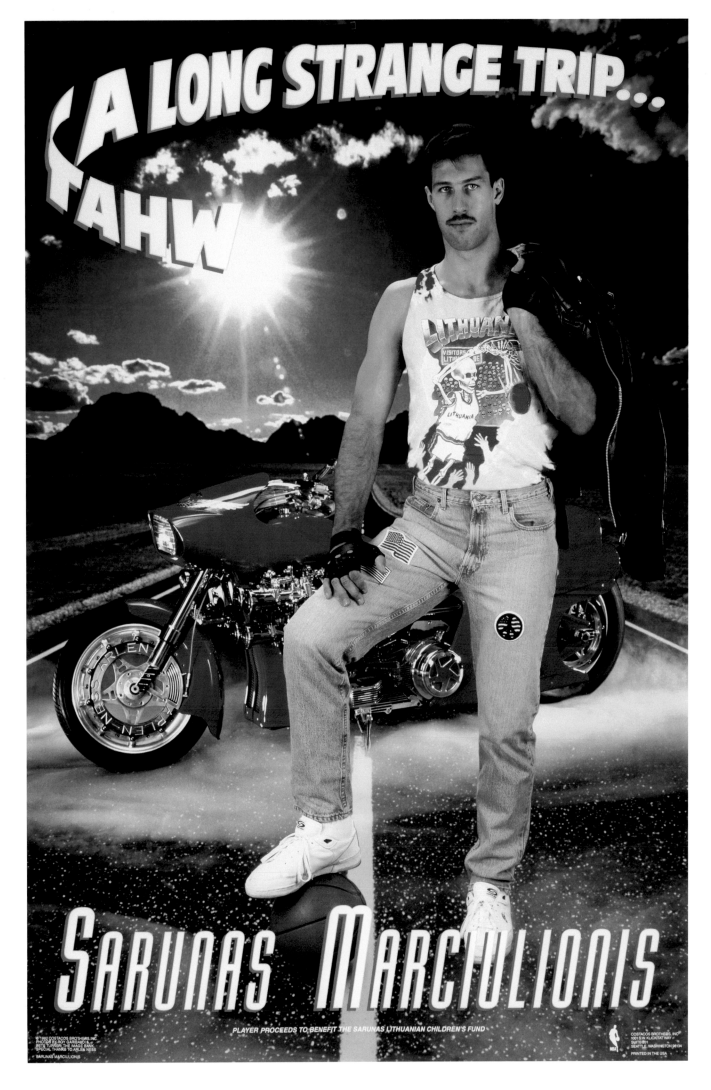

Shaquille O'Neal

Orlando Magic
1993 NBA Rookie of the Year

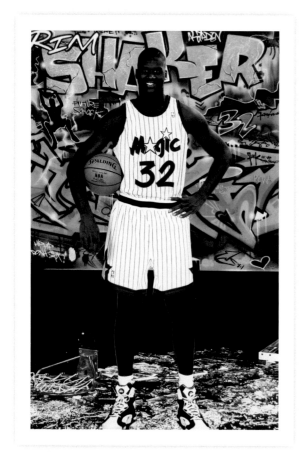

The original design had
a shattered backboard
on the ground.

Shaquille O'Neal is a big kid. We're not talking about his size—we're talking about how he is a little kid in a man's body. Despite being plenty grown-up, he has a great sense of youthful fun. Put him in a room with a bunch of people, and he'll find the little kids and hang out with them. When we went out to dinner with him and a group of people after he was in Seattle for a game, he spent most of the time talking to and doing magic tricks with a 10-year old boy who was there.

When Shaq came into the league out of LSU, it was big news, and of course we wanted him on posters. With our NBA license, we almost immediately released posters from game action shots, but we wanted a studio shot for him. As luck would have it, we were able to get a meeting—6,000 miles from home.

We met with Shaq in Athens, Greece. He was there on a Reebok promotional tour, and we were there on vacation. Our friend, photographer Andy Bernstein, was on the tour, and he got us all together and we spent a bunch of time with Shaq, his agent, a French basketball journalist, and Shaq's two very funny bodyguards, Mike and Jerome.

The Reebok people took us all out on a yacht to the Island of Paros so we could go swimming and riding on Jet Skis. Every time Shaq fell off his Jet Ski, one of us would have to get off ours and into the water to counterbalance his so he could get back on it. It's too bad we don't have video of him trying to climb back on the Jet Ski by himself, because it just kept rolling over because he's so big.

And, behaving like a big kid, Shaq went to the bridge of the yacht—which was probably about 15 feet over the water—and after standing there debating the idea for a couple of minutes, he attempted to do a flip into the water. He completed about three-quarters of the flip before slapping down onto the water on his side. He and his bodyguards laughed themselves silly. The guy enjoys life, he likes people, and every time we've met him, he's always been great to be around. (Plus, we have some priceless video of him telling us the naughty Greek words he had learned.)

The NBA made us redesign and reprint this one. Shaq literally broke backboards—he had shattered a number of glass boards with his powerful dunks—so we were going to title it "Backboard Breaker," but changed it to "Rim Shaker." We put a shattered glass backboard on the ground, got the design approved by the NBA, and printed it. Then the NBA changed their minds and told us we had to redo it.

We understood why they didn't want us printing anything with Michael Jordan's tongue sticking out—it would've been awful if children stuck their tongues out and accidentally bit themselves while trying to be like Michael. But what was a shattered glass backboard going to make children do? Put on 200 pounds and shatter backboards themselves? Oh, well, getting the NBA's approval was part of our licensing contract, so we swapped in an unshattered backboard in the background.

The only thing we regretted was that we didn't have the artist paint one of the walls inside our warehouse so we could permanently keep it. The guy did an amazing job, and we would have loved to see his art every day.

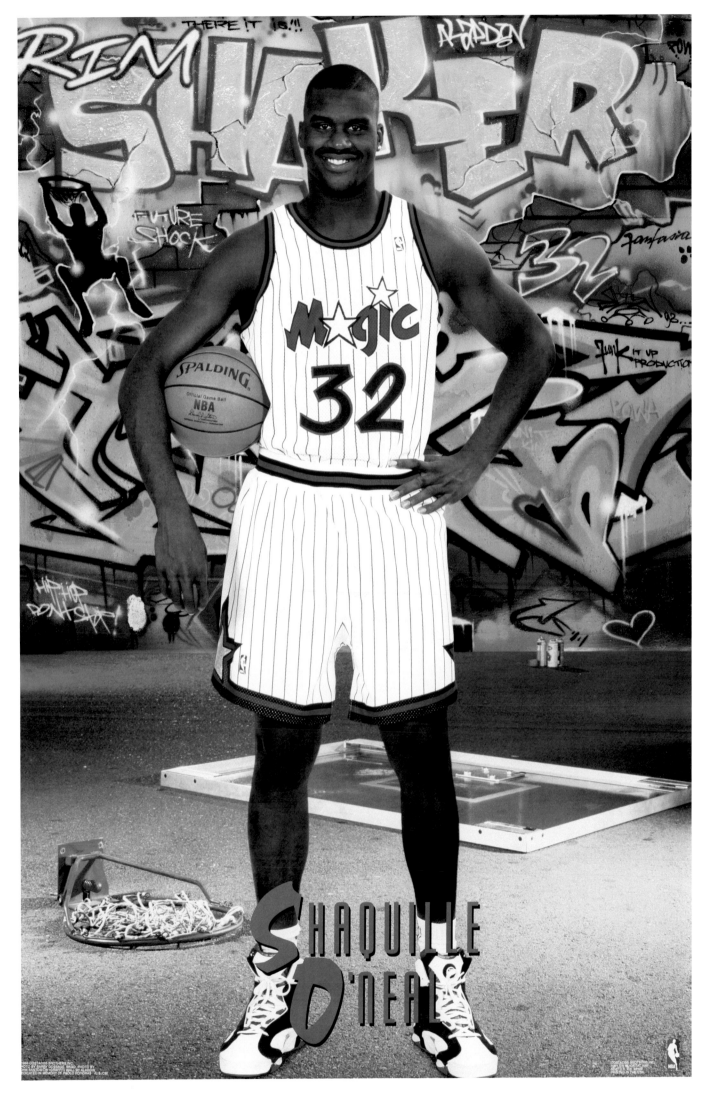

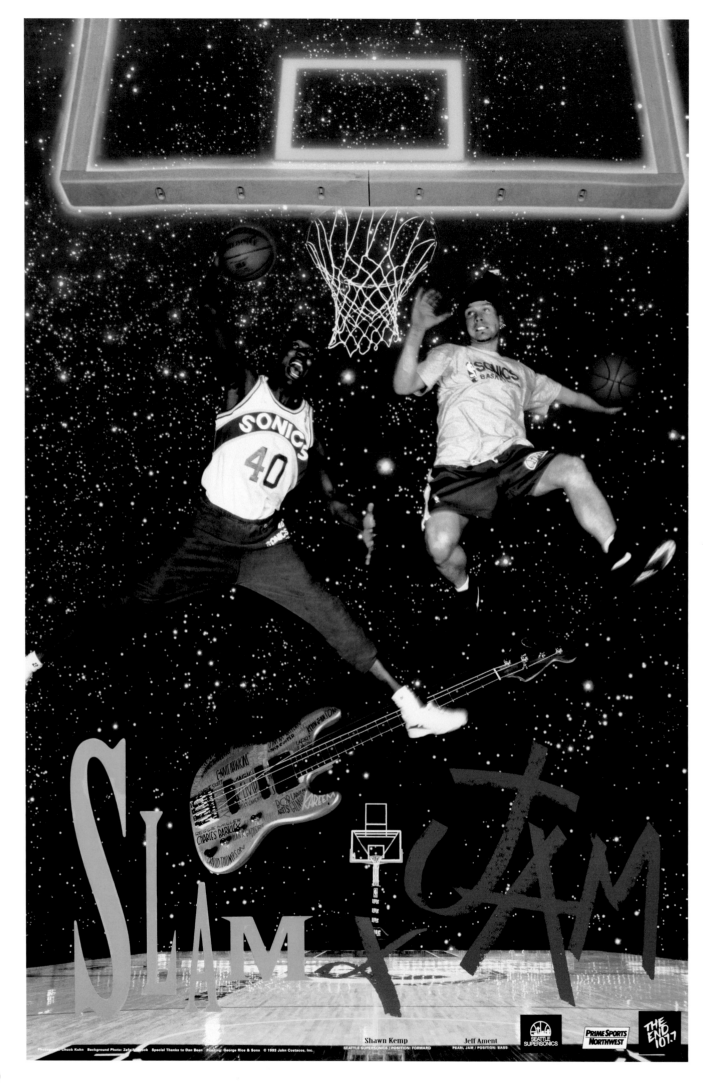

Shawn Kemp
SEATTLE SUPERSONICS / POSITION: FORWARD

Jeff Ament
PEARL JAM / POSITION: BASS

Shawn Kemp & Jeff Ament

Seattle SuperSonics & Pearl Jam
15,347 Points & 21 Top 10 Singles Combined

John and Jeff at the shoot—Jeff's bass has his favorite NBA players written on it for inspiration when he plays.

Being in Seattle in the early '90s was as fun as it could be if you liked basketball, music, and especially both. George Karl, who became the head coach midway through the 1992–93 season, turned the Sonics into one of the most exciting teams in the NBA. They played tough defense and their transition game was—well, if it were today, we'd call it "The Fast and the Furious."

At the same time, the grunge music scene had exploded in Seattle, and the city was alive with new bands and music venues. Nirvana, Alice in Chains, and Soundgarden had become international successes, as had a little band called Pearl Jam. Their smash debut album *Ten* had been released in August 1991, but it kept gaining momentum and peaked the next year at No. 2 on the *Billboard* charts and sold more than 10 million records.

At that time, if you went to a Sonics game and looked down behind the south baseline, you'd see Jeff Ament, Pearl Jam's bass player. He was a big Sonics fan and loved basketball, and seeing him at Sonics games was as dependable as seeing Jack Nicholson at Lakers games. In fact, before Pearl Jam settled on that name, they toured with Alice in Chains as Mookie Blaylock, named after the NBA player. I had gotten to know Jeff a little bit, and we had talked about how Charles Barkley was his favorite player, and I invited Jeff to dinner to meet Charles when he was in town. (Afterward, I asked Jeff which he would choose if he could be either a musician or an NBA player. He said both, but if he had to pick one industry, it would probably be music, because you can do it longer.)

Tock and I often played a game where we'd think about what the poster theme for a particular person—a friend, a family member, or even a celebrity—would be. When we were at Starbucks once, we wondered what Starbucks CEO Howard Schultz's nickname would be: "the Caffeinator," of course. One night, when I saw Jeff at a Sonics game, I told him that when Jeff made an NBA roster, his poster theme would be "Slam and Jam." We had a good chuckle about it, and later I thought about pairing Sonics player Shawn Kemp—who I knew from the "Reign Man" poster and was a really great guy—with Jeff, and made a call to Shawn. He loved the idea.

We shot it on the Sonics home court at Key Arena. To be sitting under the basket while Shawn Kemp is coming at you and laying down dunk after dunk after dunk was unbelievable. The power and explosiveness up close—wow. And believe it or not, Jeff was equally impressive. We set up a mini trampoline in the key and a 12-inch-thick crash pad for him to land on, and Jeff laid down his own string of spectacular dunks that were worthy of All-Star Weekend.

Pairing an NBA All-Star with a rock star for a poster isn't something you'd normally expect to see, but with Shawn Kemp being the dunking machine that he was and Jeff being an icon of the Seattle music scene and a genuine fan of the Sonics, it was a great match. Besides, Jeff's band was called Pearl *Jam!*

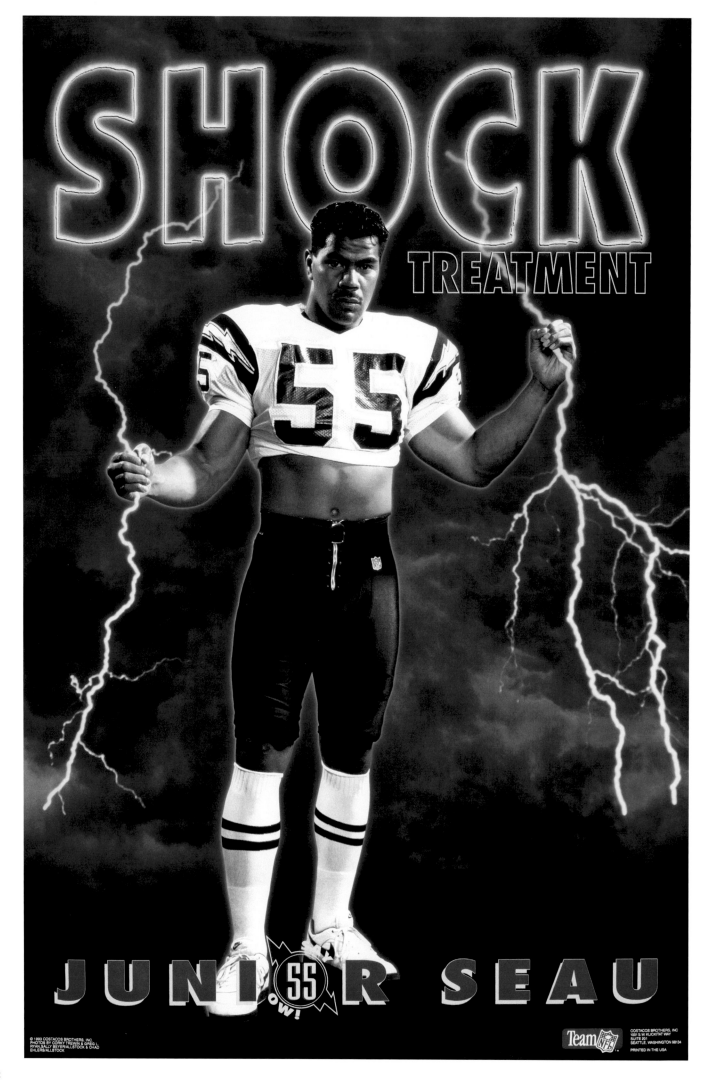

Junior Seau

San Diego Chargers
1992 NFL Defensive Player of the Year

Junior and John,
trying to figure out
who was bigger.

W e were familiar with Junior Seau because he had played college ball at USC, one of our alma mater's foes in the Pac-10 Conference. He had been the Pac-10 Defensive Player of the Year in 1989, and he became the fifth pick in the NFL Draft, by the San Diego Chargers. (It was Junior's stellar play at linebacker that originated USC's tradition of "Club 55," inspired by his jersey number, which was henceforth bestowed only on linebackers who were thought to have the potential to live up to Junior's legacy of excellence.)

He would go on to great heights in the NFL, earning eight All-Pro First Team selections and the NFL Man of the Year award in 1994, being selected to the NFL 1990s All-Decade Team, and having his number retired by the Chargers. But here we were with him in one of the first years of his career, shooting a poster with him in Hawaii.

At this point, we were starting to make a lot more titles than before. We still got to create, but we just had to do more of it. With the large number of titles we needed to produce to satisfy the market (as well as our licensors), we had to line things up early and get them in the pipeline. One way to do this was to shoot at the Pro Bowl, where all the star players congregated and which took place seven months prior to the start of the next season.

Junior was a great guy and extremely nice. He loved the beach and spent a bunch of time with us there just hanging out. He enjoyed shooting the bull with us about everything—and nothing—and we liked that about him. Junior had just won the 1992 Defensive Player of the Year award, and the guy was so unassuming about it, you never would have known.

We should have made the lightning bolts thicker on this one, more bold and explosive-looking. This is one of the posters that marked a bit of a change in the feel of our work. The imaging industry was starting to have more digital content and effects that we could take advantage of. We were utilizing the technology available at the time, but we often asked ourselves if we should be doing that or trying to stick to our original style of physical props and sets.

One of the titles we considered for Junior included "Say Ow!" with an opposing player on the ground, as if he'd just been hit. Had it been in the earlier years, before we were officially licensed, we could have done that, but now, that wasn't going to fly with the NFL. "System Shocker" and "Get Shocked" were others that we considered, referencing the Chargers name.

We had also talked about putting him in a traditional Samoan warrior costume, but that probably wouldn't have been acceptable to the NFL under our license. One of the other titles that was kind of interesting was "All Shocked Up." We took it from the phrase "All Shook Up," like the title of the Elvis Presley song, but the NFL said no because they thought it had to do with "All F*@%ed Up." You can't please everybody.

SERGEI FEDOROV

AGENT 0091

FROM RUSSIA WITH LOVE

Sergei Fedorov

Detroit Red Wings
1991 NHL All-Rookie Team

We later made posters
of Sergei's former CSKA
Moscow teammates, the
Vancouver Canucks' Pavel
Bure (above) and the
Buffalo Sabres' Alexander
Mogilny (below).

NHL fans got a great windfall as the Iron Curtain began to come down. The defection of Alexander Mogilny in 1989 was the beginning of an invasion of talented hockey players from the former Soviet Union, mostly from Russia. One of them was Sergei Fedorov.

The only time we saw Soviet athletes while we were growing up was during the Olympics. There was a sinister feel to the way we viewed them because the Soviet Union was the enemy and their athletes didn't get interviewed on American television, so we had no connection with them as regular people. The Iron Curtain was also a media curtain, so we knew almost nothing about them. It's not like any of them were going to be guests on *The Tonight Show*.

From today's perspective, this seems odd. Some of the greatest athletes in the world were people we didn't know about, and many Americans had barely even heard of them? When the United States beat the Soviet Union in the "Miracle on Ice" game during the 1980 Winter Olympics, most non–hockey fans learned for the first time that the Soviet Union was considered the best in the world. We'd get to see them only every four years in the Olympics, and only when they played Team USA. But in 1989, we started to get to know them with the debut of Alexander Mogilny with the Buffalo Sabres, and in 1990 we got a close look at Sergei Fedorov.

Fedorov was one of the best not just among Russian hockey players but also in the entire world, and that's why he's in the Hall of Fame. He was a strong and talented forward who came to the Red Wings and eventually helped bring the Stanley Cup back to Detroit.

We loved James Bond movies, and the poster's theme title came from the 1963 Sean Connery film *From Russia With Love*. It was a simple shoot with Sergei in a tux and two Bond girls—we chose Playboy Playmates Cathy St. George and Rebecca Ferratti. We wanted to put them in cocktail dresses, but the NHL had a problem with that: They didn't want us showing too much skin and preferred we put them in hockey jerseys. This defeats the purpose of having the Bond girls, but the NHL had veto power as the licensor. (Ironically, look at the NHL Ice Girls today: Their outfits show a lot more skin than a cocktail dress does.) We got used to this kind of scrutiny.

Usually, we didn't use makeup for the players. The problem wasn't the cost of the makeup artist; it was the cost of the time it took. We were making posters for kids, not advertisements for *Vogue*, and we wanted to minimize the athlete's time. But Bond girl Cathy St. George (on the left in the poster) was a professional makeup artist. She took a look at Sergei and said his skin needed "smoothing." Cathy's not the kind of person you argue with when she's on a mission, so she grabbed her makeup kit, and a short while later, Sergei was . . . smoother?

There were times we had gotten fairly elaborate with our shoots and put a lot of extra elements in them, but for this one we wanted a simple and clean look. Sergei looks great, and the girls do, too. (But, seriously, Bond girls in hockey jerseys?)

Randy Johnson

Seattle Mariners
1993 MLB All-Star

This pose put Randy's
hand in an awkward
position, so we had him
lean on his other side.

They called him the Big Unit, and for good reason. Randy was a 6-foot-10 pitcher who often clocked 100-plus-mile-per-hour fastballs during the prime of his career. Another player told us that standing at the plate with Randy Johnson on the mound was "the scariest thing in baseball, because with his long step toward the plate, it feels like he's on top of you when he releases the ball." Lucky for us, he was playing with the Mariners starting in 1989.

When Randy was traded to our home team, he was known as a powerful—but slightly wild—pitcher. He led the American League in walks for three straight years, and hit batters for two seasons. But starting in 1993, he mastered his control and dramatically cut down on his walks and struck out a league-leading 308 batters. With Randy on the mound and Ken Griffey Jr. at the plate, our perennially not-anywhere-near-the-playoffs Mariners were building into some of the best teams they ever had, finally making the playoffs for the first time in the mid-'90s. There was a lot of excitement for the team, and Randy was a big part of it.

We made a few posters of him over the years, but this is the one we like most. Everyone knew his nickname, but we never knew where it had come from until Randy told us: One day, when he and Tim Raines had been teammates with the Montreal Expos, Tim, who had finished batting practice, walked into Randy, who was a rookie at the time. He looked at Randy and said, "Hey, you're a big unit."

We shot Randy at our warehouse, which was just a few minutes' drive from the Kingdome, where the Mariners played home games. Seeing Randy on the field is much different than seeing him in person. He's tall and skinny and looks like a guy who can throw heat. It was an easy shoot, and Randy was fun and personable and took pictures with everybody afterward—nearly our whole office got photos with Randy that day.

The final product was a combination of three photos: Randy, the city of Seattle, and the lightning. Digital technology was beginning to change our industry, but it was still in its infancy, so we still used the photo lab to compose the three photos together.

A couple of years later, at the beginning of the season, our art director, Bart Unger, happened to call Randy on the day of a start— they had become friends over the years. Randy won the game. Bart called a few more times, all coincidentally on a day Randy was pitching, and he won those starts, too.

Baseball players are superstitious, and Randy was no exception. He had a winning streak going whenever Bart called him and didn't want to mess with it, so Randy told Bart to call him before the game on every day he pitched. He said, "If you don't get ahold of me, leave a message. But just call."

Randy finished that 1995 season with an 18-2 record, a 2.48 ERA, and 294 strikeouts, and won his first Cy Young award. Of course, nobody can prove that Bart was the reason . . . but then again, nobody can prove that he wasn't!

Derek Kennard, Wade Wilson, Irv Smith, Vaughan Johnson, Quinn Early & Willie Roaf

New Orleans Saints
12-4 Record in 1992

This is one that we had the least control over. In the beginning, we went on all the shoots, but by 1993, we were cranking out so many titles that we were spread pretty thin. Even though we were doing fewer studio and location shots as we transitioned into using action shots stripped into backgrounds, we had to have some of our guys do shoots by themselves.

By this time, we had enough experience working with our regular photographers that we felt we could send detailed sketches along with some specific direction, and the photographers could do it without us there. This was less fun than us being there, and it felt more risky, because we had less control, but it was necessary given the number of posters we were producing.

We had a good relationship with the New Orleans Saints from our "Dome Patrol" poster in 1988. It had become a classic in that city, but we felt it had run its course after five seasons. After the 1992 season, in which the Saints went 12-4, we wanted to create something for the 1993 season. We came up with "Delta Force" because New Orleans is at the Mississippi River Delta, and the US Special Forces has a special unit with that name. That made sense for a poster, as well as for T-shirts and other apparel.

Our original plan was to feature the defense—the Saints had finished the 1992 season with the tenth-ranked offense, but their defense was the best in the NFL. But for team unity, the players wanted the poster to consist of both offensive and defensive players. That was fine by us. So, in addition to Pro Bowl linebacker Vaughan Johnson, this poster includes quarterback Wade Wilson, guard Derek Kennard, tight end Irv Smith, and wide receiver Quinn Early— and a rookie left tackle named Willie Roaf, who would go on to become one of the greatest players in Saints history.

Art Director Bart Unger drew up a detailed sketch of exactly how we wanted it to look like. Exactly. It especially needed to be framed to our standard 23-inch-by-35-inch size, so the aspect ratio had to be accurate. We combined the sketch with a list of specific instructions and sent it to photographer Bob Rosato. We had a few phone conversations, and Bob was good to go.

We felt strangely confident that it would turn out the way we wanted it to. We'd made enough posters that the photographers knew how we worked, and they had enough examples of our posters that it seemed like this would work. Plus, they all knew more about photography than we did! We actually love admitting that—every photographer we shot with taught us something about styles, equipment, personalities, and approach. We got to learn from the best.

Despite the experience we had gleaned from working with such pros, it wasn't nearly as much as the experienced logged by the guys who shot sports photos every day for years and sometimes decades. We worked very hard to create concepts, and sometimes we'd be very involved in art-directing a shot to match what was in our heads. At other times, we'd turn the photographer loose. And even when we took total control of the shoot, after we felt we got what we needed, we would tell the photographer it was his turn and told him to see what he could come up with. With this one, Bob nailed it.

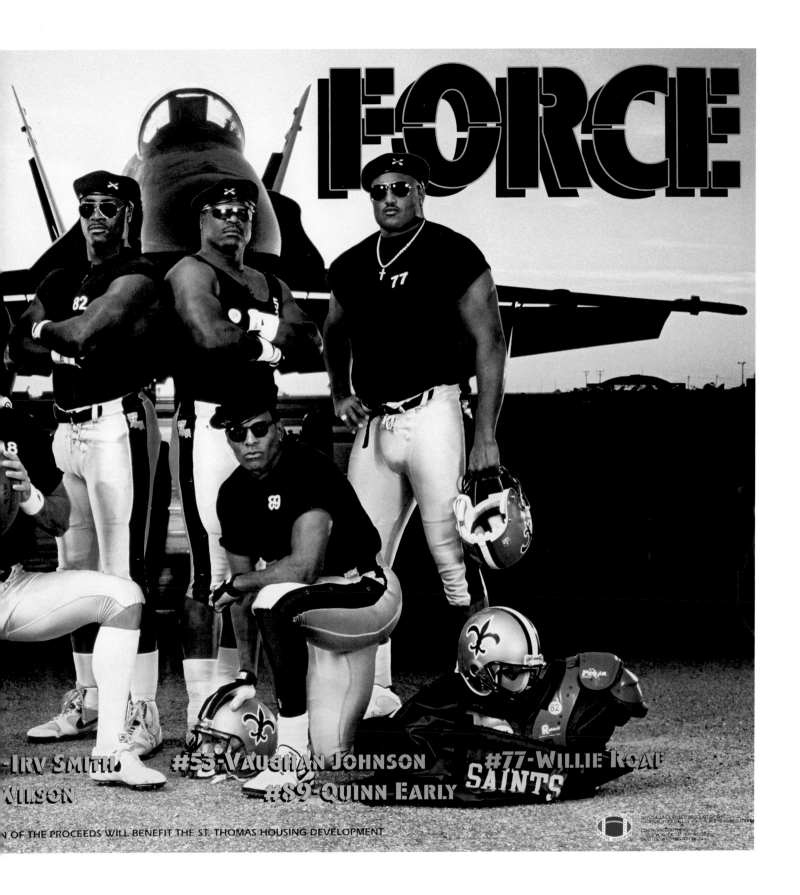

FORCE

#—IRV SMITH
WILSON
#53—VAUGHAN JOHNSON
#89—QUINN EARLY
#77—WILLIE ROAF

N OF THE PROCEEDS WILL BENEFIT THE ST. THOMAS HOUSING DEVELOPMENT

David Stern

National Basketball Association
Commissioner, 1984–2004

MICHELE BROWN

Hi John,

I've enclosed photos of David Stern.

Remember do not make a mockery of the
Commissioner.

Please send me artwork of the poster
before you produce it!!!

Michele

DAVID J. STERN
COMMISSIONER

February 15, 1993

Mr. John Costacos
John Costacos Incorporated
801 Fourth Avenue
Seattle, Washington 98104

Dear John:

 Based upon early returns, "Sterminator" is an unabashed
hit with visitors to my office. I'm already enjoying it, and
wanted to thank you for your thoughtfulness and kind words.

 Thank you again for the one-of-a kind classic, and best
personal regards

 Sincerely,

DJS/lat

(top) This memo came
with the photo I used
for the poster. It almost
reads like she didn't
trust me.

(above) Commissioner
Stern sent me a
thank-you note for the
"Sterminator" poster.

We thought it was so cool that NBA Commissioner David Stern stopped by our booth each year at the sporting goods show in Atlanta to see what we'd been up to. We were so small compared to the league's big, important partners like Nike, Logo 7, and Starter. I had never met him because I was always out of the booth, but everyone said he was very warm and genuinely interested in our work and wanted to see the new images. Not a whole lot of licensees had the commissioner stop by, so it made us feel pretty good.

On April 28, 1992, the Sonics had a home playoff game against the Golden State Warriors, and I was invited to the game by my friend Nancy Welts. Nancy had previously worked for the Sonics and is the sister of Rick Welts, who was the head of NBA's licensing and is now president of the Warriors. When I got to the game, I found out we were the guests of Commissioner Stern. I sat next to him and tried my best not to say anything stupid.

I had a nice time talking with Commissioner Stern about the game, basketball in general, and our business. At halftime, I thanked the commissioner for the ticket and told him it was nice meeting him. The commissioner said, "You're leaving?" I replied, "I have third-row tickets for Bob Dylan at the Paramount. It starts in a half hour." The commissioner just looked at me and repeated, "It's halftime." Not knowing if he was really offended or not, I explained, "My girlfriend's meeting me there." Commissioner Stern repeated, "It's halftime." I thought the commissioner was just having a little fun with me, but I wasn't sure, and I apologized profusely before leaving for the concert.

Two months later, I was in Portland for the debut of the 1992 Dream Team at an Olympics qualifying tournament. The NBA had a hospitality area for sponsors and licensees, and when I noticed the commissioner standing next to me at the buffet line, I asked, "Hey, Commissioner, remember me?" He looked at me with a straight face and said, "Costacos Brothers—guy leaves a playoff game at halftime to go see Bob Dylan." I said, "Come on, you gotta forgive."

The commissioner said it was too late for that but smiled a little when he said it, so I figured he was still just giving me a hard time. "Take me to another game," I said, "I'll stay the whole time, I promise—but they better be good seats." The commissioner started laughing, so I said, "Come on—I'll make it up to you. How about I make a poster of you?" He replied, "Nope—too late," but we chatted about the Dream Team and the Olympics for a few minutes.

I was good friends with our licensing manager at the NBA, Michele Brown, and she swore me to secrecy when I asked her for a portrait photo of the commissioner. As you can see from her note, she knew me well enough not to feel completely safe with whatever I was going to do with it. I had a photo lab combine a photo of Earth with a picture of a basketball to create a basketball planet for the background, and I printed the poster and sent it to the commissioner's office.

A little while later, a letter arrived from the league headquarters, thanking me for the "one-of-a kind classic." While it was nice of the commissioner to send the thank-you note, "one-of-a kind" isn't exactly accurate—a second copy of the poster exists, framed on my wall as a reminder of our conversations.

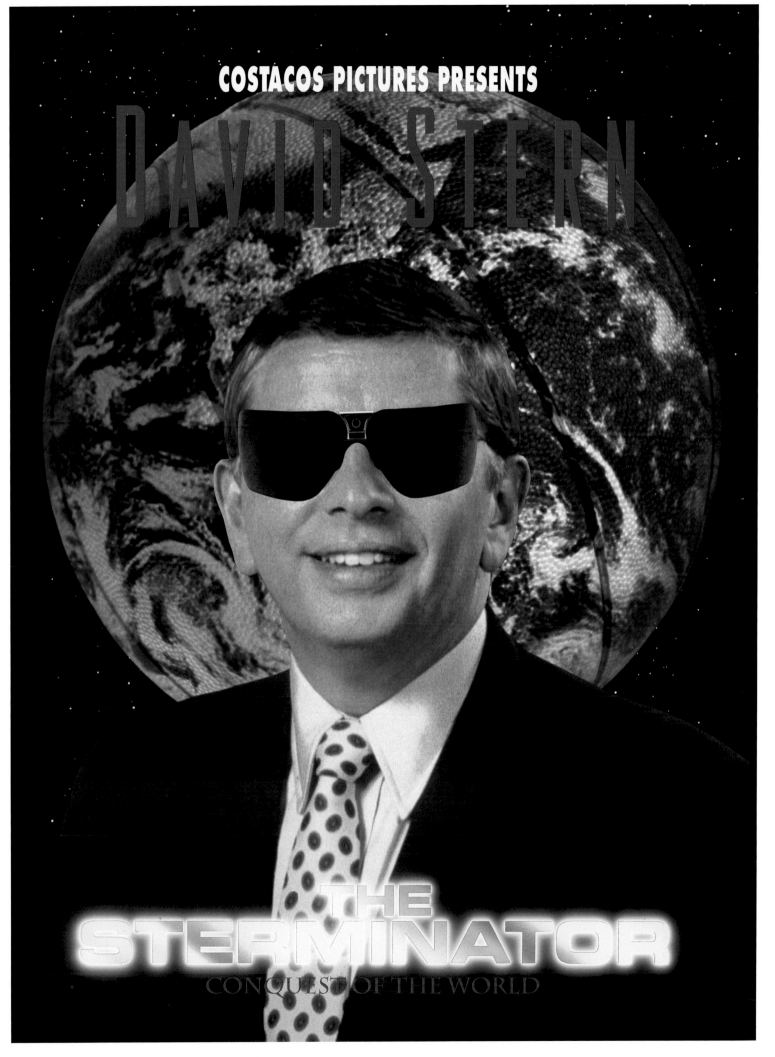

WAYNE GRETZKY

NHL'S ALL-TIME LEADING GOAL SCORER

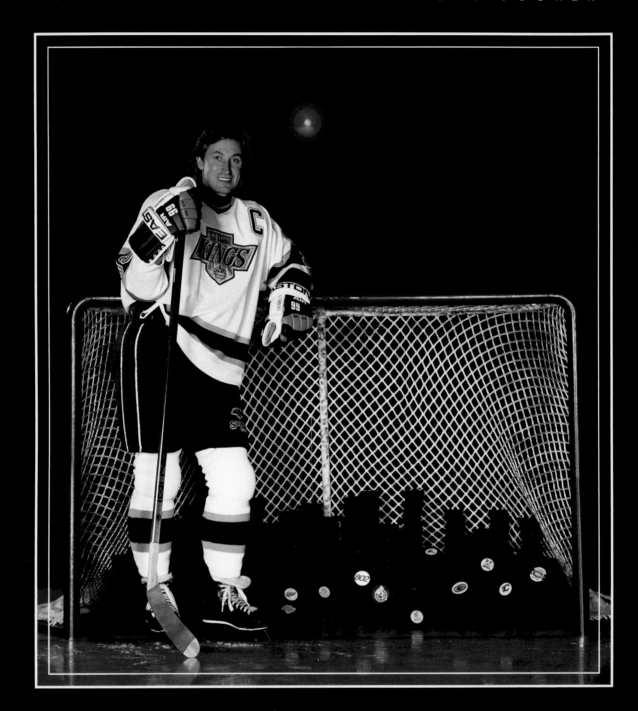

THE
GREATEST
ONE

Wayne Gretzky

Los Angeles Kings
1994 NHL Points Leader

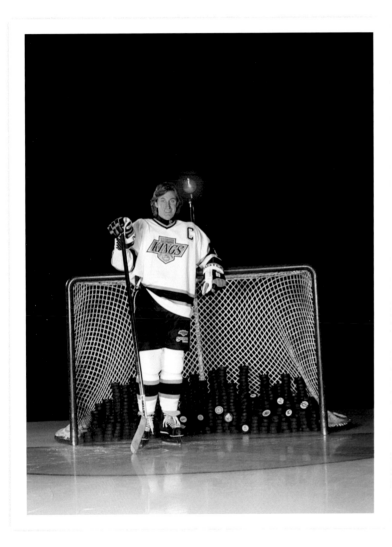

Wayne is every
bit as nice as he's
rumored to be.

There are exactly 802 hockey pucks in the net of this poster. We know, because we counted every single puck ourselves and placed them in the background—we wanted it to be completely authentic.

They called Wayne the Great One for good reason. He scored his first NHL goal on October 14, 1979, and continued to pile up awards and accolades throughout his career. He was just something special on the ice. It was pretty amazing for a guy who wasn't a particularly big, strong, or fast player.

We had been making posters for eight years, and whenever people asked which athlete we still wanted to work with, Wayne was always at the top of that list. As he closed in on the all-time NHL record of 801 career goals, we started talking to Wayne's agent, Michael Barnett. Any all-time scoring title is a pretty big deal, but what Wayne was about to do was truly amazing: The legendary Gordie Howe had set the record at 801 goals over twenty-six seasons. Wayne was poised to break it in just his fifteenth season.

A big part of the story was that Gordie Howe was Wayne's childhood hero, and they had become friends over the years. On March 23, 1994, Wayne broke Howe's record at a home game in Los Angeles, coincidentally against his former team, the Edmonton Oilers. We waited a couple of days until all the noise died down and contacted Michael Barnett to see about shooting the poster, and we got the deal. We went down to Los Angeles and shot it on the Kings home ice at the Forum.

Wearing everyday clothes and sneakers, we went down to one end of the ice to pile up all the pucks in the net. Eight hundred and two pucks is a lot, especially when you have to carry them across ice in sneakers. But once we looked at the pile in the net, it didn't look quite big enough. Through the lens, 802 seemed like it should look . . . bigger. The Kings had a ton more pucks and offered them to us, and since no one would be able to count them in the photo, we considered using them to augment the pile in the net. But in the end, we decided we wanted the number to be authentic.

This was a fairly easy set because we didn't have to build anything. All we had to do was put the pucks in the net and wait for Wayne. So, there we were at the Forum, on our hands and knees on the ice, carefully stacking pucks to make them look the way we wanted, and we heard something. All of a sudden, slowly skating toward us in his uniform was Wayne Gretzky. We felt like Wayne and Garth from *Saturday Night Live*'s "Wayne's World" skit, and we started chanting, "We're not worthyyyy . . . we're not worthyyyy!"

We were just joking around, but being alone with Wayne on his home ice was like standing in a boxing ring and having Muhammad Ali enter wearing his trunks and gloves and saying hello. It's different than bumping into him in regular clothes on the street. The photo we chose is a little smaller on the poster than our normal designs in order to give the accomplishment a truly commemorative look.

Kendall Gill, Gary Payton & Nate McMillan

Seattle SuperSonics
1993–94 NBA Team Steals Leader

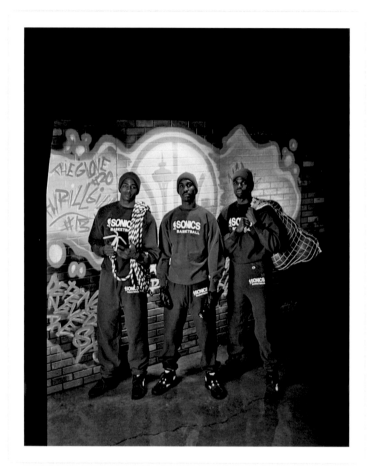

We tried some shots
with the guys wearing
sweats, but their
uniforms looked
much sharper.

Mizuno, the athletic-shoe company, had done an advertisement they had also used as a poster in the late '80s featuring Vince Coleman and Rickey Henderson with the caption "You'll Never Catch Them in Our Shoes." They both wore Mizuno shoes and regularly led their respective leagues in stolen bases. It was clever, and we noticed it. We were constantly looking at what was being done in the industry, looking at everything we could, to compare it to our work in order to get better.

Then, we received a phone call from someone at Mizuno who asked if we'd be interested in doing some posters for them, and a new poster of Vince and Rickey was at the top of their list. We wanted to shoot them in a warehouse hideaway in front of a mountain of stolen bases piled up behind them and call it "Partners in Crime." Mizuno appeared to like it, and we talked a few more times, but somehow, we never got it done, but we loved the concept and filed it away in case a good opportunity came around. Eventually, it did.

Gary Payton and Nate McMillan were two of the best defenders in the league, and when Seattle traded for Kendall Gill, the Sonics added one more premier athlete for Coach George Karl's smothering style of defense. The Sonics piled up 1,053 steals during the 1993–94 season, with Payton, McMillan, and Gill all in the top 14 in the category. (Each of them would individually lead the league in steals at some point in their careers.) In another stroke of luck for us, we could use "Partners in Crime" for our hometown team—but it would be about stealing basketballs instead of bases.

We worked with the Sonics on this one, and they arranged for us to shoot at Key Arena before a team practice. One of our artists had painted the background earlier. We got set up in an area on the lower concourse and had about an hour before the players were to arrive, so we sat in some courtside seats in the mostly dark arena. While we were waiting, the lights turned on—not the full arena lights, just over the court. So here we were, next to the floor where our team played—where we'd watched Sonics games from the time we were little guys—and it was like a spotlight had just been put on the court. There was literally nobody else around—but there were racks of basketballs next to us. What would you do?

Our crew went onto the court and did everything that came to mind. We played full court, shot free throws, pretended to shoot game-winners at the buzzer, played a game of H-O-R-S-E, and took shots from midcourt. And nobody kicked us off.

Eventually, Nate, Gary, and Kendall arrived, and we had to get to work. They all had entirely different personality types—Gary was, unsurprisingly, the cut-up of the group—but were all good to work with. We shot them in both sweats and uniforms, but clearly the uniforms looked better.

We didn't sell this poster, which is why it's so rare. It was a sponsored giveaway, and we printed only a few thousand. We love the way it turned out and loved working with our Sonics. But whenever we talk about this one, we remember how awesome it was to play on an NBA court and be kids again.

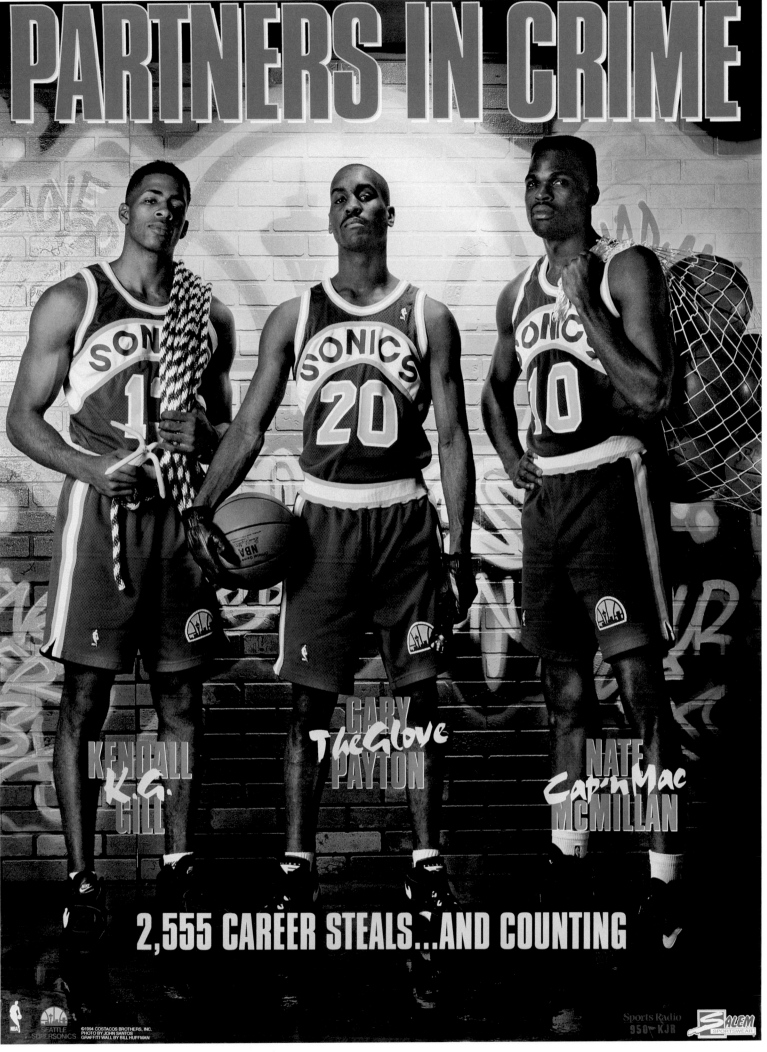

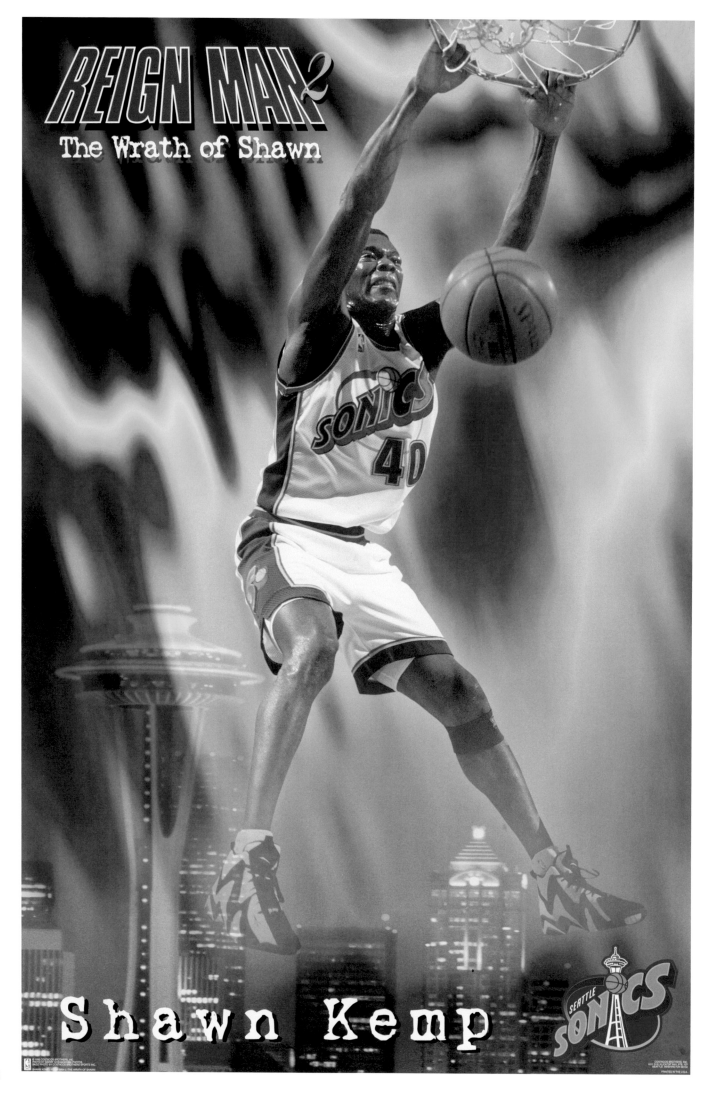

Shawn Kemp

Seattle SuperSonics
1993–94 All-NBA Second Team

John and Shawn on
the court when
Shawn was proudly
representing our
country as part of
Team USA.

There was beauty and violence in the way Shawn Kemp dunked the ball. It seemed like his teammates Gary Payton and Nate McMillan were tossing lobs way up just to see if Shawn could jump that high and throw them down. Even when they looked too high for anyone to reach, Shawn seemed to get up into the air, grab the ball, and slam it through. He was one of the most exciting players in the league. And he relished Reign Man, the nickname our production head, Tom Rees, had come up with for him.

Shawn told us that from the time he was a rookie, he had wanted his teammates to respect him and the fans to love him. He said he realized how much the fans enjoyed it when he dunked, so he did it as often as he could. And he said that once he got that nickname, "I wanted to be the Reign Man." That made us feel good.

The business was changing by the early '90s, and we felt greater pressure from the sports leagues and the players associations to increase our sheer volume, so we started adding new titles with the guys whose posters were selling the most. Our first "Reign Man" poster still sold well, but we needed more Shawn Kemp product.

For the title on this one, we went back to our old movie roots. One of the early Star Trek movies starring actors from the original series was called *Star Trek II: The Wrath of Khan*. Ricardo Montalban came back as Khan, a villain from a 1967 TV episode who returns years later to take revenge on Captain Kirk—kind of like how Kemp seemed to be taking revenge on all the rims around the NBA.

By this time, only about one or two in every 10 posters we did was shot in the studio anymore. The rest of them were made using action shots we got from the NBA. Also, Adobe Photoshop 3 had come out, and that made a big difference. At this point, we were moving away from composing posters in the photo lab and doing a lot of that work ourselves with computer software.

In the earlier days, it had been much harder to cut around a player and make him look like he belonged in a separate background, and the photo lab could do it better than we could. But that started to change, and our digital work looked on par with what the labs could do. And there were a lot of new special effects coming with each upgrade. When we look back on this time, it's fascinating to see the changes and upgrades that unlocked our capabilities. Each year, every year, we could simply do more. Everything we did became faster, easier, and less expensive. It's like comparing a smartphone to an old landline telephone—the difference in capability is awesome.

It took the same amount of time to design this kind of poster, and we had drastically fewer logistics to work out for photo shoots. But creating out of necessity—stemming from the number of posters we needed to produce—rather than out of love, is a different mind-set. We adjusted, and it worked out fine—somehow, it always did! This is one that we're really proud of—we love the way it looks. The colors are amazing in person with this thing full size on a wall, and using a shot of Shawn in action captures the emotion and power he played with.

The Poster Pipeline

By the early '90s, we had licenses with all the major sports leagues and their respective players associations, which had dramatically changed our business. At the beginning, we were more of a creative marketing company, working with players to produce a poster and then marketing it.

After we acquired the licenses, though, we became more of a mass-producing poster company. Instead of picking and choosing the posters we wanted to make, we had to meet obligations to satisfy our contracts with the licensors. In order to meet these obligations, we really had no choice but to change from shooting in the studio to using existing action photos and stripping them into backgrounds. These posters cost about 20 percent of the cost of a studio shoot. And it enabled us to make posters of more players. Many of these were athletes we wouldn't have done posters with under the old system because of the cost.

But being in a studio or on a set with an athlete to create something fun for their fans, improvising while we're there, and working *together* to make something memorable is more rewarding than sorting through slides and saying, "This one looks good." There's no comparison.

So, when we got a nice offer for our business from a good company, we thought, "We've had more fun than in any other career we could have imagined. Let's move on with almost a decade of unbelievably fun memories." And that's when we sold our poster business.

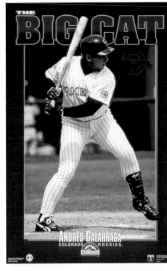

THE BIG CAT

Andrés Galarraga
COLORADO ROCKIES

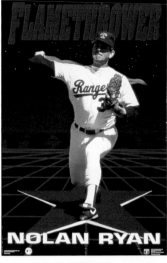

FLAMETHROWER

NOLAN RYAN

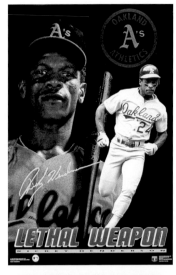

LETHAL WEAPON

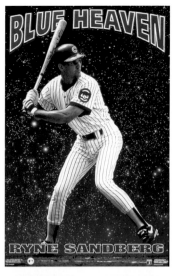

BLUE HEAVEN

RYNE SANDBERG

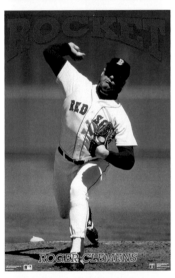

ROCKET

ROGER CLEMENS

Sabo
CINCINNATI REDS

CHRIS SABO

RED HOT

BARRY LARKIN

Spirit of St. Louis

MARK McGWIRE

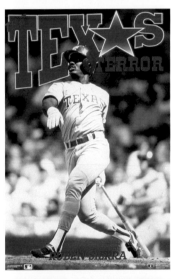

TEXAS TERROR

RUBEN SIERRA

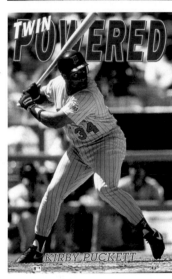

TWIN POWERED

KIRBY PUCKETT

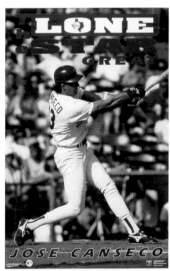

LONE STAR GREAT

JOSE CANSECO

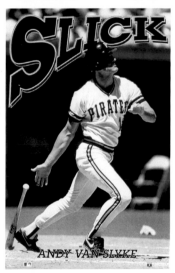

SLICK

ANDY VAN SLYKE

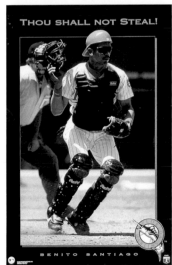

THOU SHALL NOT STEAL!

BENITO SANTIAGO

TRIPLE THREAT

ERIC DAVIS
BRETT BUTLER
DARRYL STRAWBERRY

THE BOB SQUAD

MIKE PIAZZA
hard TARGET

239

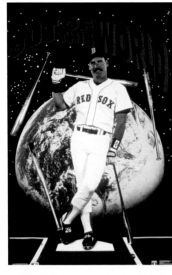

BOBBY BONILLA

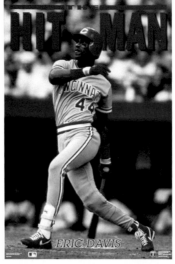

ERIC DAVIS

GREGG JEFFERIES

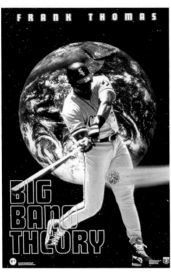

FRANK THOMAS

BIG BANG THEORY

BRADY PUNCH!

BRADY ANDERSON

ROBIN VENTURA

HOT CORNER

TRAVIS FRYMAN

PIRATES TREASURE

ANDY VAN SLYKE

MIRACLE NINTH

1992 NATIONAL LEAGUE CHAMPIONS

THE GOODBYE KID · KEN GRIFFEY JR.

RISING STAR

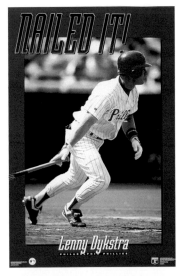

NAILED IT!

Lenny Dykstra
PHILADELPHIA PHILLIES

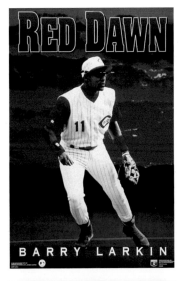

RED DAWN

BARRY LARKIN

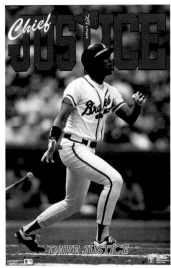

Chief JUSTICE

DAVE JUSTICE

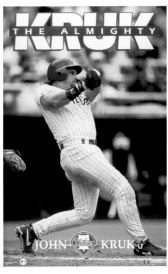

KRUK
THE ALMIGHTY

JOHN KRUK

KERRY WOOD

J
SOX
BLACK JACK
BLACK JACK
JACK McDOWELL
CHICAGO
SOX

BULLDOG

OREL HERSHISER

KID DYNAMITE

KEN GRIFFEY JR.

New York Yankees

VENOM

Matt Williams

DAVID NIED

THE NIED FOR SPEED

Dante Bichette
Vinny Castilla
Darryl Kile
WALKER
33
Larry Walker

ROCK THE HOUSE

TREVORLAND

TREVOR LINDEN

JET POWERED

TEEMU SELANNE

MONTREAL CANADIENS

THE WALL

PATRICK ROY

IN THE LINE OF FIRE

FELIX POTVIN

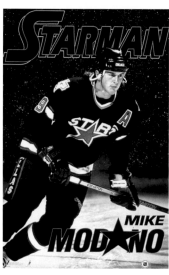

STARMAN

MIKE MODANO

RUNNING WITH THE DEVILS

BERNIE NICHOLLS

WENDEL CLARK

CAPTAIN CRUNCH

ERIC LINDROS

FORCE

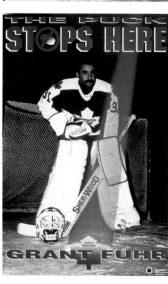

THE PUCK STOPS HERE

GRANT FUHR

ICE WARRIOR

MARK MESSIER

1997 STANLEY CUP CHAMPIONS 1998

BACK TO BACK

STANLEY CUP

BRIAN LEETCH
NEW YORK RANGERS

MADE IN AMERICA

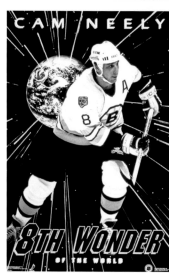

CAM NEELY

8TH WONDER
OF THE WORLD

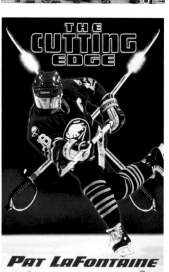

THE CUTTING EDGE

PAT LaFONTAINE

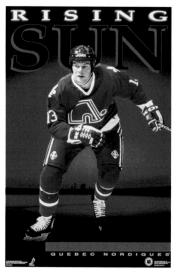

RISING SUN

QUEBEC NORDIQUES

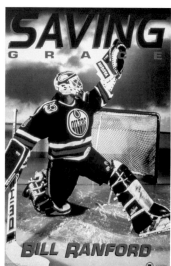

SAVING GRACE

BILL RANFORD

242

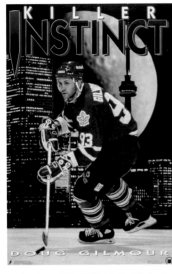

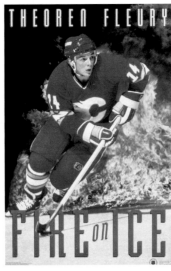

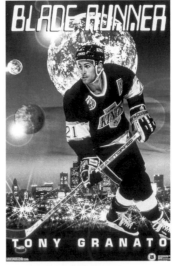

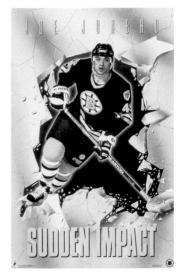

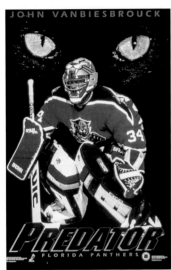

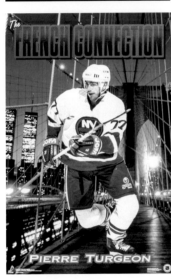

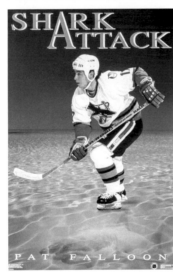

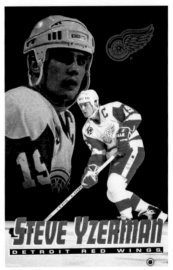

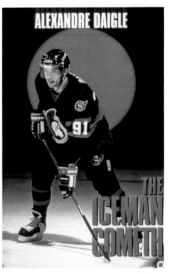

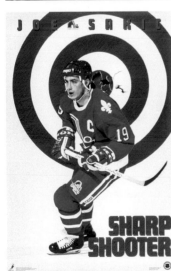

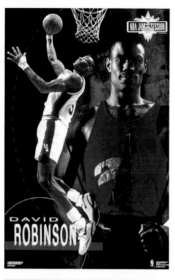

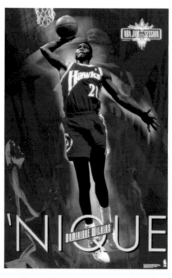

DAVID ROBINSON

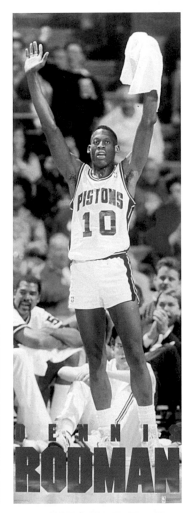

DENNIS RODMAN

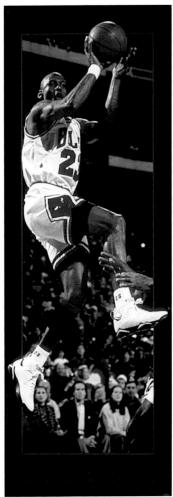

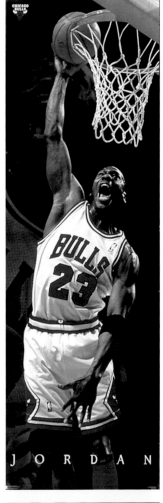

JORDAN

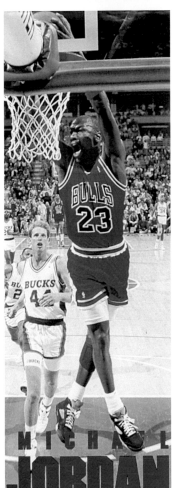

MICHAEL JORDAN

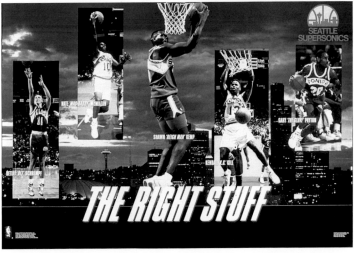

SEATTLE SUPERSONICS

THE RIGHT STUFF

JAMAL MASHBURN

SKYSCRAPERS

KNICKS

JOHN STARKS CHARLES SMITH PATRICK EWING CHARLES OAKLEY DEREK HARPER

BERNARD KING

CAPITAL OFFENSE

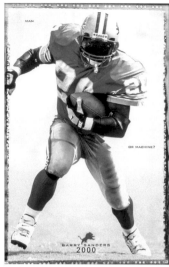

MAN

QB MACHINE7

BARRY SANDERS
2000

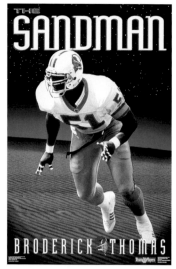

THE
SANDMAN

BRODERICK THOMAS

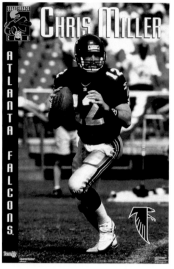

QUARTERBACK

CHRIS MILLER

ATLANTA FALCONS

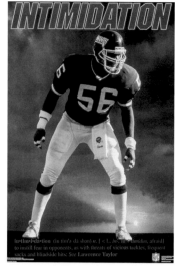

INTIMIDATION

in•tim•i•da•tion (in tim'ə dā'shən) n. [< L., in < L. timidus, afraid]
to instill fear in opponents, as with threats of vicious tackles, frequent
sacks and blindside hits; See Lawrence Taylor. NFL

RAGING WATERS

CHRIS SPIELMAN

KING
of the
BEASTS

DOMINATION
BRUCE SMITH

dom•i•na•tion (dŏn'ə-nā'shən) n. 1. the act of dominating with power.
2. Control; authority over offensive linemen, running backs and quarter-
backs. [<L. dominari, to rule, dominate] – See Bruce Smith.

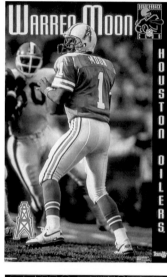

QUARTERBACK

WARREN MOON

HOUSTON OILERS

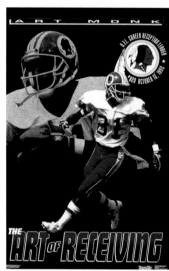

ART MONK

NFL CAREER RECEPTIONS LEADER

THE ART OF RECEIVING

JEFF GEORGE

THE SHERIFF

QUARTERBACK

PHIL SIMMS

GIANTS

TEXAS TWISTER

EMMITT SMITH

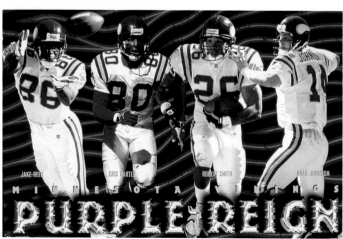

JAKE REED CRIS CARTER ROBERT SMITH BRAD JOHNSON

MINNESOTA VIKINGS
PURPLE REIGN

BONE CRUSHERS

GIANTS

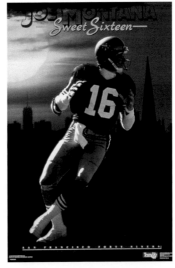

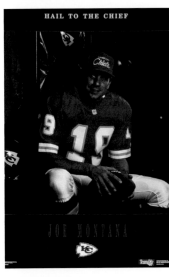

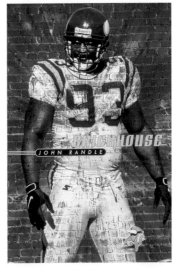

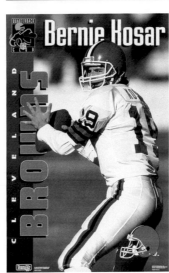

Chris Berman

ESPN

Broadcasting Icon

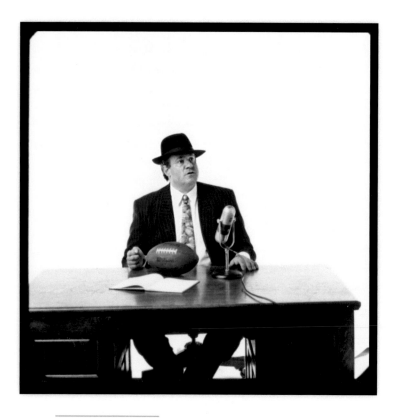

This test shot featured Chris wearing a football-themed tie, but he changed to a classier, white tie.

After we sold the company in 1996, Tock stayed on board, but I left and checked out of sports for a while. It had become so much of my daily life that I needed a break from it. When I started paying attention again, I got to watch a game for the game itself without any self-interest or thought about how the outcome would affect business.

But I was always creating, which is something I don't know how to turn off. Sometimes, ideas come to me while I watch a game, but far more often, it's when I'm just driving or talking with someone. I entertain myself this way (and I drove pretty much every girlfriend I've ever had crazy from it).

And one day, "The Gridfather" came to me. I don't remember if I'd seen *The Godfather* that week, but it just came to me. So I called Chris and told him about it. He liked it. A week or so later, I received a phone call and was greeted with Chris's unmistakable Boomer voice: "This is the Gridfather. They're in. We're on."

I watched the Godfather movies for inspiration and looked at their theatrical posters and video covers (back when "videos" were giant VHS cassette tapes). The costume was easy—a pinstripe mob-guy suit and a classic-looking microphone connected the dots of Chris being the longtime don of football broadcasting.

The shoot was scheduled for a Monday, and Chris told me that I could come the day before and hang out at ESPN Studios, so of course I showed up on Sunday. First, I watched Chris and his team tape the *NFL Countdown* pregame show. Then I went into a room that had a big wall of TV screens with every NFL game being played live. There was a ton of food (no beer, though), and I watched all the games with Chris and Tom Jackson. Steve Young and Stuart Scott were also there. I observed firsthand how this group of broadcasters identified things in the games that they would later point out on the *NFL PrimeTime* postgame highlight show, all the while still enjoying the games as fans and having a lot of fun banter between them.

Once the games were over, I watched in amazement as Chris and Tom Jackson performed for the *NFL PrimeTime* cameras—there was a lot of information coming at them so fast, but they handled it so smoothly. Viewers generally don't think about everything that's going on behind the scenes, because they're just taking it all in. It was one of my sports-fan dream days.

The next day was the photo shoot. Chris looked great in the pinstripe suit, very classy. It was shot right there in the ESPN studio. Chris is so used to being in front of a camera that it was easy and as natural as any shoot we ever did. We shot the background back in Seattle in the law office of Ron Neubauer, a friend of mine. Ron had a beautiful traditional wood cabinet behind his desk with glass, which worked very nicely. I particularly liked the football-shaped globe in the back and the *Godfather* caption reference: "The NFL on ESPN . . . an offer you can't refuse."

To be able to make a nickname poster for the greatest nicknamer of them all was a great experience. And the best part about it was spending the day with Chris. Whenever anyone asks, I tell them that the guy you see in front of the camera is the guy he is in person. And he sounds the same, too!

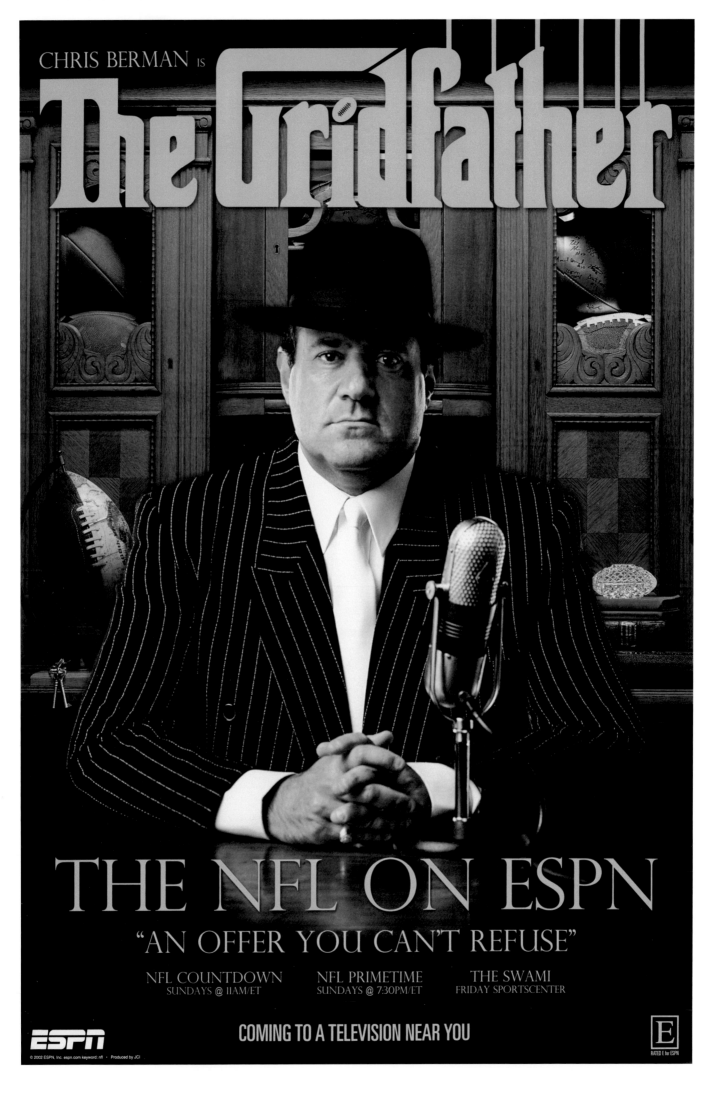

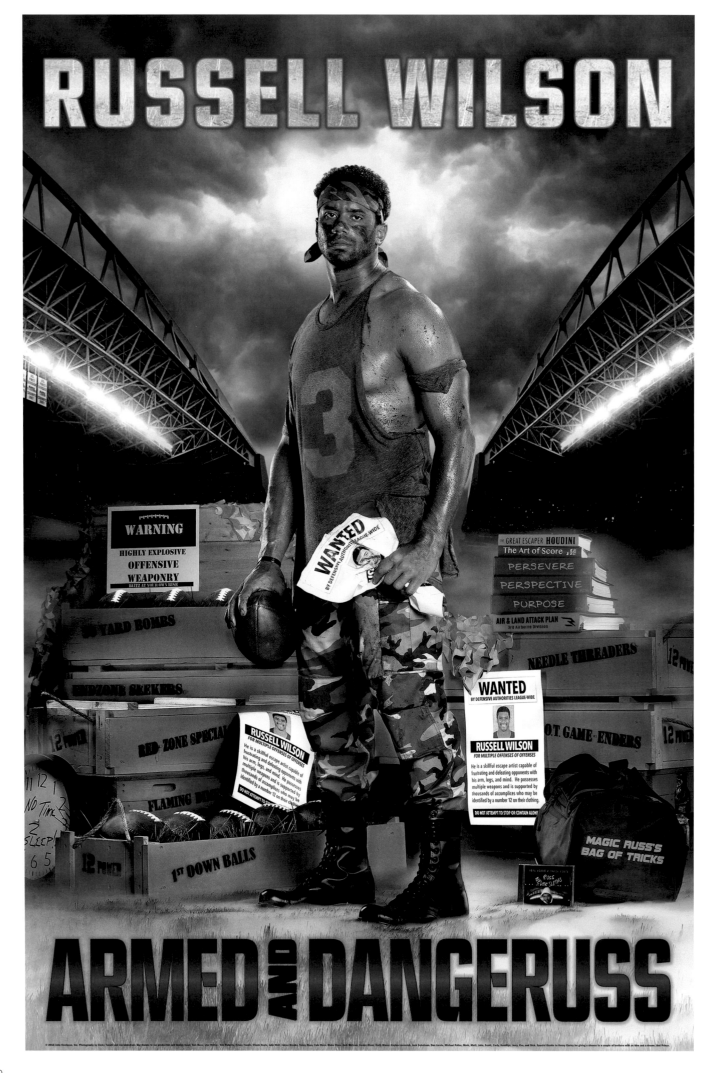

Russell Wilson

Seattle Seahawks
2015 NFL Passing Touchdowns Leader

Here's Russell
reviewing shots
with the crew.

We had first contacted Russell's agent, Mark Rodgers, in November 2013, which turned out to be during the season the Seahawks won the Super Bowl. We told Mark we didn't have a concept for him yet, but we'd be interested in working with Russell and would contact him when we had an idea.

There was a lot to draw from for Russell. He uses the name "dangeruss" for his social media, and he has a lot of sayings he uses to motivate himself, such as "There's no time to sleep" and "Why not you?" We played around with Dangeruss, and we had "Dangeruss Gamer" and "Danger Zone." Seattle radio broadcaster Warren Moon called him Houdini, so we thought about "The Magician" and "Magic Russ." Our production head, Tom Rees, came up with "The Rainmaker." In early 2016, we presented Mark and his team a list of 15 ideas, and they instantly liked "Armed and Dangeruss."

Russell was familiar with our old posters and wanted something that was full-on retro Costacos. After all, it was the first Costacos Brothers poster that we had worked on together in 20 years, and May tends to be our month. It was May 1986 when we shot our first poster, featuring Seahawk Kenny Easley, and May 1996 when we closed on the sale of our company, and now, in May 2016, we were back at it, shooting Russell.

It certainly felt like we were going back in time. For props and costumes, we went back to Jack Schaloum's army-surplus store, the same place we'd shopped in 1986. We went to the signage company Trademarx, where Bob Jarvis had made the signs for our Kenny Easley poster. Corky Trewin, who had shot our first posters, was in. We added photographer Joe Lindstrom, who is a lighting genius. Tom Rees, our production head, came back and brought his two teenage sons to work as production assistants. Our very first designer, Tom Roberts, who had done the "Purple Reign" shirts, came up from Los Angeles. Another designer, Lisa Walker, also came back. Tom quoted a line from The Blues Brothers: "We're puttin' the band back together." And we were.

One addition to our old crew was a production assistant named John Wall. For a charity auction, we had donated a chance to come to one of our poster shoots in the early '90s, and John had bought it. But we were never able to schedule it, and then we sold the company. We always felt bad about this, so we called the guy up and put him to work, and he had a blast.

The posters we had made in the past had two or three extra background details, but we got a chance to load this one up. "Magic Russ" is a nod to our generation of fans of the Who and their song "Magic Bus." Russell took the hands off the clock on the left and handwrote his "There's no time to sleep" motto. We added to that by parodying the Neil Young and Crazy Horse album Rust Never Sleeps by changing it to "Real Young and Crazy Force" and "Russ Never Sleeps."

The poster, released in late July 2016, was unveiled at a fundraiser for Russell's Why Not You Foundation, and the event raised over $450,000. The first two posters off the press went at the auction for $30,000 each. Former Seahawks and '80s Costacos Brothers poster boys Brian Bosworth and Steve Largent both came. It was really fun to get back into the scrimmage.

Aaron Judge

New York Yankees
2017 AL Home Run Leader

John and Aaron on the
set for his new poster.
Whose gavel is bigger?

This one took just 10 days from the initial phone call to shooting. Tock was retired from the poster business, but I was back, and I had to move fast. In late February, I received a call from a guy named Jeff Harding from Kamp Grizzly, an advertising and marketing company that has Adidas as a client.

Adidas, which had signed Aaron to an endorsement contract, wanted to announce it—with a Costacos poster. I asked what they had in mind, and he told me they were thinking of a judge's robe and white wig and calling it "The Judge." It was a good starting place, and I asked when they wanted to shoot it. The reply? "Next week or the week after."

I drove to Portland two days later for a meeting. I didn't like the idea of the judge's robe, because Aaron is a big, muscular guy, and you don't cover that kind of guy up in a poster. They didn't want to do "Judgement Day," so I suggested "Judgement Time," because that's what I'd call it if I was in the stands when Aaron comes to bat. We decided to put baseballs in the boxes and label the balls with the dates, cities, and distances for each of Aaron's league-leading 52 home runs in 2017. Since Aaron chews two pieces of Dubble Bubble chewing gum during each game, we'd also put two wrappers on the ground. We worked out the rest of the details, and a week later, we were in Tampa to shoot.

Kamp Grizzly had professional production people there already, working on the set, the props, the costumes, and everything else. We had half a day to perfect it all, and we were ready. I had never met photographer Tom DiPace before, though I'd spoken with him hundreds of times. He had shot dozens of posters for us, but our guys Tom Rees and Bart Unger had always been at those shoots, and it was nice to finally meet him in person and work with him.

Aaron showed up, and let me tell you, he is huge. He's bigger than Dave Winfield and bigger than the Bash Brothers. And he may be the nicest and most polite player I ever worked with. He brought his parents to the shoot, which says a lot about him. Aaron is adopted, and when Tom DiPace asked his parents when they knew he was going to be big, they answered, "We had an idea when he was drinking twice the amount of formula a baby usually takes."

He was very trusting and tried everything we asked of him. We went for a lot of different looks and poses, and he was willing to try everything we asked. This was good, because the poses we thought would look best didn't, and one of those down the list in the progression is the one that worked. We had found a hundred-year-old image of Ty Cobb and Shoeless Joe Jackson, each with three bats on his shoulder, and this was on the list, and it looked great when Aaron posed like them.

Once we had what we wanted, Kamp Grizzly wanted to try the judge's robe and white judge's wig. I could tell by the look on his face that Aaron hated it. While I was straightening the robe on him, I said quietly, "I'll fight to the death to make sure these don't see the light of day." He smiled and said, "Thanks."

Adidas put this shot on digital billboards all over New York, including a 70-foot-tall one near Madison Square Garden. That pretty much makes it our biggest poster ever.

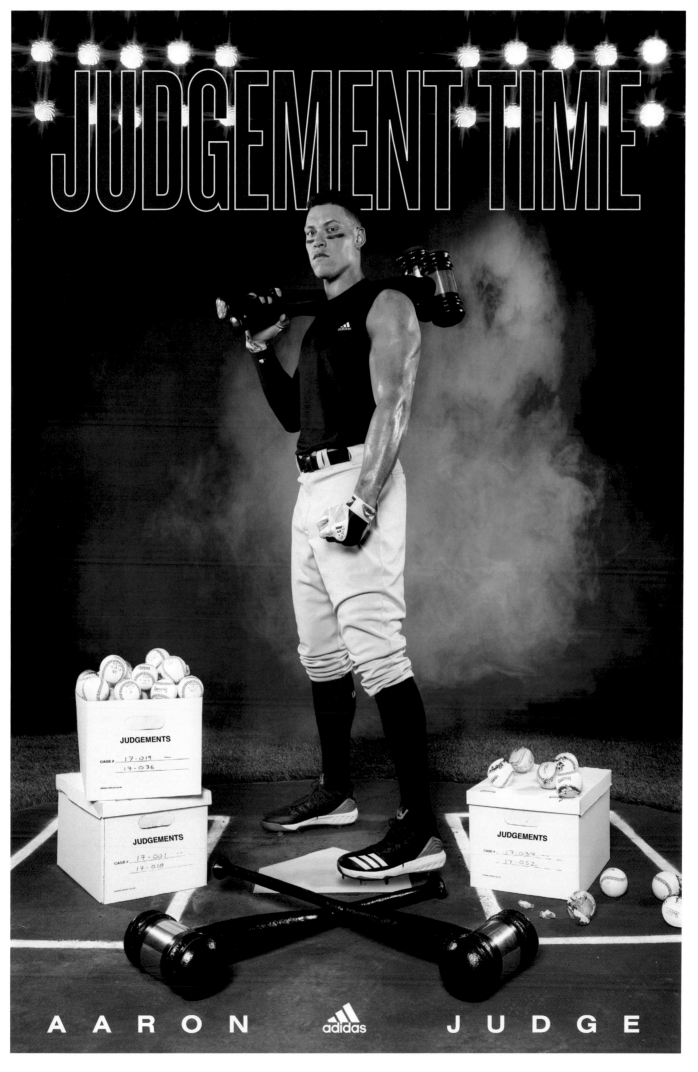

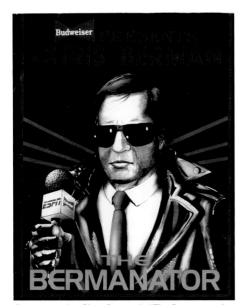

Concept art for Chris Berman's "The Bermanator" poster showing how the proposed colors would look.

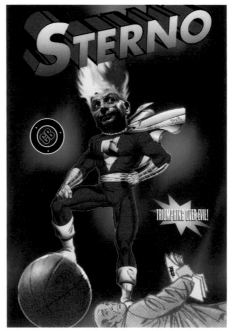

We ran into Commissioner Stern at his hotel, and sent a mockup of this "Sterno" comic book and some chocolates up to the commissioner's room. A thank-you note arrived a while later from New York.

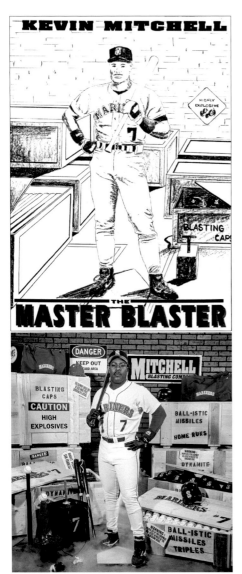

A concept sketch and outtake for Kevin Mitchell's "Master Blaster," from his 1992 season in Seattle.

Back in 1993, we shot this poster of Larry Johnson's Grandmama character, which was part of a hugely popular Converse advertising campaign. He really was like a semi coming at opponents on the court.

(from top left) Kendall Gill, Gary Payton, Nate McMillan, Tock, and John, after the "Partners in Crime" photo shoot.

Here is an outtake from the "Field of Dreams" poster, where we had Jack McDowell also pose in a modern White Sox uniform and then we split his image down the middle.

We shot a whole series of photos of Dallas Cowboys wide receiver Michael Irvin in different poses and with different facial expressions for the 1992 poster that became "Playmaker."

Harold Reynolds has baseball on his mind during his "Turning Point" photo shoot.

In the hands of Aaron Judge, the giant prop baseball bat gavels don't look as ridiculously big as they really are, as seen in this outtake from the March 2018 shoot in Florida.

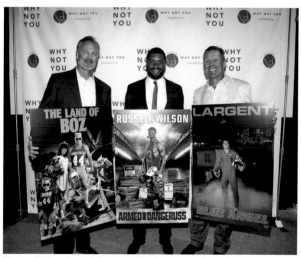

Former Seahawks and Costacos Brothers poster boys Brian Bosworth and Steve Largent flank Russell Wilson at Russell's charity event.

Author Acknowledgments

We dedicate this to our parents Jerry and Eva who are our biggest heroes. Thank you for all you taught us by your example, for teaching us to always strive to do the right thing, for your constant love and support, and for always being there for us and so many others.

Thanks to our friends and family who encouraged us throughout. Thanks to Kenny Easley for giving a chance to a couple of guys with an idea and nothing to back it with other than a willingness to work hard and do our best. Thanks to our skeptics who helped by making us even more determined. Thanks to Al Doggett and the geniuses at Ivey Seright and Duck Island for all the great post-production work.

Thanks to all the sports agents who worked through the creative process with us and trusted us with their clients.

We thank our licensing managers at the sports leagues and players associations for working with us through all the ups and downs in that constantly changing world we were in, and a special thanks to John Bello for your support for our crazy ideas.

We thank all the photographers for your friendship, the great work you did for us, your professionalism, and your patience with all our crazy ideas: Manny Akis (p127), Kevin Banna (p17), Robert Beck (p232), Andrew D. Bernstein (pp143, 149, 193, 206, 213), Jim Berry (p186), John Biever (p163), Bochene Photography (p60), Tom DiPace (pp173, 253) Roy Garibaldi (p217), Jay Goble (p18), Barry Gossage (pp209, 219, 236) Tony Inzerillo (p214), Dick Kaiser (p195), Chuck Kuhn (p220), Doug Landreth (pp34, 38, 50, 77) Joe Lindstrom (p250), Steve Lipofsky (p183), V.J. Lovero (p42), James P. McCoy (pp47, 96, 156, 165, 175, 190), Layne Murdoch (p180), Tom Rehder (pp146, 227), Wen Roberts (p224), Bob Rosato (p228), John Santos (p235), Chris Savas (pp41, 44, 63, 73, 74, 82, 85, 86, 89, 90, 93, 94, 99, 100, 102, 105, 107, 110, 113, 115, 116, 119), Chris Schwenk (pp20, 23, 25, 33, 127, 200), Jon SooHoo (pp189, 193, 211), Bill Smith (pp52, 54, 64, 68, 71, 120, 158), Corky Trewin (pp12, 15, 25, 26, 37, 48, 57, 67, 108, 128, 130, 133, 135, 136, 139, 140, 144, 150, 166, 168, 170, 184, 199, 222, 250), Hung Tran (p161), Ron Vesely (p214), Chris Vleisides (p196), Michael Zagaris (pp59, 146), and many others.

Thanks to our creative team at Costacos Brothers for making the magic with us: Reesini, Bartelli, The Great Santini, Sandstrini, Michaelangelo, Randini, Louigi, Enzo, Philippe, Torrelli, Christini, Chucky D, and Scott "The Kid."

To all our sales reps and our employees, every last one of you from the beginning through the end, in every department whether it was in accounting, customer service, warehouse, sales, or the creative room, you were all a necessary and important part of our family. We love and miss you all and the days down at Klickitat. We remember our employee Randy Huvaere who we lost to cancer. And to Jonah, we were proud to gather the whole company together and sing "God Bless America" for your U.S. citizenship.

Thanks to Mr. and Mrs. Pope, Zagorakis, Andy B., Savas, the Reesinis, the Ungers, Brown, Fitz, Renault, Sowholy, Spock, Yorgo, Chas B., Chris B., Jeff M., Rusty H., Andrea G., and Judge Lester for your continued friendship.

Thanks to Mike Folise for keeping us on the safe side, to Bob Nuber and John Hackett for your sustained and steady advice, to Tom Rehder for your help in so many ways and being there from start to finish, and to the whole crew at George Rice and Sons for the best quality work we could ever ask for. Rest in peace Bruce Tyler.

Tock: Thanks to Jim Daley for encouraging me to go for it with this business, to Helmi for helping me build the foundation, to JJ for your tireless work and your genius, to Teri for building CS, and to Kevin and Mr. Mayor for coming through at crunch time.

John: Thanks to my brother for putting up with me, my ex-girlfriends for putting up with me, and to all my friends for being my friends throughout the whole crazy ride.

To all our athlete clients, we thank each and every one of you for working with us and letting us make a little magic for the walls of the kids whose heroes you were.

And a big thanks to Prince. Without you, there'd have been no "Purple Reign" shirts and then no conversation that led us into posters. The number of friendships that came from this business is enormous. The smiles and amount of laughter that have added to our lives from those we met along the way can't be measured. So thanks, Prince. And rest peacefully . . . in the Purple Rain.

weldonowen

President & Publisher Roger Shaw
SVP, Sales & Marketing Amy Kaneko
Associate Publisher Mariah Bear
Acquisitions Editor Kevin Toyama
Creative Director Kelly Booth
Art Director Allister Fein
Production Designer Howie Severson
Production Director Michelle Duggan
Production Manager Sam Bissell
Imaging Manager Don Hill

Weldon Owen would like to thank Mark Nichol for his copyedit expertise, Precision Scans for digitally archiving these works of art, and Scott Thorpe, Brett MacFadden, Karoline Hatch, and Shannon Mitchner for their invaluable teamwork.

Library of Congress Cataloging-in-Publication Data is available.

ISBN: 978-1-68188-404-2

Printed and bound in China

Designed by Karoline Hatch for MacFadden & Thorpe

10 9 8 7 6 5 4 3 2 1
2018 2019 2020 2021

Weldon Owen
1045 Sansome Street, Suite 100
San Francisco, CA 94111
www.weldonowen.com

Weldon Owen is a division of Bonnier Publishing USA.

The information in this book is presented for an adult audience and for entertainment value only. The publisher and author assume no responsibility for any errors or omissions and make no warranty, express or implied, that the information in this book is appropriate for every individual, situation, or purpose. This book is not intended to replace professional advice from experts in the relevant fields. You assume the risk and responsibility for all of your actions, and the publisher and author will not be held responsible for any loss or damage of any sort—whether consequential, incidental, special, or otherwise—that may result from the information presented here.